Praise for *Adobe Photoshop One-on-One*

"As a Photoshop author, I hate picking up a book and learning things I didn't already know. But Deke's done it to me again! If you want to learn Photoshop CS5 from the ground up, look no further."

—Scott Kelby
President, National Association of Photoshop Professionals

"Deke McClelland has probably forgotten more than most people will ever know about Photoshop. He's insanely thorough (and just maybe insane), with a teaching style that's both engaging and practical. I think you'll love what he has to offer."

—John Nack
Principal Product Manager, Adobe Photoshop and Bridge, Adobe Systems

"In my past life as a Photoshop Product Manager, I continually turned to Deke and his books to dive deeper into the product. Whether you're a newbie or a hardened user, his *One-on-One* series will speak to you. There's nobody I would trust more to teach me Photoshop."

—Karen Gauthier
Senior Product Manager, Adobe Photoshop (1998–2005)
Director, Product Management, Gridiron Software (current)

"*Adobe Photoshop CS5 One-on-One* is like having Deke next to you while you learn how to organize, correct, retouch, and sharpen your photos. To me it's crystal clear! Deke loves exploring software to find the best techniques for improving images. And his easy-to-understand, cut-to-the-chase explanations are invaluable."

—Katrin Eismann
Chair, Digital Photography, School of Visual Arts

"It's like having Deke right there with you, with all his friendly insights, sharp skills, and vast experience. Only you don't have to feed him."

—Michael Ninness
Senior Product Manager, Adobe InDesign, Adobe Systems

"It's obvious why Deke is one of the most popular teachers of Photoshop. Throughout the book, he blends humor and authority in a way that makes simple work of Photoshop's most complex features. You feel like he's right there with you. It really is one-on-one!"

—Julieanne Kost
Photoshop Evangelist, Adobe Systems

Praise for *Adobe Photoshop One-on-One*

"What an awesome way to get deep inside Photoshop CS5: with lessons and techniques that are easy to follow and bring a new insight! Thanks Deke, for the pearls of wisdom and wonderfully illustrated lessons and references. This book helps us develop techniques to bring image quality to a new level. A great source of learning, *one on one!*"

—Eddie Tapp, M.Photog.,Cr.,MEI,API,CPP
imaging and workflow consultant, educator, photographer, author

"Once again Deke pushes Photoshop training to the next level. His new book is a giant leap forward in the evolution of teaching Photoshop in easy-to-learn and understandable steps. *Adobe Photoshop CS5 One-on-One* is the next generation of how to learn Photoshop!"

—Kevin Ames
photographer, author of *Adobe Photoshop: The Art of Photographing Women*

"*Adobe Photoshop CS5 One-on-One* provides more bang-for-the-buck than any Photoshop book I've seen. With the very readable full-color pages and the incredible video training, Deke gives you a multi-media package, rather than just a Photoshop book. Informative and entertaining, instructional and engaging, *One-on-One* is appropriate both for self-study and classroom use. It's the fundamentals of Photoshop taught by one of the most accomplished Photoshop instructors of all time!"

—Pete Bauer
Help Desk Director, National Association of Photoshop Professionals

"With his *One-on-One* series, Deke McClelland has created what might just be the best all-around way to learn Photoshop. The combination of video material, which is created specifically for the book, along with the project-based lessons in each chapter, is unbeatably effective. Highly recommended!"

—Colin Smith
Proprietor, *photoshopCAFE.com*

"Diving into Deke's latest Adobe Photoshop CS5 book is like a brilliant undersea adventure. Discovering his 'Pearls of Wisdom' makes each new chapter like a fantastic treasure hunt of great tips and techniques. Get out your digital swim fins and get ready to learn a boat load of information about CS5!"

— Cap'n Russell "Mad Sea-Dog" Brown
Senior Nautical Director, Adobe Systems

Adobe
Photoshop CS5
one-on-one™

Also from Deke Press

Photoshop Elements 8 One-on-One
Adobe InDesign CS4 One-on-One
Photoshop CS4 Channels and Masks One-on-One

Upcoming titles from Deke Press

Adobe Illustrator CS5 One-on-One

Adobe
Photoshop CS5
one-on-one™

DEKE McCLELLAND

deke™
PRESS
O'REILLY®

BEIJING • CAMBRIDGE • FARNHAM • KÖLN • SEBASTOPOL • TAIPEI • TOKYO

Adobe Photoshop CS5 One-on-One

by Deke McClelland

Copyright © 2010 Type & Graphics, Inc. All rights reserved.
Printed in the United States of America.

This title is published by Deke Press in association with O'Reilly Media, Inc., 1005 Gravenstein Highway North, Sebastopol, CA 95472.

O'Reilly Media books may be purchased for educational, business, or sales promotional use. Online editions are also available for most titles (*safari.oreilly.com*). For more information, contact O'Reilly's corporate/institutional sales department: 800-998-9938 or *corporate@oreilly.com*.

Managing Editor:	Carol Person	**Video Producer:**	Max Smith
Associate Editor:	Susan Pink, Techright	**Software Development Manager:**	Charles Greer
Organizeuse:	Toby Malina	**O'Reilly Online Wranglers:**	Kirk Walter, Gavin Carothers
Indexer:	Julie Hawks	**Live-Action Video:**	Jacob Cunningham, Loren Hillebrand, Andrew Brown
Technical Editor:	Ron Bilodeau		
Manufacturing Manager:	Sue Willing	**Video Editors:**	Paavo Stubstad, Ashly Blodgett, Nick Passick, Josh Olenslager
International Co-conspirator:	Colleen Wheeler		
Design Mastermind:	David Futato		
Junior Art Director:	Max McClelland		

Print History:

July 2010: First edition.

Special thanks to Michael Ninness, Lynda Weinman, Bruce Heavin, David Rogelberg, Sherry Rogelberg, Stacey Barone, Jason Woliner, Kevin O'Connor, Mordy Golding, Betsy Waliszewski, Sara Peyton, Melissa Morgan, and Tim O'Reilly, as well as Patrick Lor, Garth Johnson, Chad Bridwell, Megan Ironside, Danny Martin, Val Gelineau, Scott Kelby, John Nack, Bryan Hughes O'Neil, Zorana Gee, and the gangs at Fotolia, iStockphoto, PhotoSpin, NAPP, Peachpit Press, and Adobe Systems. Extra special thanks to our relentlessly supportive families, without whom this series and this book would not be possible. In loving memory of Marjorie Baer.

This book was typeset using Adobe InDesign and the Adobe Futura, Adobe Rotis, and Linotype Birka typefaces.

ISBN: 978-0-596-80797-9 [C] RepKover™ This book uses RepKover,™ a durable and flexible lay-flat binding.

We gave
them names.

But they shaped
themselves.

Max & Sam

CONTENTS

PREFACE

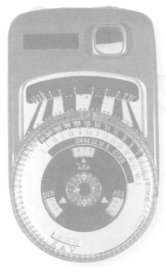

HOW ONE-ON-ONE WORKS

Welcome to *Adobe Photoshop CS5 One-on-One*, another in a series of highly visual, full-color titles that combine step-by-step lessons with more than four hours of video instruction. As the name *One-on-One* implies, I walk you through Photoshop just as if I were teaching you in a classroom or corporate consulting environment. Except that instead of getting lost in a crowd of students, you receive my individualized attention. It's just you and me.

I created *One-on-One* with three audiences in mind. If you're an independent graphic artist, designer, or digital photographer—professional or amateur—you'll appreciate the real-world authenticity of the tutorials and your immediate ability to apply what you learn in your own work. If you're a student working in a classroom or vocational setting, you'll enjoy the personalized attention, structured exercises, and end-of-lesson quizzes. If you're an instructor in a college or vocational setting, you'll find the topic-driven lessons helpful in building curricula and creating homework assignments. *Adobe Photoshop CS5 One-on-One* is designed to supply beginners with all the guidance they need to get started in Photoshop, while giving more advanced users the depth of knowledge that will fortify their expertise. And I've seen to it that each lesson contains a few techniques that even experienced Photoshoppers don't know.

Read, Watch, Do

Adobe Photoshop CS5 One-on-One is your chance to master Photoshop under the direction of a professional trainer with more than twenty years of computer design and imaging experience. Read the book, watch the videos, do the exercises. Proceed at your own pace and experiment as you see fit. It's the best way to learn.

Figure 1.

Adobe Photoshop CS5 One-on-One contains twelve lessons, each made up of three to six step-by-step exercises. Every lesson in the book includes a corresponding video lesson (see Figure 1), in which I introduce the key concepts you'll need to know to complete the exercises and see features that are best explained in action. Best of all, every exercise is project-based, culminating in an actual finished document worthy of your labors (like the example in Figure 2). The exercises include insights and context throughout, so you'll know not only what to do but—just as important—why you're doing it. My sincere hope is that you'll find the experience entertaining, informative, and empowering.

All the videos and sample files required to perform the exercises are available for download at *oreilly. com/go/deke-PhotoshopCS5*. If you already have an oreilly.com account and are logged in, you can click straight through to a site where you can play the videos, download them to your computer if you like, and get the sample files. (If you don't have an oreilly.com login, you'll be invited to create one, and then be sent properly on your way.) Together, the book, sample files, and videos form a single, comprehensive training experience.

Figure 2.

Previous installments of *Adobe Photoshop One-on-One* provided the video and practice files on a DVD bound in the back of the book. For the first time, I've made the decision to deliver video and practice files online instead. It's a more flexible, less wasteful approach that gives you the same great *One-on-One* instructional experience. Plus, I'm not limited with regard to sample file selection or video length—and I have a place to post updates, bonus material, and anything else I might want to share with you.

One-on-One Requirements

The main prerequisite to using *Adobe Photoshop CS5 One-on-One* is having Photoshop CS5 or Photoshop CS5 Extended installed on your system. You may have purchased Photoshop CS5 as a stand-alone product or as part of Adobe's Creative Suite 5. You *can* work through many of the exercises using an earlier version of Photoshop, but some steps will not work as written. All exercises have been fully tested with Adobe Photoshop CS5 but not with older versions.

Adobe Photoshop CS5 One-on-One is cross-platform, meaning that it works equally well whether you're using Photoshop installed on a Microsoft Windows-based PC or an Apple Macintosh.

Any computer that meets the minimum requirements for Photoshop CS5 also meets the requirements for using *Adobe Photoshop CS5 One-on-One*. Specifically, if you own a PC, you need Windows XP with Service Pack 3, Windows Vista (Home Premium or better) with Service Pack 1, or Windows 7. If you own a Mac, you need Mac OS X version 10.5.7 or higher.

Regardless of platform, your computer must meet the following minimum requirements:

* 1GB of RAM

* 2GB of available hard disk space

* 16-bit color graphics card that supports OpenGL 2.0 (as do most modern cards, including those from market-leader nVidia)

* Color monitor with 1024-by-768 pixel resolution

* Broadband Internet connection for sample files and videos

* QuickTime Player software (if it is not already installed and you want to watch downloaded versions of the videos offline; available at *www.apple.com/quicktime*)

One-on-One Installation and Setup

Adobe Photoshop CS5 One-on-One is designed to function as an integrated training environment. So before embarking on the lessons, I'm going to request that you install a handful of files onto your hard drive:

- Lesson files used in the exercises (700MB in all)

- *One-on-One* Creative Suite color settings

- Custom collection of keyboard shortcuts called *dekeKeys*

- A custom color workflow settings file

- The twelve lesson videos (if you want to view them offline; playing them online doesn't require any downloading)

- QuickTime Player software (if it is not already installed and you want to watch downloaded versions of the videos offline)

As you'll see, these files are all available at *www.oreilly.com/go/deke-PhotoshopCS5*, with the exception of QuickTime Player, which you can download from *www.apple.com/quicktime*.

I'll also have you change a few preference settings. These changes are optional—you can follow along with the exercises in this book regardless of your preferences. Even so, I advocate these settings for two reasons: First, they make for less confusion by ensuring that you and I are on the same page, as it were. Second, some of Photoshop's default preferences are just plain wrong. So, welcome to your first one-on-one style exercise:

1. *Go to* **www.oreilly.com/go/Deke-PhotoshopCS5.** This is the companion site for the book, where you can get all the supplemental materials you'll need. It's also where I'll be posting technical updates (in the event that Adobe makes significant changes to Photoshop), bonus content, and other things I find relevant. If you already have an oreilly.com account, you'll be asked to log in to the site straight away. If you need to create an account (it's free), you'll be taken through that process and returned to the companion page when you're done.

2. *Examine the table of contents.* At the companion site, you'll notice that each lesson has an entry in the table of contents. That's where you'll find each lesson's complement of sample files, archived in a separate *.zip* file for easier downloading. Once you get those files on your hard drive, you can right-click the *.zip* file and choose **Extract All** to create an unzipped folder for each particular lesson.

Stash the files somewhere convenient and memorable, so that when I direct you to open one during an exercise, it won't be hard to find. I'm going to suggest you make a *Lesson Files-PsCS5 1on1* folder on your desktop into which you drag those separate folders for each lesson. If you follow this suggestion, the instructions I've supplied at the beginning of each exercise will lead you right where you need to go.

3. **Decide whether you want to watch the videos at the site or offline.** At the outset of each book-based lesson, I'll ask you to play the companion video lesson. These video lessons introduce key concepts that make more sense when first seen in action. On the companion site, click the **Watch** button next to the video you want, and it will play in a spiffy online player (see Figure 3), which doesn't require that you download the movies or acquire a separate piece of software for playing them. I think it's a fairly nice experience, actually.

But if you have an unreliable Internet connection or you'd just rather have the freedom of keeping the videos where you can always get to them, click the **Download** button next to each lesson to save them to your hard drive (and remember you'll need QuickTime to watch them if you choose that route).

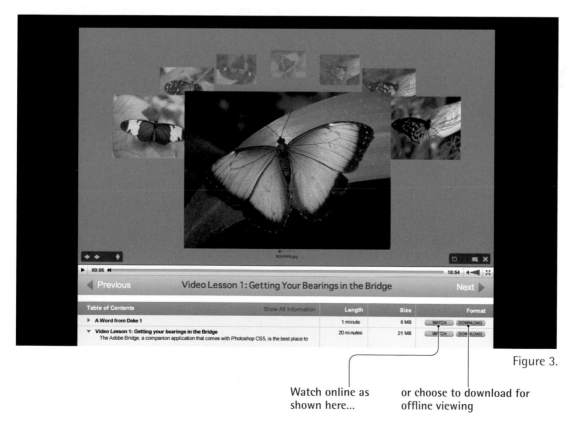

Figure 3.

Watch online as shown here...

or choose to download for offline viewing

I recommend Apple's QuickTime Player software because it's free and offers great playback functions.

4. ***Download the dekeKeys and color settings files.*** While you're online, notice that I've also provided two files to streamline and improve your Photoshop experience. One contains my custom keyboard shortcuts, and the other, my preferred color settings. So download *Best workflow CS5.csf* and *dekeKeys-Photoshop-CS5.zip*, put them somewhere you'll remember, and I'll show you how to install them in the next steps.

5. ***Move the color settings to the appropriate folder.*** Move the *Best workflow CS5.csf* file to one of two locations on your hard drive, depending on your platform and operating system. (Note that, in the following, user indicates your computer login name.)

 • Under Windows 7 and Vista, the location is
 C:\Users\user\AppData\Roaming\Adobe\Color\Settings

 • Under Windows XP, it's
 C:\Documents and Settings\user\Application Data\Adobe\Color\Settings

 • On the Mac, choose **Go→Home** and copy the color settings to the folder
 Library/Application Support/Adobe/Color/Settings

If you can't find the *AppData* or *Application Data* folder on the PC, it's because Windows is making the system folders invisible. Choose **Tools→Folder Options**, click the **View** tab, and turn on **Show Hidden Files and Folders** in the scrolling list. Also turn off the **Hide Extensions for Known File Types** and **Hide Protected Operating System Files** check boxes. Then click the **OK** button.

6. ***Start Photoshop.*** If Photoshop CS5 is already running on your computer, skip to Step 7. If not, start the program:

 • On the PC, go to the **Start** menu (⊕ under Windows Vista) and choose **Adobe Photoshop CS5**. (The program may be located in the **Programs** or **All Programs** submenu, possibly inside an **Adobe** submenu.)

 • On the Mac, choose **Go→Applications** in the Finder. Then open the *Adobe Photoshop CS5* folder and double-click the Adobe Photoshop CS5 application icon.

7. *Change the color settings to Best Workflow.* Now that you've installed the color settings, you have to activate them inside Photoshop. Choose **Edit→Color Settings** or press the keyboard shortcut, Ctrl+Shift+K (⌘-Shift-K on the Mac). In the **Color Settings** dialog box, click the **Settings** pop-up menu and choose **Best Workflow CS5** (see Figure 4). Then click the **OK** button. Now the colors of your images will match (or very nearly match) those shown in the pages of this book.

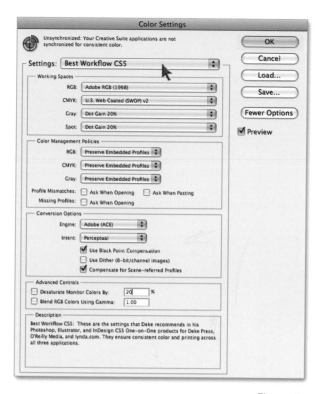

If you own the full Creative Suite 5 package, you'll need to synchronize the color settings across all Adobe applications. Launch the Adobe Bridge by choosing **File→Browse in Bridge**. Inside the Bridge, choose **Edit→Creative Suite Color Settings**. Locate and select the **Best Workflow CS5** item in the scrolling list. Then click **Apply**. Now all your CS5 applications will display consistent color.

8. *Install the dekeKeys keyboard shortcuts.* Return to the desktop level of your computer (or wherever you stashed *dekeKeys-Photoshop-CS5.zip*) and unzip the file. Then double-click *dekeKeys PsCS5 1on1.kys*. Photoshop will spring to the foreground. (If you get a message asking if you want to save the changes to your preexisting shortcuts, click **Yes**, give the shortcuts a filename, and click **Save**. But more likely, you won't see any message.)

9. *Confirm the dekeKeys installation.* To confirm that the dekeKeys shortcuts have installed successfully, choose **Edit→Keyboard Shortcuts** and do the following:

 • Confirm that the **Set** option at the top of the **Keyboard Shortcuts** dialog box reads **Photoshop Defaults (modified)**, meaning that some sort of shortcuts shift has occurred.

 • Set **Shortcuts For** to **Application Menus**.

 • Click the ▶ triangle to the left the **File** entry to view the commands in the File menu.

 • Scroll down to the **Place** command (between Revert and Import). If it lists the shortcut Alt+Shift+Ctrl+D (or Option-Shift-⌘-D)—as circled in Figure 5 on the next page—you're looking at dekeKeys.

Figure 4.

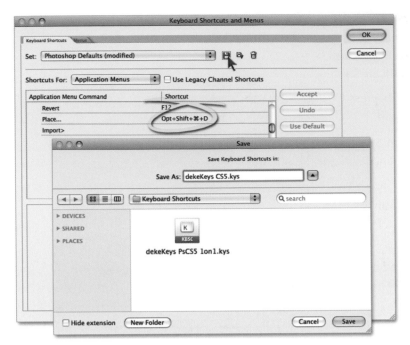

Figure 5.

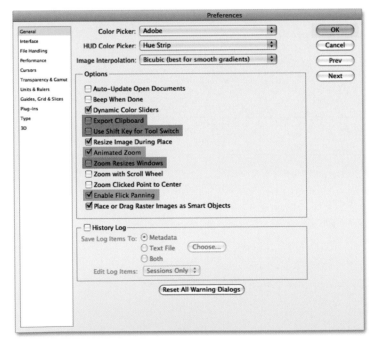

Figure 6.

PEARL OF WISDOM

For information about the wonderful features that rely on OpenGL, watch Video Lesson 2, "Navigation" (see page 40).

10. **Save the dekeKeys shortcuts.** Click the disk icon (💾) to the right of the **Set** option to save the modified shortcuts. Name the new shortcuts "dekeKeys CS5" (or your own name if you plan on customizing them further), and click **Save**, as in Figure 5. Then click **OK** to complete the process. You now have shortcuts for some of Photoshop's most essential commands, including Variations, Color Range, and Smart Sharpen.

11. **Adjust a few preference settings.** To minimize confusion and maximize Photoshop's performance, I'd like you to modify a few preference settings. Choose **Edit→Preferences→General** (that's **Photoshop→Preferences→General** on the Mac) or press Ctrl+K (⌘-K). I've highlighted these settings in Figure 6 and the next four figures. Red means turn the option off, green means turn it on.

- Photoshop lets you copy big images. And when you switch programs, Photoshop conveys those copied images to the system. Problem is, that takes time and the operation often fails. Avoid complications by turning off the **Export Clipboard** check box.

- Turn off the **Use Shift Key for Tool Switch** check box. This makes it easier to switch tools from the keyboard, as we'll be doing frequently over the course of this book.

- Make sure that both the **Animated Zoom** and **Enable Flick Panning** check boxes are available and on. If they're dimmed, you either have a system that is incompatible with the graphics acceleration standard OpenGL or need to update your graphics card driver.

- If you use a Mac, turn off **Zoom Resizes Windows**. (On the PC, it's off by default.) In Photoshop CS5, the Zoom commands and the zoom tool share the same window resizing behavior, and trust me, you don't want the zoom tool resizing the window.

- Click **Interface** in the left-hand list. Or press Ctrl+2 (⌘-2 on the Mac). This switches you to the next panel of options.

- Set all **Border** options in the top-right area of the dialog box to **None**. This makes for less confusion when gauging the boundaries of an image.

- By default, every image opens in a tabbed window, permitting you to switch between images just by clicking a tab. Sometimes I like the tabbed interface; sometimes I don't. You can disable it by turning off **Open Documents as Tabs**. In other words, I'm just letting you know it's an option. Hence the yellow highlighted check box in Figure 7.

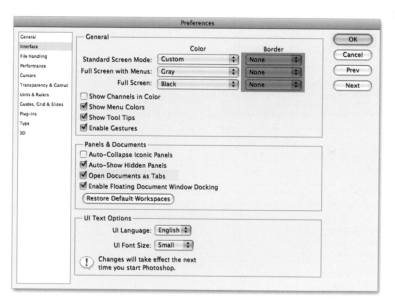

Figure 7.

- Click **File Handling** in the left-hand list or press Ctrl+3 (⌘-3) to switch panels. Notice the pop-up menu labeled **Maximize PSD and PSB File Compatibility?** Unless you're a video professional or you trade images between Photoshop and Lightroom (a separate program from Adobe), this option is best set to **Never**, as I've done in Figure 8.

Figure 8.

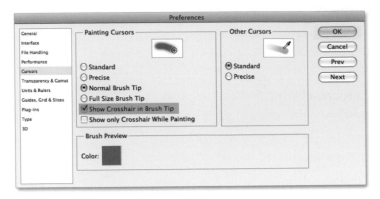

Figure 9.

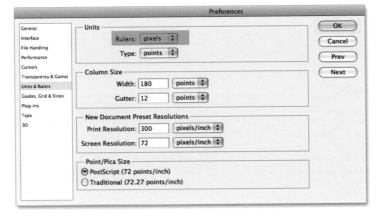

Figure 10.

- Click **Cursors** in the left-hand list, or press Ctrl+5 (or ⌘-5) to switch panels.

- Turn on the **Show Crosshair in Brush Tip** check box. Highlighted green in Figure 9, this option adds a + to the center of every brush cursor, which helps you align the cursor to a specific point in your image.

- Click **Units & Rulers** in the left-hand list, or press Ctrl+7 (or ⌘-7) to display another panel of options.

- Set the **Rulers** pop-up menu to **Pixels**, which I've highlighted green in Figure 10. As you'll see, pixels are far and away the best unit for measuring digital images.

- Your preferences now match those of the loftiest image-editing professional. Click **OK** to exit the Preferences dialog box and accept your changes.

12. *Quit Photoshop.* You've come full circle. On the PC, choose **File→Exit**; on the Mac, choose **Photoshop→Quit Photoshop**. Quitting Photoshop not only closes the program but also saves the changes you made to the color settings, keyboard shortcuts, and preference settings.

Congratulations, you and I are now in sync. Just one more thing: If you use a Macintosh computer, please read the following section. If you use a PC, feel free to skip the next section and move along to the following one, "Structure and Organization."

Reassigning the Mac OS X Shortcuts

Adobe intends for the function keys to display or hide common panels. Meanwhile, pressing ⌘ and Option with the spacebar should access the zoom tool. But in recent versions of OS X, these keys will tile or hide windows according to Apple's Exposé or will invoke search functions via Apple's Spotlight. To rectify these conflicts, do the following steps:

1. *Open your OS X System Preferences.* From the menu, choose **System Preferences.** Click the **Keyboard & Mouse** icon, and then click the **Keyboard Shortcuts** button.

2. *Reset the Dashboard & Dock settings.* In the left-hand pane, click **Dashboard & Dock**. In the right-hand pane, click the **F12** shortcut to highlight it. Then press Control-F12 (which appears as ^F12 in the window).

3. *Switch to the next group of shortcuts.* Click **Expose & Spaces**, replace **F9** with Control-F9, **F10** with Control-F10, and **F11** with Control-F11.

4. *Reset the ⌘-spacebar functionality.* Spotlight, Mac's questionably useful search feature, has taken over the ⌘-spacebar and ⌘-Option-spacebar shortcuts. In Photoshop, these shortcuts let you zoom in and out of your images with immensely convenient efficiency. Reclaim this handy feature by choosing **Spotlight** in the left-hand pane. Next, click ⌘**Space** and replace it with ⌘-Control-F1, and click ⌥-⌘-**Space** and replace it with the shortcut ⌘-Control-Option-F1 (which shows up in reverse order as ^⌥⌘F1).

5. *Close System Preferences.* Finally, click the ⊗ in the top-left corner of the window to close the system preferences.

From now on, the panel and zoom tool shortcuts will work according to Adobe's intentions, as well as the directions provided in this book.

Structure and Organization

Each of the lessons in the book conforms to a consistent structure, designed to impart skills and understanding through a regimen of practice and dialog. As you build your projects, I explain why you're performing the steps and why Photoshop works the way it does.

Each lesson begins with a broad topic overview. Turn the first page of each lesson, and you'll find a section called "About This Lesson," which lists the skills you'll learn and provides you with a short description of what you'll find in the video-based component of the lesson.

As you read in "One-on-One Installation and Setup," on page xvi, the videos can be streamed or downloaded from the book's companion Web site, found at *www.oreilly.com/go/deke-PhotoshopCS5.*

These video lessons are an integral part of my plan for helping you really get your bearings in Photoshop. Ranging from 15 to 45 minutes apiece, these high-quality videos introduce key concepts, focusing on those features and techniques that make more sense if you first see them in action.

Theoretically, you can watch the video lessons in any order you like. However, each video makes the most sense and provides the most benefit when watched at the outset of the corresponding book-based lesson.

Edited and produced by the trailblazing online training company lynda.com, the video lessons are not traditional low-budget DVD-style video training. They were made specifically to work with the exercises in this book, not excerpted from versions of my full-length video training. A great deal of care—both in form and in content—has gone into making the video lessons.

One final note: Unlike the exercises in the book, most of the video lessons do not include sample files. The idea is that you work along with me in the book; you sit back and relax during the videos.

Next come the step-by-step exercises, in which I walk you through some of Photoshop's most powerful and essential image-manipulation functions. A globe icon (like the one on the right) appears whenever I ask you to open a file from the *Lesson Files-PsCS5 1on1* folder that you created on your computer's hard drive.

To make my directions crystal clear, command and option names appear in bold type (as in, "choose the **Open** command"). The first appearance of a figure reference is in colored type. More than 800 full-color, generously sized screen shots and images diagram key steps in your journey, so you're never left scratching your head, puzzling over what to do next. And when I refer you to another step or section, I tell you the exact page number to go to. (Shouldn't every book?)

To make doubly sure there are as few points of confusion as possible, I pepper my descriptions with the very icons you see on screen, critical icons like 👁, *fx*, ⬚, and ⬚. So when I direct you to add a layer to your document, I don't tell you to click the Create a New Layer icon at the bottom of the Layers panel. (The only time you see the words *Create a New Layer* is when you hover your cursor over the icon, which is hard to do if you don't know where to hover your cursor in the first place.) Instead, I tell you to click the ⬚ icon, because ⬚ is what it is. It has meant hand-drawing nearly 400 icons to date, but for you, it was worth it.

Along the way, you'll encounter the occasional "Pearl of Wisdom," which provides insights into how Photoshop and the larger world of digital imaging work. Although this information is not essential to performing a given step or completing an exercise, it may help you understand how a function works or provide you with valuable context.

More detailed background discussions appear in independent sidebars. These sidebars shed light on the mysteries of color, bit depth, resolution, and other high-level topics that are key to understanding Photoshop.

A colored paragraph of text with a rule above and below it calls attention to a special tip or technique that will help you make Photoshop work faster and more smoothly.

Some projects are quite ambitious. My enthusiasm for a topic may even take us a bit beyond the stated goal. In such cases, I cordon off the final portion of the exercise and label it "Extra Credit."

If you're feeling oversaturated and utterly exhausted, the star icon is your oasis. It's my way of saying that you deserve a break. You can even drop out and skip to the next exercise. On the other hand, if you're the type who believes quitters never prosper (which they don't, incidentally), by all means carry on; you'll be rewarded with a completed project and a wealth of additional tips and insights.

I end each lesson with a "What Did You Learn?" section featuring a multiple-choice quiz. Your job is to choose the best description for each of twelve key concepts outlined in the lesson. Answers are printed upside-down at the bottom of the page.

A "Further Investigation" marker includes information about further reading or video training. For example, let me use this one to refer you to the lynda. com Online Training Library. Oftentimes, I refer you to the lynda.com Online Training Library, which contains tens of thousands of movies, more than a thousand of them by me. And all available to you, by subscription, every minute of every waking day. Just to be absolutely certain you don't feel baited into making yet another purchase, I've arranged a time-limited back door for you. Go to *www.lynda.com/deke* and sign up for the 7-Day Free Trial Account. This gives you access to the entire Online Training Library. But remember, your seven days start counting down the moment you sign up, so time it wisely. Then again, if you find the service so valuable you elect to subscribe, we're happy to have you. You'll be happy, too.

The Scope of This Book

No one book, including this one, can teach you everything there is to know about Photoshop. Here's a quick list of the topics and features discussed in this book and in the videos, as well as a visual preview (in Figure 11) of what you'll encounter in the integrated videos that accompany each lesson.

- Lesson 1: Opening and organizing files, including the Adobe Bridge, ratings, workspaces, stacks, metadata, keywords, and the Batch Rename command

- Lesson 2: Navigation and cropping, including moving around with OpenGL, the crop and rotate tools, and the Image Size and Canvas Size commands

- Lesson 3: Selection tools, including the lasso, magic wand, and quick selection tools, as well as the Select menu and the Refine Edge command

- Lesson 4: Painting and retouching, including the paintbrush, dodge, burn, sponge, healing brush, and red eye tools, as well as the new bristle brushes and the History panel

- Lesson 5: Layer functions, including the Layers and Layer Comps panel, scaling and repositioning, blending options, and knockouts

Video Lesson 1: Browsing in the Bridge

Video Lesson 2: Navigation

Video Lesson 3: The Selection Tools

Video Lesson 7: Introducing Filters

Video Lesson 8: Liquify in Motion

Video Lesson 9: Exploring Camera Raw

- Lesson 6: Luminance adjustments, including the Levels, Curves, Shadows/Highlights, Hue/Saturation, and Brightness/Contrast commands and the Histogram panel

- Lesson 7: Filters and smart objects, including the Smart Sharpen filter and smart filters

- Lesson 8: Distortions, including the Free Transform, Liquify, and new Puppet Warp commands, and content-aware scaling

- Lesson 9: Professional photographic tools, including Adobe Camera Raw, Photomerge, and HDR Pro

- Lesson 10: Masking functions, including the Color Range command, the Calculations function, the pen tool, and the Channels panel

- Lesson 11: Text and shape layers, including the type and shape tools, the Character and Paragraph panels, custom shapes, type on a path, and the Warp Text dialog box

- Lesson 12: Output functions, including Save for Web and Devices, the Print and Color Settings commands, print quality, the Custom CMYK option, dot gain, and packaging images in a PDF document from the Bridge

Video Lesson 4: Brushes and Painting

Video Lesson 5: Layer Manipulations

Video Lesson 6: Color Adjustments

Video Lesson 10: Masking

Video Lesson 11: Creating Vector Art

Video Lesson 12: Exporting for the Web

Figure 11.

Note that this book does not address every feature in Photoshop, including the following: the Actions panel; changing pixel aspect ratio for video; or any of the 3-D, video, medical, and architectural features available in Photoshop CS5 Extended but absent from the more affordable standard edition of the software.

FURTHER INVESTIGATION

If actions in particular are of interest to you, I have an eighteen-hour video series that covers the wide world of actions, batch processing, droplets, and scripting called *Photoshop Actions and Automation.* To gain access to it right this minute, go to *www.lynda.com/deke* and sign up for your seven days.

I now invite you to turn your attention to Lesson 1, "Open and Organize." I hope you'll agree with me that *Adobe Photoshop CS5 One-on-One*'s combination of step-by-step lessons and video introductions provides the best learning experience of any Photoshop training resource on the market.

FEAR IS a great motivator. And the good folks at Adobe must agree. Otherwise, why would they have created Photoshop, a program seemingly designed to frighten and intimidate? Why did they make the program vast and complicated, with redundant options, misleading commands, and downright ritualistically obscure functions, all devoted to the seemingly prosaic task of changing the color of a few pixels? And why is Photoshop so intent upon revealing the complexities of color corrections, image manipulations, and brushstrokes instead of hiding them, the way other computer applications do?

The answers are as numerous as Photoshop's features. As much as I love Photoshop—call me sick, but as much as a man can love a retail computer application, I ❀♡*love*❀! this one—I'm the first to admit that virtually every feature requires a separate defense. Thankfully, the pain of learning this vast and at times ungainly behemoth is its own reward. Mastering a powerful tool such as Photoshop focuses the mind. It toughens the spirit. And in time, it transforms you into an image warrior.

This book takes you on that journey of pain and reward. Sure, there may be occasional times when you'll wonder if Photoshop is Adobe's idea of the Nine Circles of Hell. But just as Dante emerged from the lowest circle by climbing down the very Devil himself, we'll conquer Photoshop by descending directly into it and coming out the other side. We will make peace with Photoshop through understanding, the understanding borne by knowledge, the knowledge wrought by experience. In time, you (like me) will be sick with your ❀♡*love*❀! for Photoshop. Perhaps not as sick as Figure 1-1, but sick nonetheless. That is to say, mastery will be yours.

IN THE NINTH CIRCLE:

YOU WILL COME TO LOVE PHOTOSHOP

Figure 1-1.

Scary artwork istockphoto.com/prill

ABOUT THIS LESSON

Project Files

Before beginning the exercises, make sure you've downloaded the lesson files from *www.oreilly.com/go/Deke-PhotoshopCS5*, as directed in Step 2 on page xvi of the Preface. This means you should have a folder called *Lesson Files-PsCS5 1on1* on your desktop (or whatever location you chose). We'll be working with the files inside the *Lesson 01* subfolder.

Before you can use the vast array of tools and functions inside Photoshop, you must know how to find and open the image you want, and that means organizing your image files in the Bridge. As glad fortune would have it, that's precisely what this lesson is about. In the following exercises, you'll learn how to:

Video Lesson 1: Browsing in the Bridge

The Adobe Bridge, a companion application that comes with Photoshop CS5, is the best place to get organized and oriented. Besides easily finding the file you want to open in Photoshop, you can sort, preview, examine, group, and compare your photos in the Bridge. And with Bridge CS5's new Export panel, you can save an entire folder's worth of raw format files as JPEGs for easy portability.

To get your bearings in the Bridge, visit *www.oreilly.com/go/deke-PhotoshopCS5*. Click the **Watch** button to view the lesson online or click the **Download** button to save it to your computer. During the video, you'll learn these shortcuts:

Operation	Windows shortcut	Macintosh shortcut
Open an image file	Ctrl+O (that's the letter *O*)	⌘-O (that's the letter *O*)
Zoom in or out	Ctrl+⊡ (plus), Ctrl+⊡ (minus)	⌘-⊡ (plus), ⌘-⊡ (minus)
Stack photos in a group	Ctrl+G	⌘-G
Expand a stack to see all the photos	Ctrl+→	⌘-→
Collapse a stack	Ctrl+←	⌘-←
Enter Review mode	Ctrl+B	⌘-B
Exit Review mode	Esc	Esc
View a full-screen preview	spacebar	spacebar

What Is Photoshop?

Photoshop, as the fellow says, is an *image editor*. It lets you open an image—whether captured with a scanner or a digital camera or downloaded from the Web—and change it. You can adjust the brightness and color, sharpen the focus, retouch a few details, and do scads more. When you're finished, you can save your changes, print the result, attach it to an email, post it to your blog, whatever. If you can imagine doing something to an image, Photoshop can do it. It's that capable.

But it doesn't end there. You can also use Photoshop to enhance artwork that you've scanned from a hand drawing or created with another graphics program. If you're artistically inclined, you can start with a blank document and create a piece of artwork from scratch. If that's not enough, Photoshop offers a wide variety of illustration tools, special effects, and text-formatting options, from placing type on a path to checking your spelling.

Opening an Image

Like every other major application on the face of the planet, Photoshop offers an Open command in the File menu. Not surprisingly, you can use this command to open an image saved on your hard disk or some other media. But Photoshop offers a better way to open files: the Adobe Bridge. I'll be showing you several ways to use this independent and powerful application throughout this lesson. The following steps explain the basics:

1. **Start the Bridge.** Assuming that Photoshop is running (see Step 6 on page xviii of the Preface), click the Br icon in the application bar or choose **File→Browse in Bridge**. Both icon and command appear in Figure 1-2. (The application bar sits to the right of the menu bar on the PC and below it on the Mac. I show it above the menu bar in the figure so you can see the details better.) A few moments later, the Adobe Bridge will come into view.

2. **Navigate to the McClelland Boys *folder*.** The Bridge window is, by default, divided into five main panels: two on the left, the large *content browser* in the middle, and two more on the right, each labeled black in Figure 1-3 on the following page. (Blue-green labels show ancillary options.) The top-left section contains tabs that let you switch between the Favorites and Folders panels. The Favorites panel gives you instant access to commonly used folders, as well as a few places that Adobe

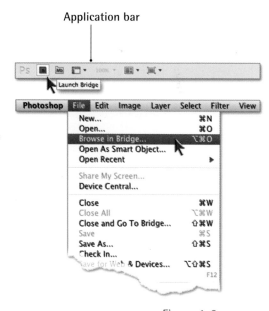

Figure 1-2.

thinks you'll find useful. The Folders panel lets you navigate to a specific folder on your hard disk or other media that contains the file or files you want to open. With that in mind, here's what I want you to do:

- Click the **Folders** tab in the top-left corner of the window to access the *folder tree*, thus termed because it branches into folders and subfolders.

- Scroll to the top of the list until you find the blue **Desktop** icon. (This assumes you installed the lesson files on the desktop, per my instructions in Step 2 on page xvii of the Preface.)

- See the gray "twirly" triangle (▶) in front of the word **Desktop**? Click it to expand (or twirl open) the desktop and reveal the folders on your computer's desktop.

- Locate the folder called *Lesson Files-PsCS5 1on1* (they should appear in alphabetical order) and click its ▶ to expand it.

- Click the ▶ in front of the *Lesson 01* folder.

Parent folders/favorites

Recent file/folder

Return to Photoshop

Back/forward

Get photos

Refine

Open in Camera Raw

Content browser

Sort/filter options

Compact mode

Thumbnail quality

Application bar

Workspaces

Output

Path bar

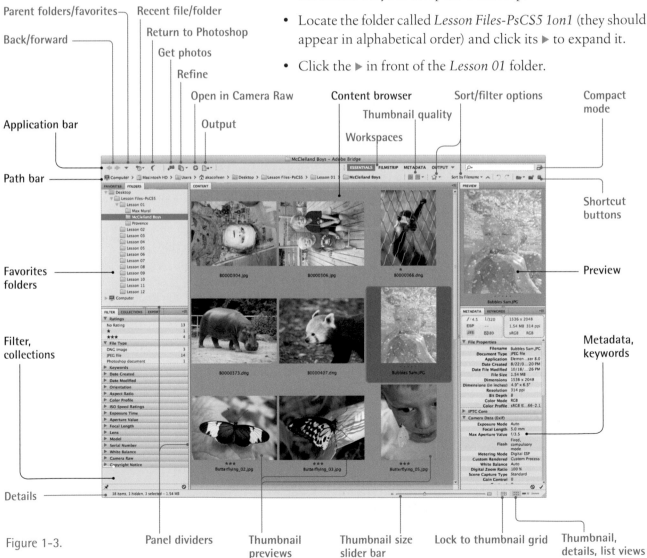

Shortcut buttons

Preview

Favorites folders

Metadata, keywords

Filter, collections

Details

Figure 1-3.

Panel dividers

Thumbnail previews

Thumbnail size slider bar

Lock to thumbnail grid

Thumbnail, details, list views

- You'll see a folder called *McClelland Boys*, because these are photos I took while out with my kids. Click that folder to fill the content browser with a collection of eighteen tiny photographic *thumbnails*, as in Figure 1-3.

To change the size of the thumbnails, drag the slider triangle in the bottom-right corner of the window (labeled *Thumbnail size slider bar* in Figure 1-3).

3. *Select a thumbnail.* Locate and click the file called *Butterflying_03.jpg*, highlighted in Figure 1-4. (Some of these images were captured and automatically named by a digital camera, hence their cryptic filenames.) This activates the image and displays it in the Preview panel on the right side of the Bridge window.

To see more detail, enlarge the Preview panel by dragging the vertical and horizontal panel dividers that separate the five panels.

4. *Double-click the thumbnail.* Double-click the thumbnail in the **Content** panel, and choose **File→Open** or press Ctrl+O (⌘-O on the Mac). The Bridge hands off the image to Photoshop, which in turn loads the photo. I turned off Open Documents as Tabs (see page xxi of the Preface), so for me the photo appears in a new image window, as in Figure 1-5.

The title bar or tab lists the name of the image and magnification level followed by a color notation, RGB/8*. These six characters convey three pieces of information. RGB tells you that you're working with the three primary colors of light—red, green, and blue—the standard for scanners and digital cameras. Next, /8 lets you know that the image contains 8 bits of data for each of the red, green, and blue color channels, which permits the image to include any of 16.8 million colors. Finally, the asterisk (*) alerts you that you're working in a color environment other than the one you specified in the Color Settings dialog box (see Step 7, page xix). The upshot: Photoshop is aware of this image's specific needs and is doing its best to accommodate them, thus ensuring accurate color.

Step 2 Step 3

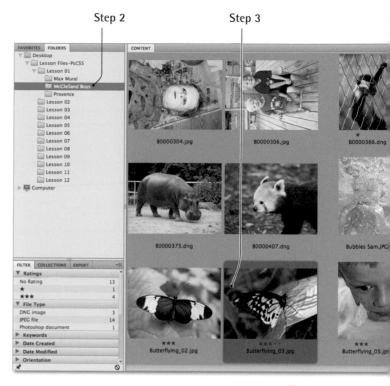

Figure 1-4.

Independent window (better for grabbing screen captures)

Color notation in parentheses

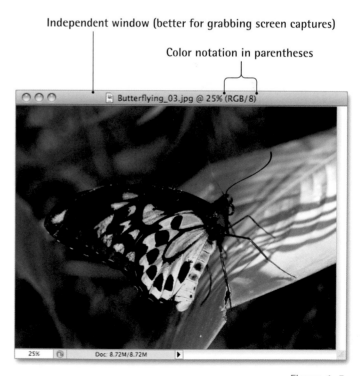

Figure 1-5.

Interface and Image Window

As with most computer applications, bossing around Photoshop is a matter of clicking and dragging inside the program's interface. Labeled in the figure below (which features an evocative photograph by Aleksandra Alexis from the iStockphoto image library), the key elements, in alphabetical order, of the not particularly revamped Photoshop CS5 interface are:

- **Application bar:** The application bar provides access to the Bridge, navigation functions, and window viewing controls. Under Windows, the application bar is located to the right of the menu bar.

- **Cursor:** The cursor (sometimes called the *pointer*) is your mouse's on-screen representative. It moves as your mouse moves and changes to reflect the active tool or operation. Keep an eye on it and you'll have a better sense of where you are and what you're doing.

- **Docking pane:** A docking pane contains many panel groups, stacked one above the other. Drag a panel tab (or the blank area next to a tab) and drop it onto a docking pane to add a panel to the stack. Drop a panel next to an existing pane to begin a new pane. Click the dark gray bar at the top of the pane to collapse the pane. You can also drag the dark gray bar to move the pane.

- **Image window:** Each open image appears in a separate window, thus permitting you to open multiple images at once. In Photoshop, the image window is your canvas. This is where you paint and edit with tools, apply commands, and generally wreak havoc on an image.

- **Menu bar:** Click a name in the menu bar to display a list of commands. Click a command in order to choose it. A command followed by three dots (such as New...) displays a window of options called a *dialog box*. Otherwise, the command works right away.

- **Options bar:** The settings here modify the behavior of the active tool. The options bar is *context sensitive*, so you see a different set of options each time you switch to a different tool. If the options bar somehow disappears, you can restore it by pressing the Enter or Return key.

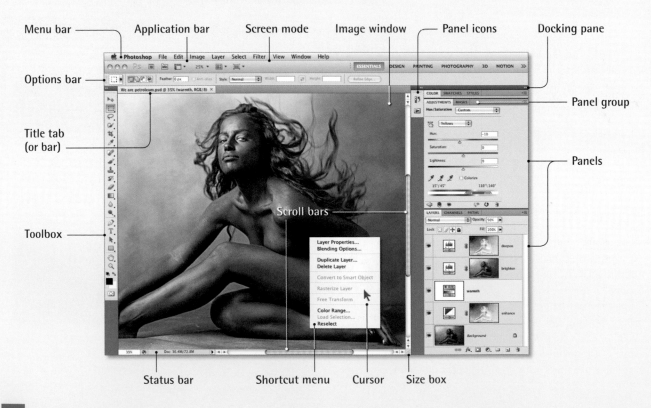

- **Panels:** A panel (formerly called a palette) is a window of options that remains visible regardless of what you're doing. To switch between panels in a side-by-side group, click a named tab. You can move a panel out of a group by dragging its tab. Click the tiny ▾≡ in the top-right corner of a panel to bring up the *panel menu*.

Drag the left edge of any panel to make the entire panel wider or narrower.

- **Panel group:** Drag a panel and drop it onto another panel to group them so that their tabs appear side-by-side (such as the Layers, Channels, and Paths group). Drag the blank gray area to the right of the tabs to move the entire group. Click the blank area to collapse the group so you see only tabs. Click again to expand the group.

- **Panel icons:** When you collapse a docking pane, Photoshop shows its panel as icons. Click an icon to temporarily display the panel. Click again to hide it. Drag the left edge of the pane to show or hide panel names next to the icons.

- **Screen mode:** Click the final icon in the application bar (this icon used to be at the bottom of the toolbox) and select an option, or press the F key to cycle between three variations of the image window. An open image may appear in a tabbed or an independent window, fill the entire screen, or further encroach on screen real estate by squeezing out the menu bar. Press Shift+F to cycle backward between modes.

- **Scroll bars:** Only so much of an image can fit in the image window at once. In the standard screen mode, the scroll bars let you pan the image horizontally or vertically to display hidden areas. If a scroll bar is empty, the screen is zoomed out far enough for you to see the entire width or height of the image. For more information on zooming and scrolling, watch Video Lesson 1, "Browsing in the Bridge," introduced on page 4).

- **Shortcut menu:** Right-click to display a shortcut menu of options for the active tool. If your Macintosh mouse doesn't have a right mouse button (older mice from Apple don't), press the Control key and click. Photoshop provides shortcut menus in the image window and inside many panels. When in doubt, right-click.

- **Size box:** When working with a free-floating image window, you can drag the bottom-right corner to make the window bigger or smaller. When working with a tabbed window, the size box does not function.

- **Status bar:** The bottom-left corner of each and every image window sports a status bar that includes a zoom value, the file size, a preview box, and a pop-up menu of various preview options. The status bar disappears when you enter one of the full-screen modes.

- **Title tab (or bar):** By default, Photoshop CS5 fills the screen with an image and tops it off with a small tab. The tab lists the name of the last saved version of the file on disk. If you haven't saved the image, it may appear as *Untitled*. Click a tab to switch between open images. Drag a tab and drop it away from the options bar to create a free-floating window topped by a title bar. Drag that title bar onto a tab, or to the top, bottom, or side of the image area to restore the window to the tabbed treatment.

- **Toolbox:** The toolbox provides access to Photoshop's selection and editing tools, as well as common color controls. Click an icon to select a tool and then use the tool in the image window. A tool icon with a triangle (◢) in the bottom-right corner indicates that many tools share a single slot. Click and hold such an icon to display a flyout menu of alternates. Or press the Alt (or Option) key and click an icon to cycle between tools.

Press the Tab key to hide the toolbox, options bar, and all panels. Press Tab again to bring them back. To hide or show the panels independently of the toolbox and options bar, press Shift+Tab. Hover your cursor over the right edge of the screen to temporarily see the panel when hidden.

Organizing and Examining Photos

A cynic might argue that the first incarnation of the Creative Suite was largely a marketing scheme designed to get Photoshop users to take up excellent but less popular products such as Illustrator and InDesign. But over time, the collection has matured, and the standalone Bridge deserves a lot of the credit. The Bridge is no mere image opener—in many regards, it's a full-blown *digital asset manager*. In the Bridge, you can review images and illustrations, rotate them, delete them, move them to different folders, organize them into collections, and flag them for later use. You can even preview images at full size, filter which images you see and which you don't, and group related images into stacks. If you have just a few dozen images lying around your hard drive, this may seem like overkill. But if you have a few hundred, a thousand, or a hundred thousand, the Bridge is an absolute necessity.

PEARL OF WISDOM

In many ways, the Bridge is a better and more flexible navigation tool than the Windows or Macintosh operating system. Where else can you whip through a folder of images or illustrations and view instantly scalable, high-quality thumbnails? Or rename a group of files in a single operation? It's a media manager's dream.

To get a sense of what the Bridge can do, including resizing and prioritizing thumbnails, try the following steps. (These steps assume that the Bridge is set to the Essentials workspace, as it is by default.)

1. *Open the Bridge.* Click the ▸Br icon in the application bar. Or press the shortcut, Ctrl+Alt+O (or ⌘-Option-O).

2. *Navigate to the* **McClelland Boys** *folder.* Click the **Folders** tab in the top-left corner of the Bridge and use the folder tree to navigate to the *McClelland Boys* folder. Again, it's inside the *Lesson 01* folder inside *Lesson Files-PsCS5 1on1*.

3. *Enlarge the thumbnails.* By default, the thumbnails in the content browser are tiny. That's great for assessing the broad contents of a folder but less than optimal when gauging the images' appearance. To increase the size of the thumbnails, drag the slider triangle in the bottom-right corner of the window, which I've circled in orange in Figure 1-6.

Alternatively, you can zoom thumbnails from the keyboard. After selecting a thumbnail, press Ctrl+⊞ (or ⌘-⊞) to make the thumbnails larger; press Ctrl+⊟ (⌘-⊟) to make them smaller. The maximum thumbnail size is 1024 pixels in either direction.

Figure 1-6.

4. *Move the Preview panel.* Since we're working with large thumbnails, the Preview panel serves little purpose, because the thumbnails in the Content folder are just as big as in the Preview panel. So let's tuck it away. Grab the **Preview** panel by its tab and drag it all the way to the left side of the window until a bright blue outline appears around the Folders panel. Release the mouse button to drop the panel into the top-left section of the Bridge.

5. *Rearrange some more panels.* Choose **Window→Collections Panel** to hide that panel, since we won't be using it for the moment. Then do the same for the Export panel by choosing **Window→Export Panel**. Drag the **Metadata** panel from the top-right corner of the window to the bottom-left, as demonstrated in Figure 1-7. And drag the **Keywords** panel there as well. This empties the right panel.

PEARL OF WISDOM

New to Photoshop CS5 is the Mini Bridge, a Flash-based panel that appears in the Photoshop interface and allows you handy Bridge-like access to all your files. The usefulness of the Mini Bridge really comes into play when you're working with multiple images in Photoshop, so we'll save our coverage of hands-on use of this handy new tool for Lesson 9.

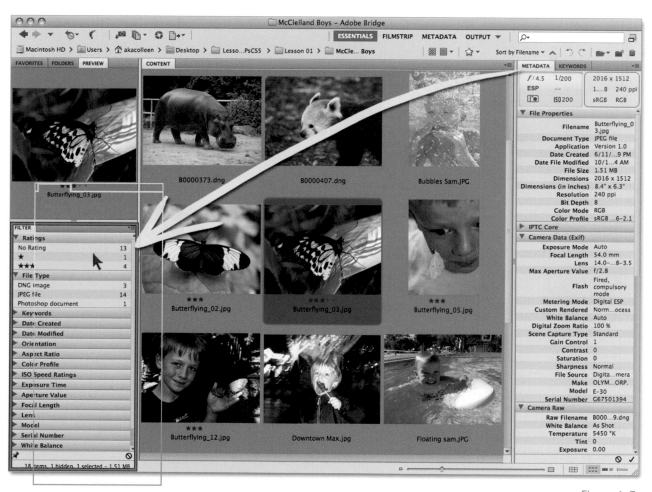

Figure 1-7.

6. *Hide the empty panel.* Double-click the vertical divider that runs along the right edge of the content browser to hide the now-empty right panel, as in Figure 1-8. Then click the **Preview** and **Metadata** tabs to bring these important panels to the front. Drag the horizontal divider between these two upward, to give the Metadata panel more vertical room.

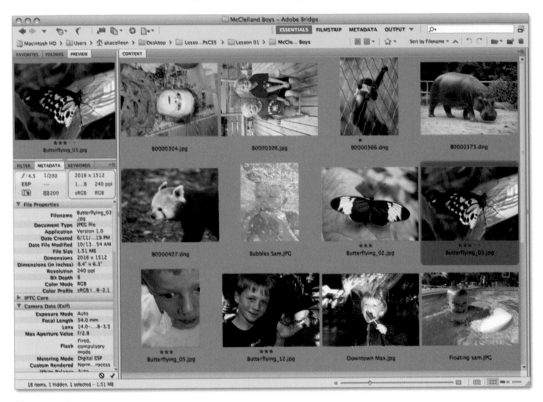

Figure 1-8.

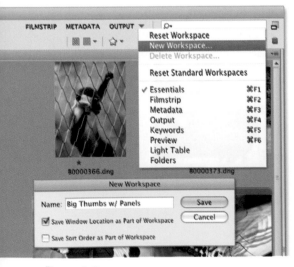

Figure 1-9.

7. *Save this workspace.* In both Photoshop and the Bridge, a *workspace* stores the basic configuration of the interface—which panels are visible, how panels are arranged, and even the size of the thumbnails in the content browser. To save your current workspace, click the ▼ on the far-right side of the application bar (in Figure 1-9, ▼ appears immediately to the right of the word **Output**) and choose the **New Workspace** command. Then do the following:

- Name this setting "Big Thumbs w/ Panels."

- If you like the size and position of the Bridge window, leave the **Save Window Location as Part of Workspace** check box turned on.

In many ways, the Bridge behaves like your operating system's desktop-level file manager (called Windows Explorer on the PC and the Finder on the Mac). For example, if you click a thumbnail's filename, the Bridge invites you to enter a new name. Choose File→New Folder to create a new folder. Press the Delete key to toss a selected image in the trash. Through it all, the Bridge magically tracks your changes, never once asking you to save your work.

This may lead you to believe that every change you make is permanent and will be recognized not only by Adobe applications but also by the operating system and other programs. But some actions are recorded in ways that only Adobe's programs can recognize, and sometimes even they ignore them.

For the record, here are some permanent changes you can make in the Bridge that all applications will recognize:

- Renaming or deleting a file

- Creating or renaming a folder

- Dragging a file from one folder to another

Other changes are permanent, but they are written in such a way that only Photoshop and other applications that support Adobe's XMP (Extensible Metadata Platform) protocol recognize. If an application does not recognize a particular XMP tag, the change is ignored. Such changes include:

- Rotating an image

- Assigning a rating or label

- Custom Camera Raw settings

The final variety of changes are temporary. The Bridge saves these to proprietary files called *caches*:

- The sort order of files in a folder

- Any and all image stacks

- Stunning high-quality thumbnails

Although permanent and XMP changes are 100 percent safe, sort order and thumbnails are maintained only if you move and rename files and folders inside the Bridge. This is because the Bridge tracks temporary changes based on the *path*, or specific location, of a file. If that path changes even slightly without the Bridge knowing about it—say, if you rename files

or move them from the desktop—the program loses track of the files and the information is lost.

It might seem a tad fastidious to worry about such quick and invisible changes. It takes only a moment for the Bridge to draw a single thumbnail. But transfer a folder containing hundreds or even thousands of images to a DVD or external hard drive and those moments can add up to a massive delay.

What's a savvy user to do? Tell the Bridge to stop hoarding centralized cache files deep in the system level of your computer and instead save them in the same folder as the images themselves. This way, the cache files stay with their images no matter what you name a folder or where you move it:

- Choose **Edit→Preferences** (**Adobe Bridge CS5→Preferences** on the Mac) or press Ctrl+K (⌘-K).

- Click the word **Cache** on the left side of the dialog box and select the **Automatically Export Caches to Folders When Possible** option (circled below). Then click **OK**.

From now on, the Bridge will add invisible cache files to every folder that you view in the program.

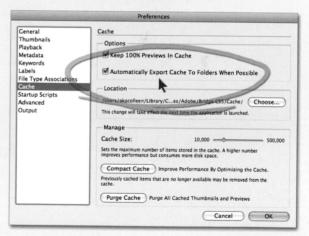

If you used a previous version of the Bridge, I recommend that you search your computer's main hard drive for a folder called Bridge CS3 or CS4 (as appropriate) residing in an Adobe folder. Inside that, you should find a subfolder called Cache. Check its size. In the case of my MacBook Pro—a notebook with limited hard drive space—this folder weighed in at 4GB. If you're no longer using Bridge CS3 or CS4, you're no longer using that folder. Throw it away and regain a lot of space.

- To keep things flexible, turn off the second check box, **Save Sort Order as Part of Workspace**, so that you can maintain custom sort orders even after switching workspaces.

- Click **Save**. The saved setting name appears alphabetically in the application bar—so in this case, before Essentials—and is automatically assigned a keyboard shortcut of Ctrl+F1 (⌘-F1 on the Mac).

8. *Increase the size of the content browser.* One of the downsides of larger thumbnails is that you can see fewer of them at a time. The next few steps will go more smoothly if we can see most if not all the thumbnails at once. The solution? Increase the amount of screen real estate devoted to the content browser:

 - Maximize the Bridge window so it fills the entire screen by clicking ☐ on the far right side of the Windows title bar or ⊕ on the far left side of the Macintosh title bar.

 - To gain still more room, turn over the entire Bridge to the content browser by pressing the Tab key. And by all means, feel free to drag the bottom-right slider triangle again so that the thumbnails adequately fill their new space.

At this exaggerated size, you might feel a bit intimidated by the sheer magnitude of the Bridge. Luckily, the program includes a *compact mode* that lets you toggle between the full view and a pocket-size view. To toggle the compact mode, click the ⊟ icon in the top-right corner of the window or press Ctrl+Enter (⌘-Return on the Mac). The compact Bridge stays in front of other applications. This means you can preview the contents of a folder while editing an image in Photoshop. Or drag a thumbnail into Microsoft Outlook or Apple's Mail program to create an email attachment. To exit the compact mode, click the ⊡ icon.

9. *Select all sideways images.* The digital camera I used to shoot these photos, an Olympus Evolt E-300 SLR, is smart enough to automatically rotate portrait shots. But once in a while, a digital photo that should be vertical comes in horizontally. Among our sixteen images in the *McClelland Boys* folder, three are lying on their sides. No problem; the Bridge can turn them upright. Select the three images highlighted with yellow borders in Figure 1-10 on the facing page by clicking one and Ctrl-clicking (or ⌘-clicking) the other two.

If the images were sequential, you could click one and Shift-click another to select the entire range in between. Or hold down Shift while pressing an arrow key (↑, ↓, ←, →). With each keystroke, the Bridge adds a single thumbnail to the selection.

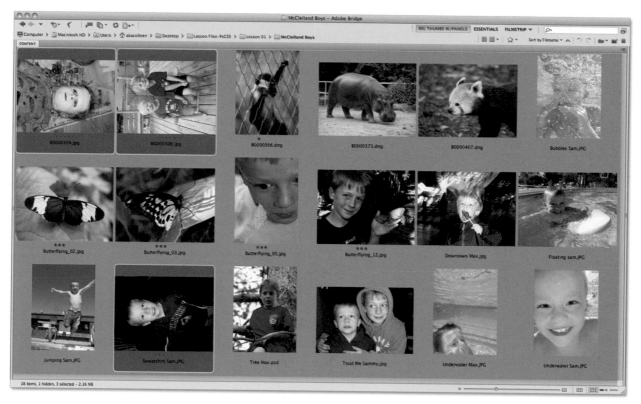

Figure 1-10.

10. *Stand the thumbnails upright.* In the upper-right corner of the Bridge is a group of five shortcut buttons. Click the ↻ button, as I'm doing in Figure 1-11. This rotates the selected thumbnails 90 degrees clockwise, so two of them are now upright.

11. *Rotate the first image 180 degrees.* Click the thumbnail in the top-left corner so that only it is selected. Press the Ctrl key (or ⌘ on the Mac) with the right bracket key, ⬜, to rotate the thumbnail 90 degrees clockwise, and then do it again to turn the thumbnail upright.

Press Ctrl+⬜ or ⌘-⬜ to rotate the thumbnail counterclockwise.

It might sound odd, but the Bridge does not rotate the actual images when you click ↻ or use the keyboard shortcut to turn them. Rather, it rotates the thumbnails and appends a bit of extra information to the files that lets Photoshop know to rotate the images when you open them. A program that does not recognize this rotation instruction—such as your operating system, a Web browser, or even an older version of Photoshop (CS or earlier)—will open the image as it really is, on its side.

Figure 1-11.

12. **Prioritize thumbnails by dragging them.** You can sort thumbnails by filename, creation date, size, and several other attributes by choosing a command from the top-right corner of the Filter panel or from the View→Sort submenu. But you can also create a custom sort by dragging selected thumbnails in the Bridge. We want all the vertical (portrait-oriented) images at the top of the window. The first three are already in place. Hold down the Ctrl key (⌘ on the Mac) and click each of the other vertical (portrait-oriented) images, starting with *Bubbles Sam.jpg*. Then drag the selected thumbnails so that they follow the monkey in *B0000366.dng*, as illustrated in Figure 1-12. A thick vertical line shows where the thumbnails will land.

The Bridge automatically saves your manual thumbnail reorganization as a custom sort state. This means you can choose View→Sort→By Filename to alphabetize the thumbnails, and later restore your manual sort state by choosing View→Sort→Manually.

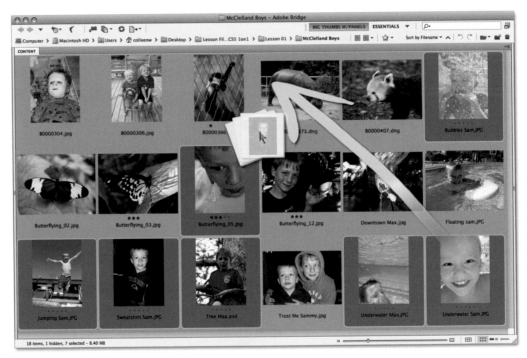

Figure 1-12.

13. **Switch to the Filmstrip workspace.** Our next task is to evaluate a few images and decide which ones are the money shots, the photos worth enhancing and manipulating in Photoshop. And that means being able to view and compare images in a generously allotted Preview panel. To establish such a panel, we'll customize one of the Bridge's default workspaces:

- Up in the applications bar, click the word **Filmstrip**, located by default between Essentials and Metadata. The Bridge switches to a predefined workspace that displays a slim, horizontal Content panel along the bottom of the screen with a large Preview panel above it.

- Having the Content panel at the bottom of the screen compromises the size of portrait-style (vertical) images without helping us much with the landscape-style (horizontal) ones. Better to run the thumbnails in a vertical column on the right side of the screen. To open up such a column, double-click the vertical divider you hid in Step 6 (page 12).

- Now drag the **Content** panel tab from the bottom of the screen and drop it into the empty column.

- Drag the vertical divider to the right to make the Content panel narrower, so the thumbnails line up in a single column, as in Figure 1-13. This maximizes the space dedicated to the Preview panel, which we'll need for landscape photos.

Assuming that your reordered thumbnails remain selected, you should now see enlarged views of all seven images in the Preview panel (again, witness Figure 1-13), thus making comparisons a snap. In contrast, the previous version of the Bridge allowed you to preview just one image at a time.

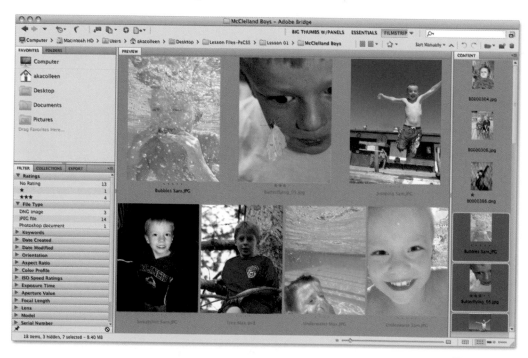

Figure 1-13.

14. *Hide the panels on the left.* Double-click the vertical divider along the left edge of the Preview panel to hide the panels on the left side of the Bridge window and devote more room to the large image preview.

15. *Advance from one image to the next.* Click the top image in the content browser and see an expanded version of the image in the Preview panel. Press the ↓ or → key to select the next thumbnail in the filmstrip.

16. *Single out the exemplary images.* You can mark images you like for later attention. The Bridge lets you assign each image a specific level of importance by rating it from one to five stars. For example, let's say you gauge the shot of the blue and white butterfly—filename *Butterflying_02.jpg*—to be a four-star image. Here what I want you to do:

- Choose **Label**→ ★★★★, as in Figure 1-14.

- In the row of five dots immediately below the selected thumbnail, click the fourth dot. The · · · · · changes to ★★★★.

- Press Ctrl+4 (⌘-4 on the Mac).

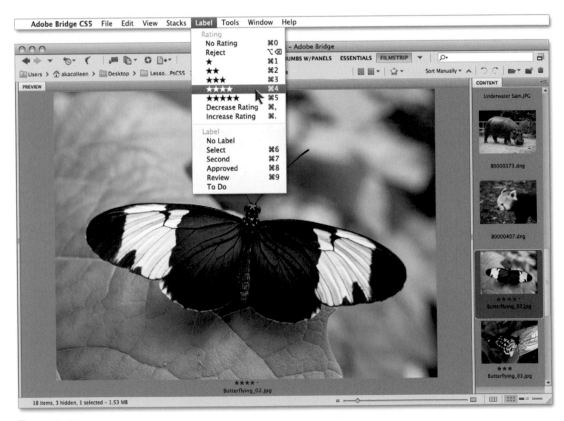

Figure 1-14.

To assign another thumbnail three stars, select it and click the third dot or press Ctrl+3 (⌘-3). To remove a star rating, click to the left of the first ★ (so that you see a small, momentary ⊘) or press Ctrl+⓪ (⌘-⓪).

If a yellow hint box obscures your view as you try to click below a thumbnail, turn off the hinting. Press Ctrl+K (⌘-K) to bring up **Preferences**, click **Thumbnail** in the left column, and turn off **Show Tooltips** near the bottom of the dialog box.

EXTRA ★ CREDIT

At this point, I extend you the courtesy of opting out of the following steps. After all, you've stuck with it this far. If you're tiring, take a break. But like any good teacher, I have to let you know that I wouldn't have included the remaining steps if I didn't consider them of the utmost importance. So even if you take a break now, try to rejoin me later. Lots of good stuff coming up.

17. *Loupe the next butterfly.* Advance to the next photo, *Butterflying_03.jpg*, which features another butterfly from my sons' and my visit to the Denver Butterfly Pavilion. I like the image, but before I can assign it a rating, I need to inspect the quality of the detail. The Preview panel includes a loupe (pronounced *loop*) function that—like a traditional optical loupe—lets you magnify small areas in a photo. To invoke the loupe:

- Move the cursor over the image in the Preview panel. It immediately turns into a magnifying glass with a plus symbol (the standard zoom cursor).

- Click the detail that you want to magnify. A rounded square appears with a sharp corner pointing to the center of the magnified view. (In Figure 1-16 on the next page, I colored the loupe outline white to make it stand out; it's actually always black.)

- Drag the loupe to magnify other details in the image. If you drag too close to an edge, it adjusts to accommodate.

Use your mouse's scroll wheel (or scroll ball) to zoom in or out with the loupe. If your mouse lacks a scroll wheel, press the ⊞ and ⊟ keys. You can zoom in as far as 800 percent and as far out as 100 percent, as listed at the bottom of the Preview panel.

Check out the key elements of the image—the wing detail, proboscis, legs, and antennae—for focus. When you are finished with the loupe, click the ✕ in the bottom-right corner to dismiss it. Or click inside the loupe.

PEARL OF WISDOM

The Bridge offers three other ways to inspect images. There's the slide show function, which allows you to magnify images so they fill the entire screen. Select the images that you want to view, and then choose View→Slideshow or press Ctrl+L (⌘-L). Use the ← and → keys to navigate from one image to the next. Press the ⊞ key to zoom in, or use the scroll wheel on your mouse. Then drag the image to pan it. Press ⊟ to zoom out. You can also rotate the images, assign star ratings, and more. To see a full menu of keyboard tricks, press the H key for help. When you've finished reviewing your images, press the Esc key to return to the Bridge. You can also quickly inspect an image or two with less overhead, press the spacebar to enter the full-screen preview (where many of those same slide show techniques work). Or finally, you can choose View→Review Mode or press Ctrl+B (⌘-B) to switch to the Lazy Susan–style image-on-a-wheel mode.

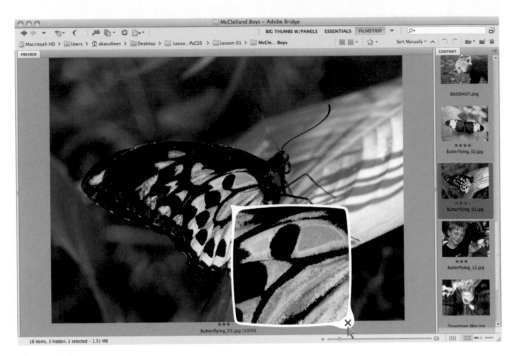

Figure 1-15.

18. *Upgrade the image's star rating.* The focus checks out pretty well, although it's not perfect. So upgrade the image from its current three-star status to four by clicking the dot where the fourth star should be under the thumbnail in the filmstrip.

19. *Filter and rate the unrated images.* The Bridge lets you cut through the clutter by limiting, or *filtering*, the thumbnails that appear in the content browser. To see just those images that you haven't rated, double-click the vertical divider on the left to reopen those panels, and then click the **Filter** panel tab if you need to bring it to the front. (If it's not available, choose **Window→Filter Panel**.) Then twirl open **Ratings** in the **Filter** panel list, and click **No Rating**. All star-rated images temporarily disappear, allowing you to focus your attention on images you may have overlooked. Click **No Rating** again to turn off the filter. Try other filter settings to limit which thumbnails you see. The Filter panel is great for sifting through a big day of shooting.

20. *Restore the saved workspace.* It's time to do some final organizing in the Big Thumbs workspace you saved in Step 7 on page 12. Up in the application bar, drag **Filmstrip** to the left to make it the first workspace. Changing the order of the workspaces changes their priority and their shortcuts. This means you can click **Big Thumbs w/ Panels** as in Figure 1-16 or press Ctrl+F2 (⌘-F2) to return to your practical, homegrown workspace.

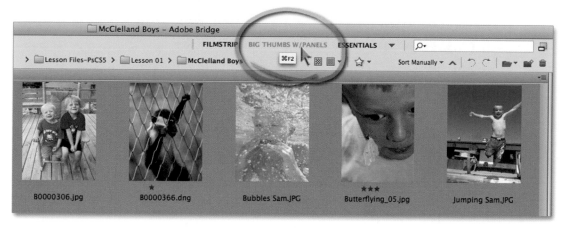

Figure 1-16.

The Bridge offers an organizational tool called an *image stack*. A stack is most useful when trying to cull one or two of the best pictures from a half dozen or more shot in a single sitting or under similar circumstances. All photos of the bride and groom cutting the cake in one stack, all shots of the bride dancing with her father in another—that kind of thing. I didn't photograph any brides during my animal adventures with my boys, so we'll assemble an image stack from my children instead.

21. *Select all pics of my children.* Most likely, you don't know my family. So I'll make it easy: The pics of my sons are the ones with boy-people in them. Assuming the images are still sorted in the custom order and you know a boy when you see one, here's how I recommend you select them:

 • Click the first thumbnail, the one of the my elder son, Max, getting the mummy treatment (labeled ❶ in Figure 1-17 on the next page).

 • Press the Shift key and click the next thumbnail—the one with my two boys when they were small enough to fit in the same chair (labeled ❷) to add it to the selection.

 • Skip the monkey (although there are days I mistake my children for less evolved primates). Ctrl-click (⌘-click) the next image, *Bubbles Sam.jpg* (labeled ❸), and then Ctrl-Shift-click (⌘-Shift-click) *Underwater Sam.jpg* to select the range of thumbnails in between (labeled ❹ in the figure). You should now have nine images selected.

 • Skip the next four nonhuman creatures, and then perform the same Ctrl-click, Ctrl-Shift-click (⌘-click, ⌘-Shift-click) operation to add the last four images to the selection (labeled ❺ and ❻ in the figure on the next page).

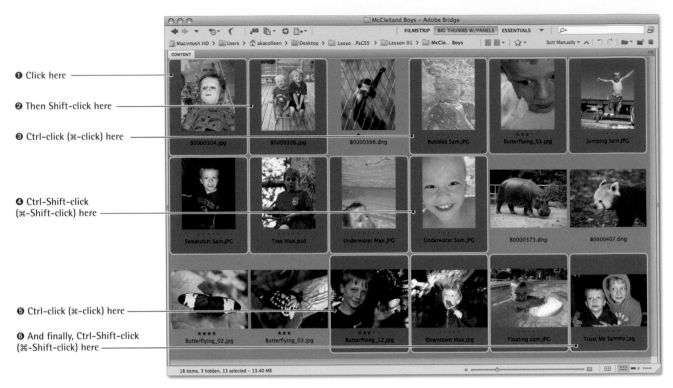

❶ Click here ——————

❷ Then Shift-click here ——————

❸ Ctrl-click (⌘-click) here ——————

❹ Ctrl-Shift-click (⌘-Shift-click) here ——————

❺ Ctrl-click (⌘-click) here ——————

❻ And finally, Ctrl-Shift-click (⌘-Shift-click) here ——————

Figure 1-17.

22. *Group the selected images into a stack.* Choose **Stacks→Group as Stack** or press Ctrl+G (⌘-G) to combine the selected images into a single, compact stack, as circled in Figure 1-18. A number in the upper-left corner of the top thumbnail ❸ identifies the quantity of images in the stack. The first image sequentially becomes the stack's thumbnail.

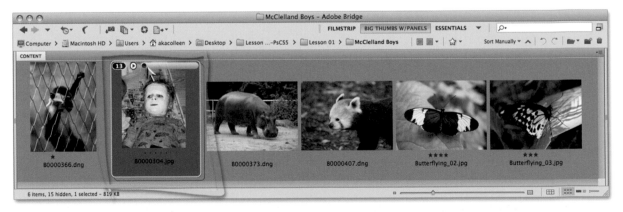

Figure 1-18.

Now that you have a stack, you may wonder what can you do with it. Here are a few things:

• Click the number (in our case, ❸) to expand the stack and see all the files.

- Hover over the top image and click the $\mathbf{\Theta}$ button that appears next to the number to see a preview slide show of the images in the stack. Unfortunately, the preview slide show is too fast to be of any real use.

- To scroll through the images in the stack at a saner pace, manually move the black circle to the right of the $\mathbf{\Theta}$ button along its gray track, as I'm doing in Figure 1-19. (Again, you need to be hovering over the thumbnail with your mouse cursor to see this control.)

- With the stack expanded, drag a file to the front of the line or choose **Stacks**.

- **Promote to Top of Stack** to make the file the lead image for the stack.

- Drag a file to a location outside the stack to remove it from the stack. You can also drag files into the stack. If you drag one stack into another, the files are assimilated into the second stack and the first stack goes away. (The Bridge does not support nested stacks.)

- Click the number **13** again to collapse the stack to a single thumbnail.

- When working with a collapsed stack, clicking the stack selects just the lead image. Drag the thumbnail to move the corresponding file out of the stack. To select all images in the stack, click the border of the outer thumbnail or Alt-click (Option-click) the thumbnail. When the entire stack is active, the outer border lights up, as Figure 1-21 illustrates.

Note that this ability to select images does not work if you've used the slider to stop the preview slide show manually and left something other than the "official" top-of-stack image on top.

- When an entire stack is selected, you can rate all the images in the stack using any of the techniques described in Step 16 on page 18. You can also rotate all images and view them together in the Preview panel.

- The Bridge even permits you to drag a selected stack and drop it into a different folder in the folder tree. However, note that this ungroups the stack and moves all images to the new location as independent thumbnails.

Figure 1-19.

Click inside the thumbnail
to select the lead image only

Click the edge, or Alt-click
inside, to select the entire stack

Figure 1-20.

- To ungroup a stack and return the images to independent thumbnails, add Shift to the standard grouping shortcut, as in Ctrl+Shift+G (⌘-Shift-G on the Mac).

Note that a stack is a Bridge convention. A stack does not change the files themselves or the location or configuration of the files at your computer's desktop level.

23. *Add a folder to Favorites.* If you want to view images in a specific folder on a regular basis, save the folder as a favorite. Click the **Folder** tab to open that panel, right-click the *McClelland Boys* folder, and choose **Add to Favorites** from the pop-up menu. Then switch to the **Favorite** panel to see the new McClelland Boys item, indicated by the red arrow in Figure 1-21.

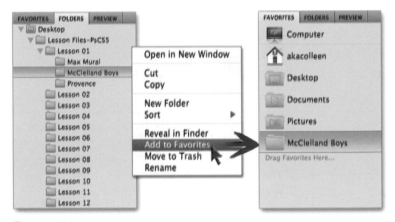

Figure 1-21.

If you have a single file that you use on a regular basis, you can make it a favorite as well. Just drag the file from the content browser and drop it in the empty area at the bottom of the Favorites panel. This technique works for folders as well.

To get rid of a favorite, right-click it and choose Remove from Favorites. For example, I save the vast majority of my photographs to an independent hard drive, so I have no use for the preset Pictures folder. If you work similarly, right-click **Pictures** and choose **Remove from Favorites**. To reinstate one of Adobe's default favorites, press Ctrl+K (or ⌘-K) to bring up the **Preferences** dialog box. Then select **General** in the left list and turn on and off the **Favorite Items** check boxes as desired.

Using Metadata

The prefix *meta* comes from the ancient Greek preposition meaning (among other things) *after*. Nowadays, based in part on English critic Samuel Johnson's derisive characterization of fanciful 17th-century poets as "metaphysical" (by which he meant contrived), it has come to mean *beyond*. And so it is, *metadata* is data beyond the realm of the image.

In sum, metadata is extra information heaped on top of the core image that most applications don't pay any attention to. True to Johnson's vision, metadata is whatever the poet decides to make of it.

Fortunately, despite its otherworldly timbre, metadata has practical applications. Digital cameras use metadata to record the focal length, exposure time, f-stop, and other illuminating information. Search engines use it to retrieve topics and keywords. And designers and photographers can use it to store copyright statements and contact information. If that doesn't stoke the fires of your pecuniary self-interest, perhaps the following steps will:

1. *Open the Bridge.* If you're still in the Bridge, stay there. If you've wandered into Photoshop, mosey back out by pressing Ctrl+Alt+O (⌘-Option-O) or clicking the ⌐Br⌐ icon in the options bar.

2. *Navigate to the* **Provence** *folder.* This folder is located inside the *Lesson 01* folder inside *Lesson Files-PsCS5 1on1*. Therein, you'll find eight photos from a trip I took to the South of France, where I spent a glorious week overindulging on cheese and gorgeous photo opportunities.

3. *Shift your focus to the Metadata panel.* You'll be working inside the Metadata panel in the bottom-left portion of the Bridge, so start by clicking the **Metadata** tab on the left side of the screen to bring it to the front, as I did in Figure 1-22. If you're in a different workspace from where we left off in the last exercise, and the Metadata panel isn't available, choose **Window→Metadata Panel**.

Figure 1-22.

Figure 1-23.

4. **Make more room for the metadata.** Assuming again that you're working in the same Big Thumbs workspace in which we ended the preceding exercise, drag the horizontal divider between the Folders and Metadata panels upward, as illustrated in Figure 1-23. This expands the Metadata and Keywords panels to about twice their previous size.

5. **Save your workspace.** It may seem compulsive, but there's no time like the present to develop good habits. And saving workspaces is about the best habit I know of that doesn't involve a toothbrush. Choose **Window→Workspace→New Workspace** from the Photoshop menu bar, name the setting "My Metadata," and click **Save**. Now you have a customized metadata view that will serve you well into your dotage.

6. **Select a single thumbnail.** Each image contains different metadata, so you'll generally want to review one image at a time. Choose **Edit→Deselect All** or press Ctrl+Shift+A (⌘-Shift-A) to deselect all the thumbnails. Then click the picture titled *Pont du Gard.jpg*. This image represents the pinnacle of my insane love for all things old and Roman. (So that you can see the photo and its subject in all its glory, I zoomed the thumbnail as far as possible in Figure 1-24.)

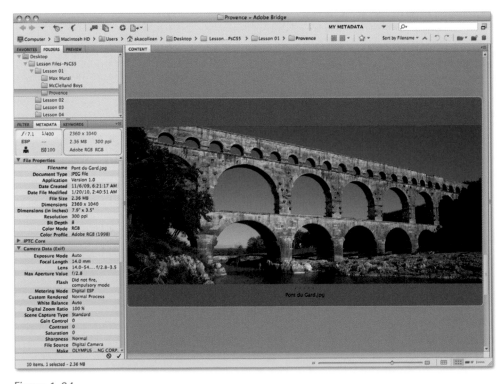

Figure 1-24.

7. *Review the metadata.* The Metadata panel starts off with the *metadata placard*. Detailed in Figure 1-25, the placard lists the most essential information about a photograph in the way it might be presented by a digital camera. A blank (--) means that the information is missing or isn't available in a way the placard understands. For example, I didn't use any exposure compensation when I shot this image.

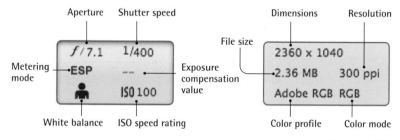

Figure 1-25.

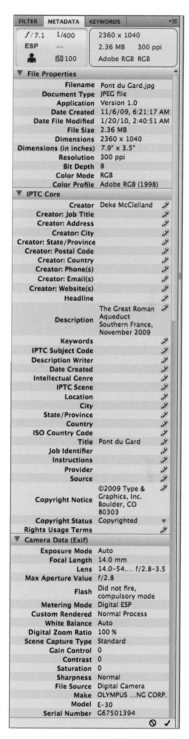

Figure 1-26.

Below the placard, you'll see a few metadata categories that you can open or close by twirling the ▶ to the left of each one. Pictured in the elongated Figure 1-26, the categories you are most likely to use often are as follows:

- **File Properties** houses the most elemental image specifications, such as the name of the file, the date it was last modified, the height and width in pixels, and other attributes that have been listed in the header of digital images since the early years of personal computing.

- **IPTC Core** comes from the International Press Telecommunications Council, a group in charge of standardizing the inclusion of credits and instructions in the field of photojournalism. The tiny pencils next to the IPTC items indicate that you can edit the metadata, as we shall in Step 9. The *Core* part is there only to distinguish this recent update from the format's earlier versions.

- **Camera Data (EXIF)** describes the inception of your photograph as witnessed by a digital camera. *EXIF* stands for Exchangeable Image File, supported by virtually every digital camera sold today. The EXIF data for this particular photograph tells us, among other things, that it was shot with my Olympus E-30, I used Auto exposure and white balance settings, and the flash did not fire.

Figure 1-27.

8. *Customize the metadata display options.* Click ⯆≡ in the top-right corner of the **Metadata** panel to display the panel menu. Choose the **Preferences** command to open the Bridge's **Preferences** dialog box with the Metadata options in full view. Then turn on and off the check boxes as illustrated in the impossibly long Figure 1-27. You'll probably need a magnifying glass to see those check boxes, so I document my recommended changes in the following list:

- If necessary, twirl open the **File Properties** category at the top of the list. Then turn off the check boxes that duplicate properties that appear in the metadata placard, namely **File Size**, **Dimensions**, **Resolution**, **Color Mode**, and **Color Profile**. You might also turn off Filename since the filenames are listed in the content browser. But I suggest you leave this check box on; seeing the filename in the Metadata panel helps you confirm which image is active.

- Scroll down and turn off the **IPTC Core** and **IPTC Extension** check boxes—which deactivates a whole slew of properties—and twirl them closed. Now you might think, wait a second, some of that stuff was useful. Creator, Description, Copyright—these are properties any professional might need. I agree, which is why I have you restore those options next.

- Twirl open the preceding category, **IPTC (IIM, legacy)**. Short for *Information Interchange Model*, IIM is an older version of the IPTC standard. But most of its properties are the same, and those that aren't tend to be more compatible with Photoshop's other metadata editor, the File Info dialog box (which we'll see shortly). Turn on the following properties: **Document Title**, **Headline**, **Keywords**, **Description**, **Instructions**, **Author**, **Author Title**, **City**, **State/Province**, **Country**, **Copyright**, and **Copyright Info URL**.

- Skip down to **Camera Data (EXIF)** and twirl it open if need be. Then turn on three helpful check boxes, **Orientation** near the middle and **Make** and **Model** at the end. The first tells you whether an image has been rotated by the camera or in the Bridge. The other two list the make and model of the camera used to capture the image.

- Twirl closed everything that follows **Camera Data (EXIF)** —there's a lot!—to quicken the process of scrolling down the list. (Or zip down with your mouse's scroll wheel; totally up to you.) Then turn off the **DICOM** category if you are using Photoshop Extended. And by all means, if other categories such as Fonts, Linked Files, Plates, Document Swatches, Audio, and Video are cluttering your Metadata panel, turn them off, too.

Take a moment to make sure the **Hide Empty Fields** check box at the bottom of the dialog box is selected. This frees up room in the panel that would otherwise be wasted on blank attributes that the camera did not record. Then click **OK**.

As shown in Figure 1-29, the Metadata list is now a more manageable length. In a glance, you can see the important information about the image. For example, right at the top of the list, we learn that I shot the photo in November 2009—at 6:21:17 A.M.—but I edited it today. In the Description field, I can be more specific about exactly where and what the subject is. The metadata ends by reminding me that I captured the photo with an Olympus E-30.

Note that the accuracy of the Date Created property hinges on the veracity of the information recorded by your camera. So if you use a digital camera, make sure you set its time and date properly. A few months from now—when you haven't the vaguest idea of what you did when—you'll be glad that you can trust your metadata. In the case of this photo, we can guess that I probably didn't reset the time on my camera for the south of France, supported by the fact I am rarely up at 6:21 A.M. on any continent.

9. *Modify the IPTC information.* Most categories of metadata are fixed attributes of the file. But the IPTC information is editable directly from the Bridge. Go to the **IPTC** area and click the text to the right of **Author**. The item becomes active, permitting you to edit it. In this example, I changed it to my name, which happens to be accurate on several counts, but you can enter anything you want. Then press the Tab key to advance to the

Figure 1-28.

Figure 1-29.

Figure 1-30.

next editable item, my Title, "Touriste Américan." Other entries appear in Figure 1-30. If you want to follow them, fine; if not, feel free to go your own way—I was never much of a stickler for metadata decorum. When you finish, press the Enter key on the keypad. If that doesn't work, try Alt+Enter or click the ✔ at the bottom of the panel.

To enter the copyright symbol © in the Copyright field, make sure Num Lock is active. Then hold down the Alt key, type 0-1-6-9 on the numeric keypad, and release Alt. (On the Mac, just press Option-G.)

10. *Switch to the Keywords panel.* Click the **Keywords** tab to the right of the Metadata tab. *Keywords* allow you to identify specific items in a photograph and then search for them later. The most obvious concepts for keywords are who, what, and where, represented by the default categories People, Event, and Place, respectively. According to convention, these categories are keywords; the items indented below them are subkeywords.

11. *Make your own keywords.* Unless all your photos are of people named Matthew and Ryan (or perhaps Julius), and all your sightseeing happens in the five cities already listed, you'll need to create your own keywords. Right-click the **Events** item and choose **New Sub Keyword**, and then type "Vacation" and turn on the check box that goes with it. I also added a couple of subkeywords under **Place**, namely France and Provence (see Figure 1-31). If you're feeling ambitious, you can add your own categories—such as Deke, Cheese Tour, or Overindulgence—by right-clicking in the panel and choosing **New Keyword**.

12. *Mark the image as copyrighted.* Not all metadata info is available from within the Bridge. For example, to mark an image as copyrighted—so that Photoshop displays a copyright symbol in the title bar when you open it—you have to dig a little deeper. Choose **File→File Info** or press the keyboard shortcut Ctrl+Shift+Alt+I (⌘-Shift-Option-I). The ensuing **File Info** dialog box repeats much of the IPTC data you've already entered, including keywords. But one notable addition is **Copyright Status**. Set this option to **Copyrighted**. Then click **OK**.

EXTRA ★ CREDIT

At this point, you're basically finished. The only problem is that it took twelve steps to annotate a single image. Wouldn't it be great if you could annotate the others without repeating all these steps again? Fortunately, there is a way, as I explain in the remaining three steps.

13. *Create a metadata template.* Click the ▾≣ icon in the top-right corner of the **Metadata** panel to display the panel menu, and choose **Create Metadata Template**. In the top field of the dialog box that appears, give your template a name like "French Vacation," as shown in Figure 1-31. If we're going to collect these annotations to use for the entire folder's worth of images, we'll need to make the template a little more general (the specific description has to go). So turn on the check boxes next to only those things that apply to the entire set, namely **Keywords**, **Author**, **Author Title**, **Copyright**, and **Copyright Info URL**. Then click **Save**.

14. *Select the other images.* Once back inside the Bridge, press Ctrl+A (or ⌘-A) to select all the thumbnails. Then Ctrl-click (⌘-click) the *Pont du Gard.jpg* image to deselect it.

Figure 1-31.

15. *Apply the template.* Click the ▾≣ icon in the top-right corner of the **Metadata** panel and choose **Replace Metadata→French Vacation**. Just like that, the Bridge updates the information in the Metadata panel for all selected images, as in Figure 1-32.

Photoshop has now applied your IPTC information, your keywords, and the copyright status to all the images inside the *Provence* folder. And unlike sort order, stacks, and thumbnails (see "The Bridge and Its Slippery Cache," page 13), metadata and keywords are permanently appended to the image file without any additional saving. To confirm this, click any one of the thumbnails. Scroll to the top of the Metadata panel and look at the Date File Modified item in the File Properties section (circled in Figure 1-32). The date should be today; the time, just a few seconds ago. (Pay no attention to the time in the image; writers keep strange hours.) You can copy these images anywhere you want and your changes to the metadata will travel with them.

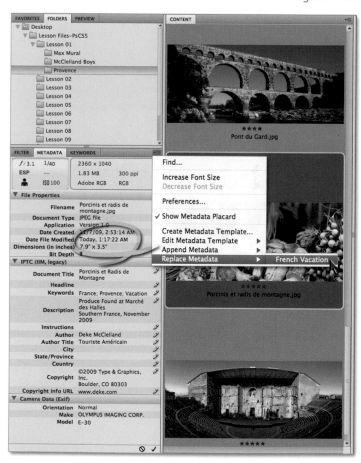

Figure 1-32.

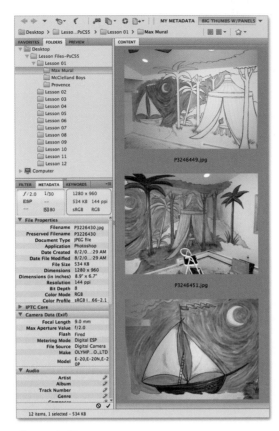

Figure 1-33.

Figure 1-34.

Batch Renaming

The mysterious number that comes out of your digital camera is not the most meaningful of filenames. All these exercises, and we have yet to name a single image. Well, that's about to change. In the next steps, you'll not only name a single image, you'll name lots of images, and all at the same time:

1. *Restore the saved workspace.* We're still inside the Bridge for this exercise. Assuming that you saved the custom workspace and shifted it to the second position (see Step 20 on page 20), then added another workspace in Step 5 on page 26, you can choose **Big Thumbs w/ Panels** in the applications bar or press Ctrl+F3 (⌘-F3) to revive that workspace now.

2. *Navigate to the* **Max Mural** *folder.* Locate the *Lesson 01* folder inside the *Lesson Files-PsCS5 1on1* folder, and open the *Max Mural* folder (see Figure 1-33). Inside are a dozen photographs shot over the course of several weeks. They show the progress of a mural I painted in my eldest son's bedroom, inspired by what was for a brief moment his favorite book, Maurice Sendak's *Where the Wild Things Are.* (I keep thinking *this* will be his favorite book, but that hasn't happened yet.)

3. *Rename the first image.* Click the first image to select it, and then click its filename, located below its thumbnail, which is *P3226430.jpg.* (Or press the F2 key for a handy shortcut.) The Bridge highlights *P3226430* so you can rename it without changing the *.jpg* extension. (I assume you can see the extension, which is a system-level preference setting. If you can't, don't worry about it.) Type a more descriptive filename, such as "MaxBedroomPencil-1" (see Figure 1-34). Then press the Tab key to record the name and advance to the second image.

4. *Rename the second image.* By pressing Tab, you advance to the second image and highlight its name. Enter the by-now-approved, improved filename "MaxBedroomPencil-2." Press Tab to accept the change and move to the third thumbnail.

5. **Select the remaining thumbnails.** The Tab key makes it convenient to jump from one filename to the next. But manually renaming images is a chore. Thankfully, the Bridge gives you a way to rename multiple images in one operation. Start by clicking the first painted version of the mural, *P3246445.jpg*. Then scroll down to the last image, *P4286767.jpg*, and Shift-click it to select the entire range of ten images.

6. **Initiate Batch Rename.** Choose **Tools**→**Batch Rename** or press the shortcut Ctrl+Shift+R (⌘-Shift-R on the Mac). The Bridge opens the **Batch Rename** dialog box, shown in Figure 1-35.

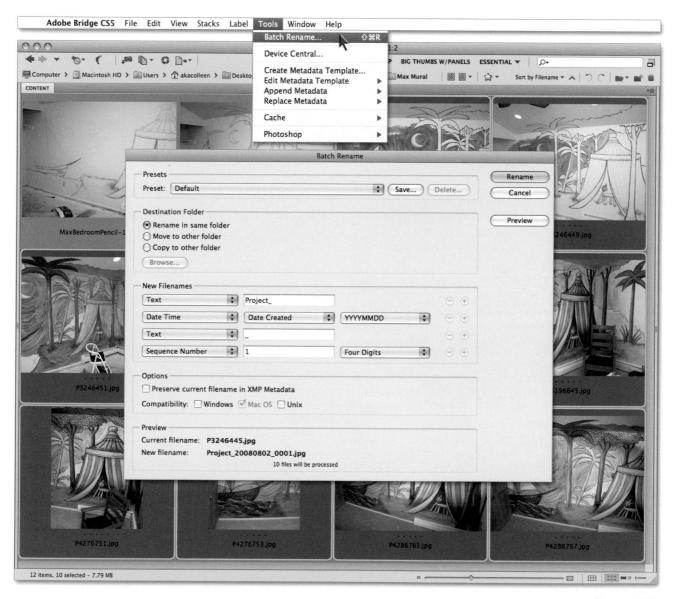

Figure 1-35.

7. *Delete the excess rows.* By default, you should see four rows of New Filenames options in the middle of the dialog box, as in the figure. We don't need that many. Click ⊟ (⊖ on the Mac) to the right of the second row a total of three times to delete all but the first row.

8. *Enter a base name.* By default, the row of New Filenames options begins with *Text*. If you see something else, click the ☑ arrow (or ⬓ arrow) to the right of the first option name and choose **Text** from the pop-up menu. Double-click in the field to the right of Text (which reads *Project_* by default) and change it to "MaxBedroomMural-" complete with the hyphen at the end. This becomes the base name for all selected images.

9. *Assign a two-digit sequence number.* Click ⊞ (or ⊕) at the end of the line to add more text to the filenames. Choose **Sequence Number** from the new pop-up menu on the left. Yet another pop-up menu appears on the right; set this one to **Two Digits**, which will sequentially number the selected images from 01 to 10, as indicated by the **New Filename** item (circled) in the bottom of Figure 1-36.

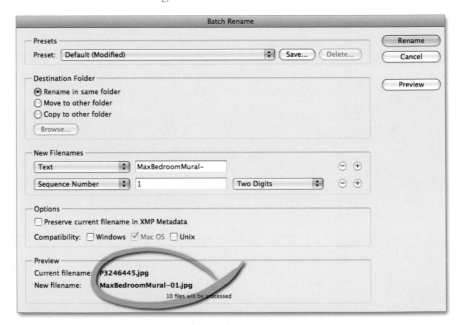

Figure 1-36.

You don't have to start the numbering at 01; you can start it anywhere. Just enter the desired starting number in the middle field, which is set to 1 by default. Select as many digits as you need from the pop-up menu. In other words, if you select Three Digits and want to start at 7, the Bridge would start at 007 whether you enter "7," "07," "007," or "0007" as the starting number.

10. ***Turn on all Compatibility check boxes.*** Just because you're working on a Mac today doesn't mean you won't be using a UNIX box tomorrow. (Well, in a way, you already are, but that's another story.) And the 95 percent of you folks who use Windows may come to love your iPhone so much that you'll decide to switch over to Apple technology. All I know is, it's a cross-platform world and you might as well be ready for anything that comes your way. The **Compatibility** boxes (seen at the bottom of Figure 1-37) ensure that your filenames subscribe to the naming conventions of other operating systems. You'll see that one check box is dimmed (the check box for your operating system) and the other two are available. Turn on both available check boxes.

11. ***Copy the original filename to the metadata.*** Turn on the **Preserve Current Filename in XMP Metadata** check box to store the filename assigned by the digital camera with the metadata for each file. It's a good precaution in case you ever need to match an edited image to its source. The old filename will be listed in the File Properties area of the Metadata panel as a property called Preserved Filename.

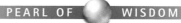

Figure 1-37.

12. ***Rename the images.*** When your settings match those pictured in Figure 1-37, click the **Rename** button to send the Bridge on its merry batch-renaming way.

Assigning a filename that more accurately reflects the contents of an image can help you locate the image later. Choose Edit→Find or press Ctrl+F (⌘-F) to search for images by filename, as well as by date, keywords, description, and other metadata. The Bridge displays the results of the search as a series of thumbnails. If you think there's the slightest chance that you might want to recall the results of a search, click the Save as Collection button. You can then return to the search results at any time by clicking the Collections tab.

13. *Move the pencil drawings to the top of the sort order.* Press the Tab key to hide all panels except Content. Then zoom the thumbnails so all twelve are visible at once. Select the two thumbnails that lack paint and drag them to the beginning of the group, as shown in Figure 1-38. The photos now appear in chronological order.

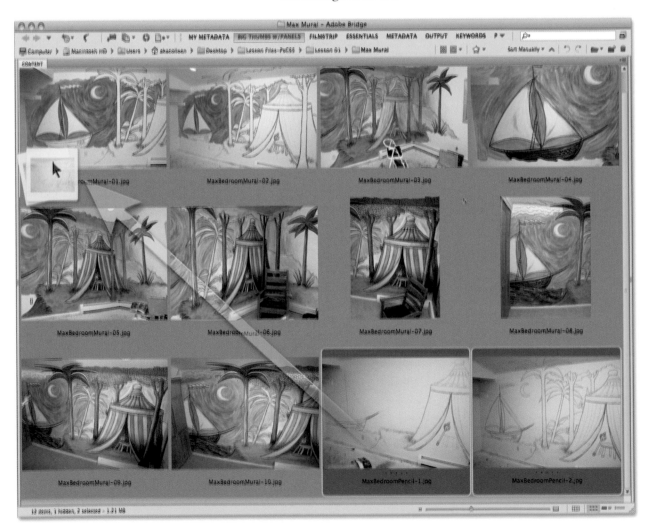

Figure 1-38.

WHAT DID YOU LEARN?

Match the key concept in the numbered list below with the letter of the phrase that best describes it. Answers appear upside-down at the bottom of the page.

Key Concepts

1. Adobe Bridge
2. Content browser
3. Favorites
4. New Workspace
5. Cache
6. Rotate clockwise/Rotate counterclockwise
7. Loupe function
8. Slide Show
9. Metadata
10. EXIF
11. File Info
12. Batch Rename

Descriptions

A. A command that lets you examine and save the descriptions, credits, and keywords assigned to one image so that you can apply them to others.

B. Available exclusively inside the Bridge, this command lets you expand one or more images to fill the entire screen as well as zoom and navigate from the keyboard.

C. The portion of the Bridge that contains thumbnail previews.

D. A command used to assign document names, sequence numbers, and more to multiple image files at a time.

E. By default centralized and sequestered—deep in the system level of your hard drive—this file stores transient information from the Bridge, such as sort order and high-resolution thumbnails.

F. Any information above and beyond the core image data, including the date the image was last saved, the copyright holder, and how the image was captured.

G. Click inside the Preview panel to access this feature, which allows you to zoom an image's detail from 100 to 800 percent.

H. Drag a folder that you use on a regular basis to this panel, and you'll never have to burrow through folders and subfolders to find your pictures again.

I. A Bridge operation that stands portrait-style photographs upright and writes the results to metadata. You can perform the operation from the keyboard by pressing Ctrl (or ⌘) and a bracket key, [or].

J. A standalone application for opening and managing files that ships with all versions of Photoshop CS5.

K. A specific kind of metadata saved by most modern digital cameras that records the time and date a photograph was captured as well as various camera settings.

L. A command that saves the size of thumbnails, the position and visibility of panels, and the size of the Bridge window itself.

Answers

1J, 2C, 3H, 4L, 5E, 6I, 7G, 8B, 9F, 10K, 11A, 12D

STRAIGHTEN, CROP, AND SIZE

IT'S ENTIRELY POSSIBLE that on some planet, there are those who believe that the perfect photograph is one that needs no editing. On this far-flung world, programs like Photoshop are tools of last resort. The very act of opening a photograph in an image editor is a tacit declaration that the photo is a failure. Every command, tool, or option applied is regarded as a mark of flimflam or forgery.

But that's hardly the case here on Earth. Although I do know a few traditionalists who disparage *any* edits—whether applied with Photoshop or otherwise—as unscrupulous cheats, such beliefs can hardly be characterized as mainstream. Despite oft-voiced and sometimes reasonable concerns that modern image editing distorts our perception of places and events, image manipulation is and has always been part and parcel of the photographic process.

There's no better example of this than cropping. Long before computers were widely available and eons before Photoshop hit the market, professional photographers would frame a shot and then back up a step or two before snapping the picture. That way, they had more options when it came time to crop. And nothing said you had to crop the image the way you first framed it; you could crop it any way you wanted to. Even in the old days—back when, say, giant insects roamed the plains (see Figure 2-1)—photographers shot their pictures with editing in mind because doing so ensured a wider range of post-photography options.

Whole-Image Transformations

If image editing is the norm, the norm for image editing is whole-image transformations. This includes operations such as scale and rotate applied to an entire image at a time. Although whole-image transformations may sound like a dry topic, they can produce dramatic and surprising effects.

Figure 2-1.

ABOUT THIS LESSON

Project Files

Before beginning the exercises, make sure you've downloaded the lesson files from *www.oreilly.com/go/Deke-PhotoshopCS5*, as directed in Step 2 on page xvi of the Preface. This means you should have a folder called *Lesson Files-PsCS5 1on1* on your desktop (or whatever location you chose). We'll be working with the files inside the *Lesson 02* subfolder.

In this lesson, we explore ways to crop, straighten, and resize digital photographs using a small but essential collection of tools and commands. You'll learn how to:

Video Lesson 2: Navigation

Navigation is about moving around inside an image: magnifying part of a photo so you can do detail work, panning to the area you want to modify, even stepping back and taking in the whole thing. Some of the best techniques covered in this video depend on OpenGL. (The OpenGL-dependent shortcuts are marked with ∗.)

To see how to navigate naturally in Photoshop, visit *www.oreilly.com/go/deke-PhotoshopCS5*. Click the **Watch** button to view the lesson online or click the **Download** button to save it to your computer. During the video, you'll learn these shortcuts:

Previous Video Lesson 2: Navigation Next ▶

Operation	Windows shortcut	Macintosh shortcut
Move to next image (in tabbed view)	Ctrl+Tab	⌘-~ (tilde key)
Zoom in or out	Ctrl+⊞ (plus), Ctrl+⊟ (minus)	⌘-⊞ (plus), ⌘-⊟ (minus)
Magnify the image with the zoom tool∗	Press Z, click and hold in image	Press Z, click and hold in image
Shrink the image with the zoom tool∗	Press Z, add Alt, click and hold	Press Z, add Option, click and hold
Zoom in (on-the-fly)	Ctrl-spacebar-click	⌘-spacebar-click
Zoom out (on-the-fly)	Alt-spacebar-click	Option-spacebar-click
Scroll with the hand tool	spacebar-drag in image window	spacebar-drag in image window
"Bird's-eye" wide-angle pan∗	Press H, click and hold in image	Press H, click and hold in image
Zoom to 100% or fit on-screen	Ctrl+⊡ (Ctrl+1) or Ctrl+⊙ (Ctrl+0)	⌘-⊡ (⌘-1) or ⌘-⊙ (⌘-0)
Hide or show the toolbox and panels	Tab	Tab

More importantly, whole-image transformation forces you to think about basic image composition and ponder some big-picture questions:

- The photo in Figure 2-2 is clearly at an angle. What angle might that be? How can Photoshop help you find your footing when the world is askew?

- After you rotate the image, you have to crop it. Never content to limit you to a single approach, Photoshop dedicates one tool, four commands, and a score of options to the task (symbolically illustrated in Figure 2-3). Variety is the spice of life, but which one do you use when?

- After the crop is complete, there's the problem of scale. Should you reduce or increase the number of pixels? Or should you merely reduce the resolution to print the image larger, as in Figure 2-4?

I provide these questions merely to whet your appetite for the morsels of knowledge that follow. If they seem like a lot to ponder, never fear; the forthcoming lesson makes the answers perfectly clear.

Figure 2-2.

Figure 2-3.

Figure 2-4.

Straightening a Crooked Image

Try as we might to keep our pictures (and lives) in balance, the forces of nature, fatigue, and skewed perspective occasionally conspire to create an image that's tilted at an undesirable angle. Straightening an image used to be one of the ultimate Photoshop secret handshakes, something you never could have figured out on your own without special initiation. But Photoshop CS5 makes it easier than ever to correct this common composition problem.

In the past, when you wanted to realign your image with the horizon or some other dependable touchstone of perspective, you actually had to use a command called Arbitrary. But *arbitrary* was Photoshop-code for *highly specific*. There you were, filled with the simple desire to set the world to rights, and it always seemed like the most arbitrary things about the act of straightening were the insulting name and the complexity of the tool you were required to use. At last, in Photoshop CS5, we're given a much more straightforward (and sensibly named) tool. In this exercise, we'll employ this gift from Adobe engineers to straighten out the horizon in an image of a notoriously askew landmark.

1. **Open a crooked photograph.** Open the file named *Crooked Pisa.jpg,* located in the *Lesson 02* folder inside *Lesson Files-PsCS5 1on1.* This image, shown in Figure 2-5, comes from Fotolia photographer Soul Catcher. Like many photos of this famous tower, the leaning nature of the building seems to wreak havoc with the photographer's sense of the horizon. Our job is to straighten the earth, so that the tower's angle is shown accurately but the tourists who have traveled to Pisa to see it don't have to compromise their posture in the process. And isn't a leaning tower much more interesting if everything else is actually upright?

2. **Select the ruler tool in the toolbox.** Click and hold the eyedropper icon near the top of the toolbox and choose the ruler tool from the flyout menu (see Figure 2-6). This tool lets you measure the distance and angle between two points. But even more importantly for our current purposes, it gives you access to a new feature in Photoshop CS5, the Straighten button, which appears in the options bar when you evoke the ruler tool.

Figure 2-5.

Figure 2-6.

3. ***Drag inside the image with the ruler tool.*** For the best results, we want to drag along an edge or along another element that ought to be exactly horizontal or vertical. Nothing is better for horizontal orientation than the actual horizon, so click under the corner of the building to the left of the tower and drag across the horizon, as shown in Figure 2-7.

Figure 2-7.

As you work with the ruler tool, the options bar notes the angle (A) and distance (D1) of the line. Angle is the inclination of the line, which translates to the number of degrees the line is out of plumb (off from absolute vertical or horizontal). Distance is the length of the line. When straightening an image, D1 is of no concern; only A matters. And it matters only for your own curiosity because Photoshop is going to straighten the image for you automatically.

If you drag from left to right, as I did, the A value will be something like –2.7 degrees. But if you drag from right to left, the A value will be more in the neighborhood of 177.3 degrees. Which is correct? As it turns out, both. Which should you use to rotate the image? Neither, because Photoshop will do it for you in the next step.

4. ***Click the Straighten button.*** As soon as you draw a line with the ruler tool, the **Straighten** button in the options bar becomes available (see Figure 2-8). Click this button and watch as Photoshop magically aligns the photo. We still have a leaning tower, but the people, trees, and other buildings are properly upright.

Figure 2-8.

5. ***Check to see what Photoshop threw away.*** The deceptively simple Straighten button actually performs two separate operations. First, it rotates the image on the *canvas* (the entire image, including the area with no pixels) according to the angle you indicated with your line. Then, it crops away the empty wedges of canvas that are naturally created by the rotation and pares the image to its original shape, showing you only the finished product. To see what I mean, we need Photoshop to reveal what happened in between those two steps.

Choose **Edit→Undo** or press Ctrl-Z (⌘-Z on the Mac) to go one step back. Lo and behold, Photoshop reveals what the image looked like before the clean-up cropping. As you can see in Figure 2-9, before the crop there were wedges filled with the background color (which is white by default). Photoshop automatically cropped the wedges, leaving as much of the image as possible intact but necessarily trimming some of the photo as well.

Canvas background added
during phase one to allow rotation

Parts of original image cropped
during phase two

Figure 2-9.

Boundary of crop applied during phase two

6. *Recrop the image manually.* Photoshop did a pretty good job, but in its desire to crop to the original dimensions, it left too much of the distracting building on the left and cut off too much of the flagpole at the top. You can fix this by manually recropping the straightened photograph:

- Select the rectangular marquee from the toolbox, as shown in Figure 2-10.

- Drag a rectangle around the tower. Keep as much of the flagpole on top as you can without grabbing white space, and get rid of the extraneous details on the sides, as I did in Figure 2-11.

Figure 2-10.

Figure 2-11.

Figure 2-12.

- When you have the marquee where you want it, choose **Image→Crop**.

The final cropped image is shown in Figure 2-12. You can save this skewed monument by pressing Ctrl+Shift+S (⌘-Shift-S) and naming it "Not So Leaning Pisa.psd."

Using Rotate View with the Crop Tool

If you need to selectively cut away unwanted parts of your image, nothing beats the crop tool. With it, you can also rotate the boundary to accommodate a crooked image. And paired with the rotate view tool, you can preview the angle of rotation.

Introduced in Photoshop CS4, the rotate view tool lets you rotate your view of the image without affecting its real orientation or how it prints. (For a demonstration, see Video Lesson 2, "Navigation," introduced on page 40.) The tool is designed for angling an image so that you can better paint or edit it, but it's also great for previewing the angle of rotation required to straighten a crooked image.

1. *Open an image that needs cropping.* Open the image called *Woman smiling.jpg*, located in the *Lesson 02* folder inside *Lesson Files-PsCS5 1on1*. Pictured in Figure 2-13, on the facing page, this photograph comes to us from Jordan Chesbrough of iStockphoto and features a lovely young woman leaning slightly to the left. Although lively and cheerful, the model might benefit from a more perpendicular aspect. Plus, I think we could increase the effect of the photo by closing in on her face, with a bit of shoulder and collarbone for context.

PEARL OF WISDOM

The crop tool—which we'll use in just a moment—lets you rotate and crop an image in one operation, but it doesn't permit you to preview the rotation. Crazy as it may sound, you have to tilt your head to gauge how the image will look when straightened. (Which is a pain in the neck, literally of course, but also because if you get it wrong you have to undo and start over again.) To the rescue: the rotate view tool. Which would be great if Photoshop let you switch back and forth between the tools. Only it doesn't. The crop tool locks you into a claustrophobic "mode" that blocks you from using the rotate view tool, not to mention 99 percent of the rest of the program (see Step 5). The upshot: You have to rotate the view first and crop second, just as we'll do in these steps.

2. **Select the rotate view tool.** In the toolbox, press and hold the hand tool and select the rotate view tool from the flyout menu, as in Figure 2-14. Alternatively, you can press the R key.

3. **Rotate the view 6 degrees.** Drag in the image window to rotate the image. In the center of the window, you'll see a white compass rose, with an inset red-and-white pointer that rotates with the image. You can eyeball the change, or monitor or modify the Rotate Angle value in the options bar. Rotate the image 6 degrees clockwise, which puts her eyes and mouth on an even horizon, as in Figure 2-15.

To access the rotate tool temporarily, press and hold the R key, drag with the tool in the image window, release the mouse button, and then release the R key. Photoshop then returns you to the previously active tool.

Figure 2-13. Figure 2-14.

Figure 2-15.

Figure 2-16.

4. **Select the crop tool in the toolbox.** Click the crop tool in the toolbox (see Figure 2-16) or press C for Crop (not to mention Clip, Cut, and Curtail).

5. **Draw the crop boundary.** Drag inside the image window to draw a rectangle around the portion of the image that you want to keep. Because you've rotated your view of the image, the upright crop boundary will appear at an angle, along with the rest of the photograph, as in Figure 2-17.

You can adjust the position of the crop boundary on-the-fly by pressing and holding the spacebar. But don't get too hung up on getting things exactly right. You can easily move and resize the crop boundary after you draw it, as demonstrated in Step 7.

The moment you release the mouse button, you enter the crop mode. From now until you press Enter (Return) or Esc, most of Photoshop's commands and panels are unavailable. You have made a commitment to cropping.

PEARL OF WISDOM

In the CS5 version of cropping, when you release the mouse button after designating the crop, a grid overlay automatically appears over your image to help guide your crop. If you're rotating an image, it may be useful to have these extra vertical and horizontal lines. But by default, the grid is set to a "rule of thirds" display, which is of marginal use in general and becomes particularly meaningless and somewhat distracting for portraits. Hey, creativity and rules just don't go together in my book. You can turn off the grid by going to the Crop Guide Overlay pop-up menu in the options bar and setting it to None, as I did here.

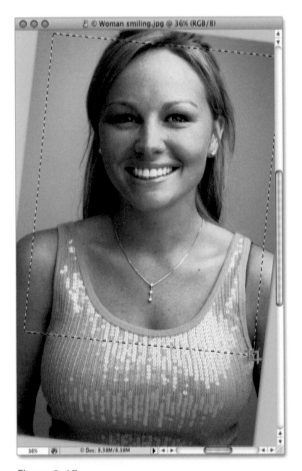

Figure 2-17.

6. **Adjust the appearance of the shield.** Photoshop indicates the area that will be cropped away by covering it with a translucent *shield*. Black by default, the shield doesn't give us much of an idea of how the image will look when set against a white page or a Web site. In the options bar, click the **Color** swatch to display the **Color Picker** dialog box. Set the **Color** to white by setting the R, G, and B values each to 255, and then click **OK**. I also like to lower the **Opacity** value to 50 percent, as circled in Figure 2-18.

7. **Rotate the crop boundary.** To rotate the rectangular crop boundary, move your cursor outside the boundary and drag. Rotate the boundary so it appears straight up-and-down (see Figure 2-19), thus matching the angle of the view.

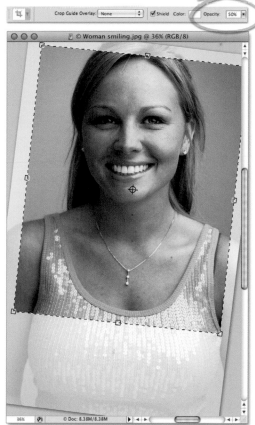

Figure 2-18.

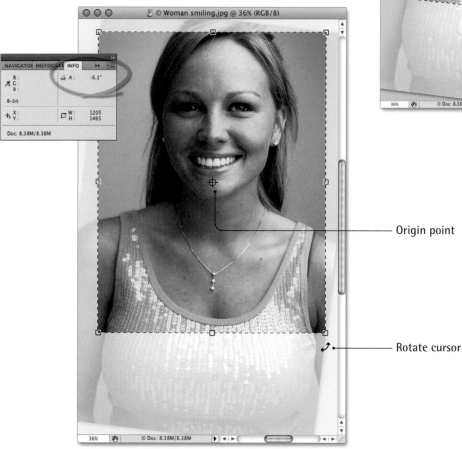

Origin point

Rotate cursor

Figure 2-19.

To monitor the angle of the rotation, choose Window→Info or press the F8 key to display the Info panel. Then note the angle value (A) in the upper-right corner of the panel. I finally settled on an angle of −6.1 degrees, as pictured in Figure 2-19 on the preceding page.

You may notice that Photoshop rotates the boundary around a central *origin point*, labeled in that same figure. To rotate around a different spot, drag the origin from the center of the boundary to the desired location.

8. **Move and scale the crop boundary.** Drag inside the crop boundary to move it. Drag the crop outline or one of the eight square handles surrounding the crop boundary to scale it (that is, change its size). Also worth noting:

 • Press the Shift key while dragging a corner handle to scale the boundary by the same percentage horizontally and vertically.

 • Press the Alt key (Option on the Mac) while dragging to scale the boundary with respect to the origin point. In other words, the corners move but the origin stays fixed in place. It's a great way to scale an image with respect to a specific location.

 I sized the boundary to expose about 100 pixels of shoulder on either side of the woman's blouse, and moved the bottom edge about 100 pixels below the necklace, as shown in Figure 2-20. I also moved the top edge high enough to expose some hair—so she's not all forehead—which results in an empty wedge in the top-right corner, labeled in the figure. This wedge is all background, making it relatively easy to fix, as you'll soon see.

9. **Apply your changes.** Click the ✔ on the right side of the options bar or press the Enter or Return key to accept your changes. Photoshop crops away the pixels outside the boundary and rotates the image upright.

By which I mean, Photoshop rotates the image to match the rotated view, as witnessed by the left image in Figure 2-21 on the facing page. To restore the view to its standard upright self, select the rotate view tool and click the Reset View button in the options bar. Or better yet, don't switch tools, just press the Esc key. Either way, you'll end up with the upright image on the right side of Figure 2-21.

Empty wedge

Figure 2-20.

The result is an sunny, engaging, tightly composed head shot. I wish we had more headroom to work with, but enough remains to demonstrate that the model does indeed have hair on the top of her head.

Figure 2-21.

Bad news: As warned, the image still suffers from an empty wedge. Plus, I think the image could benefit from a couple of mattes, like those used in traditional picture framing. Filling in the wedge is a job for the magic wand. Framing turns out to be an "uncropping" operation in which you add to the canvas using the Canvas Size command. If you're not interested, skip to the next exercise, "Resizing an Image," which begins on page 55. Otherwise, let's complete the image.

10. *Select the magic wand.* Select the magic wand from the toolbox (it lives with the quick selection tool, as shown in Figure 2-22) or press the W key a couple of times (or Shift-W if you haven't followed my directions in the Preface.) In the options bar, make sure the **Tolerance** value is somewhere in the 0 to 50 range and **Anti-aliased** and **Contiguous** are both turned on.

Figure 2-22.

11. **Click in the wedge.** When retouching with a selection tool, you always select the thing that you want to get rid of or heal over, which in this case is the wedge. Click with the magic wand tool in that triangular space, and you'll see Photoshop select the white area, as indicated by a "marching ants" outline.

12. **Expand the selection.** The selection needs to be a bit larger than the wedge to prevent any telltale seams when you fill it in. Choose **Select→Modify→Expand**, set the **Expand By** value to 3 pixels, and click **OK**. You'll notice in Figure 2-23 that the selection outline moves out slightly into the gold-colored background.

13. **Fill in the wedge with information from the surrounding area.** We'll fill in the white wedge using one of the truly useful new features in Photoshop CS5: *content-aware fill*. Basically, you give the instruction, and Photoshop takes its best guess on how to fill the selection based on what it knows about the nearby pixels. To see this in action, choose **Edit→Fill** (or press Shift+F5). In the **Fill** dialog box, leave everything set to the default, as shown in Figure 2-24, and click **OK**.

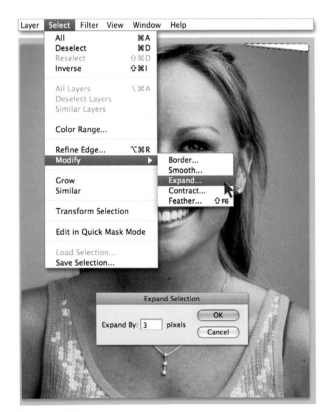

Figure 2-23.

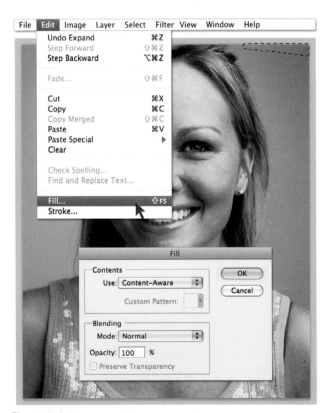

Figure 2-24.

14. *Deselect the image.* Press Ctrl+D (or ⌘-D) to deselect the image and reveal the genius of your seamless edit, pictured in glorious detail in Figure 2-25.

15. *Copy the image to a new layer.* To create the matte effect, we'll need a brief introduction to layers (to tide us over until we cover them in more detail in Lesson 5). Choose **Layer→New→Layer via Copy**. Or more simply, press Ctrl+J (⌘-J on the Mac).

16. *Expand the canvas.* Choose **Image→Canvas Size** or press Ctrl+Alt+C (⌘-Option-C) to display the **Canvas Size** dialog box. Make sure that the **Relative** check box is on, as shown in Figure 2-26, so that the **Width** and **Height** values add to the existing canvas. Values of 50 pixels for each will extend the canvas 25 pixels (half of 50) in all directions.

17. *Assign a canvas color.* Go down to the **Canvas Extension Color** option and choose **Other** from the pop-up menu, or click the color swatch to the right of the menu. In the color picker dialog box, change the first three values to **H: 210**, **S: 15**, and **B: 65** to get the bluish gray you see in Figure 2-26. Click **OK** to exit the color picker, and then click **OK** again to extend the canvas size.

Figure 2-25.

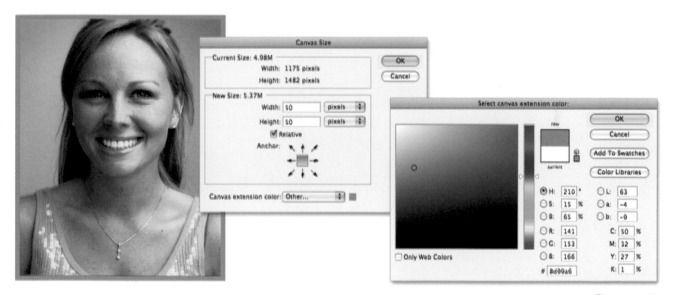

Figure 2-26.

18. *Give the matte a beveled edge.* Go to the **Layers** panel. (If you don't see it, choose Window→Layers.) Make sure **Layer 1** is active by clicking it. Then click the *fx* icon at the bottom of the panel and choose **Bevel and Emboss** to display the immense **Layer Style** dialog box, as shown in Figure 2-27 on the next page.

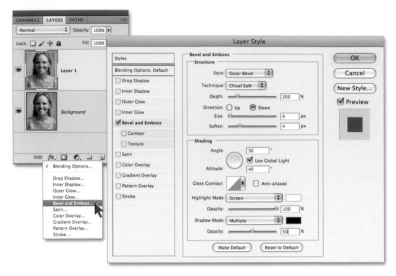

Figure 2-27.

19. *Apply the Outer Bevel effect.* Choose **Outer Bevel** from the **Style** pop-up menu at the top of the dialog box. This ensures that the bevel extends out from the image into the matte. Then you can either accept the defaults or enter the custom settings shown in Figure 2-27. When you're finished, click **OK**.

20. *Copy the Background layer.* Click the **Background** item in the **Layers** panel to select the layer that contains the matte color. Then press Ctrl+J (⌘-J on the Mac) again to clone the image to a new layer.

21. *Again choose Canvas Size.* Choose **Image**→**Canvas Size** or press Ctrl+Alt+C (⌘-Option-C) to display the **Canvas Size** dialog box. Then do the following:

 • Make sure **Relative** is turned on, and then change the **Width** and **Height** values to 150 pixels each.

 • Click the **Canvas extension color** swatch. In the color picker dialog box, raise the **S** value to 20, and lower the **B** value to 45. (The H value should remain 210.) This results in a darker bluish gray.

 • Click **OK** to exit the Color Picker dialog box. Then click **OK** again to extend the canvas size.

22. *Duplicate the layer style.* See the *fx* icon to the right of **Layer 1** in the **Layers** panel? This represents the Bevel and Emboss effect you applied in Steps 18 and 19. To duplicate this effect, press the Alt (or Option) key and drag the *fx* icon to the **Background Copy** layer. This copies the layer style from the top layer to the middle layer, creating another layer of matte.

The result is the double-matte effect that appears in Figure 2-28, and a preview of the layers we'll study in greater depth in Lesson 5.

Figure 2-28.

Resizing an Image

Now we leave the world of rotations and canvas manipulations in favor of what might be the single most essential command in all of Photoshop: Image Size. Designed to resize an entire image all at once—canvas, pixels, the whole shebang—Image Size lets you scale your artwork in two very different ways. First, you can change the physical dimensions of an image by adding or deleting pixels, a process called *resampling*. Second, you can leave the quantity of pixels unchanged and instead focus on the *print resolution*, which is the number of pixels that get packed in an inch or a millimeter of page space when you print the image.

Whether you resample an image or change its resolution depends on the setting of a check box called Resample Image. As we'll see, this one option has such a profound effect on Image Size that it effectively divides the command into two functions. In this next exercise, we explore how and why you might resample an image. To learn about print resolution, read the "Changing the Print Size" sidebar on page 58.

1. *Open the image you want to resize.* Go to the *Lesson 02* folder inside *Lesson Files-PsCS5 1on1* and open *CW with clipboard. jpg*. Shown in Figure 2-29, this is my Web site co-conspirator, Colleen Wheeler, holding the script for "101 Photoshop Tips in 5 Minutes," an episode of my free, every-other-weekly dekePod video series, which involved a fair amount of location shooting. The image contains the most pixels of any file we've seen so far (excluding layers).

2. *Check the existing image size.* To see just how many pixels make up the image, click and hold the box in the bottom-left corner of the image window, the one that reads **Doc: 18.0M/18.0M**. As pictured in Figure 2-29, this displays a flyout menu that lists the size of the image in pixels, along with its resolution. This particular image measures 2048 pixels wide by 3072 pixels tall, which translates to a total of 2048 × 3072 = 6.29 million pixels. When printed at 300 ppi, the image will measure approximately 6⅚ inches wide by 10¼ inches tall.

Figure 2-29.

In the status bar, *Doc: 18.0M/18.0M* refers to the size of the image, as measured in megabytes, in your computer's memory. (The size of the file on disk is usually smaller, thanks to compression.) The value before the slash is the flat version of the file; the value after the slash includes layers. Because this is a flat image, both values are the same. To change the kind of information displayed in the status bar, click the ▶ to the right of the Doc item, and then choose an option from the pop-up menu.

3. *Magnify the image to the 100 percent zoom ratio.* Press Ctrl+1 (⌘-1 on the Mac). Then scroll around until you can see the clipboard and script. Pictured in Figure 2-30, the text is sufficiently legible that you can read every word, save those covered by Colleen's hand (thus suggesting that "101 Photoshop Tips in 5 Minutes" might not have been an extemporaneous rant).

4. *Determine how many pixels you need.* Because resampling amounts to rewriting every pixel in your image, it's a good idea to map out a strategy before you plow ahead.

For example, let's say you want to email this image to a couple of friends. Surely your friends can print the image smaller than 6⅚ by 10¼ inches. In fact, in all likelihood, they won't print it at all; they'll just view it on the screen. A typical high-resolution monitor can display 1600 by 1200 pixels, a mere 30 percent of the pixels in this photo. So the photo will be automatically downsized by whatever software your friends use to view it, possibly in ways that make the image look awful.

Figure 2-30.

Also worth noting, pixels come at a price. Lots of pixels consume lots of space in memory and on your hard drive, plus they take longer to transmit over the Internet. If you were to email this JPEG file, as is, over a typical suburban DSL or cable modem connection, it could take as long as a minute to send and 30 seconds to receive. Those times grow exponentially in rural areas. Most Internet users aren't interested in spending that kind of time on still images, not even ones of Colleen.

Conclusion: Resampling is warranted. This is a job for Image Size.

5. *Choose the Image Size command.* Choose **Image→Image Size** or press Ctrl+Alt+I (or ⌘-Option-I). Pictured in Figure 2-31, the ensuing **Image Size** dialog box is divided into two parts:

 - The Pixel Dimensions options let you change the width and height of the image in pixels. Lowering the number of pixels is called *downsampling*; raising the pixels is called *upsampling*. We'll be downsampling, by far the more common practice.

 - The Document Size options control the size of the printed image. They have no effect on the size of the image on the screen or on the Web.

6. *Turn on the Resample Image check box.* Located at the bottom of the Image Size dialog box, turn on the **Resample Image** option to change the number of pixels in an image.

7. *Select an interpolation setting.* Below the Resample Image check box is a pop-up menu of interpolation options, which determine how Photoshop blends the existing pixels in your image to create new ones. When downsampling an image, only three options matter. Note: In my following discussions of these options, I've omitted the parenthetical references (e.g., best for smooth gradients) because they are at best misleading and at worst just plain wrong.

 - When in doubt, select Bicubic, which calculates the color of every resampled pixel by averaging the original image in 16-pixel blocks. It is slower than Nearest Neighbor and Bilinear (neither of which should be used when resampling photographs), but it does a far better job as well.

 - Bicubic Smoother compounds the blurring effects of the interpolation to soften color transitions between neighboring pixels. This helps suppress film grain and *noise* (random brightness and color variations between neighboring pixels).

 - Bicubic Sharper results in crisp edge transitions. Use it when the details in your image are impeccable and you want to preserve every nuance.

Because this particular image contains so little noise and you want it to look nice and sharp after you reduce it, **Bicubic Sharper** is the best choice.

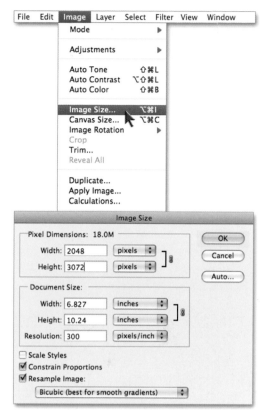

Figure 2-31.

Changing the Print Size

As often as not, you have no desire to change the number of pixels in an image; you just want to change how it looks on the printed page. By focusing exclusively on the resolution, you can print an image larger or smaller without adding or subtracting so much as a single pixel.

For example, let's say you want to scale the original *CW with clipboard.jpg* image so that it prints 8 inches wide by 12 inches tall. Would you upsample the image and thereby add pixels to it? Absolutely not. The Image Size command can't add detail to an image; it just averages existing pixels. So upsampling adds complexity without improving the quality. Upsampling is helpful at times—when matching the resolution of one image to another, for example—but those times are few and far between.

The better solution is to modify the print resolution. Try this: Open the original *CW with clipboard.jpg*. (This assumes that you have completed the "Resizing an Image" exercise and saved the results of that exercise under a different filename, as directed in Step 14 on page 60.) Then choose the **Image Size** command from the **Image** menu and turn off the **Resample Image** check box.

Note that the Pixel Dimensions options are now dimmed and a link icon (⑧) joins the three Document Size values, as in the screen shot below. This tells you that it doesn't matter which value you edit or in what order. Any change you make to one value affects the other two, so you can't help but edit all three values at once.

For example, change the **Width** value to 8 inches. As you do, Photoshop automatically updates the Height and Resolution values to 12 inches and 256 ppi, respectively. So there's no need to calculate the resolution value that will get you a desired set of dimensions; just enter one of the dimensions and Photoshop does the math for you.

Click **OK** to accept your changes. The image looks exactly the same as it did before you entered the Image Size dialog box. This is because you changed the way the image prints, which has nothing to do with the way it looks on the screen. If you like, feel free to save over the original file. You haven't changed the structure of the image; you just added a bit of sizing data.

To change only the print size, turn off this check box

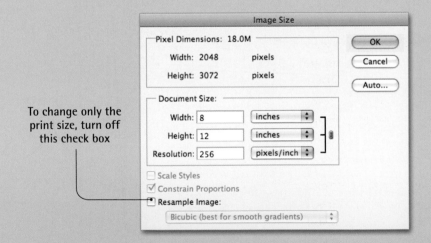

8. **Turn on the Constrain Proportions check box.** Unless you want to stretch or squish your image, leave this option turned on. That way, the relationship between the width and height of the image—known as the *aspect ratio*—will remain constant.

9. **Specify a Resolution value.** When the Resample Image option is turned on (Step 6), any change made to the Resolution value affects the Pixel Dimensions values as well. So if you intend to print the image, it's a good idea to get the Resolution setting out of the way first. Given that we're emailing the image and we're not sure if it will ever see a printer, a **Resolution** of 200 ppi should work well enough.

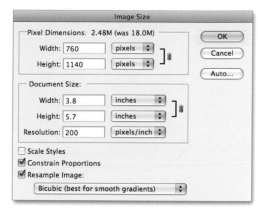

Figure 2-32.

10. **Adjust the Width or Height value.** The Pixel Dimensions have dropped to 1365 by 2048 pixels. But that's still too tall because the maximum height of most screens is 1200 pixels. Reduce the **Width** value to 760 pixels, which changes the Height value to 1140 pixels. (Of course, you could adjust the Height value directly if you prefer. I chose these values because they're even and fall under the 1200-pixel maximum.) This also reduces the Document Size to 3.8 by 5.7 inches (see Figure 2-32), plenty big for an email picture.

11. **Note the new file size.** The Pixel Dimensions header should now read 2.48M (it was 18.0M), where the *M* stands for *megabytes*. This represents the size of the image in your computer's memory. The resampled image will measure 866,400 pixels (760 × 1140), a mere fraction of its previous size. The complexity of a digital photo hinges on its image size, so this downsampled version will load, be saved, and email much more quickly.

12. **Click OK.** Photoshop reduces the size of the image on screen and in memory. Printed full size at 200 ppi in Figure 2-33, the result looks a little choppy in print. But when you consider that high-quality materials (glossy paper, commercial-grade inks) exaggerate both the strengths and flaws in an image, I reckon it's not half bad.

Figure 2-33.

Figure 2-34.

13. ***Magnify the image to the 400 percent zoom ratio.***
Press Ctrl+⊡ (plus sign) (⌘-⊡) to zoom in on the
clipboard, as in the first example in Figure 2-34. The
words are no longer readable—no surprise given the
meager number of pixels assigned to them—but you
can tell they're words. And if you scroll around the
image, you can still make out some interesting details,
such as the reflection of the photographer in the sun-
glasses (highlighted slightly in the second example).
You'd be hard-pressed to identity that the photogra-
pher is I, but that's a sacrifice I'm willing to make for
a smaller image.

14. ***Choose File→Save As.*** Or press Ctrl+Shift+S (⌘-Shift-S).
Then give the file a new name or save it to a different
location. I have you do this to emphasize the following
very important point.

PEARL OF ⬤ WISDOM

Avoid saving your downsampled version of the image over the
original. *Always* keep that original in a safe place. I don't care
how much better you think the downsampled image looks; the
fact remains that it contains fewer pixels and therefore less
information. The high-resolution original may contain some bit of
detail that you'll want to retrieve later—such as the more detailed
reflections in Figure 2-35—and that makes it worth preserving.

Figure 2-35.

WHAT DID YOU LEARN?

Match the key concept in the numbered list below with the letter
of the phrase that best describes it. Answers appear upside-down
at the bottom of the page.

Key Concepts

1. Cropping
2. Whole-image transformations
3. Ruler tool
4. Straighten button
5. Canvas
6. Rotate view
7. Origin point
8. Content-aware fill
9. Print resolution
10. Downsampling
11. Bicubic Sharper
12. Aspect ratio

Descriptions

A. This tool lets you measure angles and distances in Photoshop, as well as gives you access to the Straighten button.

B. A means of cutting away the extraneous portions of an image to focus the viewer's attention on the subject of the photo.

C. An interpolation setting that results in crisp edge transitions, perfect when the details in your image are impeccable and you want to preserve every nuance.

D. The number of pixels that will print in a linear inch or millimeter of page space.

E. New to CS5, this tool lets you quickly confirm a line that you want to designate as the new vertical or horizontal basis of your image.

F. To change the physical dimensions of an image by reducing the number of pixels.

G. A new feature in CS5 that fills in selections automatically based on what Photoshop understands about surrounding pixels.

H. This tool lets you preview the proper angle for a crooked image before you crop it.

I. The relationship between the width and the height of an image.

J. Operations such as Image Size and the Rotate Canvas commands that affect an entire image, including any and all layers.

K. The center of a rotation or another transformation.

L. The boundaries of an image, as measured independently of the contents of the image itself.

Answers

1B, 2J, 3A, 4E, 5L, 6H, 7K, 8, 9D, 10F, 11C, 12I

MAKING SELECTIONS

MANY COMPUTER applications let you manipulate elements on a page as objects. That is to say, you click or double-click an object to select it, and then you modify the object in any of several ways permitted by the program. For example, to make a word bold in Microsoft Word, you double-click the word and then click the Bold button. In Adobe Illustrator, you can make a shape bigger or smaller by clicking it and then dragging with the scale tool. In QuarkXPress, you move a text block to a different page by clicking and dragging it.

The real world holds a similarly high regard for objects. Consider the three sunflowers pictured in Figure 3-1. In life, those flowers are objects. You can reach out and touch them. You can even cut them and put them in a vase.

Although Photoshop lets you modify snapshots of the world around you, it doesn't behave like that world. And it bears only a passing resemblance to other applications. You can't select a sunflower by clicking it—as you could had you drawn it in, say, Illustrator—because Photoshop doesn't perceive the flower as an independent object. Instead, the program sees pixels. And as the magnified view in Figure 3-1 shows, every pixel looks a lot like its neighbor. In other words, where you and I see three sunflowers, Photoshop sees a blur of subtle transitions, without form or substance.

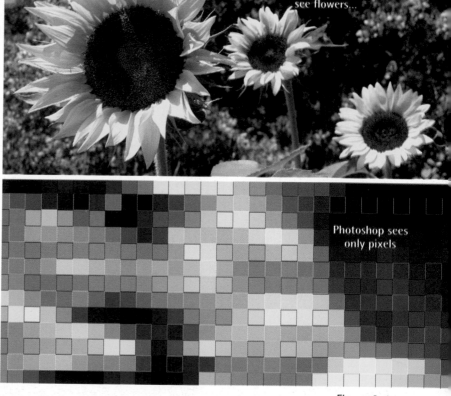

Where you see flowers...

Photoshop sees only pixels

Figure 3-1.

ABOUT THIS LESSON

Project Files

Before beginning the exercises, make sure you've downloaded the lesson files from *www.oreilly.com/go/Deke-PhotoshopCS5*, as directed in Step 2 on page xvi of the Preface. This means you should have a folder called *Lesson Files-PsCS5 1on1* on your desktop (or whatever location you chose). We'll be working with the files inside the *Lesson 03* subfolder.

This lesson examines ways to select a region of an image and edit it independently of another region using Photoshop's magic wand, quick selection, lasso, and marquee tools as well as a few commands in the Select menu. You'll learn how to:

- Isolate an image with an irregular shape page 66
- Make selections based on color value page 74
- Extract a problematic element with a combination of selection tools page 80
- Understand the mercurial magnetic lasso tool. . . . page 83

Video Lesson 3: The Selection Tools

Photoshop's selection tools rank among the program's most fundamental capabilities. Simply put, unless you want to apply an operation to an entire image or layer, you have to first define the area that you want to affect with a selection tool. In this video lesson, you'll see a range of selection tools employed to move a model from one background to another—from the straightforward marquees and flexible lasso tools to the edge-detecting magic wand and quick selection tools. Then we'll finish with the fine-tuning refine edge command.

To see selections in action, visit *www.oreilly.com/go/deke-PhotoshopCS5*. Click the **Watch** button to view the lesson online or click the **Download** button to save it to your computer. During the video, you'll learn these shortcuts:

Video Lesson 3: The Selection Tools

Operation	Windows shortcut	Macintosh shortcut
Deselect the image	Ctrl+D	⌘-D
Reposition a marquee	spacebar-drag	spacebar-drag
Subtract from a selection	Alt-click or drag with tool	Option-click or drag with tool
Add to a selection	Shift-click or drag with tool	Shift-click or drag with tool
Inverse (reverse the selection)	Ctrl+Shift+I	⌘-Shift-I
Hide or show the selection outline	Ctrl+H	⌘-H
Copy an entire image	Ctrl+A, then Ctrl+C	⌘-A, then ⌘-C
Paste an image into a selection	Ctrl+Shift+V	⌘-Shift-V

So rather than approaching an image in terms of its sunflowers or other objects, you have to approach its pixels. This means specifying which pixels you want to affect and which you do not using *selections*.

Isolating an Image Element

Let's say you want to change the color of the umbrella shown in **Figure 3-2**. The umbrella is so obviously an independent object that even an infant could pick it out. But Photoshop is no infant. If you want to select the umbrella, you must tell Photoshop exactly which group of pixels you want to modify.

Fortunately, Photoshop provides a wealth of selection functions to help you do exactly that. Some functions select entire regions of colors; others automatically detect and trace edges. Still others, like the tools I used to describe the bluish regions in **Figure 3-3**, select geometric regions. And if none of those tools does what you need it to, you can whip out the big guns and painstakingly define a selection by hand, one meticulous point at a time. These tools can all be used together to forge the perfect outline, one that exactly describes the perimeter of the element or area that you want to select.

As if to make up for its inability to immediately perceive image elements such as umbrellas and sunflowers, Photoshop treats *selection outlines*—those dotted lines that mark the borders of a selection—as independent objects. You can move, scale, or rotate selection outlines independently of an image. You can combine them or subtract from them. You can undo and redo selection modifications. You can even save selection outlines for later use (as you'll see later in Lesson 10).

Selected umbrella

Colorized using Gradient Map

Figure 3-2.

Figure 3-3.

Figure 3-4.

Furthermore, a selection can be every bit as incremental and precise as the image that houses it. Not only can you select absolutely any pixel inside an image, you can also specify the degree to which you want to select a pixel—all the way, not at all, or in any of several hundred levels of translucency in between.

This means you can match the subtle transitions between neighboring pixels by creating smooth, soft, or fuzzy selection outlines. In Figure 3-4, I selected the umbrella and the man who holds it and transferred the two elements to an entirely different backdrop. I was able to not only maintain the subtle edges between the man and his environment but also make the darkest portions of his coat translucent so they would blend with the backdrop. Selections take work, but they also deliver the goods.

Selecting an Irregular Image

We'll start with one of Photoshop's oldest and most straightforward sets of selection tools. The lasso tools let you select irregular portions of an image. The default lasso tool requires you to drag around an image to trace it freehand. But like freehand tools in all graphics programs, the lasso is haphazard and hard to control. That's why Photoshop also includes a polygonal lasso, which allows you to select straight-edged areas inside an image. Admittedly, the polygonal lasso tool doesn't suit all images, particularly those that contain rounded or curving objects. But as you'll see, the polygonal lasso tool is easy to control and precise to boot.

In the following exercise, you'll experiment with both the standard and polygonal lasso tools and get a feel for why the latter is typically more useful. We'll also incorporate Photoshop's ability to leverage its marquee-creation tools when creating a selection. You'll even get the opportunity to play with a couple of special-effects commands in Photoshop's Filter menu, because once you've created a selection, the point is to do something interesting to the areas you've singled out.

1. ***Open two images, one foreground and one background.*** Open *Courthouse.psd* and *Fireworks.jpg*, both located in the *Lesson 03* folder inside *Lesson Files-PsCS5 1on1*. Photographed by Matt Duncan of iStockphoto, the courthouse is a nifty piece of architecture, but the composition lacks luster. A structure like this deserves a celebration—hence the fireworks. The result of four photographs from the PhotoSpin image library combined with the Screen blend mode, the fireworks image is precisely the sort of over-the-top background that our sleepy courthouse needs. For reference, both images appear in Figure 3-5.

2. ***Click the lasso tool in the toolbox.*** Or press the L key. As I said, the lasso tool (shown in Figure 3-6) can be difficult to control. But I'd like you to experience the tool for yourself so you can decide what you think of it firsthand.

3. ***Try dragging around the courthouse.*** The portion of the building I'd like you to select appears highlighted in Figure 3-7. Trace along the yellow line to select the area inside the building. (I colored the sky orange to show that the sky is outside the selection.)

Figure 3-5.

Figure 3-6.

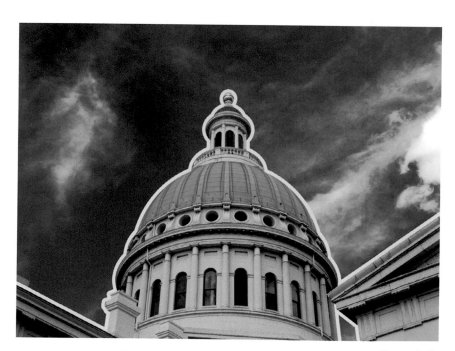

Figure 3-7.

The lasso is exceedingly flexible, automatically scrolling the image window to keep up with your movements and permitting you to drag outside the image to select the extreme edges. But it drops the ball when it comes to precision. If you're anything like me, you'll have a heck of a time getting halfway decent results with it.

4. *Deselect the image.* Assuming your selection looks like garbage, choose **Select→Deselect** or press Ctrl+D (⌘-D on the Mac) to throw it away and start over. Now that we've seen the wrong way to do it, let's see the right way.

5. *Select the polygonal lasso tool in the toolbox.* Click the lasso icon to display a flyout menu of additional tools, and then select the polygonal lasso as shown in Figure 3-8. Or just press the L key (or Shift+L if you skipped the Preface). The polygonal lasso lets you select straight-sided areas inside an image by clicking at the corners.

6. *Fill the screen with the image.* Many of the areas that we want to select exist on the perimeter of the photograph. When selecting such areas with the polygonal lasso, it helps to have a little extra room to work with. So press the F key to enter the full-screen mode, which surrounds the image with an area of gray pasteboard. Scroll the image (spacebar-drag) until you can see about an inch of pasteboard below and to the right of it. Then zoom in so your screen looks something like the one in Figure 3-9.

Figure 3-8.

By default, the pasteboard is a light gray that too closely matches the gray of the building. I recommend that you darken the pasteboard to increase the contrast. Right-click anywhere in the pasteboard, and choose **Select Custom Color** from the shortcut menu. In the **Custom Background Color** dialog box, change the first three values to H: 0, S: 0, and B: 50 (medium gray), and click **OK**.

Figure 3-9.

7. *Select the bottom-right building.* The yellow arrowheads in Figure 3-9 point to the seven corners you need to click. Start by clicking at the corner labeled ❶. There's no reason to start at this particular corner; it's as good a point of reference as any. Then move the cursor down to corner ❷, stopping a bit beyond the edge of the roof. As you do so, a straight line connects the cursor to ❶. Make sure the line follows the edge of the roof, and then click to set the corner in place. (Note that we're simplifying this corner of the building; that's okay because it will ultimately be incorporated into the selection around the dome.)

Keep clicking the corners in the order indicated in the figure. Don't worry too much about making these points perfectly precise; if anything, err on the side of overlapping the building instead of the sky. After you click at corner ❼, you have two options for completing the selection:

- Click corner ❶ to come full circle and close the selection outline.

- Double-click at ❼ to end the selection and connect points ❶ and ❼ with a straight segment.

8. *Select the elliptical marquee tool.* The central dome comprises a series of arcs, circles, and other ellipses. You could try to select these shapes using the lasso. But Photoshop allows you to use the *marquee tools* to draw simple geometric selections, and it's often useful to grab curved areas with the elliptical marquee. Press the M key a couple of times (Shift+M if you skipped the Preface) or select the elliptical marquee from the marquee tool flyout menu, as shown in Figure 3-10.

If you need to move your image to see the entire dome, remember you can press and hold the spacebar to temporarily get the hand tool, and then drag to reposition your image on screen.

Figure 3-10.

9. *Select the elliptical area around the base of the dome.* This shape is illustrated by the red ellipse with the inset selection outline pictured in Figure 3-11. This turns out to be a tricky step, so read the following paragraph before you begin.

Press the Shift key and drag with the elliptical marquee tool to add the new ellipse to the existing straight-sided selection. (Shift always adds to a selection; Alt or Option subtracts from the selection.) After you begin your drag, you can release the Shift key.

As you drag, you can move the ellipse on-the-fly by pressing and holding the spacebar. When you get the ellipse into position, release the spacebar and continue dragging. This repositioning tip is especially useful when you're acclimating to the elliptical marquee. When the ellipse is properly sized (as in Figure 3-11), release the mouse button.

Figure 3-11.

Figure 3-12.

Figure 3-13.

10. ***Add two more ellipses to the selection.*** Press the Shift key and drag a couple more times to add two more elliptical areas to the selection. These areas appear outlined in red and yellow in Figure 3-12. Remember to choke the selection into the dome—meaning don't let it drift out into the sky but rather keep your selection boundary slightly inside the dome's edges. And feel free to ignore the little outcroppings and other surface details that fall outside the ellipses. Their absence will not be noticed when we add the fireworks.

11. ***Add the tower to the selection.*** As illustrated in Figure 3-13, the tower of the courthouse can be expressed as a combination of five ellipses (which I've outlined in red) and a four-sided polygon (in yellow). If you want the practice, you *could* draw the selection manually. Press the Shift key and trace each of the red shapes with the ellipse tool. Then press L to switch to the polygon lasso, press the Shift key, and click around the polygon.

 However, all this ellipse-drawing might cross the line between good practice and sheer tedium. So in a moment of uncharacteristic charity, I've drawn the selection for you. Here's how to get to it:

 - Choose **Select→Load Selection**.

 - In the **Load Selection** dialog box, make sure **Document** is set to the present one, **Courthouse.psd**.

 - Set the **Channel** option to **Tower**. You'll see other selections there too, which you could load to duplicate the efforts we did in Step 7 (Right Side) and Steps 9 and 10 (Central Dome).

 - Select **Add to Selection** from the **Operation** options. This will add the tower to the existing selection.

 - Click the **OK** button.

 I really do spoil you.

12. ***Select the polygonal lasso.*** Click the polygon lasso icon in the toolbox or press L to grab the tool.

13. **Select the lower section of the structure.** Press the Shift key to add to your selection, and click around the remaining portions of the building (releasing the Shift key after the initial click). By my reckoning, you're looking at a grand total of seventeen corners, all indicated by the proliferation of yellow arrowheads in Figure 3-14. It's a complex selection—especially along that geometric column on the left side of the dome—so don't feel like you have to pull it off in one pass. As long as you start with the Shift key down, you can add areas to your selection in as many pieces as you like.

Figure 3-14.

If you find yourself struggling, failing, or on the brink of tears, go ahead and use my seventeen-point selection outline, which is ready and waiting for you. Choose **Select→Load Selection**. In the dialog box, set the **Channel** option to **Left & Bottom**. Turn on **Add to Selection** and click **OK**.

However you get there, the entire courthouse—from one extreme to the other—should appear encased in one great animated selection outline. Granted, we've rounded off a few details here and there, but nothing that the viewer is going to miss.

14. **Arrange your images so you can drag between them.** Depending on a variety of decisions you've made up to this point, either with or without my supervision, you may find yourself in a view that does not allow dragging a selection from one image into another. So before we attempt just such a maneuver, click the Arrange Documents icon in the application bar and choose the vertical 2 Up icon from the menu, as shown in Figure 3-15.

Figure 3-15.

15. ***Drag the courthouse into the fireworks image.*** Press and hold Ctrl (⌘ on the Mac) to get the move tool and then drag the selected portion of the courthouse from *Courthouse.psd* into the *Fireworks.jpg* image window. Before you drop the building into place, press and hold the Shift key. Release the mouse button and then release both keys. Shown in Figure 3-16, the result is spectacular but hardly credible. However impeccable the building's perimeter, its lighting and coloring broadcast that it's nowhere in the remote vicinity of a fireworks display. Thankfully, we can suggest otherwise using layer styles.

Figure 3-16.

Figure 3-17.

16. ***Choose the Color Overlay style.*** Click the *fx* icon along the bottom of the **Layers** palette and choose **Color Overlay** in the pop-up menu, as in Figure 3-17. Photoshop displays the **Layer Style** dialog box and fills the entire courthouse with red. Clearly, it's not the effect we want, but it will be soon.

17. ***Bathe the building in an orange glow.*** Here's how to change the color and the way the building interacts with the courthouse:

 • In the Layers Style dialog box, change the **Blend Mode** setting to **Overlay**. The red and building merge to create a sinister house of justice. Great for marching off to the gallows; bad for fireworks.

- Click the red color swatch to the right of **Overlay** to display the **Color Picker** dialog box. Select a dull orange by changing the first three values to **H:** 20, **S:** 70, **B:** 80, as in Figure 3-18. Then click the **OK** button to return to the **Layer Style** dialog box.

18. *Darken the top of the tower.* I imagine that our courthouse is lit by ambient light from the fireworks reflecting off the ground and the surfaces of neighboring buildings. As a result, the light should decline as the structure rises. This means casting the top of the building in shadow.

Click **Gradient Overlay** in the list on the left side of the **Layer Style** dialog box to make the effect active and display its options. Because the Color Overlay effect mixes with the Gradient Overlay below it, Photoshop fills the building with an opaque fountain of colors. Let's change that:

- Set the **Blend Mode** to **Multiply**. This burns in the black and drops out the white, giving the building a dark base. It's a nice effect but rather the opposite of what I want.

- Change the **Angle** value to –90 degrees to place the top in the gloom.

- Reduce the **Opacity** to 65 percent.

- You can position a gradient just by dragging it. Move your mouse into the image window to see the ▶₊ cursor. Then drag the gradient downward an inch to expand the shadow.

Confirm that your settings look like those in Figure 3-19, and then click **OK** to accept your changes and close the dialog box.

Figure 3-18.

Figure 3-19.

Figure 3-20 shows the final effect, complete with radiant courthouse and bombs bursting in air. Granted, it's an unlikely composition. But given that it's the product of a few polygons and ellipses, I'd rate it a soul-stirring success.

Figure 3-20.

Selecting Regions of Continuous Color

Next, we'll take a look at one of Photoshop's oldest and most automated selection tools, the magic wand, which lets you select an area of color with a single click. This tool gets short shrift from some, who argue that it became obsolete when the quick selection tool came along, but they miss the point.

Whereas the quick selection tool (which we'll see in the next exercise) works by detecting edges, the magic wand allows you to make one-click selections based on similar colors and luminance values. This makes it especially useful for removing skies and other relatively solid backgrounds, as we'll see in this exercise.

1. **Open two image files.** Locate the *Lesson 03* folder inside *Lesson Files-PsCS5* and open the files *ManlySaw image.jpg* and *Ad composite.psd*, both shown in Figure 3-21. The former was shot by me of me, manly sawyer that I am, and the latter is a composite I created using a background image captured by Fotolia photographer Catherine Jones. The goal of this exercise is to select the saw and place it into the unquestionably masculine background I've created for it.

How did I manage to shoot what is clearly my own left hand from this angle and distance without some serious contortionist moves to keep my left elbow out of the shot? No, I'm not an incredible arm-extending robot; I used a simple Photoshop trick. I shot the image with the saw pointing straight up, as in Figure 3-22, which allowed me to extend my left arm high in the sky, lean back, and release the shutter with my right hand. Then I rotated the image in Photoshop by choosing Image→Image Rotation→90° CCW. If you've installed dekeKeys, you can alternately press Ctrl+Shift+Alt+☐ (⌘-Shift-Option-☐ on the Mac) to perform such a maneuver. The result is an image capture that should be impossible for a nonrobot such as myself, yet was actually quite painless.

Figure 3-21.

Completely plausible angle

Amazing robot-contortionist angle

Figure 3-22.

Figure 3-23.

2. **Arrange the workspace to focus on the saw image.** Since the *ManlySaw image.jpg* file will be the primary focus of our selection work, let's bring it to the front so we can concentrate on it. Click the ⬛▾ icon in the application bar and choose the ⬛ (Consolidate All) option from the pop-up menu. Then, if necessary, click the ManlySaw image.jpg tab to bring it to the front.

3. **Select the magic wand tool from the toolbox.** Click and hold the quick selection tool icon (fourth tool down) to display a fly-out menu of alternate tools, and then select the magic wand, as in Figure 3-23. Or press the W key twice in a row.

4. **Confirm the options bar settings.** Pictured in Figure 3-24, the options bar displays a series of settings for the magic wand. Confirm that they are set as follows:

 - The **Tolerance** value defines how many colors the wand selects at a time. I discuss this important option in Step 6. In the meantime, leave it set to its default, 32.

 - Turn on the **Anti-alias** check box to soften the selection outline just enough to make it look like an organic, photographic boundary.

 - Turn on **Contiguous** to make sure that the magic wand selects uninterrupted regions of color. You'll get a sense of how contiguous selections work in Step 8.

 Because this image does not include layers, the Sample All Layers check box has no effect.

Figure 3-24.

5. **Click in the sky.** Since we're trying to transport the saw to a new background, you may think that we should try to capture the saw directly. But said power tool is made up of a variety of colors and luminance values: the yellow handle, the dark glove, the black accents on the saw, and the silver blade. Trying to round up these areas based on similarity of color would be a tedious process that would convince you that the magic wand tool had earned its "tragic wand" moniker. Instead, we'll select the relatively homogeneous sky and later take advantage of Photoshop's ability to reverse a selection.

For the record, I clicked at the location illustrated by the cursor in Figure 3-25. The problem is that the relatively light blue color of the sky is too close to the silver of the saw blade. I tried a bunch of different spots with the magic wand tool and could not avoid picking up areas of the blade because the tolerance setting is too high. At the current Tolerance value, Photoshop cannot distinguish between the blue sky and the silver blade's reflection of the blue sky.

6. **Raise the Tolerance value.** The Tolerance setting determines how many colors are selected at a time, as measured in luminosity values. By default, Photoshop selects colors that are 32 luminosity values lighter and darker than the click point (64 values in all). After that, the selection drops off. Given that Photoshop kept grabbing parts of the blade, the Tolerance must be too high.

I suggest lowering the **Tolerance** value to 12. The easiest way is to press the Enter or Return key to highlight the value, enter 12, and press Enter or Return again. Note that this has no immediate effect on the selection. Tolerance is a *static* setting, meaning that it affects the next operation you apply, as Step 7 explains.

7. **Click the sky again and again.** If you click in the area I've indicated with a ❶ in Figure 3-25, you'll find that the saw blade is now nicely avoided, but so is the right side of the sky itself. So press and hold the Shift key, and click in the spot indicated with a ❷. We're getting closer to capturing all the sky, but we still need help from another selection command.

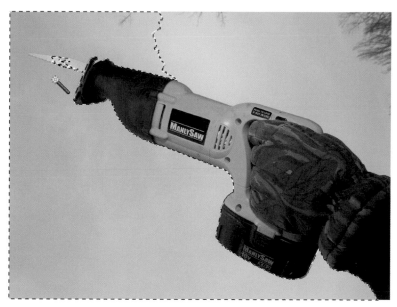

Figure 3-25.

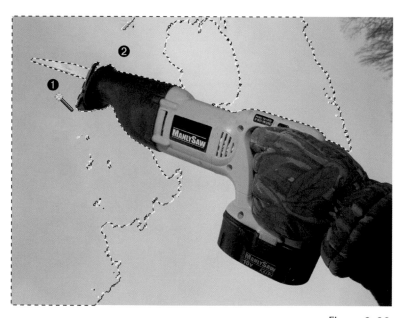

Figure 3-26.

8. ***Expand the selection using the Grow command.*** The Select menu provides two commands that let you expand the range of a selection based on the Tolerance setting. They both affect any kind of selection, but they were created with the wand tool in mind:

- Select→Grow reapplies the magic wand, as if we had clicked all the pixels at once inside the selection with the magic wand tool. In other words, it uses the selection as a base for a larger selection. Grow selects only *contiguous* pixels—pixels that are adjacent to the selected pixels.

- Select→Similar is identical to Grow, except it selects both adjacent and nonadjacent pixels. So where Grow would select blue sky pixels up to the point it encounters nonblue pixels, Similar selects all blue pixels within the Tolerance range regardless of where they lie.

In our case, these two commands would have almost the identical effect, since all the blue in the image is in one large uninterrupted area, except for the bits of sky between the branches in the upper-right corner, which we'll deal with later. So choose **Select→Similar**, as shown in Figure 3-27.

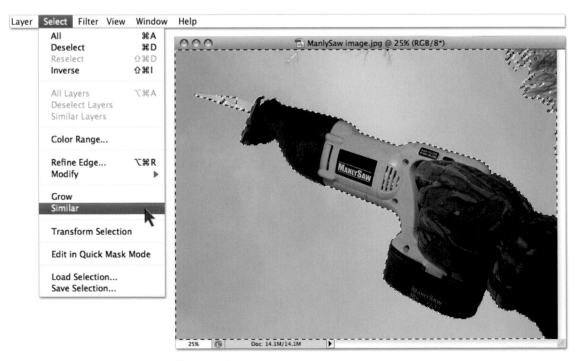

Figure 3-27.

9. ***Grab any stray blobs with the lasso tool.*** The magic wand tool did about as good a job as it's going to, so it's time to clean up the remaining areas by hand. While the lasso tool may not be great for intricate freehand selection drawing, it's handy for quickly incorporating stray areas into your selection. Press the L key as many times as needed to grab the lasso tool, press and hold the Shift key, and then draw around any stray blobby areas you may still have in the sky.

As you learned in the previous exercise, pressing and holding the Shift key while employing a selection tool adds to your selection. Pressing and holding the Alt (or Option) key subtracts from your selection. This is true of all the selection tools *except* the quick selection tool, which adds automatically, as we'll see in the next exercise.

10. ***Clean up the upper-right side with the rectangular marquee tool.*** The rectangular marquee is an indispensable tool for grabbing large areas of a selection when precision isn't an issue. In this case, it's perfect for those last remaining areas in the branches. Press the M key to switch to the rectangular marquee tool, press and hold the Shift key, and drag to select the final stray areas along the right edge of the image. The red dotted line in Figure 3-28 indicates the part of the selection I've added with the marquee tool.

New addition to the selection

Figure 3-28.

Figure 3-29.

11. **Reverse the selection.** You'll recall that what we really want to select for our composite is the manly saw and the manly hand wielding it. So now that we've gone to such lengths to select the background, choose **Select→Inverse** to switch the areas that are and are not selected.

As you can see circled in Figure 3-29, the saw blade, that troublesome area that caused problems earlier, is still missing from the selection. Don't fret and try to slice things up with your incomplete power tool. We can remedy the problem of the missing blade by employing some of Photoshop's other useful tools in the next exercise. For now, press Ctrl-Shift-S (⌘-Shift-S) and save your file as "My toothless saw. psd." Then click **OK**.

Quick Selection and the Quick Mask Mode

Adobe is slow to add selection tools. Seventeen years after introducing the world to the magic wand, it ushered in the speciously named quick selection tool. (Little about its performance suggests that you'll complete your selection chores faster.) In contrast to the magic wand, the quick selection tool is sensitive not to color ranges but to *edges*, which are sudden transitions from dark to light. Paint inside the element you want to select and Photoshop increases the selection outline to what it considers the outlying edges of that element.

In this lesson, we'll take a look at how well the quick selection tool handles our problematic saw blade from the preceding exercise. We'll use Photoshop's venerable History panel to save selection variations along the way, just to be safe. I'll also show you how you can check the quality of your selections by reviewing them in the quick mask mode, and address any problems you might see there.

1. *Continue with the files from the preceding lesson.* We're still trying to fix that selection outline we began in the last exercise, so I'm hoping you still have *My toothless saw.psd* and *Ad composite.psd* open and the selection on the saw image still active. (If you need a catch-up file, open *Toothless-Saw image.jpg* instead. Then choose Select→Load Selection, choose Bladeless from the Channel pop-up menu, and click OK to resume where we left off in the last exercise.)

2. *Zoom in on the saw blade.* This is a good chance to use a new zoom technique in CS5. Press Ctrl-spacebar (⌘-spacebar), place your cursor near the tip of the blade, and drag to the right, zooming in on the blade area until you reach a value of around 200 percent, as in Figure 3-30.

3. *Select the quick selection tool.* As you'll recall from the last exercise, the quick selection tool is paired in the toolbox with the magic wand tool. Select it from the flyout menu, or press W (Shift+W if you skipped the Preface) to toggle from the magic wand to the quick selection tool.

4. *Turn on the auto-enhance feature.* In the options bar, be sure to turn on the **Auto-Enhance** check box. Auto-Enhance seems to smooth out the otherwise crummy job that the quick selection tool does when making a selection outline.

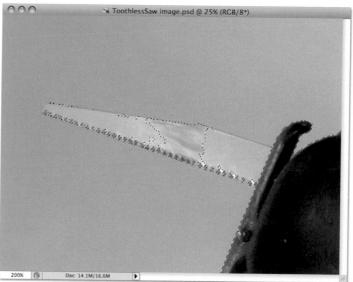

Figure 3-30.

Auto-Enhance occasionally makes the quick selection tool behave erratically. But in my opinion, the tool is plenty erratic on its own and adding a little more erratic behavior in the interest of smoother edges is worth it.

5. *Adjust the brush settings.* Move the cursor into the image window; you'll notice that the cursor turns into a round brush, anticipating your ability to paint a selection. Click the ▾ arrow next to the number 30 with the dot over it in the options bar to set some important brush options:

- Where this image is concerned, the default brush is too large. To make it smaller, lower the **Diameter** value in the ensuing pop-up panel to 15 pixels, as in Figure 3-31.

- Make sure the **Hardness** value is set to 100 percent, which will help keep the selection from leaking out beyond the edges of the saw blade.

Leave the other items set to their default and click the ▾ arrow again to close the options.

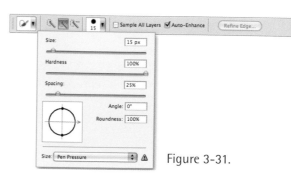

Figure 3-31.

If you ever need to return to the default settings for any tool, click the ▾ arrow to the right of the tool icon on the far left of the options bar to open the tool presets and then click the ⊙ arrow at the upper-right corner of the pop-up menu and choose Reset Tool.

Figure 3-32.

Figure 3-33.

Figure 3-34. Click here and then release the Alt (Option) key and the mouse... then click here and go back and click at the beginning.

6. **Select the missing parts of the blade.** Click in the deselected part of the blade nearest the saw, as indicated in Figure 3-32, and drag your brush out to the tip. You can make additional passes and continue adding to the selection as necessary. The quick selection tool is configured by default to add to the selection (without pressing and holding the Shift key to add as you would with other selection tools). If you go too far, press and hold the Alt (Option) key and click just outside the selection to remove any weird bumps that the quick selection tool might add. At first, the selection will look dismal, but when you release the mouse button, Photoshop will do an auto-enhance calculation that will improve it to roughly what you see in Figure 3-33.

7. **Switch to the magnetic lasso tool.** In a moment, I'll show you how to assess this selection for accuracy. But even to the naked eye, there's an obvious problem in the lower corner, where the blade meets the saw. A convenient tool for fixing this kind of problem is the magnetic lasso tool. You can get it by clicking and holding the ♀ icon in the toolbox (third item down) and selecting the magnetic lasso tool from the flyout menu. Or if you've followed the directions in the Preface, simply press the L key to cycle through the lasso tools until you get the magnetic lasso.

8. **Deselect the problem corner area.** Press and hold the Option (Alt) key to inform Photoshop that you want to subtract from your selection, as confirmed by the minus sign that appears next to the cursor. Click once in the spot indicated in Figure 3-34. After you click, release the Alt (Option) key and the mouse button. Then click up in the corner indicated in the figure and click back at your starting point. That small bit of sky in the corner should disappear from your selection.

The final lasso tool in the toolbox, the magnetic lasso, is one of the most amazing selection tools in Photoshop's arsenal. No kidding, this tool can actually sense the edge of an object and automatically trace it, even when the contrast is low and the background colors vary. But as miraculous as this sounds, the magnetic lasso has never won the hearts and minds of Photoshop users the way, say, the magic wand has. Why? Part of the reason is that it requires you to work too hard for your automation. Perhaps worse, the tool makes a lot of irritating mistakes. Even so, the magnetic lasso can work wonders, especially when tracing highly complex edges set against relatively evenly colored backgrounds.

Select the magnetic lasso from the lasso tool flyout menu. As when using the polygonal lasso, click along the edge of the image element that you want to select to set a point. Next, move the cursor—no need to drag, the mouse button does not have to be pressed—around the image element. As you move, Photoshop automatically traces what it determines is the best edge and lays down square *anchor points*, which lock the line in place. In the figure below (familiar from the previous exercise), I clicked the bottom-left corner of the courthouse dome and then moved the cursor up and around to the right.

Some other techniques:

- If the magnetic lasso traces an area incorrectly, trace back over the offending portion of the line to erase it. Again, just move your mouse; no need to press any buttons.

- Anchor points remain locked down even if you trace back over them. To remove the last anchor point, press Delete or Backspace.

- Photoshop continuously updates the magnetic lasso line until it lays down a point. To lock down the line manually, just click to create your own anchor point.

- Of the various settings on the options bar, the most useful is Width, which adjusts how close your cursor has to be to an edge to "see" it. Large Width values allow you to be sloppy; small values are great for working inside tight, highly detailed areas.

The best thing about the Width setting is that you can change it from the keyboard. While working with the magnetic lasso, press [] to make the Width value smaller; press [] to make it larger.

- To complete the selection, double-click or press Enter (Return). You can also click the first point in the shape. Press the Esc key to cancel the selection.

Photoshop's smartest lasso tool is clearly the most challenging to use. But it's usually worth the effort. And remember, you can always combine it with other tools.

Figure 3-35.

9. **Save a snapshot of your selection.** Given the amount of work we've accomplished so far, it would be nice to bookmark this place in the selection process in case we want to come back to it later. Photoshop gives you the ability to do this using the History panel. Here's how it works:

- Open the panel by choosing **Window→History** or pressing Alt+F9 (Option-F9 on the Mac).

- As you can see in Figure 3-35, Photoshop has been keeping track of each step in the process so far. (One look at all those passes and you might think the quick selection tool needs a more accurate name.)

- You can click any entry in the history and your image will be restored to that particular state, including the state of your selection.

- Press the Alt (Option) key and click the 📷 icon at the bottom of the panel to take a snapshot of your current state. In the **New Snapshot** dialog box that appears, name your snapshot "Quickblade" and press **OK**.

Pressing the Alt (Option) key while you click the 📷 icon allows you to name the new snapshot while you're creating it. As we'll see, this works the same in many Photoshop scenarios when you're creating something such as a snapshot or a layer.

Figure 3-36.

Once you've created a snapshot, you can simply click the Quickblade entry in the History panel and restore this state of your selection. However, you lose the individual history states in the list, as indicated by their being dimmed in Figure 3-36. If you were to restore with the snapshot and start performing new steps, you'd lose the ability to revisit any of those individual states and Photoshop would start recording a new history of your activities. To bring back those individual states, click the final item in the list before doing anything else.

You can save up to 20 history states in Photoshop, but they are active only while you have the image open. If you close the document or close Photoshop, the items and your ability to step back through them are gone. However, you can save entire selections. In Lesson 10, I'll show you how to save a selection as an alpha channel, which is how I was able to create *ToothlessSaw image.jpg*, the catch-up document with which we started this exercise.

10. **Enter the Quick Mask mode.** The "marching ants" outline prevents us from seeing the edges of the selection directly. To test for accuracy and smoothness, we'll use a Photoshop feature that allows us to view the selection in a less distracting environment. Start by clicking the icon at the very bottom of the toolbox, as shown in Figure 3-37, which allows us to enter the Quick Mask mode. (Alternatively, you can press the Q key.) In this view, Photoshop creates a facsimile of an old-school rubylith mask that covers the deselected areas of your image with transparent red and leaves the selected area in regular view.

Figure 3-37.

11. **Examine the mask directly.** Pretty in pink it may be, but the effect is still not the best view for judging the edges of the selection. Click the tab for the **Channels** panel, and you'll see a quick mask created for this view at the bottom of the entries. (It's an alpha channel, which we'll learn more about in Lesson 10.) To see the mask by itself, independently of the image, click the ◉ next to the **RGB** entry at the top of the Channels panel to turn off the visibility of the image. What remains is the mask.

As you can see in Figure 3-38, Photoshop now reveals the selected area in white and conceals the deselected area with black. What is revealed is that the quick selection tool did a fairly hideous job (especially when you compare it to the relatively smooth edges created by the supposedly inferior magic wand tool on the body of the saw.) Press the Q key to exit the Quick Mask mode, and let's see if we can improve this selection with another tool.

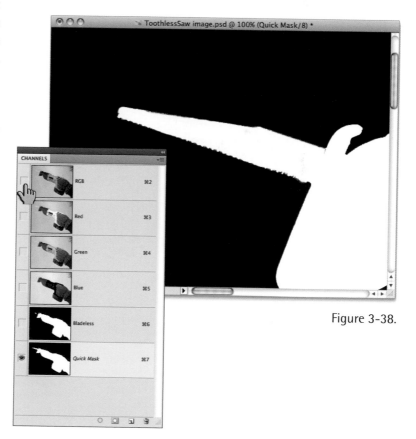

Figure 3-38.

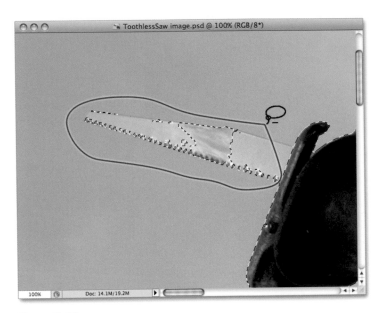

Figure 3-39.

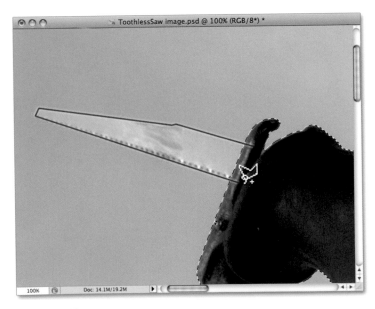

Figure 3-40.

12. ***Revert the image.*** To get rid of the quick selection version of the saw blade selection, we need to get back to where we started in this exercise:

 - If you're using the *ToothlessSaw image.psd* file, choose **Select→Load Selection**, select the **Bladeless** channel again, and click **OK**.

 - If you're using the file from the preceding exercise, return to the **History** panel and click the state that reads **Select Inverse**.

 Either way, you'll end up back where you were when we finished with the magic wand tool.

13. ***Select the lasso tool.*** Press the L key to return to the standard lasso tool. Press the Option (Alt) key so that you're deselecting (you'll see the telltale minus sign), and draw around the blade area as shown in Figure 3-39 to deselect the blade.

14. ***Switch to the polygonal lasso.*** Press L again to switch to the polygonal lasso tool. Press and hold the Shift key to add to the selection, and click inside the body of the saw and then at the corners of the blade, following the path indicated in Figure 3-40. When you get back to the black area inside the saw, double-click. Don't worry about the individual serrated blade edges; the focus is blurry enough that trying to grab each tooth of the saw is an exercise in insanity. Even I wouldn't try it. Instead, cheat your line along the edge.

15. ***Check the new selection in the quick mask mode.*** Press the Q key to quickly return to the quick mask mode, and then once again turn off the 👁 next to the **RGB** composite in the **Channels** panel to see the black and white mask.

You'll discover, as you can see in Figure 3-41, that the blade selection is now much crisper. In fact, the entire selection has only one tiny flaw, which we'll fix in the next step.

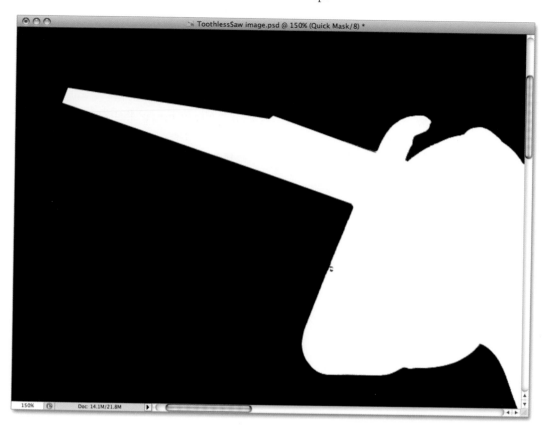

Figure 3-41.

16. ***Paint away the small spot inside the handle.*** We're already in the quick mask mode, so we can paint away the small flaw on the handle with the paintbrush tool. Press the D key to make sure your colors are set to their default masking values of white (foreground) and black (background), as shown in Figure 3-42. (Note that this is reversed from the regular default colors.)

Then press the B key to grab the paintbrush tool. Right-click to bring up the brush options and set the **Hardness** value to 100 percent. Carefully click inside the handle to remove that small spot near the edge, but stay inside the white area. Wherever you add white to this mask will become part of your selection. At last, our saw is ready for its background. Press the Q key to leave the quick mask mode.

White is the foreground color

Figure 3-42.

17. ***Drag the selection to the new background.*** After all that work, it's finally time to move the saw over to the background file that's been patiently waiting for most of this lesson. I'm presuming you're still in the consolidated tabs view. (See Step 2 on page 76 if you don't see a ■ in the application bar.) Press and hold the Control key (⌘ key) to grab the move tool on-the-fly, click inside your saw selection, and drag the saw up to the tab for the *Ad composite.psd* document. Wait a brief second for Photoshop to switch images, press and hold the Shift key to align the two images, and then release. You can see the results in Figure 3-43.

Figure 3-43.

Figure 3-44.

18. ***Zoom into the edge artifacts.*** The composite looks pretty good. But if you press and hold the Z key and click a few times near the bottom area of the saw handle, as shown in Figure 3-44, you'll see some severe blue fringing around the selection edges. This effect is common for two reasons. First, the foreground often has some memory (in the form of reflection or other cast) from its former background. Second, in this case, the sharpening features of the digital camera I used to shoot the saw picture created that blue fringing you see around the edges, especially the bottom of the saw handle.

19. ***Delete the saw layer from the composite image.*** To get rid of that fringing, we need to do some work directly on the selection back in the original document. So for now, delete the saw layer by dragging the **Layer 1** entry to the trash can icon at the bottom of the **Layers** panel. Then click the tab to return to the *ToothlessSaw image* file.

20. ***Refine the selection edges in the original* Toothless-Saw *image.*** Click the tab to return to the original saw image, and then choose **Select→Refine Edge**. (This is the same command that is available via the Refine Edge button that appears anytime a selection tool is open.) The **Refine Edge** dialog box can do a great deal to improve your selections, and we'll spend a lot of time with it in Lesson 10 when we cover masking. For now, set the dialog box like so:

Figure 3-45.

- Set the **View** to **On Black** by clicking the ⬇ arrow next to the small preview of the current setting and choosing it from the pop-up menu, as in Figure 3-46. This view will allow a better inspection of the refinement process. Click away from the pop-up menu to dismiss it.

- Set the **Feather** to 1 px to give the edges some softness. The other settings need some softness to work properly.

- Set the **Contrast** to 25 percent.

- The Shift Edge control expands or contracts the edge. Contracting is just what we need. Set **Shift Edge** to –100.

The Shift Edge percentage is based on softness of the selection's edge. Since our selection had very hard edges, setting Feather to 1 px was crucial for Shift Edge to have anything to work on.

Figure 3-46.

To see what you've accomplished with these settings, turn on the **Show Original** check box at the top of the dialog box. We've drastically reduced the blue glow around the selection. Click **OK**.

21. ***Drag the saw back to the composite background.*** Now that we've cleaned up the edges, press and hold the Control key (⌘ key) and drag the saw selection back to the *Ad composite.psd* file again. This time, as you can see in Figure 3-47, the edge artifacts are much less noticeable. And while the saw may not look realistic in its new environment, it's perfectly acceptable for the unrealistic world of a saw and a hand floating in front of an advertisement backdrop!

Congratulations on making your way through the varied world of Photoshop selections. As you've now seen, selections involve much more than moving things or recomposition. They allow you to apply the many useful features of the program to specific parts of your image, while leaving areas outside the selection unaffected. You'll be using the tools you learned in this lesson throughout the rest of the book.

Figure 3-47.

WHAT DID YOU LEARN?

Match the key concept in the numbered list below with the letter
of the phrase that best describes it. Answers appear upside-down
at the bottom of the page.

Key Concepts

1. Selection outline
2. Marquee
3. Polygonal lasso
4. Move tool
5. Magic wand
6. Tolerance
7. Antialiasing
8. Grow
9. Magnetic lasso
10. Snapshot
11. Quick Mask
12. Refine Edge

Descriptions

A. A slight softening effect applied most commonly to selection outlines to simulate smooth transitions.

B. Use this tool to select free-form, straight-sided areas in an image.

C. A setting in the options bar that determines how many colors the magic wand selects at a time, as measured in luminosity values.

D. This selection tool can actually sense the edge of an object and automatically trace it.

E. This viewing mode allows you to quickly see the mask created by a selection and assess the edges accurately.

F. Accessible by pressing Ctrl on the PC (⌘ on the Mac), this tool permits you to move selected pixels, even between images.

G. Click with this tool to select regions of color inside an image.

H. A set of selection tools that allow you to draw simple geometric shapes.

I. An intricate command that lets you edit a selection using a series of slider bars and preview the results of those edits as you work.

J. A set of dotted lines that indicate the borders of a selected region, also known as "marching ants."

K. This command expands a selection to include additional contiguous colors that fall inside the magic wand's Tolerance range.

L. This feature of the History panel lets you bookmark a specific state in your work, allowing you to restore it later.

Answers

1J, 2H, 3B, 4F, 5G, 6C, 7A, 8K, 9D, 10L, 11E, 12I

RETOUCH, HEAL, AND ENHANCE

NOW THAT YOU'VE learned to make large-scale compositional changes to your images, it's time for some old-fashioned, roll-up-your-sleeves, slather-on-the-elbow-grease, sometimes-toilsome-but-always-rewarding artistic labor. Such is the nature of painting and retouching in Photoshop. In fact, it's probably what most people think of when they hear the word *Photoshop* used as a verb. Whether you want to augment a piece of artwork or fix the details in a photograph, it's time to turn your attention to the toolbox.

Photoshop devotes fully one-third of its tools—all those in the second section of the toolbox plus those that appear when you click and hold any of the icons pictured in Figure 4-1, 23 in all—to the tasks of applying and modifying colors in an image. The idea of learning to use so many tools may seem intimidating. And because these tools require you to paint directly in the image window, they respond immediately to your talent and dexterity, not to mention your lack thereof. Fortunately, despite their numbers, the tools are a lot of fun. And even if your fine motor skills aren't everything you wish they were, there's no need to fret. I'll show you all kinds of ways to constrain and articulate your brushstrokes.

Mind you, not every one of these 23 tools is a winner. As with everything in Photoshop, some tools are good and some tools aren't. In this lesson, we focus on what I consider to be the most essential.

Background composite istockphoto.com/lisegagne

Figure 4-1.

ABOUT THIS LESSON

Project Files

Before beginning the exercises, make sure you've downloaded the lesson files from *www.oreilly.com/go/Deke-PhotoshopCS5*, as directed in Step 2 on page xvi of the Preface. This means you should have a folder called *Lesson Files-PsCS5 1on1* on your desktop (or whatever location you chose). We'll be working with the files inside the *Lesson 04* subfolder.

The exercises in this lesson explain how to use Photoshop's paint, edit, and healing tools to brush color and effects onto an image. You'll learn how to:

- Retouch a face using the dodge, burn, sponge,and red-eye tools page 95

- Fix eyes, teeth, and hair color issues in a portrait . . page 101

- Heal undesirable features in an image using information from other areas in the image . . page 104

- Apply a line-drawing effect to a photograph. page 116

Video Lesson 4: Brushes and Painting

Many of Photoshop's paint, edit, and healing tools rely on a common group of options and settings that Adobe calls the *brush engine*. These options include such elements of brushstroke behavior as size, hardness, roundness, angle, pressure-sensitive taper, and bristle type. Photoshop CS5 introduces some amazing brush features, like the new Mixer brush tool, which allows you to combine colors in your image to mimic real-life painting.

To peruse your painting options, visit *www.oreilly.com/go/deke-PhotoshopCS5*. Click the **Watch** button to view the lesson online or click the **Download** button to save it to your computer. During the video, you'll learn these shortcuts:

Tool or operation	Windows shortcut	Macintosh shortcut
Show or hide the Brushes panel	F5	F5
Eyedrop color when using the brush tool	Alt-click	Option-click
Display a list of blend modes	Shift-right-click with brush	Shift-Control-click with brush
Incrementally enlarge or shrink the brush	⬚ or ⬚ (right or left bracket)	⬚ or ⬚ (right or left bracket)
Make the brush harder or softer	Shift+⬚ or Shift+⬚	Shift-⬚ or Shift-⬚
Adjust brush size with preview	Alt-right-drag	Control-Option-drag
Adjust hardness with preview	Shift-Alt-right-drag	⌘-Control-Option-drag

The Three Editing Styles

Photoshop lets you use the tools in the second section of the toolbox to apply and modify colors in three ways:

- The *painting tools*—the brush, the paint bucket, and others—permit you to paint lines and fill shapes with the foreground color. I drew the lines in Figure 4-2 with the brush while switching the foreground color between black and white.

- *Editing tools* is a catchall category for any tool that modifies rather than replaces the existing color or luminosity of a pixel. The burn tool darkens pixels, the smudge tool smears them, and the color replacement tool swaps hue and saturation values, as demonstrated in Figure 4-3.

- The *healing tools*—the healing brush, patch tool, and history brush among them—permit you to clone elements from one portion or state of an image to another. The history brush clones pixels from an older version of the image. The healing brush and patch tool go a step better, merging the cloned details with their new background to create a gradual or seamless match, as illustrated in Figure 4-4.

The frequent recurrence of the word *brushes* may lead you to think that these tools are best suited to creating original artwork. Although many people create artwork from scratch in Photoshop, it's not really what the program's designers had in mind. The real purpose of these tools is to help you edit photographic images, and that's how we'll use them in this lesson.

Figure 4-2.

The brush-based tools rely on Photoshop's brush engine. A single dollop of paint—the "brush" itself—is repeated over and over with such rapidity that Photoshop appears to be painting a smooth line. The options bar lets you control the size and shape of the brush; the exhaustive Brushes panel offers additional attributes. I introduce you to both in Video Lesson 4, "Brushes and Painting" (as explained on the opposite page).

Figure 4-3.

The Tone-Editing Tools

When I use the term *editing*, I mean using Photoshop's tools to modify the colors, luminance levels, and color transitions in a photographic image.

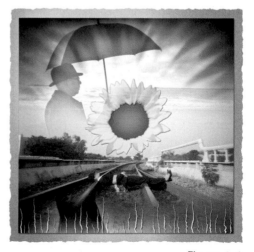

Figure 4-4.

We start with the Photoshop editing tools that are specifically designed to adjust tone, which are as follows:

- The dodge tool lightens pixels as you paint over them.

- Conversely, the burn tool darkens pixels as you paint over them. If you're having problems keeping the dodge and burn tools straight, think of toast—the more you burn it, the darker it gets.

- The third entry in this arsenal is the sponge tool, which adjusts the vibrancy of colors, either dulling them or making them more vivid.

- Lifted from Photoshop's kid sibling Photoshop Elements, the red eye tool does one thing well: removes red eye.

The following exercise explains how to use the tone-editing tools along with the history brush to solve some common retouching problems. We'll also take a look at how a filter designed for smoothing out "noise" (random color variations) and JPEG artifacts can come in handy in an unlikely situation.

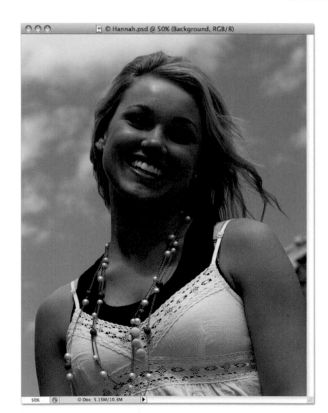

Figure 4-5.

1. ***Open a backlit portrait.*** Open the image titled *Hannah.psd* in the *Lesson 04* folder inside *Lesson Files-PsCS5 1on1*. Shot especially for me by photographer Dustin Steller, this image of the photographer's sister appears in Figure 4-5. Of the shoot, Steller writes: "I didn't have any diffusers or reflectors with me because it was a perfect slightly overcast day, but the clouds went away right before the shoot. So I tried to use the drama of the outdoor light to the best advantage." As a result, Hannah appears backlit, with too much shadow across her otherwise cheerful and expressive face.

2. ***Click the dodge tool in the toolbox.*** A couple of icons up from the T (see Figure 4-6 on the facing page), the dodge tool is the first of Photoshop's *toning tools*. To get the dodge tool from the keyboard, press the O key.

3. ***Drag over the details you want to lighten.*** Press the right bracket key ⬚ to increase the diameter of the brush to about 80 pixels and then paint away. I painted over all the shaded areas in the face and neck. If possible, it's best to perform this initial edit in one big drag. Because each stroke of the dodge tool compounds the one before it, I achieved the best results by beginning my edits with one big brushstroke and then adding multiple shorter strokes as needed.

4. **Set the Range to Shadows.** By default, the dodge tool affects midtones while protecting highlights and shadows. That's typically a good setting, but where this image is concerned, the shadows need help. Go to the options bar and set the **Range** option to **Shadows**. Or press the shortcut Shift+Alt+S (Shift-Option-S on the Mac).

5. **Revisit the shaded areas.** You can choose any approach you like, but here are the brushstrokes I applied:

 - One long stroke from the right side (her left) of her temple down and around to the left side (her right) of her jaw.

 - Two strokes apiece below her cheeks and nose, followed by one stroke across her mouth and smile.

 - One long stroke across her brow and under her eyebrows.

 - With a larger brush, two strokes across each eye, then one stroke over each ear and inside the shadows of her hair.

 - Finally, I restored the **Range** setting to **Midtones** and painted one big stroke over all the shaded areas.

The result is more balanced lighting that brings out the details in Hannah's face, as witnessed by the first two examples in Figure 4-7.

Figure 4-6.

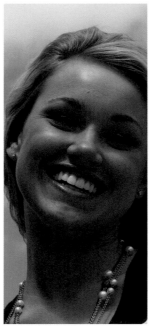

Original image

The result of 17 strokes of the CS4 dodge tool

A single stroke of the CS3 dodge tool

Figure 4-7.

Figure 4-8.

Figure 4-9.

6. **Bring up the History panel.** If the History panel isn't already on screen, choose **Window→History**. As you saw in the previous lesson, the History panel tracks the most recent changes you made to an image, thus permitting you to step back to one of several previous states. As if that's not enough, you can paint back portions of a previous state using the history brush.

PEARL OF WISDOM

It's this last option that makes the History panel so useful when retouching an image. After painting in an edit effect, you can turn around and erase portions of it with the history brush—provided, that is, that you manage your history states properly. As we saw in the preceding lesson, Photoshop tracks the last 20 operations. But as Figure 4-8 shows, it's easy to click and drag more than 20 times with the dodge tool without being aware of it. And once a state gets bumped off the History list, you can't restore it. Of course, you could raise the number of history states, but you'd have to do so in advance of painting your first brushstroke, and it can dramatically slow down Photoshop when applying large-scale adjustments. A much better practice is to create a snapshot that can be used as a source for the history brush (which we'll use in the next step).

7. **Create a snapshot of the current state.** Press the Alt (or Option) key and click the camera icon (📷) at the bottom of the **History** panel, labeled in Figure 4-8. In the **New Snapshot** dialog box, name the new snapshot "Dodged Image" and click the **OK** button.

8. **Select the burn tool in the toolbox.** Click and hold the dodge tool icon to display a flyout menu, and then choose the little hand icon that represents the burn tool, as in Figure 4-9. Or if you prefer, press Alt (or Option) and click the dodge icon to advance to the next tool. Or just press the O key (or Shift+O if you skipped the Preface).

9. **Reduce the Exposure value to 30 percent.** Located in the options bar, the **Exposure** value controls the intensity of edits applied by the burn tool. In my experience, the default value of 50 percent is too extreme for most editing work. Press the 3 key to take the value to 30 percent.

10. **Drag over the image details you want to darken.** Armed with a 100-pixel brush, I painted independent brushstrokes over the forehead, the bridge of her nose, the highlight in the left ear (her right), and the tiny wedge of a highlight above the lip. I also painted repeatedly over the cheeks, the top of the forehead, and the highlight on the chin. With a larger brush, I painted the base of the neck, both arms, and portions of the dress.

11. **Deepen the sky.** Just for fun, press the 0 (zero) key to take the **Exposure** up to 100 percent. Take the brush diameter up to 600 pixels. And then paint over the entire sky. Twice. You could never have done anything so bold before the improvements made in Photoshop CS4, but now you can burn with impunity. Figure 4-10 shows the result.

12. **Brush away any mistakes.** After you've toasted any and all desired details with the burn tool, you may want to temper the results with the history brush. Here's what I recommend you do:

 * In the **History** panel, click in front of the **Dodged Image** state to set it as the source of the history brush edits.

 * Click the history brush in the toolbox (see Figure 4-11) or press the Y key.

 * Press 5 to reduce the **Opacity** value in the options bar to 50 percent.

 * Increase the brush diameter to 200 pixels.

 * Paint separate strokes over both shoulders, which got partially incorporated into the darkening of the sky.

 * Paint one long stroke on the left side of the face (her right) from the chin to the forehead.

13. **Create another snapshot.** Having arrived successfully at another juncture in the editing process, press Alt (or Option) and click the 📷 icon at the bottom of the History panel. In the dialog box, name this snapshot "Burned Image" and click **OK**, as in Figure 4-11.

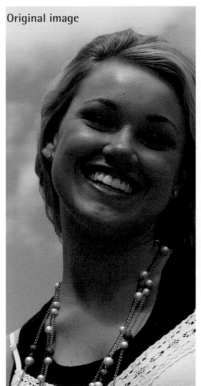
Original image

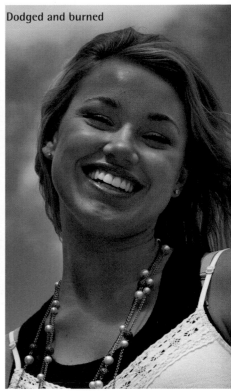
Dodged and burned

Figure 4-10.

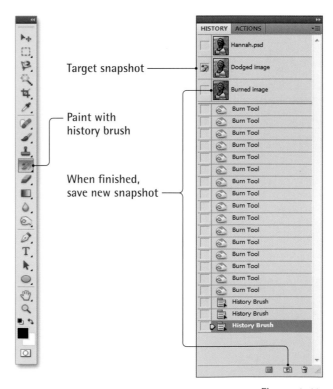

Target snapshot

Paint with history brush

When finished, save new snapshot

Figure 4-11.

Figure 4-12.

Figure 4-13.

14. *Select the sponge tool in the toolbox.* Now to modify the saturation levels. Click and hold the burn tool icon and choose the little sponge from the flyout menu, as in Figure 4-12. Or, if you loaded my dekeKeys shortcuts back in the Preface, you can press the N key, which I liberated from Photoshop Extended's 3-D tools. (Preface skippers, press Shift+O.)

15. *Reduce the Flow value to 10 percent.* Although it's calculated differently, the Flow value in the options bar serves the same purpose as the dodge and burn tools' Exposure value—it modifies the intensity of your brushstrokes. In my experience, the default value of 50 percent is way too high. Press the 1 key to knock **Flow** down to 10 percent.

16. *Drag in the image to temper overly intense colors.* The dodge tool tends to increase the saturation of colors, and burn tends to decrease saturation. (This started in CS4; it was the opposite in CS3.) Photoshop lets you alternate between adding and depleting saturation using the Mode option in the options bar:

 • Make sure **Mode** is set to **Desaturate**.

 • Get a big brush and paint over the cheeks, nose, and eyes, which are the regions that received the most attention from the dodge tool.

 • Change the **Mode** setting to **Saturate** and paint across the forehead, which was made slightly dingy by the burn tool.

17. *Create another snapshot.* Not essential, but a good idea. Alt-click (or Option-click) the icon at the bottom of the **History** panel. Name this snapshot "Sponged Colors," and click **OK**.

PEARL OF WISDOM

Speaking of saving, remember that Photoshop does *not* save anything tracked by the History panel. This goes for both states and snapshots. If you want to save a particular snapshot, drag it onto the left icon at the bottom of the History panel, which copies the snapshot as an independent image. Then use File→Save to save the image.

We've now seen all but one of the edit tools that I mentioned at the outset of this exercise. The remaining tool fixes red eye. If you don't care about red eye and you've had enough of editing, skip to "Healing and Patching," which begins on page 104. To learn how to fix yellow teeth, miscolored details, and red eyes, stick with me.

18. **Turn on the top layer in the image.** Go to the **Layers** panel. Click the layer titled **Teeth & Red Eye** to make it active. Then click the empty box to the left to reveal the ● along with the contents of the layer. Another view of Hannah, this image exhibits such defects as yellowish teeth, greenish hair highlights, and red eye, as seen in Figure 4-14.

As you saw in the previous shot, Hannah has a lovely smile. The enhancement of the yellowing in this image is a function of the way I developed the photo in Camera Raw. And the red pupils were imported from another image. Red eye is caused by the flash entering the pupil, illuminating the red tissue inside the eye, and reflecting back into your camera's lens element. Red eye is common when using a built-in flash on an inexpensive camera, but it's rare when using professional lighting equipment, as Stellar did. Are you thinking, "Unfair! You can't give us fake red eye."? No. Unfair would have been to add red pupils and not own up. This is real red eye, just from another image. Your treatment of it will be the same as when treating red eye in your own photos.

19. **Set the Mode to Desaturate.** It's tempting to attack yellow teeth with the dodge tool. But the trick to bleaching stained teeth is to remove their saturation. So with the sponge tool still selected, change the **Mode** setting in the options bar to **Desaturate**.

20. **Paint the teeth.** Reduce the brush size to 20 pixels and press the 3 key to increase **Flow** to 30 percent. Then paint very carefully inside the teeth. The reason I say "very carefully" is because you don't want to desaturate the gums. That would make them appear dead and lifeless, which won't help the smile any. It took me about eight brushstrokes to get the effect I wanted.

21. **Brighten the teeth.** Press the O key to select the dodge tool. Set **Range** to **Midtones**, **Exposure** to 30 percent, and the brush diameter to 60 pixels. Then paint across the smile to brighten it, as in Figure 4-46.

Figure 4-14.

Figure 4-15.

22. **Click the brush in the toolbox.** Or press the B key. We'll use the brush to paint away the weird green highlights.

23. **Eyedrop a representative hair color.** With the brush active, press Alt (or Option) to temporarily access the eyedropper, and then click someplace where the hair appears a natural blonde. To see what color you lifted, bring up the **Color** panel by pressing F6. Mine was in the neighborhood of **R**: 90, **G**: 70, **B**: 50. But hair has so much variation that you may end up with something different. Feel free to use your eyedropped color or enter the values suggested here—either should work fine.

24. **Select the Hue blend mode.** Go up to the options bar and change the **Mode** setting to **Hue**, or press Shift+Alt+U (or Shift-Option-U). You can now paint in new hue values while leaving the luminosity and saturation unchanged, which will lead to the most organic effects.

25. **Paint the hair.** Set the brush diameter to 70 pixels or so; leave the Hardness set to 100 percent. Then paint the green hair and watch it change to blonde, as illustrated in Figure 4-16.

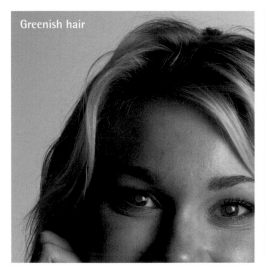 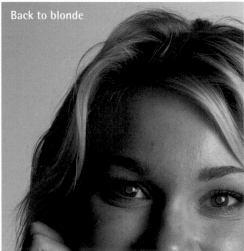

Figure 4-16.

26. **Select the red eye tool in the toolbox.** Your final task is to remove the now controversial red eye. Click and hold the band-aid below the eyedropper tool icon in the toolbox, and choose the red eye tool from the flyout menu (see Figure 4-17 on the facing page).

27. **Retouch one of the pupils.** Zoom in on the one of the pupils and then just click it with the red eye tool. Just like that, the red eye goes away. So eager is the tool to obliterate red eye that

even if you click *near* an afflicted pupil, the tool more often than not finds the pupil and turns it black. If the tool has difficulty finding a pupil (as seldom but sometimes happens), you can help it by drawing a rectangular marquee around the redness.

28. ***Undo the edit and try it again.*** The red eye tool made the pupil black, but it left a grayish, slightly red corona around the inside of the iris. We can do better. Press Ctrl+Z (or ⌘-Z) to restore the red pupil. Then go up to the options bar and change the **Pupil Size** value to 100 percent, which will ensure that the blackness extends to the outermost perimeter of the pupil.

29. ***Retouch each of the pupils.*** Click next to each of the two pupils to set them both to black. Zoomed in, you can still make out slight halos. But the effect looks great at full resolution, as shown in Figure 4-18. And to think, Adobe once considered withholding this tool from Photoshop, fearing that it might be regarded as too basic for professionals—as if professionals somehow *enjoy* performing complex, protracted, 30-step procedures. (Uh, speaking of which: Only one more step to go.)

30. ***Continue to adjust details as needed.*** Don't expect to be able to retouch an image in one pass. After all, a change made with one tool might beg you to take up another. As you work back and forth in your image, bear in mind these techniques and words of advice:

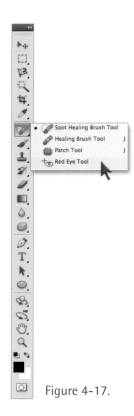

Figure 4-17.

- The dodge and burn tools are interchangeable. Just press the Alt (or Option) key to darken with dodge or lighten with burn.

- The dodge, burn, sponge, and history tools work best with a soft brush.

- Feel free to cheat by selecting an area before using one of the editing tools. If the dodge and burn tools don't do the trick, use the Levels command. If the sponge disappoints, use the Hue/ Saturation or Vibrance command to adjust saturation instead. How you get there doesn't matter; it's the results that count.

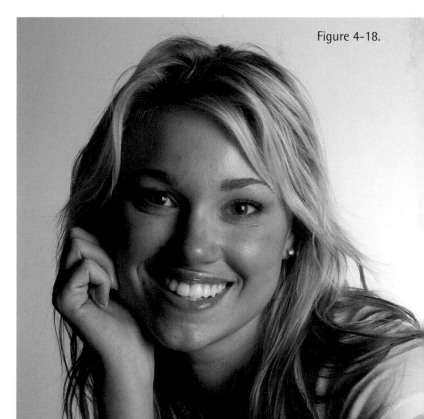

Figure 4-18.

Figure 4-19.

Figure 4-20.

Healing and Patching

The edit tools are well suited to a wide variety of retouching scenarios. But they can't create detail where none exists. To fix dust and scratches or cover up blemishes and wrinkles, you need tools that can paint imagery on top of imagery. Tools like the healing brushes and patch tool:

- The healing brushes paint one section of an image, called the *source*, onto another. One variety of the healing brush lets you specify a source; the other finds a source automatically. As the tool clones the source detail, it mixes it with the color and lighting that surrounds the brushstroke, thereby mending the offending detail seamlessly.

- The patch tool clones like the healing brushes. But instead of painting with the tool, you select areas of an image as you would with the lasso.

The following exercise shows you how to use these powerful tools to fix a variety of image challenges on the sweetly scowling face of a young pirate.

1. *Open a photograph requiring detail retouching.* Open the file called *Patchy.tif* located in the *Lesson 04* folder inside *Lesson Files-PsCS5 1on1*. This photo of a ten-year-old girl dressed up as a pirate, shown in Figure 4-19, comes from Simone van den Berg of the Fotolia image library. While children don't generally have the same kinds of skin flaws that we older folks do, Patchy has a few spots on which to test our healing skills, not to mention a suspicious bit of food on the corner of her mouth and a wicked scar on her cheek.

2. *Select the spot healing brush in the toolbox.* The spot healing brush is the default occupant of the healing tool slot. But if you're performing this step on the heels of the last exercise, you'll need to select it from the flyout menu (see Figure 4-20) or Alt-click (Option-click) the red eye tool icon in the toolbox. True to its mission, the spot healing brush looks like a band-aid next to a little circular marquee that represents the spot. I don't recommend the spot healing brush tool very often, which is why you'll find, if you loaded my shortcuts in the Preface, that I did away with its shortcut.

3. *Heal the small mark to the right of her nose.* Set the brush diameter to 20 pixels. Then zoom in on the right side of her face (your right, her left). Click once on the small mark, as shown in Figure 4-21. Photoshop dims the affected pixels, as illustrated by the left image in the figure. After you release the mouse button, the program blends the source—which it derives automatically from some other portion of the image—with the area around the brushstroke. The result is a *patch*.

The success of the patch hinges on the accuracy of the automatically chosen source. The tool may select a good source or a bad one. And which it will do is anyone's guess. Your patch may look seamless, or it may contain a bit of detail that's inappropriate. Due to the smooth face of our subject and the good detail in the photograph, the spot healing brush works well in this case.

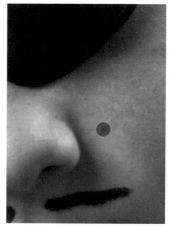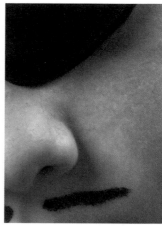

Figure 4-21.

4. *Select the healing brush in the toolbox.* Next, we'll turn our attention to that small mark on Patchy's face on the far right side of the image. Click the spot healing icon to bring up a flyout menu, and choose the healing brush, as shown in Figure 4-22. Or press the J key (Shift+J if you skipped the Preface). Unlike the spot healing brush, the healing brush allows you to specify the source point from which Photoshop will grab its healing information.

5. *Confirm the default settings.* In the options bar, make sure **Source** is set to **Sampled** and the **Aligned** check box is off. Sampled tells Photoshop to clone pixels from a spot inside an image (as you'll specify in the next step); turning off Aligned lets you clone several times in a row from that one pristine spot.

Figure 4-22.

6. **Set the source point for the healing.** The healing brush requires you to designate a specific source point so that you can clone from one portion of an image to another. To set the source point, press the Alt (or Option) key and click at the spot below the mark indicated by the crosshairs in Figure 4-23. I chose this source because it has a similar texture (slightly blurry) to the area we're trying to retouch.

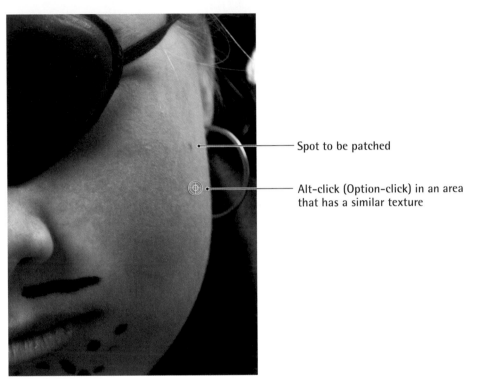

Spot to be patched

Alt-click (Option-click) in an area that has a similar texture

Figure 4-23.

7. **Heal the dark spot on the side of her cheek.** With your brush set to 20 pixels (or if you're lazy, the default 19 pixels) and a maximum hardness to avoid edge errors, paint over the small mark on the side of her face. You can watch the source point move as you paint so that you can make sure you don't stray out of the desirable area.

PEARL OF WISDOM

Beginning with CS4, Photoshop started displaying a preview of the source area as you paint, which dramatically helps you align a source to a destination. To see just the source without the brush circle around it, press the Caps Lock key.

At first, it will look as if you're painting with a darker color, as on the right side of Figure 4-24, but when you release your mouse button, you'll see that Photoshop has deftly merged the information between the source and destination areas just beautifully.

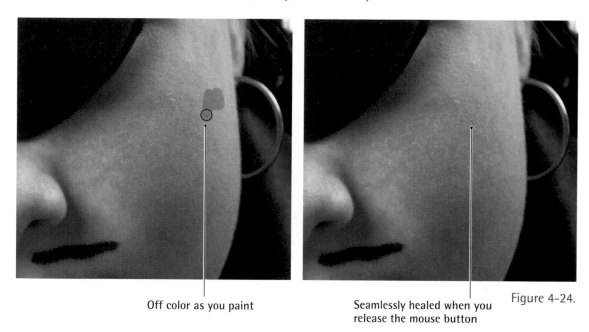

Off color as you paint

Seamlessly healed when you release the mouse button

Figure 4-24.

8. *Set a source point for the smudge at the corner of her mouth.* The next area we'll attend to is the small smudge on the left corner of her mouth. It's a tricky area because we have to avoid the crease of her lip and other odd textures when we're setting the source point. The best plan of attack is to set it "close to home" just to the left of the area we're trying to heal. As you can see in Figure 4-25, I've chosen a point that's almost adjacent to the destination spot. Hold down the Alt (Option) key and click that spot.

Figure 4-25.

PEARL OF WISDOM

Despite the increased control afforded by the healing brush, it's still at heart a highly automated tool. And the results of such tools sometimes fall short of perfection. In more challenging healing work, you may see rows of inconsistent pixels, known as *scarring*. These bad seams tell the world that your image has been modified. Fortunately, you can reheal an area by painting over it (or spot-clicking it) as many times as you like.

9. **Carefully paint the spot at the corner of her mouth.** Reduce the brush size to 10 pixels and carefully paint over the splotch, as shown in the top image in Figure 4-26. Because we're cloning from a nearby area, the edit is likely to cause a telltale repetition of pattern or edge detail that even amateur Photoshop-forensic experts are on the lookout for these days. (The repeating edge is right there next to the original.) In fact, you can see in my example in the bottom image of Figure 4-26 that the cloned area looks suspiciously like the area directly to the left.

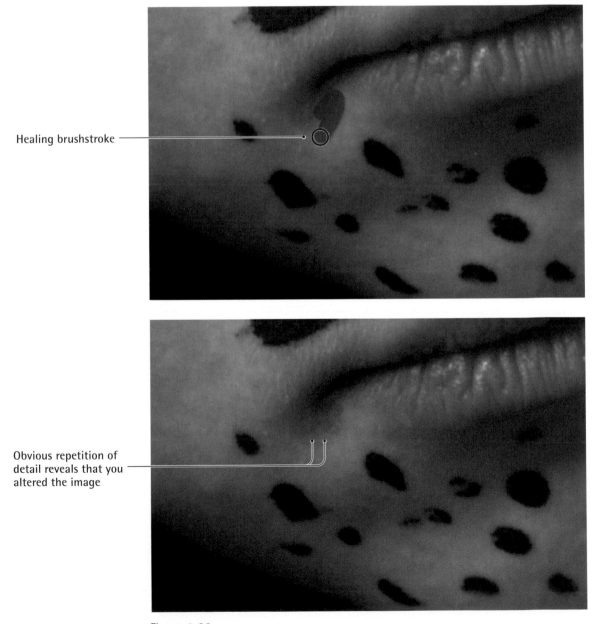

Healing brushstroke

Obvious repetition of detail reveals that you altered the image

Figure 4-26.

10. ***Paint back older information with the history brush.*** The history brush, as I alluded to in the last exercise, allows you to paint back specific areas of an image based on a snapshot in your History panel. Here's how we'll use it to solve our current problem:

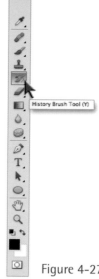

- Select the history brush from the toolbox, as shown in Figure 4-27, or press the Y key.

Figure 4-27.

- Decrease the brush size to 8 pixels by pressing the ⬚ key several times.

- Confirm in the **History** panel that you're painting from the original *Patchy.tif* state. You'll see the history brush icon next to the state that Photoshop is using for its source, as in Figure 4-28.

- Right-click with the brush and confirm that the Hardness is set to 0 percent. Then press Esc to dismiss the context menu.

Figure 4-28.

- Paint along the repeating edge as shown in Figure 4-29 to remove the duplicated detail. (Note that I've colored my brushstroke in the image to show you where I painted, but when you use the history brush in Photoshop, it will not leave any kind of indicating trail.)

11. ***Repeat the healing brush as necessary.*** If you're still not satisfied with the undetectablity of the edit, return to the healing brush and make another pass. For the second pass, I chose as my source the area just to the right of where I'd been working. Then I reduced the brush size to 10 pixels and clicked in a few key spots to cover my tracks. You can see the click points and results in Figure 4-30, on the next page.

Figure 4-29.

Healing and Patching

Figure 4-30.

Click three more
times to disrupt
repeating detail

Tracks are fairly
seamlessly covered

12. ***Turn your attention to the scar.*** Like any self-respecting pirate,
Patchy has a tragically gruesome scar on the side of her face,
which will present a proper challenge to Photoshop's healing
powers. The tough thing about healing a large area like this
is finding a suitable source point.

To see what I mean, increase the brush size of the healing brush
to 80 pixels and Alt-click (Option-click) along the jawline just
below the scar. Then attempt to heal the scar. As you move
your brush across the scar, you are likely to pick up all kinds
of undesirable information from her jacket, her moustache,
and the scar itself, as I'm doing in Figure 4-31. Clearly, this
is not the answer, so press Ctrl-Z (⌘-Z) to undo. Where are
we going to find a large enough area with similar information
from which to repair the scar?

Figure 4-31.

13. ***Set the source point on the opposite cheek.*** The answer is to think symmetrically and look to the opposite cheek, which has a large area of similarly toned and textured skin just right for healing. Alt-click (Option-click) on the other cheek, opposite the scar, to set the source point, and then move your brush to the scar and start painting. Almost immediately, you'll discover the problem.

As indicated in Figure 4-32, as you move along the scar, the source point indicator shows you that you've moved way off into the right side of her jacket, and the preview of the information Photoshop is using to heal the scar does not bode well. When you let go of the mouse button, you see disturbing results like those in the bottom image in Figure 4-32. Press Ctrl-Z (⌘-Z) to undo yet again. The approach of using the opposite cheek is still sound, but it will require some finesse.

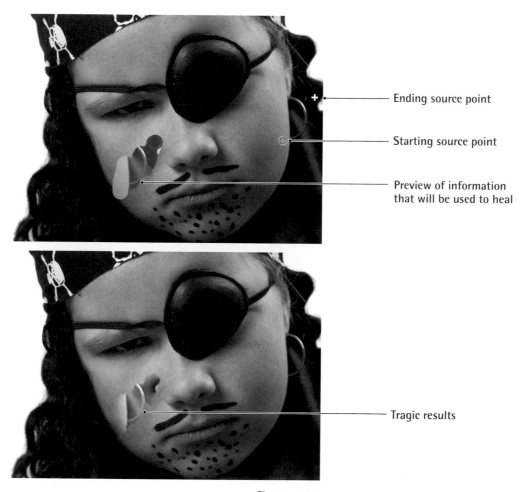

Ending source point

Starting source point

Preview of information that will be used to heal

Tragic results

Figure 4-32.

Figure 4-33.

14. ***Jump the image to a new layer and flip it.*** Press Ctrl-J (⌘-J) to create a copy of the image on a new layer. Then choose **Edit→Transform→Flip Horizontal** to create a reversed version of the image that has the good cheek on the left side. Your Layers panel should look like the one in Figure 4-33.

15. ***Choose a source point from Layer 1.*** In the **Layers** panel, make sure that **Layer 1** is active, and then Alt-click (Option-click) midway along the girl's jaw line, as shown in Figure 4-34. Based on the information in your cursor, you'll see that you now have a source point that's much better suited to the healing that we want to do in the Background layer.

16. ***Turn off visibility for Layer 1.*** Click the 👁 next to the thumbnail for Layer 1 so that you can see the Background layer underneath. Then click the **Background** layer so that it's active. You can't delete Layer 1 because it's the source of healing information, but you can make it invisible.

17. ***Enlarge the brush to see the angle of the texture information.*** Press the ⎏ key several times to make the brush unreasonably large at 400 pixels. As you can see in Figure 4-35, this allows you to really see the angle of the source information that you're working with inside the cursor and make an assessment as to how effective it will be for healing your destination area. The angle is slightly off from what we need to heal the pirate's scar.

Figure 4-34.

Figure 4-35.

18. ***Open the Clone Source panel.*** Photoshop provides a panel for the express purpose of manipulating the source of your cloning operation. Click the clone source icon in the options bar, as shown in Figure 4-36, to reveal the panel.

Figure 4-36.

19. ***Set the Clone Source to an angle of –23.*** Click in the rotation value area (circled in Figure 4-37) and press Shift+↓ to change the angle rotation value in a counterclockwise direction. (Pressing ↓ rotates the angle counterclockwise, and pressing the Shift key allows you to work in whole-degree increments.) Once you have the value selected, move the cursor back out to the image so you can see how the angle lines up properly in the preview. Press Shift+↓ until you reach –23 degrees, which aligns the source information with the destination nicely, as you can see in Figure 4-37.

Figure 4-37.

20. ***Turn on the Aligned check box.*** The Aligned check box in the options bar allows you to set the same offset for each stroke, which usually leads to unfavorable things such as detail repetition. However, in this case, the Aligned check box will maintain the careful angle of relationship we've established for source and destination. Turn on the **Aligned** check box.

21. ***Paint over the scar.*** Reduce the brush size to something more reasonable by pressing the ⬜ key several times until you reach a brush size of 90 pixels. Then paint over the scar, covering it entirely but steering clear of the pirate's moustache and whiskers. You can see the area I painted in the top image in Figure 4-38 and the results in the bottom image.

Don't be disconcerted by the fact that the source point indicator is in her hair while you're healing (as you can see in the top image). The plus sign way out on the left indicates where the source point is located on the other layer.

Indicates the source point on the other layer —————

Figure 4-38.

22. *Use the history brush to restore the transitions.* Although Photoshop does a miraculous job of healing our pirate's scar, the area along her check and jaw line have lost some of their original shadow detail and her earring has been erroneously duplicated. As we've seen, we can paint back the detail from an earlier state of the image.

Press the Y key to select the history brush. Set the brush size to 100 pixels. Then, in the **History** panel, make sure your source is still set to the original **Patchy.tif** state. Paint back along the side of her face to restore those edge transitions, as shown in Figure 4-39. Be careful at the edge to avoid restoring red splotches from the scar. Also carefully brush back in the areas above and below the scar to retain as much original information as possible.

Figure 4-39.

Figure 4-40.

Figure 4-41 shows what our buccaneer looks like after our retouching efforts. Thanks to Photoshop, there's nary a trace of her fear-producing scar—or any other blemishes, for that matter. But she still has enough ferocity in her countenance to remind us all that we'll be walkin' the plank if we cross her.

Turning a Photograph into a Line Drawing

In my capacity as a (self-proclaimed) Photoshop expert, one of the most popular questions people ask is "How do I turn a photograph into a piece of line art?" It seems people come across line drawings, say, in *The Wall Street Journal* or on Barnes & Noble shopping bags, and assume Photoshop deserves the credit. After all, these drawings are photo-realistic, and photo-realism means Photoshop, right?

Although Photoshop may play a hand in the refinement of the source photos and the adjustment of the final art, most of these drawings are hand-drawn, each the product of an artist or engraver making the most of traditional tools and God-given talents. But let's say you want to achieve a similar effect without all that hard-wrought experience and manual labor. This exercise reveals a technique that exploits Photoshop's image enhancement and graphic arts functions for just such a purpose. The result is a flexible—even fun—technique that lets you turn any photograph into a piece of high-contrast, photo-realistic art. Over the course of this exercise, you'll learn how to create a hand-drawn effect in Photoshop in a fraction of the time it would take to draw it.

1. *Open a color photograph.* Head shots work best for this technique because they usually provide subtle variations in highlight and shadow, volumetric contours, large areas of simple detail, and plain backgrounds. So open the file *Attitude.psd* in the *Lesson 04* folder inside *Lesson Files-PsCS5 1on1*. This portrait of a sneering woman in Figure 4-41 (on the facing page) by photographer Joseph Jean Rolland Dubé comes from the iStockphoto library.

2. ***Create a new layer.*** We're going to start by using one of Photoshop's filters. *Filters* are effects that can be applied directly to an image to change its appearance. Straightforward applications of filters are *destructive edits*, meaning that they permanently change the pixels in your image. So we'll apply the filter to an independent layer, leaving our background intact. Press Ctrl+J (⌘-J) to jump the image to a new layer. In the **Layers** panel, double-click the name of the new layer (probably Layer 1) and rename it "Photocopy."

You can apply Photoshop filters nondestructively, but that requires the use of smart objects, which we'll cover in Lesson 7.

Figure 4-41.

3. ***Apply the Photocopy filter.*** The Filter menu provides lots of ways to trace edges, but my favorite filter for this kind of work is Photocopy. Press the D key to set the foreground and background colors to their defaults, black and white. Then choose **Filter→Sketch→Photocopy**. When the **Filter** dialog box opens, set the **Darkness** value to its maximum, **50**. Then raise the **Detail** value until you get nice thick edges, typically in the neighborhood of 9 for a 300 ppi image, as shown in Figure 4-42. Then click **OK**.

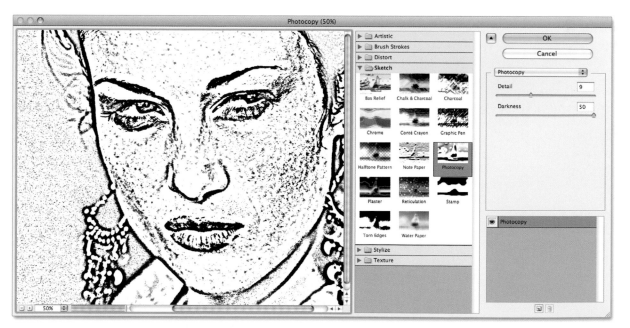

Figure 4-42.

4. **Blend the outline with the colored layer.** To merge the lines with the original color image, choose the **Multiply** mode from the blend mode pop-up menu in the **Layers** panel. The dirty filthy result appears in Figure 4-43.

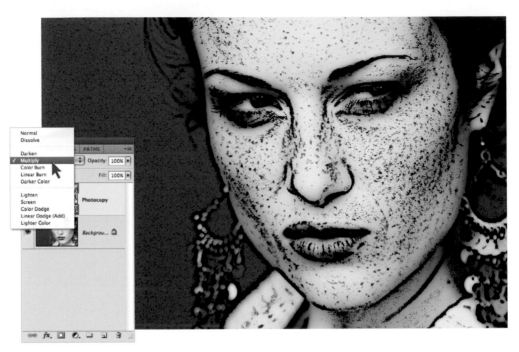

Figure 4-43.

5. **Apply another filter to facilitate cleanup.** Naturally, we don't want our subject to look like she's rubbed her face in graphite or succumbed to some dread 21st-century plague, so some cleanup is in order. We'll start with the digital equivalent of a vacuum cleaner, and then we'll do some hand-scrubbing. Choose **Filter→Blur →Gaussian Blur**. In the dialog box that opens, enter a **Radius** of **2.0** pixels, and then click **OK**. The result doesn't look any better, but it gives you some gray values that you can trim with the Levels command.

6. **Adjust the Levels.** The Levels command allows you to adjust brightness values and is the perfect tool for getting rid of the gray values we created in the preceding step. Choose **Image→Adjustments→Levels**. Increase the first **Input Levels** value to 115 to punch the blacks (make them darker), and then decrease the third value to 140 to drop out the whites, as pictured in Figure 4-44 on the facing page. Click **OK** to accept the change. The result is a much cleaner image but not clean enough.

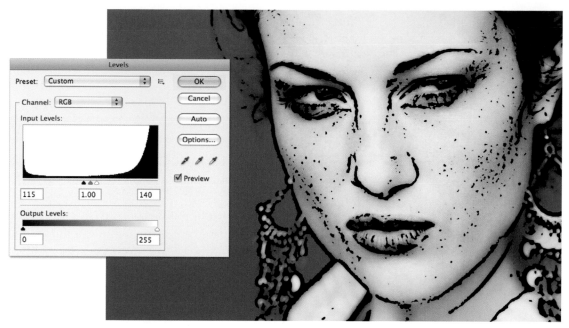

Figure 4-44.

7. ***Clean up the stray dark spot.*** Press the L key as many times as necessary to get the lasso tool, and select the stray dots and pockmarks. Then press the Backspace (Delete) key to get rid of them. You should expect to spend ten to fifteen minutes on this step. Keep only the most obvious edge outlines, as I've done in Figure 4-45.

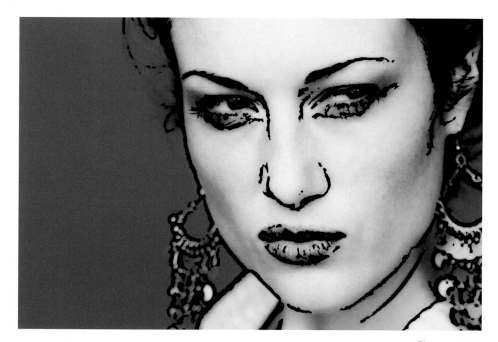

Figure 4-45.

8. *Create a new background layer.* For reasons that will become increasingly evident as you work through the steps, you need to keep the original image around for Photoshop to reference. But as it stands now, it competes fiercely with the black outlines. To lessen its effect:

- Click the **Background** layer in the **Layers** panel.

- Next, Alt-click (Option-click) the ⬓ icon at the bottom of the Layers panel to make a new layer. Name it "White" in the **New Layer** dialog box that appears, and then click **OK**.

- Press Ctrl+D (⌘-D) to deselect the image.

- Then press the D key again by itself to ensure that your foreground and background colors are set to their default black and white, respectively.

- Next, press Ctrl+Backspace (⌘-Delete) to fill the entire layer with white.

- Reduce the **Opacity** value in the **Layers** panel to 50 percent to let some of the original image show through, as witnessed in Figure 4-46.

Although the layer thumbnails in the Layers panel are visually helpful for remembering what a layer contains, nothing beats adding a descriptive name to each layer you create. You can either hold down the Alt (Option) key when you click the ⬓ button to rename on-the-fly or double-click the name after the layer is created and rename it then. Either way, it's a good habit to get into.

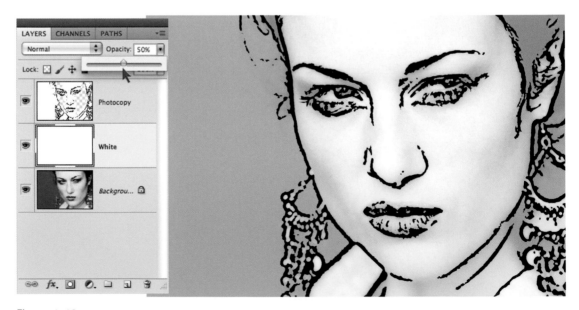

Figure 4-46.

9. ***Fill in the shadows with black.*** Although you might think that filling the shadows requires painting or selecting, it doesn't. The approach is a bit more technical, but it's also vastly more automated. Create another layer, name it "Solid Black," and this time fill it with black by pressing Alt+Backspace (Option-Delete). The result is an entirely black image, but we'll fix that in the next step.

10. ***Adjust the layer style for the Solid Black layer.*** Double-click to the right of the **Solid Black** layer's name in the **Layers** panel to display the **Layer Style** dialog box. Go down to the last slider bar, which is labeled **Underlying Layer**. Drag the white triangle to the left to a value of 160 to force through the lightest colors in the underlying layers, meaning that the black covers brightness levels of 160 and darker. The result appears in Figure 4-47. Click **OK** to exit the dialog box.

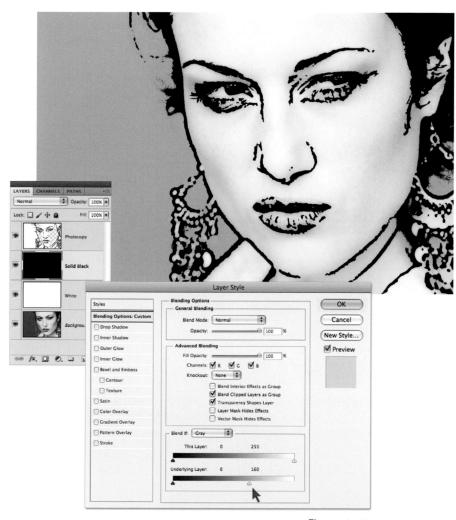

Figure 4-47.

11. **Open two crosshatch files.** At this point, we have something that vaguely resembles a line drawing traced in vellum over a photograph. The effect is okay, but to my eyes, it still looks too much like Photoshop art. So we're going to bring in a crosshatching pattern that sells the effect as a mechanical engraving. The truly amazing stuff starts now.

To form the crosshatch effect, you need to use a couple of repeating diagonal line patterns. I created two simple images (magnified to 800 percent in Figure 4-48) with the pencil tool. Navigate to the *Lesson 04* folder inside *Lesson Files-PsCS5 1on1*, and open the two files: *Thick-lines.gif* and *Thin-lines.gif*. Each image is a tessellating tile, meaning it repeats seamlessly when expressed as a pattern. Note that the angle of one pattern is a flipped version of the other.

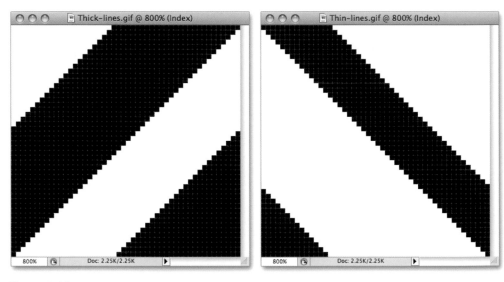

Figure 4-48.

12. **Define the tiles as patterns.** To define each tile as a pattern, choose **Edit→Define Pattern** and then click **OK** in the **Pattern Name** dialog box. Then repeat for the other file.

13. **Add a pattern fill layer.** Return to the layered photograph file and make sure the **Solid Black** layer is active in the **Layers** panel. Then Alt-click (Option-click) the ◖ icon at the bottom of the Layers panel and choose **Pattern**. Name your layer "Thin Lines" and click **OK**. In the **Pattern Fill** dialog box that appears next, click the downward arrow next to the pattern thumbnail and choose the **Thin Lines** pattern, as shown in Figure 4-49.

Figure 4-49.

You can probably visually recognize the thin lines pattern from the available patterns. But if you'd like to identify your patterns by name, click the ⊙ arrow to the right of the pattern window and choose Large List from the flyout menu. Or you can hover the cursor over each pattern and wait for the tooltip to appear, as in Figure 4-49.

In the Pattern Fill dialog box, enter 50 percent for the **Scale** value. Click **OK** when you're finished. The results are shown in Figure 4-50.

Figure 4-50.

For the best results, you always want to scale the pattern by an even fraction (50 percent, 25 percent, and so on) and keep the pattern as large as possible. Remember that the lines have to print without filling in, so a bit too big is just right.

14. *Adjust the layer style for the Thin Lines layer.* Now to integrate the pattern lines into the artwork:

 • Double-click in the empty area to the right of the **Thin Lines** layer name in the **Layers** panel to bring up **Layer Style** dialog box.

 • Set the **Blend Mode** option to **Multiply** to drop out the whites and keep the blacks.

 • Next, use the **Underlying Layer** slider to taper the lines in the photograph. Drag the white triangle until the right-hand value reads 180.

- Then press the Alt (Option) key and drag the right half of the white triangle to **240**, as in Figure 4-51.

The lines gradually dissolve into transparency across the very lightest colors in the image. Click **OK** to accept your changes.

Figure 4-51.

15. *Apply the thick lines pattern.* Press Alt-⊞ (Option-⊞) to move one layer down (back to the **Solid Black** layer). Again Alt-click (Option-click) the ◯ at the bottom of the **Layers** panel, and choose **Pattern** again. Name this layer "Thick Lines," and click **OK**. Then select the **Thick Lines** pattern. Scale the pattern by 50 percent and click the **OK** button.

16. *Adjust the Layer style for the Thick Lines layer.* In the Layers panel, double-click to the right of the **Thick Lines** layer name to bring up the **Layer Style** dialog box, and adjust as follows:

- As before, change the **Blend Mode** setting to **Multiply**.

- In the **Underlying Layer** slider, Alt-drag (Option-drag) the left half of the white triangle to 190 and set the right half to 220.

- Then click **OK**.

Photoshop merges the opposite line patterns to create a cross-hatch effect, as illustrated in Figure 4-52 on the facing page.

Figure 4-52.

17. **Add a Threshold Adjustment layer.** You could stop now and leave the cross-hatching set against a lightened version of the color photograph. But presumably, you want to convert the entire graphic to black and white. It might seem like you could just set the Background layer to white and be done with it. But thanks to the Underlying Layer settings, the behavior of the cross-hatching depends on the colors in the photograph. However, there is a way to keep the effect without keeping the colors:.

- Click the top layer in the **Layers** panel to make it active.

- Then click the ◗ icon at the bottom of the panel and choose **Threshold**. The Threshold controls will appear in the **Adjustments** panel (which will automatically open if you don't already have it visible), as shown in Figure 4-53.

- Set the **Threshold Level** value to 120 to create the ideal balance of blacks and whites. Then click press Enter (Return) or Tab to accept the adjustments.

18. **Adjust the layer styles for the two pattern layers.** After seeing the results of the Threshold command, I decided I wanted to adjust the amount of patterning across her face. This is fairly easy to do, since the layer styles we applied earlier are adjustable:

- Double-click to the right of the **Thin Lines** layer name to reopen the **Layer Styles** dialog box, and return to the **Underlying Layer** slider.

Figure 4-53.

- Drag each of the two halves of the white slider triangle so the right-hand values read 225/255. Click **OK**.

- Then double-click to the right of the **Thick Lines** layer and change its slider values to 180/240 and click **OK** again.

The point is, the cross-hatching settings remain forever editable.

The final results are shown in Figure 4-54. Without picking up a pen, pencil, or even one of Photoshop's brush-based tools, we've turned a photo into a photo-realistic line drawing.

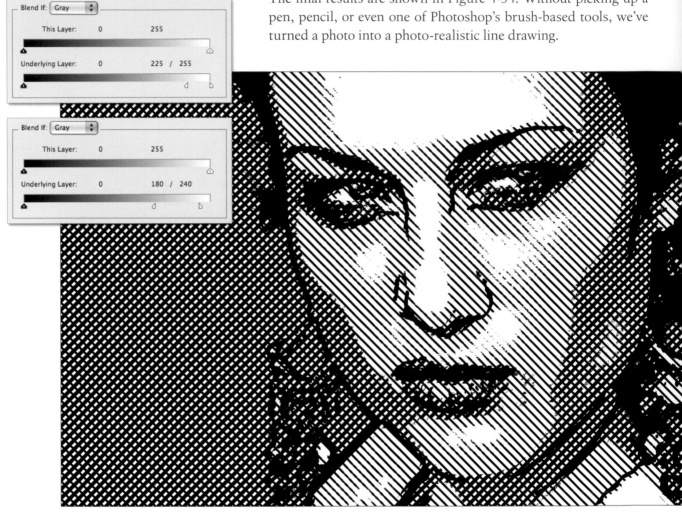

Figure 4-54.

WHAT DID YOU LEARN?

Match the key concept in the numbered list below with the letter
of the phrase that best describes it. Answers appear upside-down
at the bottom of the page.

Key Concepts

1. Editing tools
2. Painting tools
3. Healing tools
4. Dodge tool
5. Burn tool
6. Sponge tool
7. History brush
8. Snapshot
9. Source point
10. Clone Source
11. Filter
12. Destructive edits

Descriptions

A. Decreases or increases the saturation of an image, depending on the Mode setting in the options bar.

B. This tool allows you to paint back information from a previous state saved in the History panel.

C. This panel lets you scale, rotate, and even flip the source image as you paint it onto the destination, as well as preview the source as a translucent overlay.

D. A modification to an image that permanently changes the pixels to which it's applied.

E. A special kind of state in the History panel that remains available well after twenty operations.

F. This tool lightens portions of an image as you paint, which makes it great for bringing out naturally shaded areas such as eyes.

G. A loose collection of features that modify the existing color or luminosity of a pixel without replacing its content.

H. This tool darkens pixels as you paint over them.

I. A set of Photoshop tools that permit you to clone elements from one portion or state of an image to another.

J. A Photoshop effect applied directly to an entire image or a selection.

K. The spot from which the healing brush samples information when repairing a flaw in an image.

L. Brush-based tools that allow you to paint lines and fill shapes with the foreground color.

Answers

WORKING WITH LAYERS

EVERY IMAGE begins life as a few channels of data—most commonly, one each for red, green, and blue—fused into a single pane of pixels (see Figure 5-1). Whether the image comes from the least expensive digital camera or a professional-level drum scanner, it exists entirely on one layer. One and only one full-color value exists for each and every pixel, and there is no such thing as transparency. Such an image is said to be *flat*. But add images (like the extra arms in the figure) and you add layers. Each layer serves as an independent image that you can stack, transform, or blend with other layers.

An image that contains two or more layers is called a *layered composition*. There's no need to wait until a certain point in the editing cycle to build such a composition—you can add layers any old time you like, as we have several times in previous lessons. But layers can do more than just add manipulatable imagery your composition. They give you infinite ways to control how those image components work together to create the final appearance of your artwork.

The Benefits and Penalties of Layers

Photoshop's reliance on layers makes for an exceedingly flexible (if sometimes confusing) work environment. As long as an image remains on a layer, you can move or edit it independently of other layers in the composition. Moreover, you can create relationships between neighboring layers using a wide variety of blending options, adjustments, and masks, all of which work without changing the contents of the layers in the slightest.

Figure 5-1.

ABOUT THIS LESSON

Project Files

Before beginning the exercises, make sure you've downloaded the lesson files from www.oreilly.com/go/Deke-PhotoshopCS5, as directed in Step 2 on page xvi of the Preface. This means you should have a folder called *Lesson Files-PsCS5 1on1* on your desktop (or whatever location you chose). We'll be working with the files inside the *Lesson 05* subfolder.

This lesson examines the amazing power of using Photoshop layers to isolate and manipulate parts of your image. You will learn how to:

Video Lesson 5: Layer Manipulations

Layers just might be the most powerful feature in all of Photoshop. Layers allow you to stack images on top of each other, apply settings to independent parts of your image, blend layers together for effects, clip one layer to another to limit effects, and more. And often you can do this with no destruction to your original image. In this video, I'll show you how to turn a regular woman into an otherworldly creature.

To be enlightened on layers, visit *www.oreilly.com/go/deke-PhotoshopCS5.* Click the **Watch** button to view the lesson online or click the **Download** button to save it to your computer. During the video, you'll learn these shortcuts:

Video Lesson 5: Layer Manipulations

Operation	Windows shortcut	Macintosh shortcut
Convert Background to free-floating layer	Double-click Background	Double-click Background
Select layer directly from image window	Ctrl-right-click	⌘-Control-click
Fill with foreground or background color	Alt+Backspace, Ctrl+Backspace	Option-Delete, ⌘-Delete
Change Opacity setting of active layer	1, 2, 3, . . . 0	1, 2, 3, . . . 0
Duplicate active layer to new layer	Ctrl+J	⌘-J
Move layer forward or backward	Ctrl+⬚ or Ctrl+⬚	⌘-⬚ or ⌘-⬚

But layers come at a price. Because they are actually independent images, each layer consumes space both in memory and on your hard drive. So as you add layers, your composition gets bigger, and Photoshop requires more space in memory and on disk to manage the file. Generally speaking, you can let Photoshop worry about these sorts of nitty-gritty details. But bear in mind, no matter how sophisticated your computer, its memory and hard disk are finite. And if either the memory or (worse) the hard disk fills up, your ability to edit your marvelous multilayer creations may come to a skidding halt. Fortunately, a few precautions are all it takes to keep layered compositions on a diet and Photoshop running in top form:

- First, don't let your hard disk get anywhere close to full. I recommend keeping at least 25GB available at all times, and more than that is always welcome. (Consult your computer's documentation to find out how to check the space available—or just hope and pray you're okay, like everyone else does.)

- Back up your Photoshop projects regularly to DVD, an external drive, or another storage medium. Doing so not only preserves and protects your images but also permits you to delete files from your hard disk if you start running out of room.

- As you work in Photoshop, you can keep an eye on the size of your image in memory by observing the Doc values at the lower-left corner of the image window (see Figure 5-2) or in the Info panel. The value before the slash is the size of the image if flattened; the value after the slash tells you the size of the layered composition.

- You can reduce the size of an image by *merging* two layers into one using Layer→Merge Down, which we'll put to use in this lesson.

- To merge all layers and return to a flat image, choose Layer→Flatten Image. But beware, this is a radical step. I usually flatten an image only as a preamble to importing it for another context like a book or my Web site. And even then, I make sure to save the flattened image under a different name to maintain my original layered file.

Finally, when in doubt, err on the side of too many layers. This may sound like strange advice, but it's better to push the limits and occasionally top out than unnecessarily constrain yourself and hobble your file. You can always upgrade your technology to better accommodate your massive compositions, but you can never recover an unsaved layer (one that you merged or flattened before saving).

Doc: 13.1M/96.4M

Figure 5-2.

Arranging and Modifying Layers

The most basic use for layers is to keep objects separated from each other so you can modify their horizontal and vertical position as well as their front-to-back arrangement. Photoshop also permits you to transform layers by scaling, rotating, or even warping them into all sorts of contortions, as we've seen in some previous lessons.

Composing this way has a long tradition in Western art. In fact, the classical artist who I believe would have benefited most from layers is the 16th-century imperial court painter Giuseppe Arcimboldo. Regaled in his time as a master of the composite portrait, Arcimboldo rendered his subjects as fanciful collections of fruits, vegetables, flowers, trees, animals, meats—he even famously represented one fellow upside-down (right image, Figure 5-3). We'll embark on something infinitely simpler, composition-wise—Giuseppe had to thrill and delight Emperor Maximilian II, but happily we do not. Even so, you'll get an ample sense of just how much pure imaging flexibility layers afford.

In the following exercise, you will begin the process of assembling a layered piece of artwork. You'll establish the content and order of the initial layers in the composition, and in the process, learn how to select layers, rearrange their order, duplicate them, and modify their contents and appearance.

Figure 5-3.

1. **Open a preliminary composition file.** Start by opening *Base layers.psd* in the *Lesson 05* folder inside *Lesson Files-PsCS5 1on1*. This file will serve as the basis for creating a Web banner graphic for a fantasy episode of my weekly audio podcast, "Martini Hour." The splashing martini glass you see in Figure 5-4 comes from photographer Gunnar 2000 of the Fotolia image library. But it's possible that you won't be able to see the glass or the other layers on your screen until you've dismissed the warning in the next step.

Figure 5-4.

2. **Dismiss the warning dialog box.** The text layers I created for you contain an Adobe font called Rotis Semi Sans. If you don't have this font, you'll see the warning message in Figure 5-5. Click **OK** to dismiss the warning without worrying. You won't be able to edit or scale the type if you don't have the font loaded, but you will be able to see it thanks to Photoshop's automatic storage of the pixel information for the type. So the file will look fine, and you won't have any obstacles to finishing the project.

Figure 5-5.

3. **Open the Layers panel.** If the panel is already on screen, fabulous. If not, choose **Window→Layers** or press the F7 key. The **Layers** panel shows thumbnails of every layer in the document, from the front layer at the top of the panel to the rearmost layer (usually a base Background layer) at the bottom. This arrangement of layers from front to back is called the *stacking order.*

Figure 5-6.

You can see in the panel in Figure 5-6 that the document already has five layers: the martini glass image, a layer full of color blobs, a fill layer with a vector mask, and the two aforementioned text layers (sporting the ⚠ icon if you encountered that warning). For now, the Glass 1 layer is the only one visible, as indicated by the fact that you can see a 👁 to the left of it. We'll be turning on the visibility of the other layers as well as adding even more layers during this exercise and the next.

The thumbnails in the Layers panel are useful for understanding the contents of each layer at a glance. To maximize their utility, make them as large as possible by clicking the ▾≡ in the upper-right corner of the panel to open the Layers panel menu. Then choose Panel Options and select the largest thumbnail size. Click OK.

4. *Change the transparency indicator pattern.* The checkerboard pattern you see on the right side of the image is the *transparency grid*, which is Photoshop's way of indicating that no pixel information is in that area. I find the default color scheme of the checkerboard a bit unhelpful because it uses white squares. White is a fairly common feature of images, so sometimes the white in the checkerboard can be misleading. You can change this color pattern in the Preferences dialog box, as follows:

Figure 5-7.

- Press Ctrl+K (⌘-K) to open the **Preferences** dialog box.

- Choose **Transparency & Gamut** in the left pane, as in Figure 5-7.

- Leave the **Grid Colors** set to **Light**.

- Click the white swatch below **Grid Options**.

- In the color picker, change the **B** (Brightness) value to 70 percent, as indicated in Figure 5-7.

- Click **OK** two times (or just press Enter or Return) to dismiss both dialog boxes.

The transparency grid now appears in a lower contrast version that you can see in Figure 5-8 on the facing page.

5. *Add a Background layer.* You don't need a Background layer in an image, but adding one can be helpful for visually understanding a composition.

Adding a Background layer is a two-step process:

- Click the ⬒ icon at the bottom of the **Layers** panel to create a new layer (which will land above our currently selected Glass 1 layer).

- Then from the **Layer** menu, choose **New→Background from Layer** (which will move the new layer to the bottom of the layer stack).

The new Background layer will automatically fill with white (the current background color), and the transparency grid in the image will disappear because we'll be seeing through to the white background, as witnessed in Figure 5-9.

Figure 5-9.

The white Background layer is visible through the transparent area of the Glass 1 layer

6. *Turn on the guidelines.* Photoshop gives you the ability to lay nonprinting guidelines over your image so that you can precisely position elements in your composition. To turn on the guidelines, and see the guides I've already established for later use, choose **View→Show→Guides**.

7. ***Set the guidelines to the final image boundary.*** In Photoshop files, the boundaries of any individual layer are not necessarily the boundaries of the visible document. This phenomenon is known as *big layer*, and it means that you can have content on any given layer that extends beyond the document itself. Before we examine this big layer information, we're going to use guidelines to make a record of where we want the final image edges:

 • If you can't see beyond the edges of the image, press the F key to change to Full Screen mode.

 • If the ruler is not already visible, press Ctrl+R (⌘-R) to view the horizontal and vertical rulers. Rulers are the easiest starting point when creating new guides.

 • Place your cursor over the horizontal ruler at the top of the image window and drag out a new guide. You should see a double-arrow cursor and a line indicating the position of the new guide (as you can see on the right side of Figure 5-10).

 • When the line gets to the upper edge of the image, Photoshop should snap the guide into place, at which point you can release your mouse button.

 If you don't experience a snapping sensation when the guide gets to the top of the image, choose View→Snap to→Document Bounds.

 • From the top ruler, drag out another guide for the bottom edge of the image. Then from the vertical ruler, drag out two more guides and set them at the left and right edges of the image, as shown in Figure 5-10.

Figure 5-10.

8. *Reveal the entire contents of the layer.* Now that we've left some digital breadcrumbs in the form of guides, we can safely look at the "big layer" contents of the Glass 1 layer (and still be able to return to our original image boundaries). From the **Image** menu, choose **Reveal All**. Immediately, you will see that there's more to this martini glass than originally meets the eye. Notice in Figure 5-11 that the thumbnails in the Layers panel grow to accommodate the largest layer, which in this case is Glass 1.

Figure 5-11.

If you'd like to see the thumbnails in their entirety even when they are not visible in the document, click the ▾≡ icon to open the Layers panel flyout menu. Then choose Panel Options and choose Entire Document in the Thumbnail Contents section. Alternately, you can right-click a blank area of the Layers panel (if you can find one) and choose Clip Thumbnails to Layer Bounds. Your document will retain its dimensions, but you'll be able to see which layers have bonus content.

9. *Remove the unnecessary content in the Glass 1 layer.* Press the F key twice (to change to Standard View mode), so you can view your file size in the lower-left corner of the window. Revealing the entire image has increased our flattened document size 23MB (it started at just over 5MB). Although we'll be using part of that now-revealed stem, we can get rid of the bottom part of the image and reduce the file size of our document.

Click the **Glass 1** layer to select it. Then press the M key to get the rectangular marquee tool (you may need to press it twice if you still have the elliptical marquee set from the last time we used it). Draw out a selection from the 2100-pixel mark downward, as shown in Figure 5-12. Press the Backspace (Delete) key to get rid of that information, and you'll see that the total document size has been reduced from 22.5MB to 18.3MB.

Figure 5-12.

10. *Crop to the former document boundaries.* Press the C key to grab the crop tool, and then drag out a crop boundary to the guides you set in Step 7. (Three horizontal guides should be inside the boundary, as you can see in Figure 5-13 on the facing page.)

After you release the mouse button, ensure that you've really snapped to the guides by grabbing one corner of the boundary, dragging it inward to reduce the crop boundary, and then dragging it back out until it snaps. In the options bar, check that **Cropped Area** is set to **Hide**. (Setting it to Delete would get rid of all that big layer stuff, and we want to use the stem of the glass down the line.) Press Enter (Return) to accept the crop.

Cropped Area: ○ Delete ⊙ Hide | Crop Guide Overlay: None ⬍ | ☑ Shield Color: ▮▮ | Opacity: 50% ▾ | ☐ Perspective

Figure 5-13.

After cropping, you can reset your Layers panel thumbnails to reflect the current document boundaries by right-clicking a blank section of the Layers panel and choosing Clip Thumbnails to Document Bounds.

11. *Reposition a guide.* You can move guides as needed during the creation of your composition. Let's move the second horizontal guide up closer to the center. First, press the F8 key to open the **Info** panel for guidance. Next, press and hold the Ctrl key (⌘ key) and hover over the second horizontal guide. When you get a double-arrow cursor, drag the guide upward until the **Y** value in the Info panel reads 392. Then press Ctrl-R (⌘-R) to hide the ruler.

12. *Simultaneously scale and duplicate the martini glass.* As you saw when you watched the video at the outset of this lesson, layers can be moved in many ways. One particularly useful trick is to move, duplicate, and scale the copy at the same time. Here's how:

 • Make sure the **Glass 1** layer is still selected.

 • Hold down the Alt (Option) key and choose **Edit→Free Transform**. The Free Transform command allows you to change the dimensions of your layer, and adding the Alt (Option) key creates a duplicate in the process. You can't see the copy right away; you have to complete the transform operation first.

- In the options bar, change the **W** value to 68 percent and click the ⚲ icon next to the W value to keep the scale proportional.

- In the **Layers** panel, note that you've created a layer called Glass 1 Copy. At the top of the panel, set the blend mode pop-up menu to **Multiply** so you can see the original glass underneath.

- Drag the Glass 1 Copy over to the right and position it so that its left edge is lined up with the first vertical guide and its center is aligned with the center horizontal guide, as in Figure 5-14.

- Press Enter (Return) to accept the transformation.

Figure 5-14.

13. *Rename Glass 1 Copy.* The layer name Glass 1 Copy is a little confusing, and it's only going to get more so. So double-click the **Glass 1 Copy** layer name and change it to "Glass 2."

14. *Move Glass 2 under Glass 1.* Drag the now aptly named **Glass 2** layer below Glass 1. This temporarily hides a good part of Glass 2, so click the **Glass 1** layer to select it, and change its blend mode to **Multiply** as well.

15. *Magically make a third copy.* Rather than making you repeat the entire procedure in Step 12, Photoshop gives you a fairly amazing option for repeating a transformation. Click the **Glass 2** layer to select it. Press and hold the Alt (Option) key and choose **Edit→Transform→Again**.

 Then sit back and be dazzled as Photoshop repeats the duplication, scaling, and positioning proportionately. The blend mode is correctly set to Multiply as well. All you need to do is rename the copy "Glass 3" and move it below Glass 2. We're also finished with the guidelines, so press Ctrl+; (⌘-;) to hide them. The miraculous results are shown in Figure 5-15.

Figure 5-15.

16. *Turn on the Colors layer.* Click in the space to the left of the **Colors** layer to turn on the 👁 icon and make the layer visible. We'll use this layer, which I created by simply using the polygonal lasso tool and the Fill command, to colorize our repeating martini glasses.

17. *Set the blend mode to Color.* Click the Colors layer to make it active, and set its blend mode to **Color**. This gives each of the martini glasses its own distinctive vibrant hue, as you can see in Figure 5-16 on the next page.

Figure 5-16.

18. ***Zoom in on the area between the green and yellow glasses.*** Press and hold the Z key (to get the zoom tool on-the-fly) and click the area between the glasses a few times to zoom to 200 percent. If you look closely at the flying liquids in Figure 5-17, you'll see that my color blocks didn't exactly line up where they should and that part of the liquid spilling from the green glass has turned yellow.

Figure 5-17.

19. ***Select the area that should be green.*** Press the L key to get the lasso tool. Draw a selection around the large splash from the green glass, capturing everything that is yellow when it should be green, as shown in Figure 5-18 on the facing page.

Figure 5-18.

20. *Sample the green color.* Press the I key to get the eyedropper tool, and click anywhere that is already green. By default, the eyedropper samples the composite color, so you're likely to get a pale or dark green rather than the bright green from the original Colors layer. In Figure 5-19, I've clicked a spot (with CS5's new heads-up display for color sampling) that gave me dark green for my foreground color (as indicated by the top half-circle of the heads-up display), which is not what I want.

Figure 5-19.

Fix this problem in the options bar by choosing **Current Layer** from the **Sample** pop-up menu, as in Figure 5-20. Now when you click with the eyedropper tool, the color sampler will use the Colors layer (which should be currently active) and load the original green as the foreground color.

Figure 5-20.

21. *Fill the selected area with green.* Press Alt+Backspace (or Option-Delete) to fill your selection with the foreground color and thus turn the splash appropriately green. Repeat Steps 18–21 to render the half-green, half-yellow droplet completely yellow.

The result is a nicely colorized set of martinis, which we'll continue to manipulate with blend modes and specialty layers in the next exercise. Press Ctrl+Shift+S (⌘-Shift-S) to bring up the **Save As** dialog box. Name your working file "My Colored Stemware.psd" and then click **Save**. We'll be continuing with this file in the next exercise.

Using Blend Modes and Specialty Layers

Photoshop doesn't just let you create, move, and scale layers; it gives you a great deal of control over how those layers work together in a composition. We've used blend modes already in several exercises, and now we'll be employing them with a vengeance as we finish the Martini Hour Web banner in this exercise. We'll also add specialty layers, including some that include text, some that are partially masked to let only part of their information show through, and some—known as *adjustment layers*—that don't have any content of their own but rather contain instructions for how the layers below should appear.

1. *Begin with the file from the previous lesson.* Proceed with the *My Colored Stemware.psd* file that you saved at the end of the last exercise. Or open the catch-up file *Colored Stemware.psd* (see Figure 5-21) in the *Lesson 05* folder inside *Lesson Files-PsCS5 1on1.*

Figure 5-21.

2. *Create an Invert adjustment layer.* To make this image stand out on my Web site, I want to change it so that the bright colors appear against a black background as opposed to the current white one. We could invert each layer by hand, but then we'd need to alter the blend modes manually as well. Changing all three glass layers at once with an Invert adjustment layer is easier and ultimately more flexible.

Alt-click (Option-click) the ⬤ at the bottom of the **Layers** panel and choose **Invert** from the pop-up menu. In the **New Layer** dialog box, change the name of the layer to simply "Invert" and click **OK**. The result, as you can see in Figure 5-22, is an inversion of the entire image, including the colors of the glassware.

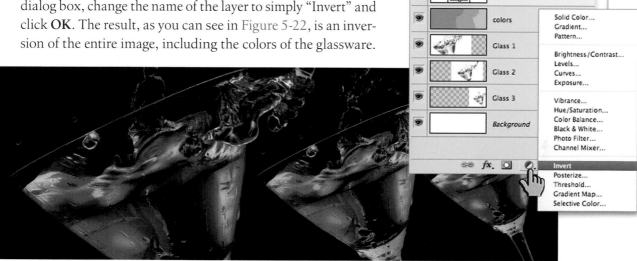

Figure 5-22.

3. *Move the Invert layer below the Colors layer.* With the Invert layer still selected, press Ctrl+☐ (⌘-+☐) to move it down one layer in the stacking order, below the Colors layer, so that it no longer inverts the colors on the Colors layer. Your image should look like Figure 5-23.

Note that the Adjustment panel will pop up with an announcement that invert has no options. No sliders or nuances here, just pure inversion.

Figure 5-23.

4. *Change the opacity of several layers at once.* New to Photoshop CS5 is the simple, convenient ability to adjust the opacity of multiple layers at a time. In the **Layers** panel, click the **Glass 1** layer and then Shift-click the **Glass 3** layer to select all three glasses. Press the 7 key to reduce the opacity of all three layers to 70 percent.

5. *Change the opacity of Glass 2 and 3 layers back to 100 percent.* That new feature is so great, I got carried away. I meant to reduce just Glass 1 to 70 percent. Click the **Glass 2** layer, Shift-click the **Glass 3** layer, and then press the 0 (zero) key to return the lower two glasses to 100 percent opacity.

6. *Turn on the visibility of the remaining layers.* In the Layers panel, drag along the column to the left of the remaining layers to turn on each layer's ◉ and make each layer visible, as I did in Figure 5-24.

Figure 5-24.

Figure 5-25.

7. *Examine the vector mask in the Martini Hour layer.* The third layer from the top features the Martini Hour logo, which I rendered using a vector mask. We'll learn more about creating a vector mask in later lessons, but for now I want to show you how it works. Shift-click the vector mask thumbnail in the Layers panel, and a big red X appears, indicating that the mask is temporarily not functioning in the composite (as in Figure 5-25). You'll see your image turn completely white, because the other component of this layer is a dynamic fill that floods the image with white. When the vector mask is on, it limits that white fill to only the *martini hour* outline. Shift-click the vector mask again to restore it, and the contents of the lower layers once again become visible because the white fill shows through only in the area defined by the mask.

8. *Add the Stars layer.* Open the *Stars.psd* file in the *Lesson 05* folder inside *Lesson Files-PsCS5 1on1*. We're going to import this field of stars into our composition, using a technique we first saw in Lesson 3. Press the V key to get the move tool. Press Ctrl+A (⌘-A) to select the entire image, and then Shift-drag the stars image onto your working composition image. Since the Martini Hour layer was active (from the preceding step), the new layer drops into place above it, blocking the logo. Drag the new layer down below the Martini Hour layer. Then double-click the layer name and change it to "Stars."

If you're in the tabbed view, Shift-drag the Stars image up to the tab for *Colored Stemware.psd* (or *My Colored Stemware.psd* if you're continuing from the last exercise), wait a moment for it to open, and then release the stars into the composition.

Figure 5-26.

9. *Drop out the black background of the Stars layer.* Although we do want a black background, the one provided with the Stars layer is blocking our view of the martini glasses. In the **Layers** panel, change the blend mode of the **Stars** layer to **Screen**. The Screen blend mode handily makes visible only the lightest element of the layer—the stars. The black background drops away.

You should now be able to see the martini glasses boldly going where no cocktail has gone before, as in Figure 5-27 on the next page.

Figure 5-27.

10. ***Turn off the Colors layer.*** Now that I see the composition with the stars *and* the text *and* the glassware, the colors look garish. We could delete the Colors layer, but you never know when you might be in the mood for garish after all. Instead, simply turn off the visibility of the **Colors** layer by clicking its 👁. Now you have the nicely monochromatic look of Figure 5-28, plus the ability to easily change your mind down the line.

Figure 5-28.

11. ***Drag a file into the composition.*** Another long requested feature from veteran Photoshop users has finally arrived in Photoshop CS5: the ability to drag files from the desktop, a Finder window on the Mac, or Windows Explorer on the PC. To see how the feature works, open the folder that contains the lesson files for this book. Navigate to the *Lesson 05* folder, and locate *Light & splash.psd*.

Drag that file directly from the desktop, the Finder, or the Explorer window to your Photoshop composition. Magically, the new file becomes its own layer in your Photoshop document. The layer arrives with handles for easy repositioning, but it's centered exactly where we want it, so press Enter (Return) to accept the size and position. You can see the results in Figure 5-29.

If you didn't set your Preferences as suggested in the Preface, your Light & Splash layer may have been placed as a smart object, indicated by the ⬕ icon in the lower-right corner of the layer thumbnail (see the Pearl of Wisdom to the right). To convert it to a normal layer, right-click the layer in the Layers panel and choose Rasterize Layer from the contextual menu.

Figure 5-29.

12. *Set the blend mode to Screen.* Change the blend mode of your new layer to **Screen**, so that the glassware is unobscured by the darker parts of the Light & Splash layer.

13. *Create a gradient shadow to make the text more legible.* To make sure that the name of our illustrious guest at the bottom of this image is immediately legible to visitors to the Web site, we'll darken the bottom of the image with a gradient fill.

 • First press the D key to establish the default foreground and background colors.

 • Then Alt-click (Option-click) the ⬤ icon at the bottom of the Layers panel and choose **Gradient**. Because you held down the Alt (Option) key, you will be presented with the **New Layer** dialog box, as shown in Figure 5-30.

Figure 5-30.

Figure 5-31.

• Type the name "Dark gradient" and click **OK**. Next, you see the Gradient Fill dialog box.

14. **Open the gradient color.** The gradient color you see in the **Gradient Fill** dialog box is based on the foreground color, which we set to black in the last step, just before creating the gradient fill layer. I want you to edit it slightly, so click the preview, as shown in Figure 5-31, to open the Gradient Editor dialog box.

15. **Change the gradient stop color and angle.** The **Gradient Editor** dialog box allows you to choose from preset gradients or customize your own. We're going to alter the default gradient by changing the color from black to a dark purple:

• Double-click the ⬠ icon below and on the far left of the gradient preview, as shown in Figure 5-32. This is what's known as a stop, designating one end of the gradient continuum.

• In the **Select Stop Color** version of the familiar color picker dialog box, type the values **H**: 285, **S**: 30, and **B**: 15. Click **OK**.

• Repeat the first two bulleted steps for the stop color on the far right side, below the gradient preview as well.

• Click **OK** to exit the Gradient Editor.

• Back in the **Gradient Fill** dialog box, change the **Angle** to 91 degrees so the gradient is slightly offset. Click **OK**.

Figure 5-32.

16. *Adjust the gradient layer blend mode and position.* Set the blend mode for the **Dark Gradient** layer to **Multiply**. The effect still seems a bit dark, so double-click the **Dark Gradient** thumbnail in the **Layers** panel to bring back up the **Gradient Fill** dialog box. Drag from the rim of the second martini glass down across the *h* in *hour,* as shown in Figure 5-33, to move the gradient downward and lighten the top of the image. Then click **OK**.

Figure 5-33.

17. *Add a new layer.* Next, we'll create a gradient stroke above the *Special Guest* text to set it off even further. Before we start, however, I want you to make a new layer to house the stroke so that you can move or alter it to suit your whim. Press Ctrl+Alt+Shift+N (⌘-Option-Shift-N) to make a new layer and rename it on-the-fly. Name your new layer "Stroke" and click **OK**.

18. *Set the options for the rectangular marquee tool.* We want the stroke to also have a gradient effect. The easiest way to make that happen is to draw out a marquee that's the desired width and height of the stroke, and then fill it using the gradient tool. Start by pressing the M key to get the rectangular marquee tool. Change the **Style** in the options bar to **Fixed Size**. In the **Width** field, enter 2360 pixels and press Tab. In the **Height** field, enter a value of 4 pixels, as I did in Figure 5-34.

Figure 5-34.

19. **Create a rectangular marquee along the guideline.** Turn on the guidelines temporarily by pressing Ctrl+; (⌘-;). Then drag your newly constrained marquee so that the top aligns with the guideline, as in Figure 5-35. Press Ctrl+; (⌘-;) when you're finished to turn off the guides.

Figure 5-35.

Once you've drawn the marquee to this fixed specification, you'll probably want to return to the options bar and reset the style for the marquee tool to Normal so your marquee will behave normally.

20. **Set the gradient tool options.** Start by pressing the X key to switch the foreground and background colors, so the foreground color is white. Press the G key to get the gradient tool. In the options bar, click the ▼ next to the gradient preview to see the gradient presets, as shown in Figure 5-36. Then click the second swatch in the top row, which goes from the foreground color to transparent. To the right of the swatch in the options bar are five gradient buttons; make sure the first one, ■, is selected.

Figure 5-36.

21. **Draw a gradient.** So that you can see what you're doing, press Ctrl+H (⌘-H) to hide the selection (although it will still be in effect). Click with the gradient tool above the first *N* in *Einstein*, as indicated by the ❶ in Figure 5-37, Shift-drag to the left to just past the large *t* in *martini*, as indicated by the ❷, and release. Although the selection is hidden, it is still active, so press Ctrl+D (⌘-D) to abandon it.

Why the Shift-drag if the marquee is keeping the stroke horizontally in place? Because you want the gradient angle to stay horizontal as well.

❷ Shift-drag to here and release ❶ Click here with the gradient tool

Figure 5-37.

The result is a 4-pixel stroke that starts solid white and fades off into the infinite universe on the left, as you can see under the turquoise arrow in Figure 5-37.

22. *Add an adjustment layer to brighten the glassware.* The martini glasses look a little faded at this point, but we can brighten them by adding another adjustment layer. Alt-click (Option-click) the ⬤ icon at the bottom of the **Layers** panel and choose **Brightness/Contrast**. Name the layer "Brighten," and click **OK**. In the **Adjustments** panel, move the **Brightness** slider to a value of 50.

23. *Move the Brighten layer.* Because of the Brighten layer's position in the layer stack, the layer is brightening everything under it, rather than just the glasses. We could drag it downward until it was just above the Glass 1 layer, but the Invert layer would then invert the brightening as well. Instead, move the **Brighten** layer so that it sits just above the **Invert** layer. The result is the shiny glassware you see in Figure 5-38.

Figure 5-38.

Figure 5-39.

Figure 5-40.

24. *Add a layer effect to the Martini Hour logo.* Another benefit of working in layers is the ability to apply layer effects to specific parts of your composition. As the name implies, *layer effects* are special effects you apply on a layer-by-layer basis. The two text layers I created for you already have effects applied, as indicated by the *fx* icon to the right of their respective layer names. If you click the ▼ to the right edge of either of those layers, you reveal the effects (in both cases, a drop shadow).

To make the logo pop out from its busy background, I want to add to the logo some layer effects— specifically, a drop shadow and a stroke. Start by clicking the **Martini Hour** layer to select it. Then click the *fx* icon at the bottom of the **Layers** panel and choose **Drop Shadow**, as shown in Figure 5-39.

25. *Choose the settings for the drop shadow effect.* You can adjust your effects in a variety of ways from the **Layer Style** dialog box. For this image, do the following:

- Turn on the **Preview** check box so you can watch the effect take place as you make changes.

- Confirm that the **Blend Mode** is set to **Multiply**.

- Click the swatch to the right of Blend Mode to bring up the **Select Shadow Color** color picker window. Set a dark purple similar to the one we used for the gradient in Step 15 by entering **H**: 285, **S**:3 0, **B**: 25. Click **OK** to dismiss the color picker.

- Back in the **Layer Style** dialog box, increase the **Opacity** to 100 percent.

- Set the **Distance** slider, which controls how much the shadow is offset from its object, to 14 pixels.

- Set the **Size** slider to 16 pixels.

For the moment, your Layer Style dialog box should look like the one in Figure 5-40. Don't click OK just yet. We're going to add another effect while we're here.

26. ***Add a Stroke effect.*** Adding a stroke is a great way to thicken letters when fonts are too lightweight for your composition, as is the case with the Zapfino lettering in the logo. With the Layer Style dialog box still open, click **Stroke** at the bottom of the list on the left. The dialog box will change to settings for your new effect, as you can see in Figure 5-41. Here's how we'll set the stroke:

- Click the **Color** swatch, and in the **Se-lect Stroke Color** version of the color picker window, enter a Brightness (**B**) value of 100 percent. Click **OK**.

- Set the **Size** value to 4 pixels.

Leave the other values as they are and click **OK**.

Figure 5-41.

The two buttons at the bottom of the Layer Style dialog box (see Figure 5-41) are new to CS5. If you use a particular effect more often than any other, you can establish it as your go-to style by using the Make Default button. If you want to return to Photoshop's idea of a default, click Reset to Default.

You can see the result of both effects in Figure 5-42. Each effect has its own listing under the Martini Hour layer. You can suppress these effects independently by clicking off their respective 👁 icons. If you want to adjust an effect's settings, simply double-click the effect entry to return to the Layer Style dialog box.

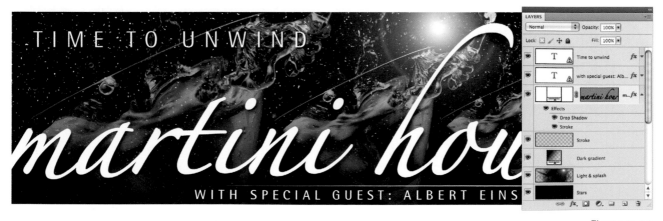

Figure 5-42.

27. *Change the text in a layer.* Let's say I want to change my usual tagline for Martini Hour, *Time to Unwind,* to honor this week's venerable guest. In the **Layers** panel, double-click the thumbnail for the **Time to Unwind** layer to put the text in editable mode.

As I warned you at the outset of this lesson, if you don't have the Rotis Semi Sans typeface, Photoshop will complain. But for experiment's sake, click OK if you see the warning in **Figure 5-43**.

Figure 5-43.

Photoshop will choose a typeface it finds appropriate; in my case, it chose Myriad Pro, which looks okay to me. I kind of enjoy the way it spreads across the starry sky. You'll see the words in the layer become active in the composition. Drag to select the words *To Unwind* and type "Is Relative" in their place. Then again in the Layers panel, click the text layer and watch as Photoshop handily renames the layer according to the new text.

The result is the multilayered extravaganza you see in Figure 5-44. If you want to save your work, press Ctrl+Alt+S (⌘-Option-S), give your file a new name, such as "Martini with Al.psd," and click **OK**. In the next exercise, I'll show you even more ways to mix and match layers and layer styles inside a composition.

Figure 5-44.

Masks, Knockouts, and Luminance Blending

We've already seen how layers permit us to blend multiple images while keeping them independent of each other. For example, changing the mode setting or Opacity value in the Layers panel blends the active layer with all the layers below it. Such operations are said to be *parametric* because they rely on numerical entries and mathematical parameters that Photoshop calculates and applies on-the-fly.

Parametric effects aren't the only way to blend layers. You can also apply one of three varieties of layer-specific masks:

- A *layer mask* creates holes in a layer without erasing pixels.

- A *clipping mask* uses the boundaries of the active layer to crop the contents of one or more layers above it.

- A *knockout* uses the contents of the active layer to cut holes in the layers beneath it.

Plus, as we've seen, you can temporarily drop out luminance levels and a whole lot more. In this exercise, you'll use these wonderful functions in combination to create a classic installment in the exciting Dinosaur Planet saga.

1. *Open a multilayer composition.* Open *The escape.psd*, located in the *Lesson 05* folder inside *Lesson Files-PsCS5 1on1*. At first blush, the file looks like nothing more than a lackluster snapshot of South Dakota's breathtaking Badlands (see Figure 5-45). But there's much more to it.

2. *Select the Badlands layer in the Layers panel.* Go to the **Layers** panel and make sure the **Badlands** layer is active. Note that there are several other layers and folders of layers (called *layer groups*), most of which are currently hidden. We'll turn on these layers in future steps.

Figure 5-45.

3. *Scoot the Badlands layer downward 200 pixels.* You can do this in a couple of ways:

 • Press Ctrl+Shift+↓ (⌘-Shift-↓) twenty times in a row. Sounds ridiculous, but it's pretty routine.

 • Press Ctrl+T (⌘-T) to enter the free transform mode. Then click the delta symbol (Δ) in the left half of the options bar to turn on relative positioning, as labeled in Figure 5-46. Change the **Y** value to 200 pixels and press the Enter or Return key. Press the Enter or Return key again to accept the transformation.

Relative positioning

X: 0.0 px Y: 200 W: 100.0% H: 100.0% Δ 0.0 ° | H: 0.0 ° V: 0.0 °

Figure 5-46.

We've revealed 200 pixels of sky from the Thin Sky layer behind the Badlands layer. The sky is dramatic, but the transition between the two layers leaves something to be desired, so let's blend them with a layer mask.

4. *Load the Planet Arc mask as a selection.* Go to the **Channels** panel and Ctrl- or ⌘-click the **Planet Arc** channel. Or just press Ctrl+Alt+6 (⌘-Option-6 on the Mac). A curved selection that I've created for you appears along the horizon of our emerging world.

5. *Click the layer mask icon.* Return to the **Layers** panel and click the tiny ▢ icon at the bottom, indicated by the arrow cursor in Figure 5-34. This converts the selection to a layer mask, creating a smoother transition between Earth and sky.

Figure 5-47.

PEARL OF ● WISDOM

The mask appears as a thumbnail in the Layers panel, identical to how it appears in the Channels panel. In fact, for all intents and purposes, you just duplicated the mask from one location to another. Where the mask is white, the layer is opaque; where the mask is black, the layer is transparent.

6. *Grab the brush tool in the toolbox.* The problem with the curved mask is that it scalps away too much of the rocky cliffs in the central and right portions of the image. But because it's a mask, you can paint the cliffs back. Press B to select the brush tool and then press D to ensure that the foreground color is white, the default setting when working in a mask.

7. *Paint inside the mask.* Make sure the blend mode is set to **Normal**. Then select a small, hard brush, about 20 pixels in diameter, and paint along the rim of the mountaintops in the image window. Assuming that the layer mask is active (as it should be), you'll reveal the tops of the ridges.

- If you reveal too much of a ridge, press the X key to switch the foreground color to black and then paint inside the image window to erase pixels.

- If you erase too much, press X again to restore white as the foreground color and then paint.

- You don't have to limit yourself to brushwork. You can select an area with the lasso tool and fill it with white to reveal an area or with black to erase it.

Keep painting until you achieve more or less the effect pictured in Figure 5-48. And don't fret too much if you end up with some stray sky pixels from the Badlands layer. We'll cover them up in a few moments. In other words, be tidy but don't knock yourself out.

If you find yourself adding white or black brushstrokes to your image, you accidentally activated the image instead of the mask. (Inspect the double outline assigned to the Badlands layer. A double outline around the first thumbnail shows that the image is active, which is not what you want. A double outline around the second tells you that the mask is active and all is well.) If you encounter this problem, undo any damage and then click the black-and-white layer mask thumbnail directly to the left of the word **Badlands** in the **Layers** panel. This returns Photoshop's attention to the layer mask, as the double outline illustrates.

Figure 5-48.

Alternatively, you can switch between the image and the layer mask from the keyboard. Press Ctrl+[⎵] (⌘-[⎵]) to activate the layer mask. Press Ctrl+2 (or ⌘-2) to switch back to the image. The double outline in the Layers panel monitors your status.

Figure 5-49.

8. **View the mask independently of the image.** To see the layer mask by itself, press the Alt (or Option) key and click the black-and-white layer mask thumbnail in the Layers panel. You should see a mask like the one pictured in Figure 5-49. Paint or otherwise modify it if you like. To return to the composite image, Alt-click (Option-click) the mask thumbnail again.

To view the mask as a rubylith overlay—thus permitting you to see both mask and image—press the backslash key, ⬚. To hide the image and view just the mask, press the tilde key, ⬚. To display the image, press ⬚ again. To hide the mask, press ⬚. Throughout, the layer mask remains active, even if you can't see it.

9. **Select the Gradient layer.** Still in the **Layers** panel, turn on the 👁 to the left of **Gradient** to display the layer, and then click the layer itself to select it. This previously hidden layer contains a combination of black and brown gradient patterns.

10. **Change the blend mode and opacity.** Choose **Multiply** from the blend mode pop-up menu in the top-left corner of the Layers panel. (You can also use the shortcut Shift+Alt+M or Shift-Option-M, but only *after* you switch from the brush tool to a selection tool.) Photoshop burns in the blacks and browns and drops out the whites, as shown in Figure 5-50 on the facing page. To temper the effect, reduce the **Opacity** value in the Layers panel to **80** percent.

11. **Set the Badlands layer to mask the Gradient layer.** Choose **Layer→Create Clipping Mask**. This *clips* the Gradient layer to the boundaries of the layer below it, Badlands. As a result, the gradient fits entirely inside the horizon mask (see Figure 5-51) that you established in Step 7. In the Layers panel, the Gradient layer appears inset; the Badlands layer appears underlined to show that it's the base of the clipping mask.

You can use two shortcuts when creating a clipping mask. One is Ctrl+Alt+G (or ⌘-Option-G). (Clipping masks used to be called clipping *groups*, hence G.) If that brings up the Google Desktop search feature, try this: Press the Alt (or Option) key and click the horizontal line between the Gradient and Badlands layers in the Layers panel. To release a layer from a clipping mask, press Ctrl+Alt+G (⌘-Option-G) or Alt-click (Option-click) the horizontal line again.

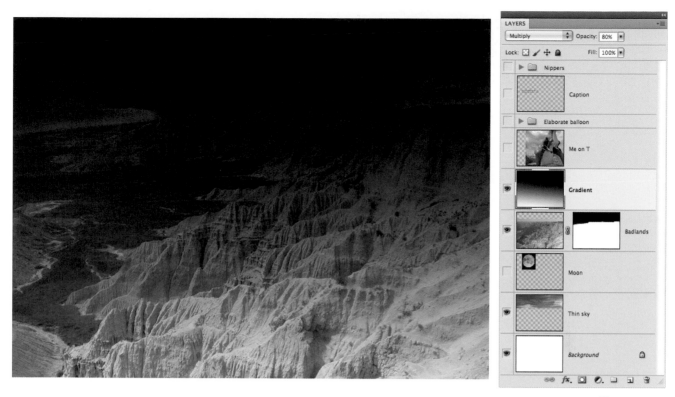

Figure 5-50.

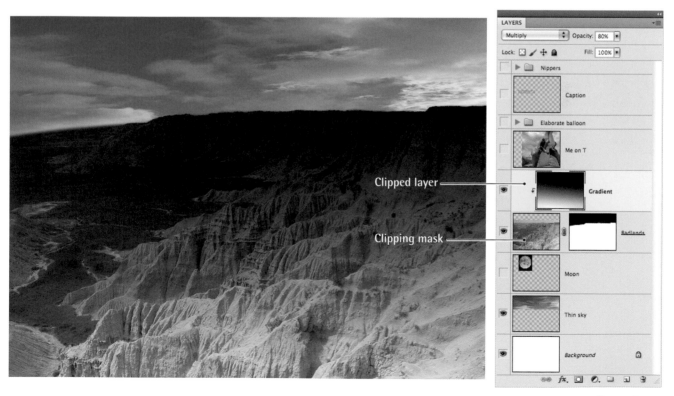

Clipped layer

Clipping mask

Figure 5-51.

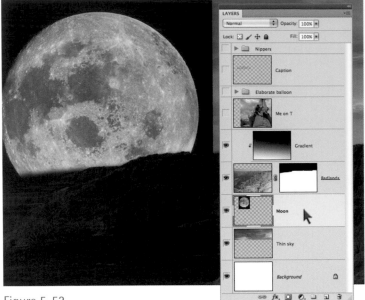

Figure 5-52.

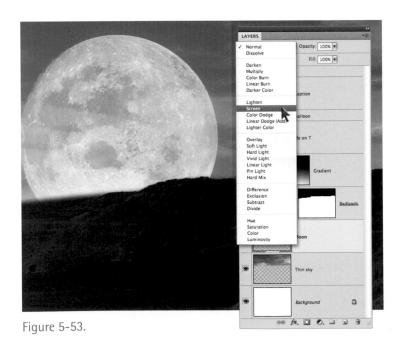

Figure 5-53.

12. *Select and show the Moon layer.* Click the **Moon** layer and turn on its 👁. The moon hovers bright and enormous over the horizon, as pictured in Figure 5-52. How did it get so big? Because it's actually the dread Dinosaur Planet in disguise! (Don't be frightened; this is just an exercise.)

13. *Set the blend mode to Screen.* Assuming a selection tool is active, you can press Shift+Alt+S (or Shift-Option-S). As I mentioned, Screen drops out the blacks and preserves the light colors. In this case, however, it adds brightness all over the place, even in the black areas (see Figure 5-53).

PEARL OF WISDOM

Well, not quite. Admittedly, the area behind the moon is quite dark, but it isn't altogether black. And unless it's absolutely pitch black, Screen makes it brighter. That means you'll have to drop out the dark colors manually using luminance blending.

14. *Double-click the Moon thumbnail in the Layers panel.* Or right-click the **Moon** layer and choose **Blending Options**. Either way, Photoshop greets you with the Blending Options panel of the **Layer Style** dialog box, which contains a vast array of parametric effect options.

15. *Drag the black This Layer slider triangle.* Confirm that the **Preview** check box is turned on. Then turn your attention to the two slider bars near the bottom of the dialog box:

- The first slider bar, This Layer, lets you drop out the darkest or lightest colors in the active layer.

- The second slider, Underlying Layer, causes the darkest or lightest colors from the composite view of all layers below to shine through the active layer. (The option name should really be plural, but I'm nitpicking.)

Drag the black triangle associated with **This Layer** to the right until the space around the moon turns invisible, as shown in Figure 5-54. I find this happens when the first numerical value reads 50, meaning that any color with a luminosity level of 50 or darker is hidden.

16. *Add some fuzziness.* The problem with the current solution is that it results in an abrupt transition between visible and invisible pixels. (If you zoom in on the left side of the moon, you'd see what I mean.) To soften the drop-off, you need to add some fuzziness. Press the Alt key (Option on the Mac) and drag the right side of the black triangle to split the triangle in half. Then drag to the right until the first **This Layer** value reads 50/105 (again, see Figure 5-54).

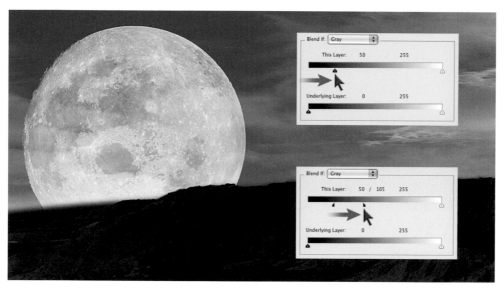

Figure 5-54.

Here's what the 50/105 values mean:

- Any color with a level of 50 or darker is invisible.

- Any color with a level of 105 or lighter is visible.

- The colors with luminosity levels between 105 and 50 taper gradually from visible to invisible, respectively. This is the fuzziness range.

The effect looks slick but not very realistic. The moon appears to be sitting on the sky instead of sunken into it. Part of the problem is that the moon is in front of the clouds. Fortunately, the Underlying Layer slider lets us push the clouds forward.

17. *Drag the white slider triangle.* Drag the white **Underlying Layer** triangle to the left until the second value reads 140, which is when about half the clouds start to obscure the moon. This uncovers any color with a luminosity level of 140 or lighter.

18. *Again, add some fuzziness.* This time, we have some wicked jagged edges. Press Alt (or Option) and drag the left side of the white triangle until the value reads 80/140. The clouds fade in and out of visibility, blending smoothly with the moon, as shown in Figure 5-55.

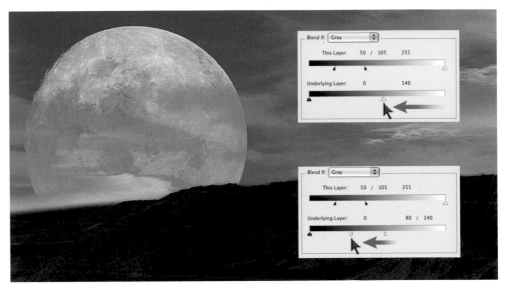

Figure 5-55.

Figure 5-56.

19. *Reduce the opacity to 40 percent.* The **Opacity** value at the top of the **Layer Style** dialog box is identical to the one you see in the Layers panel. Click **OK** to accept your changes. The resulting moon appears in Figure 5-56.

20. *Select and show the Me on T layer in the Layers panel.* This layer sports an off-center picture of me with one of Rapid City's world-famous inaccurately rendered plaster dinosaurs. This one is supposed to be a tyrannosaur! The plaster T. Rex really exists and I am really sitting on it. (I didn't have kids back then, so technically I wasn't setting a bad example.) The only change I made to the image was to add the red mittens. The poor thing looked kind of chilly.

21. *Load the Dino Outline path as a selection.* Go to the **Paths** panel. Press Ctrl (or ⌘) and click the **Dino Outline** path to convert it to the selection outline pictured in Figure 5-57 on the facing page.

22. **Click the layer mask icon.** Press F7 to switch back to the **Layers** panel. Then click the ◙ in the row of icons along the bottom of the panel. This converts the selection outline to a layer mask, eliminating my previous background and placing me and the dinosaur I rode in on squarely in the action. I'm not sure how the perspective works out, but otherwise the image looks terrific.

23. **Show the Nippers folder in the Layers panel.** Click the empty square in front of the **Nippers** folder to display a group of layers that includes two plastic toy dinosaurs enlarged to dangerous proportions and nipping at my heels, as in Figure 5-58.

Figure 5-57.

The only thing missing in this action-packed composition is dialog. After all, you'd think a guy sitting on one dinosaur and running away from others would have something to say. If you'd prefer that I remain mute, you have my blessing to move on to the next exercise, "Working with Layer Comps," which begins on page 169. If you want to stay tuned for the final dramatic steps, not to mention learn a thing or two about knockouts, keep reading.

Figure 5-58.

24. *Show the Elaborate Balloon folder and its caption.* Click in front the **Elaborate Balloon** folder to turn on the 👁, and then click the ▶ to reveal the layer group contents. The Elaborate Balloon group contains the talk balloon as well as several layers of patriotic folderol required to frame the commanding urgency of the caption. Turn on the **Caption** layer to display more of my hand-drawn text (which appeals to the dinosaur I'm riding to get a move on). Everything we're about to do works just as well with the sort of live typeset text that we discuss in Lesson 7; the hand-drawn text just happens to better suit my graphic novel composition.

As shown in Figure 5-59, the text is currently green. But that's just a placeholder color. I ultimately want the letters to cut holes through all the layers in the Elaborate Balloon group and reveal the dark shadows of the Badlands background. I can approach this vexing conundrum in two ways:

- Layer masks can be applied to individual layers or entire groups of layers. So I could create a mask for the Elaborate Balloon group in which the text was black (invisible) and the area around the text white (visible). But it would take extra work and it might limit my options in the future.

- I could establish the Caption layer as a *knockout*, thereby cutting holes in the layers behind it. Not much work + very flexible = preferred solution.

Figure 5-59.

When creating a knockout, the big question is: How deep does it drill? Knockouts are either deep, going all the way to the Background layer (or transparency if there is no Background), or shallow, ending at the base layer of a group. We want to burrow through just the Elaborate Balloon layers, so we need a group with a shallow knockout.

25. ***Select both the Caption layer and the Elaborate Balloon group.*** Click the **Caption** layer to select it. Then Shift-click the **Elaborate Balloon** group to add it to the selection.

26. ***Place the selected layers inside a new layer group.*** Click the ◄≡ at the top of the Layers panel and choose **New Group from Layers**, as in Figure 5-60. Or better yet, press the simple and memorable shortcut, Ctrl+G (⌘-G). Name the new group "Knockout Text" and click the **OK** button.

27. ***Twirl open the new layer group.*** Click the ▶ arrow in front of the **Knockout Text** folder to reveal the new group's contents.

28. ***Double-click the thumbnail for the Caption layer.*** Photoshop once again displays the always fascinating Blending Options panel of the **Layer Style** dialog box.

29. ***Choose Shallow from the Knockout pop-up menu.*** The **Knockout** option appears circled in orange in Figure 5-61. Contrary to what you might reasonably expect, this option has no immediate effect. Instead, it merely establishes the layer as a potential knockout. To put the knockout in play, see the next step.

30. ***Reduce the fill opacity to 0 percent.*** Identical to the Fill value in the Layers panel, Fill Opacity changes the translucency of pixels in a layer independently of drop shadows and other styles. But it also has a symbiotic relationship with the Knockout option. Drag the **Fill Opacity** slider triangle and watch the text fade into the background art. At 0 percent, all you see is background. To complete the effect, close the dialog box by clicking the **OK** button.

31. ***Move the Me on T layer into the group.*** If you look closely at the text, you'll see that the word *US!* is

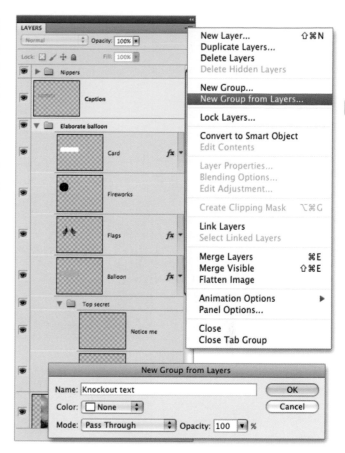

Figure 5-60.

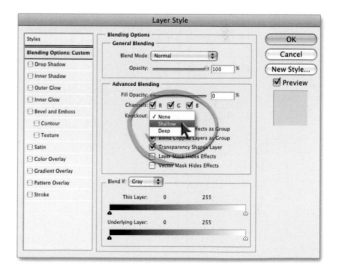

Figure 5-61.

bisected by the green back of the plaster dinosaur. To make the text bore through the dinosaur as well, move the dinosaur into the group. First, to make things easier, in the **Layers** panel click the ▼ next to the **Elaborate Balloon** layer group to twirl it closed. Then, drag the **Me on T** layer onto the Knockout Text folder icon (see Figure 5-62). When you release the mouse button, Photoshop places Me on T at the back of the group and knocks the letterforms out of the dino's hip, as witnessed by the circled areas below.

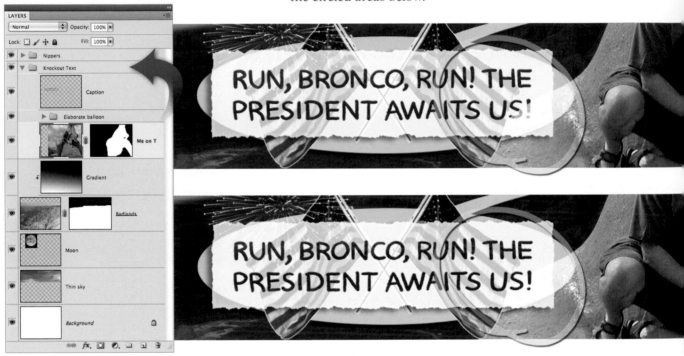

Figure 5-62.

32. *Save your composition.* Choose **File**→**Save** to update the file on your hard disk. After all, why bother with File→Save As when everything is either a mask or a parametric effect?

The beauty of this exercise is that every one of the changes you've made is reversible. You can delete the layer masks that you added in Steps 5 and 22, unravel the clipping mask from Step 11, modify the blending options applied in Steps 15 through 19, and bust up the knockout from Step 29. And the reason the composition is so exceedingly, wonderfully, downright obscenely flexible is because you never changed a single pixel on any of the core layers. If only everything in Photoshop were this flexible—well, the world would be a happier place, wouldn't it?

Working with Layer Comps

As you increase the complexity of your layered documents, you'll find yourself experimenting with different compositional arrangements. What if you moved this layer over here? What if that layer were hidden? What if you gave the third layer a drop shadow? Sometimes the answer is obvious the moment you give it a try. Other times, the answer eludes you until several steps or even sessions later.

Photoshop's Layer Comps panel lets you save the current state of a document before you venture down an unclear road. As long as you don't delete or merge any of the layers in the saved *layer comp*, you can restore the saved state in its entirety later. Layer comp states are saved as part of the PSD file on disk, just like layers, channels, paths, and other specialized data.

To learn which layer attributes the Layer Comps panel can track, see the upcoming sidebar "What Layer Comps Can and Can't Save" (page 171). To learn how to use layer comps, immerse yourself in the following steps.

1. *Open a layered composition.* Open the next episode of our gripping drama, *The capture. psd*, included in the *Lesson 05* folder inside *Lesson Files-PsCS5 1on1*. (If you get a text warning, click the Update button.) As in the preceding exercise, we see the Badlands photo and nothing more. But this time, you won't have to build the layers manually. I performed nearly all the work ahead of time and saved my progress using layer comps.

2. *Open the Layer Comps panel.* Choose **Window→Layer Comps** to display the **Layer Comps** panel. By default, it appears at the bottom of the column of icons to the left of the main panels. You can leave it there if you like, with the panel hanging open like a flyout menu (see Figure 5-63), but in my humble opinion, layer comps are too important to be given such short shrift. Which is why I recommend that you drag the 🖼 icon or **Layer Comps** tab into the main docking pane on the right side of the screen. Figure 5-63 shows me dragging Layer Comps into the panel group that includes Layers, Channels, and Paths, but you can put the panel wherever you want.

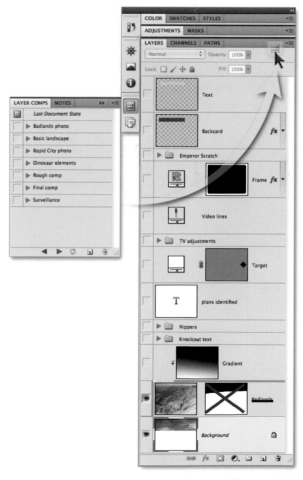

Figure 5-63.

3. *Click in front of a comp name to switch to it.* Clicking in the column on the left side of the Layer Comps panel displays a tiny manuscript icon and shows the layers and effects saved with the corresponding comp. In Figure 5-64, I clicked in front of the third comp, **Rapid City Photo**. Note that the photo is centered and fully visible. Click in front of **Dinosaur Elements** to see the photo offset and masked.

Figure 5-64.

4. *Examine a layer comp's settings.* Any comp that has a triangle next to it includes a description. To view the description, click the ▶ to twirl open the comp or double-click to the right of the comp name (not directly on the name) to display the **Layer Comp Options** dialog box shown in Figure 5-65. The dialog box lets you view the complete description, as well as which layer attributes are saved with the comp. To learn more about the check boxes, read the sidebar "What Layer Comps Can and Can't Save," on the facing page. When you're through poking around—we're not doing anything except looking around—press the Esc key to exit the dialog box.

Figure 5-65.

As shown in the dialog box on the right, a layer comp can save any of three attributes, which include the following:

- **Visibility:** This includes which layers and layer masks are turned on and off. (You turn a mask on and off by Shift-clicking its thumbnail in the Layers panel.)

- **Position:** Remarkably, a layer comp can track the horizontal and vertical position of a layered object. This means you can move layers around between saved comps.

- **Appearance (Layer Style):** Photoshop saves the Opacity setting and blend mode assigned to each layer, as well as knockouts, luminance blending, drop shadows, and all other parametric effects. This one check box is worth the price of admission.

That's all very well and good, but this list of three attributes represents a fairly small collection, especially when you consider that the list hasn't changed since the feature was introduced in Photoshop CS and the Layer Comps panel *can't* track plenty of stuff, including:

- **Arrangement:** If you move a layer up or down the stack, it changes inside all saved comps. This goes for moving layers into or out of sets as well. Frankly, I regard these oversights as enormous gaffs, but that's the way it is.

- **Clipping masks:** Mask a layer with the layer below it, and it will be masked inside all saved comps. Again, a big oversight; again, nothing we can do.

- **Scale and orientation:** Excluding smart objects, transformations are pixel-level modifications. So if you scale or rotate a layer, it changes inside all comps. Layer comps also ignore transformations applied to smart objects.

- **Pixel-level changes:** The same goes for cropping, image size, brushstrokes, color adjustments, and filters. Any of these changes affects all comps.

- **Adjustment layer settings:** Adjustment layers are specialized layers that permit you to modify the colors of underlying layers without permanently altering so much as a single pixel. Rather bizarrely, layer comps can track whether an adjustment layer is on or off and what kind of blend mode is assigned to it, but they can't track the layer's settings.

- **Smart objects and smart filters:** Another specialty layer type, smart objects receive even worse treatment. Not only are layer comps blind to a smart object's transformation and smart filter settings, they can't even see the 👁s. In other words, layer comps can't track which smart filters are turned on and which are turned off, making them useless for comparing differently filtered effects.

- **Additions:** If you add a layer, all existing layer comps treat it as off unless otherwise instructed.

- **Deletions:** If you delete a layer, merge a few layers, or delete a set, the Layer Comps panel fills with yellow ⚠ icons. In all likelihood, the comps will work as well as can be expected. But you'll have to update the comps (see Step 8 on page 174) to make the warning icons go away.

5. **Click the arrow buttons to cycle from one comp to the next.** The small ◀ and ▶ buttons at the bottom of the Layer Comps panel let you switch to the previous and next saved state, respectively. I clicked the ▶ button a few times to advance to the final comp, **Surveillance**. Shown in Figure 5-66, this comp features a few layers that we haven't seen before, including the text layer that inspired the alert message in Step 1 (page 169). If the comp is to be believed, it would seem my movements are being monitored.

Figure 5-66.

6. **Go to the Layers panel.** If you're ever curious to see how a comp was created, just refer to the **Layers** panel. There you'll find several layers and sets not included in the previous exercise, some of which are turned on to create the green-TV-artifact effect and some of which are not. Feel free to explore the layers as you see fit. With layers, you need fear nothing. Anything you turn on now you can turn off later.

7. **Delete the Plans Identified layer.** Click the layer called **Plans Identified**. This text layer is editable (not hand-drawn or otherwise rendered out to pixels) and identifies the target around the rolled-up paper so deftly hidden in Bronco the dinosaur's mitten, as seen in Figure 5-67 below.

Figure 5-67.

The idea behind the message is fine, but I ultimately decided that it ruins the subtlety of the piece. (Yes, the piece has subtlety—loads of it.) To delete the layer, click the trash can icon at the bottom of the Layers panel. Photoshop will politely ask if you're sure you want to delete the layer, as in Figure 5-68. Click **Yes** to confirm the deletion.

To bypass the confirmation and delete the layer without any grousing from Photoshop, you can Alt-click (or Option-click) the trash can. But that's the old-school sucker's route. Here's the better way.

Figure 5-68.

With the layer selected, just press the Backspace or Delete key. The layer goes away, with no warning whatsoever. Since Photoshop CS4, this technique works regardless of which tool is active.

Deleting the Plans Identified layer upsets two layer comps, Surveillance and Rough Comp, which are now marked with yellow ⚠ warning icons in the Layer Comps panel. Although only one of those particular comps actually displayed the layer, both comps were created or updated since the Plans Identified layer was introduced. Therefore, they both knew of the layer's existence; the other comps did not. To get rid of the ⚠ icons, you must update the two Plans Identified–aware comps as explained next.

Figure 5-69.

8. *Update the affected layer comps.* You update the two comps in slightly different ways:

 - Because the Surveillance comp represents the current state, you don't need to reload it. In the **Layer Comps** panel, just click the word **Surveillance** to make sure it's active. Then click the ↻ update icon at the bottom of the panel, identified by the cursor in Figure 5-69.

 - To update **Rough Comp**, first click to the left of it to restore the comp's layer settings, so you see the ▣ icon. Loading the comp before updating is very important; otherwise, you'll wreck it by overwriting it with the layer settings from the Surveillance comp. Then click the ↻ icon as before.

9. *Restore the Surveillance comp.* Now we'll create our own comp by basing it on the last comp, **Surveillance**. Click in front of the comp name to restore its layer settings.

10. *Turn on the three hidden layer items.* Go to the **Layers** panel and turn on the hidden group **Emperor Scratch** as well as the top two layers, **Text** and **Backcard**. (The quickest way to display all three 👁s is to click in the left column in front of Emperor Scratch and drag up.) The result is a malevolent duckbill skeleton—augmented with a spiffy row of suspiciously unduckbillish carnivore teeth—along with a fiendish new caption, all of which appear in Figure 5-70 on the facing page. Sounds like the skeleton is talking about me, but he's really after Bronco. Bad blood, you know. They're stepbrothers or something, I forget.

Figure 5-70.

11. **Create a new layer comp.** Click the ⬚ icon at the bottom of the **Layer Comps** panel to display the **New Layer Comp** dialog box. Name the comp "The Menacing Observer" and turn on all three check boxes. If you want to annotate the comp, enter a comment like the one shown in Figure 5-71. Click the **OK** button to add the new state to the Layer Comps panel.

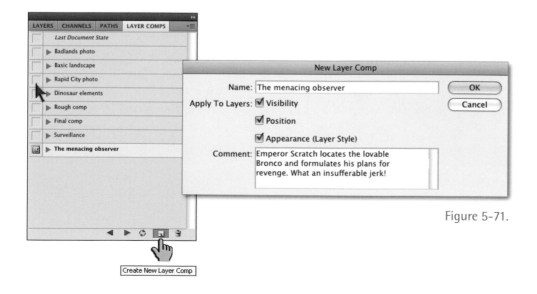

Figure 5-71.

12. **Cycle through the comps as desired.** In Figure 5-72, we see details from 3 of the 8 comps. Given that these are views of a single file, and that every one of them relies on the very same collection of 27 layers and 5 groups, it's amazing just how unique each comp is.

13. **Save your changes.** Because we deleted a layer (Step 7, page 173), I recommend that you choose **File→Save As**. Give the image a new name but keep it in the Photoshop (PSD) format. Photoshop saves all layers and comps with the file. The comp that was active when you saved the file will be in effect the next time you open it.

The results of your toils are eight independent pieces of artwork saved inside one layered composition. This file consumes much less room on disk than it would if each comp was saved as a separate PSD file. And as an added convenience, you can edit the various comps together inside a single file.

And thus ends our hands-on tour of the amazing world of layers. You'll see in several of the following lessons that the power of layers raises its head in much of what you'll do throughout this book.

Figure 5-72.

WHAT DID YOU LEARN?

Match the key concept in the numbered list below with the letter of the phrase that best describes it. Answers appear upside-down at the bottom of the page.

Key Concepts

1. Layered composition
2. Stacking order
3. Merge down
4. Big layer
5. Layer mask
6. Layer group
7. Layer effects
8. Clipping mask
9. Stop
10. Luminance blending
11. Knockout
12. Layer comp

Descriptions

A. The name given to a pair of slider bars in the Layer Style dialog box that let you hide or reveal colors based on their luminosity levels.

B. The state of a layered composition at a certain point in time, replete with visibility, vertical and horizontal positioning, blending options, and layer styles.

C. Created by pressing Ctrl+G (⌘-G on the Mac), this collection of layers appears as a folder icon in the Layers panel.

D. The arrangement of layers in a composition, from front to back, which you can adjust by pressing Ctrl or ⌘ with the bracket keys, ⬚ and ⬚.

E. An image that is made up of composite pieces that can be manipulated independently.

F. An option that uses the contents of the active layer to cut holes in the layers beneath it.

G. When working with this function, painting with black temporarily erases the pixels on a layer; painting with white makes the pixels visible again.

H. A means for cropping the contents of a group of layers to the boundaries of a layer beneath them.

I. Choose this command to combine the contents of the active layer with the layer below it.

J. Effects like drop shadows and strokes that can be applied to specific parts of an image only.

K. This phenomenon refers to the existence of extra information on layers that extends beyond the visible part of the document.

L. Indicators along a gradient preview that designate the colors at either end.

Answers

1E, 2D, 3I, 4K, 5G, 6C, 7J, 8H, 9L, 10A, 11F, 12A

ADJUSTING COLOR AND LUMINANCE

DEEP INSIDE the most primitive recesses of our minds—where thoughts such as "must eat to live" reside—we possess an implicit understanding of *luminosity*. Sunlight illuminates all things on this planet. And those things reflect highlights and cast shadows. These highlights and shadows permit our eyes to distinguish form, texture, and detail. We need variations in luminosity to see.

By comparison, color is a subjective abstraction. Can you elegantly describe *orange* or *purple*, words that you've bandied about since you were a tot? And who's to say what you call *orange* I might not call *scarlet*, *amber*, or even *red*? In day-to-day life, our tenuous understanding of color is generally sufficient. After all, it seems like color is mostly window dressing. We don't use it to identify; we use it to clarify.

However, as illustrated in Figure 6-1, you recognize a strawberry by its luminosity; you know whether it's ripe by its color. If Figure 6-2 is any indication, without variations in luminosity, you'd have a hard time identifying anything in the first place. But knowing which fruit is ripe, rotten, or possibly poisonous probably requires color distinction. Fortunately, Photoshop has excellent tools for controlling both luminosity and color in your images, as we'll see in this lesson.

A strawberry is a strawberry

Red makes it ripe

Figure 6-1.

By itself, color conveys little more than a vague imprint of an object, yet one that imparts critical information

Figure 6-2.

ABOUT THIS LESSON

Project Files

Before beginning the exercises, make sure you've downloaded the lesson files from *www.oreilly.com/go/Deke-PhotoshopCS5*, as directed in Step 2 on page xvi of the Preface. This means you should have a folder called *Lesson Files-PsCS5 1on1* on your desktop (or whatever location you chose). We'll be working with the files inside the *Lesson 06* subfolder.

This lesson examines the myriad ways Photoshop lets you control, adjust, and manipulate color and luminosity in your images. You will learn how to:

Video Lesson 6: Color Adjustments

Photoshop Adjustments, designed to fix typical color and luminance issues in your images, are available from Image→Adjustments or the Adjustments panel. In this video lesson, I'll give you a close-up look at applying a typical color adjustment using the Brightness/Contrast feature and show how the three automatic adjustment tools, which are designed to quickly fix standard color problems, work in Photoshop.

To see Photoshop's adjustments in action, visit *www.oreilly.com/go/deke-PhotoshopCS5.* Click the **Watch** button to view the lesson online or click the **Download** button to save it to your computer. During the video, you'll learn these shortcuts:

Command or operation	Windows shortcut	Macintosh shortcut
Open the Adjustments panel	F10*	F10
Select the first number field	Shift+Enter	Shift-Return
Move to the next number field	Tab	Tab
Nudge the numerical value (10x)	↑ or ↓ (Shift+↑ or ↓)	↑ or ↓ (Shift+↑ or ↓)
Open the Histogram panel	Alt-F8*	Option-F8*
	Alt+3, Alt+4, Alt+5	Option-3, Option-4, Option-5

* Works only if you loaded the dekeKeys keyboard shortcuts (as directed in Steps 7 through 9, beginning on page xix of the Preface).

What Are Hue and Saturation?

Color is too complex to define with a single set of names or numerical values. After all, if I describe a color as orange, you don't know if it's yellowish or reddish, vivid or drab. So Photoshop subdivides color into two properties, hue and saturation:

- Sometimes called the tint, the *hue* is the core color—red, yellow, green, and so on. When you see a rainbow, you're looking at pure, unmitigated hue.

- Known variously as chroma and purity, *saturation* measures the intensity of a color. By way of example, compare Figure 6-3, which shows a sampling of hues at their highest possible saturation values, to Figure 6-4, which shows the same hues at reduced saturations.

The stark contrast between Figures 6-3 and 6-4 may lead you to conclude that garish saturation values are better. But while this may be true for fruit and candy, most of the real world is painted in more muted hues, including many of the colors we know by name. Pink is a light, low-saturation variation of red; brown encompasses a range of dark, low-saturation reds and oranges. Figure 6-5 shows a collection of browns at normal and elevated saturation levels. Which would you prefer to eat: The yummy low-saturation morsel on the left or the vivid science experiment on the right?

Photoshop provides several commands that give you selective control over all aspects of color, including hue, saturation, and more specialized attributes. Armed with these commands, you have all the tools you need to get the color balance of your images just right. The first three exercises of this lesson will be primarily concerned with color adjustment.

Figure 6-3.

Figure 6-4.

Figure 6-5.

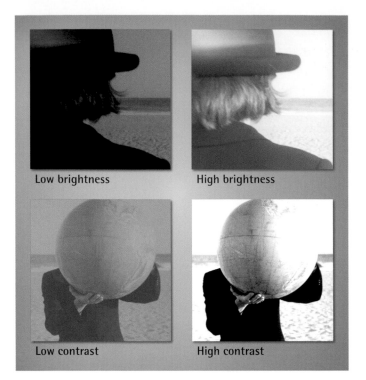

Low brightness · High brightness

Low contrast · High contrast

Figure 6-6.

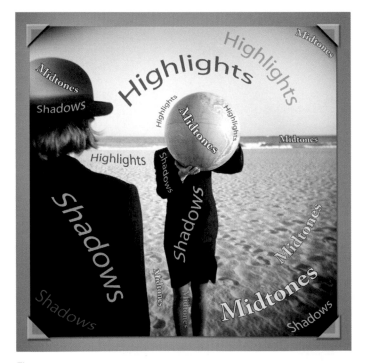

Figure 6-7.

Brightness, Contrast, and Levels

When it comes to luminosity—that is, light colors compared with dark ones—you most often hear this expressed as "brightness and contrast," where *brightness* is the lightness or darkness of a group of colors and *contrast* is the degree of difference between light and dark colors, as illustrated in Figure 6-6. These are the exact qualities that allow us to distinguish a strawberry from, say, its leaves or a bowl of inedible unstrawberry-shaped rocks.

Photoshop pays lip service to this colloquialism with its Brightness/Contrast command. Although exceedingly easy to use—and vastly improved in recent years—it lacks the control of Photoshop's more capable functions such as Levels, Curves, and Shadows/Highlights, some of which we've used cursorily in previous lessons. These tools analyze an image according to three basic attributes—*highlights*, *shadows*, and *midtones*, or what the uninitiated might call light colors, dark colors, and everything in between. But we know better (having read the last section): We're talking about brightness values rather than hue or saturation. Figure 6-7 provides some examples.

Such distinctions not only let you adjust brightness and contrast but also provide you with *selective control* over an image. You can make the shadows darker, make the midtones lighter, and leave the highlights unchanged. And you can make these changes without upsetting the color balance one iota; or you can adjust luminosity and color values together. Be it red or blue, night or day, the sky's the limit. The later exercises in this lesson will help you learn how to use these tonal tools to their best effect.

Fixing a Color Cast

One of the most common color problems associated with digital images and other varieties of photographs is *color cast*, a malady in which one color pervades an image to an unrealistic or undesirable degree. For example, an old photograph that has yellowed over the years has a yellow cast. A snapshot captured outdoors using the wrong light setting may suffer a blue czast.

Naturally, Photoshop supplies a solution—and a simple one at that. The Color Balance adjustment is designed to neutralize a prevailing color cast and restore the natural hue and saturation balance to an image. Color Balance is available from either the Image menu (by choosing Adjustments→Color Balance) or by creating a nondestructive adjustment layer directly from the Adjustments panel, as we'll do in the following exercise. Either way, Photoshop provides access to three sliders that give you the ability to balance out colors by considering them in juxtaposition to their color wheel opposites.

Figure 6-8.

1. ***Open an image.*** Open the file shown in Figure 6-8 named *Tough boys.jpg*, included in the *Lesson 06* folder inside *Lesson Files-PsCS5 1on1*. Captured in the cabin of a cruise ship under decidedly annoying lighting conditions, it nevertheless depicts my sons during a delightfully masculine display of Arnold Schwartzenegger– inspired strength and Gary Cooper–esque silent confrontation (respectively). Charming as the subjects are, this image suffers from an unfortunate too warm color skew that we'll fix in the course of this exercise.

2. ***Open the Adjustments panel.*** If it's not already open, choose **Window→Adjustments** to open the panel. You see a variety of adjustments to choose from, all of which are applied to an entire image all at once. As we saw in the preceding lesson, the adjustments are applied on an independent layer that can be turned off, moved within the layer stack, or deleted altogether, thus earning adjustments the status of "nondestructive modification."

Figure 6-9.

3. **Create a Color Balance adjustment layer.** In the **Adjustments** panel, Alt-click (Option-click) the third icon from the left in the second row, as indicated in Figure 6-9, which fittingly uses a scale to represent color balance. In the **New Layer** dialog box, type "Cast correction" and click **OK**.

PEARL OF WISDOM

If you've skipped the Preface, you may find that Photoshop has automatically created an accompanying layer mask to go with your adjustment layer by default. Turning off this somewhat annoying behavior is what I like to call a true Photoshop Secret Handshake. Return to the general Adjustments panel by clicking the ◁ arrow at the bottom of the panel. Next, click ▾≡ to open the panel flyout menu and click Add Mask by Default to turn off its check mark. Then return to your adjustment layer by choosing it from the Layers panel. Drag to the trash the default mask in the Color Cast layer that inspired you to do this ritual. (Don't click the scale icon again, or you'll create yet another new layer.)

4. **Make a preliminary adjustment to the Red values.** You'll notice that the Adjustments panel now displays three color sliders that pair colors with their opposites on the color wheel. To remove a preponderance of one color from your image, you move the respective slider in the direction of its complement on the color wheel. So, to remove what is clearly a reddish cast in the sample image, start by moving the **Cyan-Red** slider in the **Adjustments** panel away from Red and toward Cyan until the numerical value to the left of the slider reads –40. (To learn more about colors and their complements on the color wheel, see the sidebar on the facing page, "The Visible-Color Spectrum Wheel.") As you can see in Figure 6-10, we're getting closer to a realistic neutral, but the image is perhaps a bit green.

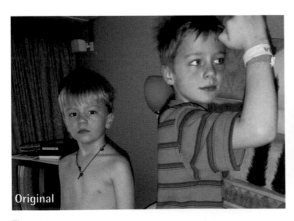
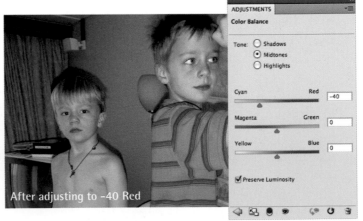

Figure 6-10.

To feel comfortable working with the Color Balance controls inside the Adjustment panel (or dialog box) and later in the Hue/Saturation versions of the same, you have to understand the composition of a little thing called the *visible-color spectrum wheel*. Pictured below, the wheel contains a continuous sequence of hues in the visible spectrum, the saturation of which ranges from vivid along the perimeter to drab gray at the center.

The colors along the outside of the circle match those that appear in a rainbow. But as the labels in the circle imply, the colors don't really fit the childhood mnemonic Roy G. Biv, short for red, orange, yellow, green, blue, indigo, and violet. An absolutely equal division of colors in the rainbow tosses out orange, indigo, and violet and recruits cyan and magenta, producing Ry G. Cbm (with the last name, I suppose, pronounced "see-bim"). Printed in large colorful type, these six even divisions just so happen to correspond to the three primary colors of light—red, green, and blue—alternating with the three primary pigments of print—cyan, magenta, and yellow. (The missing print color, black, is not a primary. Black ink fills in shadows, as we will discuss in Lesson 12.)

In theory, cyan ink absorbs red light and reflects the remaining primaries, which is why cyan appears a bluish green. This is also why Red and Cyan are treated as opposites in the Color Balance dialog box or Adjustments panel. Similarly, magenta ink absorbs its opposite, green; yellow ink absorbs blue.

Of course, Ry G. Cbm is just a small part of the story. The color spectrum is continuous, with countless nameable (and unnameable) colors in between. I've taken the liberty of naming secondary and tertiary colors in the wheel. Because no industry standards exist for these colors, I took my names from other sources, including art supply houses and consumer paint vendors. I offer them merely for reference, so you have a name to go with the color.

The practical benefit is that you can use this wheel to better predict a required Color Balance adjustment. For example, the color orange is located midway between red and yellow. Therefore, if you recognize that an image

has an orange cast, you can remove it by moving away from Red (toward Cyan) and then away from Yellow (toward blue).

Photoshop's other color-wheel-savvy command, Hue/Saturation (which we'll see in the next exercise), tracks colors numerically. A circle measures 360 degrees, so the Hue value places each of the six primary colors 60 degrees from its neighbors. Secondary colors appear at every other multiple of 30 degrees, with tertiary colors at odd multiples of 15 degrees.

To track the difference a Hue adjustment will make, just follow along the wheel. Positive adjustments run counterclockwise; negative adjustments run clockwise. So if you enter a Hue value of 60 degrees, yellow will become green, ultramarine will become purple, indigo will become lavender, and so on. It may take a little time to make complete sense of the wheel, but once it sinks in, you'll want to rip it out of the book and paste it to your wall. Trust me, it's that useful.

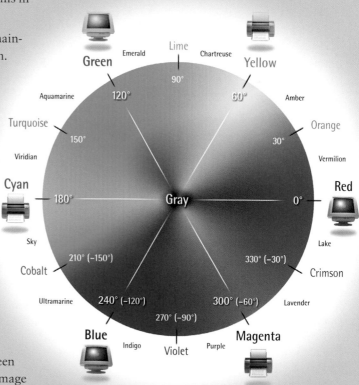

5. **Decrease the Green values.** The image appears decidedly green, so click in the numerical value field next to the **Magenta-Green** slider and enter a value of −10. This moves the Magenta-Green slider to the right, away from green. The results are depicted in Figure 6-11. The image has a lot of green objects, so it's hard to tell exactly where to stop in your attempt to remove the green-based cast. But since the overall goal is to cool down the image, we need to be judicious about contributing too much magenta, so best to be conservative here.

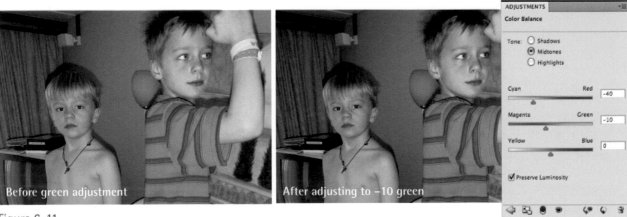

Figure 6-11.

6. **Increase the Blue values.** The image is still too warm for my taste, so cool it way down by moving the third slider all the way to +40, thus increasing the blue value. You'll notice in Figure 6-12 that the wall behind the boys and the sofa color are at last approaching a neutral gray.

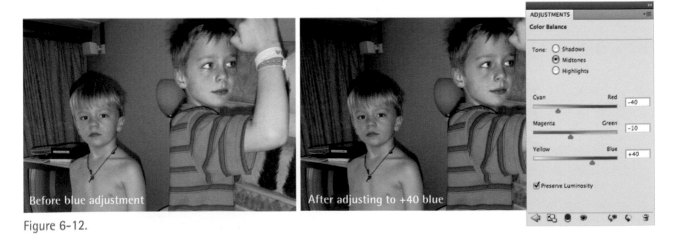

Figure 6-12.

7. *Readjust the Red values.* By now it should be obvious that using the Color Balance adjustment is a trial-and-error process. Case in point: Now that I've made the green and blue adjustments, I may not have gone far enough with my initial red adjustment because there still seems to be a discernible reddish cast to my boys' flesh tones. Click in the numerical field to the right of the **Cyan-Red** slider and press Shift+↓ to reduce it another ten points to –50. (Pressing the ↓ key by itself reduces the value in 1-point increments; adding the Shift key moves it in 10-point increments.) You can see the results in Figure 6-13. At this point, the skin tones are looking pretty darn good.

8. *Switch to the Highlights.* We've been working exclusively with the midtone areas of the image, which is probably the best place to do the heavy lifting for color-cast removal. But you also have options available to tweak colors within the highlights (the lightest values of an image) and the shadows (the darkest values of an image).

The Adjustments panel is set to Midtones by default because typically you want to be judicious here. You don't want to bring out color in either the highlights or the shadows, and it's easy to go too far. Notice that the whites of the eyes and the dark shadows in the boys' hair are nicely neutral at this point. But my older son's elbow, for instance, has a slight pinkish cast to the highlights. At the top of the Adjustments panel, click to select **Highlights** and move the **Cyan-Red** slider to –10, as I did in Figure 6-14.

9. *Adjust the Shadows slightly.* The shadows in this image are a bit dark, and you can see a slightly blue cast in the shadowy area directly behind my younger son. So choose **Shadows** at the top of the panel, and then move the **Yellow-Blue** slider to –10. This has the doubly positive effect of both brightening the image and removing that bluish cast behind Sammy.

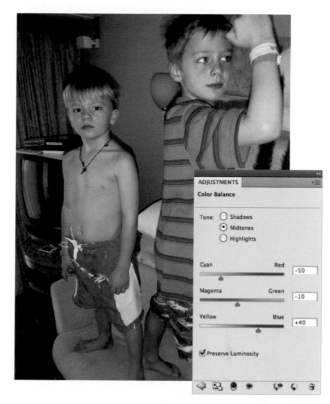

Figure 6-13.

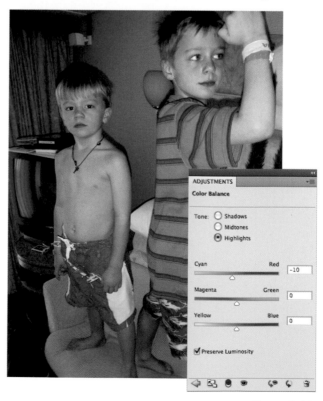

Figure 6-14.

The final results can be seen in Figure 6-15. On the left is the image before we made any adjustments to correct for the orangish color cast, and on the right is the final result of having applied a Color Balance adjustment layer. You can study your own before-and-after results by clicking the 👁 to the left of the **Cast Correction** layer to turn on and off visibility for that adjustment.

If you like, you can choose **File→Save As**, give the file a suitable name, and then click **Save** to keep this file for reference.

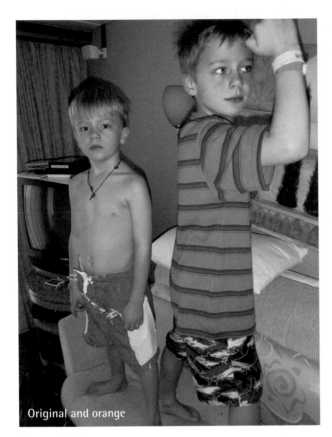

Original and orange

After and adjusted

Figure 6-15.

Tint and Color

Like the Color Balance adjustment command, the Hue/Saturation command lets you specify color values independently from other color designations, while taking luminosity into account. But where Color Balance permits you to limit your adjustments within the context of three color pairings, the Hue/Saturation command lets you modify specific hues. This means you can adjust the hue, saturation, and luminosity of an entire photograph or constrain your changes to, say, just the blue areas.

As with the Color Balance command, Hue/Saturation can be applied from the Image Adjustment menu or in an adjustment layer. To shake things up, we'll use the menu version in the following exercise.

1. **Open an image.** Open the file titled *The treehouse.tif* in the *Lesson 06* folder inside *Lesson Files-PsCS5 1on1*. Pictured in Figure 6-16, I captured this image of a neighbor's thrillingly dangerous looking treehouse while tramping with my boys through a dry streambed near our home. I was nearly out of light, which is partly why the photograph possesses little in the way of apparent color. Luckily, I was armed with a reasonably good camera—a Nikon D80—so although the color is in short supply, it *is* there, just waiting for us to draw it out.

2. **Choose the Hue/Saturation command.** Choose **Image→Adjustments→Hue/Saturation** or press the keyboard shortcut Ctrl+U (⌘-U) to display the **Hue/Saturation** dialog box, shown in Figure 6-17.

3. **Raise the Saturation value.** Press the Tab key two times to advance to the **Saturation** value. Then increase the value to +90 percent. This radical adjustment increases the intensity of colors throughout the photograph and turns what had formerly been a nearly grayscale image into a vibrant and colorful one.

4. **Lower the Hue value.** The sky looks pretty good, but the wood of the trees and treehouse is too red. My sense is that they would look better if they were a bit more yellow. According to the color wheel (see "The Visible-Color Spectrum Wheel," page 185), shifting the hues from red to yellow is a counterclockwise rotation, which requires a positive adjustment. Press Shift+Tab to select the **Hue** value. Then press Shift+↑ to increase the value to +10 degrees, which removes the red tint, as in Figure 6-18 on the next page.

Figure 6-16.

Figure 6-17.

In general, the dramatic boost to the Saturation value holds up nicely. The wood looks terrific, but the sky is too vivid and too violet. In a lesser piece of software, we'd have to settle on compromised Hue and Saturation values that split the difference between wood and sky. Fortunately, Photoshop lets us address the sky independently of the wood.

Adjust targeted
color range

Figure 6-18.

5. *Isolate the blues.* The second pop-up menu in the Hue/Saturation dialog box (the one labeled *Adjust targeted color range* in the figure) is set to Master. This tells Photoshop to transform all colors in an image by equal amounts. To limit your next round of changes to just the sky, set the option to **Blues** instead. Notice that the Hue and Saturation values reset to 0, informing you that you're about to add another layer of color modifications.

Just because you select Blues doesn't mean you've isolated the *right* blues. The blues of this particular photo might match Photoshop's definition of blue, but just as likely they lean toward ultramarine or indigo (again, see page 185). Although the pop-up menu doesn't offer these colors, it lets you identify them by moving your cursor into the image window and clicking a color. The following step explains how.

6. **Confirm the colors in the image window.** The numerical values at the bottom of the dialog box read 195°/225° and 255°\285°. According to the color wheel chart, this tells you Photoshop is prepared to modify the colors between ultramarine (225°) and indigo (255°), centered at blue. The change will taper off as the colors decline to sky (195°) and purple (285°).

Move your cursor outside the Hue/Saturation dialog box so that it becomes an eyedropper. Click below the treehouse, at the location indicated by the eyedropper cursor in Figure 6-19. The numbers at the bottom of the dialog box should shift to something in the neighborhood of 175°/205° and 235°\265°. (If your numbers differ by more than 5 degrees, move your cursor slightly and click again.) This translates to a range of cobalt (205°) to blue (235°), with a softening as far away as cyan (175°) and violet (270°). In other words, Photoshop has shifted the focus of the adjustment by –20 degrees; so instead of changing the blues in the image, you're all set to change the slightly greener ultramarines.

Admittedly, this is a lot of theory, but a single click is all it takes to put the theory into practice. And now that we've isolated the sky, it seems a click worth making.

7. **Lower the Hue and Saturation values.** Reduce the **Hue** value to –10 degrees to return the sky to its former color range. Then reduce the **Saturation** value to –40 percent to take some of the intensity out of the sky.

Photoshop CS4 introduced another way to work. Labeled in Figure 6-19, the targeted adjustment tool lets you change specific colors by dragging them. Click the tool to select it. Then drag in a portion of the image, such as the sky, to change its Saturation setting. Press Ctrl (or ⌘) and drag to change the Hue. Either way, drag left to lower the value or right to raise it. With some practice, you can use this one tool to replicate this entire page of steps.

8. **Click OK.** Or press Enter or Return to accept your changes. The image is now an accurate representation of the scene as I saw it. But I'd like to take it further still using a saturation editor that was introduced in Photoshop CS4, Vibrance.

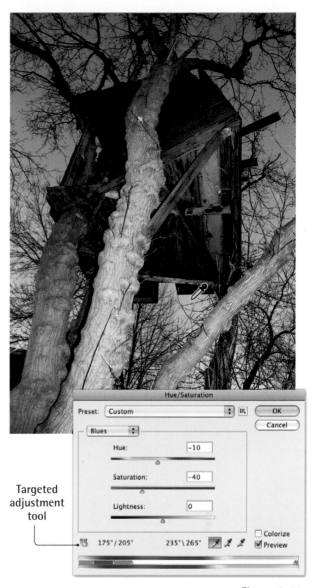

Targeted adjustment tool

Figure 6-19.

PEARL OF WISDOM

You can also use the Hue/Saturation command to desaturate the colors in your image, rendering a previously garish color photo a stark, bold grayscale image. But often better techniques give you more control. For a look at a variety of ways to convert your color image to black and white, see the sidebar "Converting an Image to Black and White," on the next page.

Converting an Image to Black and White

In a world that is saturated with color, something about the elegant simplicity of black-and-white imagery gets right to the heart of things. The removal of color allows our eyes and minds to focus on subtleties of shadow and shape in a way that's different from our everyday visual experience. Creating a beautiful black-and-white image can be very satisfying and relatively easy.

You can rob your pixels of color in Photoshop CS5 in many ways, from the classic Channel Mixer to the Black & White command and Camera Raw's Convert to Grayscale check box. Happily, each one of these functions puts you in charge of the color-to-grayscale conversion process.

Most cameras give you the option of capturing a grayscale photograph from the get-go, but where raw images are concerned, it's a fake. The color information is there, it's merely turned off by a line of metadata, often one that Camera Raw doesn't recognize and therefore ignores. But that's okay, because all that color gives you a degree of post-processing control that didn't exist in the days of traditional black-and-white photography. My recommendation: Don't worry about whether you're going black-and-white or color behind the camera; save that decision for when you're in front of your computer.

Prior to Photoshop CS3, the best way to convert a color image to black and white was the Channel Mixer. With an image open in Photoshop, choose **Image→Adjustments→Channel Mixer**. Turn on the **Monochrome** check box at the bottom of the Channel Mixer dialog box and then adjust the **Source Channels** sliders to define the amount of brightness information to draw from each color channel. Assuming you're working on an RGB image, a good place to start is **Red**: +40, **Green**: +50, and **Blue**: +10 (roughly the recipe for black-and-white television). Note that these values add up to 100 percent, thus ensuring a consistency in brightness from color to grayscale. Happily, Photoshop tracks your total as you work so you don't have to do the math on your own.

By way of example, I'll start with a full-color image from iStockphoto photographer Joseph Jean Rolland Dubé, shown below. I turned on Monochrome and set the Red, Green, and Blue values to +60, +120, and −80, respectively. That's right, it's perfectly legal to subtract the brightness levels in one channel from those in another. The result is the high-contrast portrait pictured at the bottom of this page.

Choose **Image→Adjustments→Black & White** to display a series of six slider bars, one for each of the conventional primary colors. Instead of mixing channels, the Black & White command weights colors, making for a more subjective experience. It also means you're not bound to make the values

Original full-color photograph

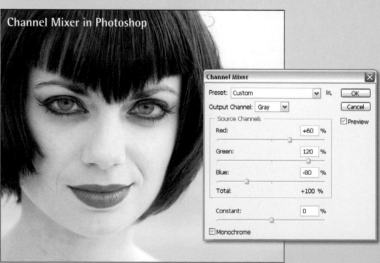

Channel Mixer in Photoshop

add up to 100 percent or any other total. Just raise a value to brighten a primary or lower the value to darken it. Once you've made a grayscale image that you're happy with, you can colorize the image by turning on the **Tint** check box and the **Hue** and **Saturation** values.

Below and to the right, you can see the results of my application of the Black & White command, as well as the specific values that I applied—40, 130, 200, 120, 70, and 300, in that order. Of more interest is the control that each slider provided. The Reds slider affected lips and skin tones. Yellows let me further adjust the skin tones independently of the lips. I used Greens to add some brightness to the irises of the woman's eyes. Cyans and Blues were strictly background colors, while Magentas gave me exclusive control over the lips and the redness in the whites of the eyes. By setting the Magentas value to its maximum, 300 percent, I was able to clear up the eyes more surely than if the model had used Visine.

Camera Raw, which we'll see up close in Lesson 9, permits you to convert an image to black and white nondestructively, whether the image begins life as a raw file or a JPEG. In the old days, the Camera Raw conversion process consisted of moving the Saturation slider all the way down to the left to −100 and then adjusting how colors were weighted with the Temperature and Tint sliders. It was chancy work and difficult to predict. Now we have dedicated controls that slightly exceed the capabilities of the Black & White command.

Start by right-clicking an image thumbnail in the Bridge and choosing **Open in Camera Raw.** Then click the ☰ icon below the histogram to switch to the **HSL/Grayscale** panel. Then turn on the **Convert to Grayscale** check box above the color sliders. The three subpanels are replaced with one called **Grayscale Mix.** Right away, Camera Raw applies its idea of the perfect mix automatically. From there, you can make any adjustments you like. To add some color, click the ▤ icon to display the **Split Toning** panel, which lets you assign independent colors to highlights and shadows to create a tritone.

To create the bottom-right example, I lowered the warm color values to darken the face and raised the cool color values to brighten the background and eyes. The lips fell completely in the Reds with the skin tones spread across the Oranges and Yellows. I was also able to integrate the Basic exposure controls and Tone Curve to balance the brightness and boost the contrast. Finally, Camera Raw automatically opened the image as a single-channel document, saving me a step.

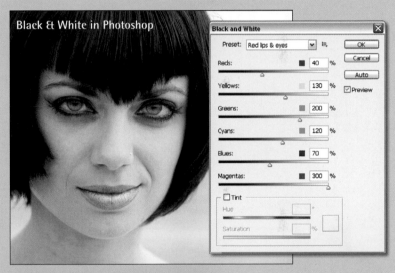

Black & White in Photoshop

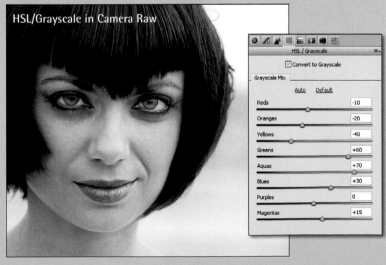

HSL/Grayscale in Camera Raw

Never once in this exercise do I ask you to change the Hue/Saturation's Lightness value. And for good reason—it's rarely useful. The Lightness value changes the brightness of highlights, shadows, and midtones by compressing the luminosity range. Raising the value makes black lighter while fixing white in place; lowering it affects white without harming black. Levels, Curves, and Shadows/Highlights produce much better results.

9. *Adjust the Vibrance and Saturation values.* Choose **Image→Adjustments→Vibrance** to bring up a dialog box with just two sliders: Vibrance, which elevates low-saturation colors more than high ones, and Saturation, which increases saturation across the board without harming luminance levels. (In contrast, Hue/Saturation's Saturation option may lighten or darken an image.) Raise the **Vibrance** value to 80 and **Saturation** to 30.

10. *Click OK.* Okay, so maybe the result in Figure 6-20 is a little over the top, but it does bear witness to what you can do with saturation. (It is a treehouse, after all.) The once natural-looking wood now radiates a yellowish glow, which—if you ask me— suits the eerie mood of the piece perfectly. But whatever you think of my aesthetics, one thing's for sure: The result is almost unbelievably more colorful than the original.

Figure 6-20.

Adjusting Brightness Levels

As I mentioned at the outset of this lesson, luminance refers to the quality of lightness and darkness of an image, as opposed to just the color values. It's the contrast of shadow and highlight that allows us to discern the edges and textures of an object, distinguish it from its background, and decide if it's something worthy of our attention. You saw Photoshop's simplest luminance control, the Brightness/Contrast command in the video at the outset of this lesson. In this exercise, we'll take a look at the Levels command, which allows greater control over how those values are represented, and how they contribute to each of the component colors in a photograph.

While not necessarily the most powerful brightness and contrast function in Photoshop's arsenal—as we'll see later, the Curves command outshines it in a few key areas—Levels provides the best marriage of form and function. It lets you tweak highlights, mid-tones, and shadows predictably and with absolute authority while maintaining smooth transitions among the three.

PEARL OF WISDOM

The Levels command is great for manipulating brightness values. And because you can work through the adjustments on a channel-by-channel basis, the Levels command also allows you to correct color cast simultaneously. See "The Nature of Channels" sidebar, on the next page, to get your bearings on how channels work to calculate colors in Photoshop.

The following exercise explains how to correct the brightness and contrast of an image with the Levels command and neutralize a color cast in the process:

1. **Open an image.** Open *Washed out beauty.jpg*, included in the *Lesson 06* folder inside *Lesson Files-PsCS5 1on1*. This image comes from the Fotolia.com photographer with the handle PhotoCD. You can see in Figure 6-21 that the photo features a red-haired beauty in a salmon-colored sweater against a pink-hued background. This convergence of similar colors only makes the lack of contrast in the image more problematic.

Figure 6-21.

To understand how to modify colors in Photoshop, you have to know how color is calculated. And this means coming to terms with the two fundamental building blocks of color: luminosity values and color channels. Be forewarned, a little math is involved. Nothing tough—no calculator required—just enough to get you grounded.

For starters, let's consider how things work without color. When you scan a black-and-white photo, the scanner converts it to a *grayscale* image, so named because it contains not just black and white but also hundreds of shades of gray. Because we're in the digital realm, each pixel in the image is recorded as a number, called a luminosity value, or *level*. A value of 0 means the pixel is black; the maximum value (typically 255) translates to white. Other luminosity values from 1 on up describe incrementally lighter shades of gray.

When you add color to the mix, a single luminosity value is no longer sufficient. After all, you have to distinguish not only light pixels from dark, but also vivid colors from drab, yellow from purple, and so on.

The solution is to divide color into its root components. There are several recipes for color, but by far the most popular is *RGB*, short for red, green, and blue. The RGB color model is based on the behavior of light. In the illustration below, we see what happens when you shine three spotlights—one brilliant red, another bright green, and a third deep blue—at a common point. The three lights overlap to produce the lightest color that we can see, neutral white. By adjusting the amount of light cast by each spotlight, you can reproduce nearly all the colors in the visible spectrum.

Now imagine that instead of shining spotlights, you have three slide projectors equipped with slightly different slides. Each slide shows the same image, but one captures just the red light

from the image, another just the green, and a third just the blue. Shine the three projectors at the same spot on a white screen and you get the full-color photograph in all its glory.

This is precisely how a digital image works, except that in place of slides, you get *channels*. Each channel contains an independent grayscale image, as shown on the right. To generate the full-color composite, Photoshop colorizes the channels and mixes them together, as in the bottom-right diagram.

In each channel, white indicates a big contribution to the full-color composite image, black means no contribution, grays contribute something in between. The background is very bright in the blue channel and darker in the other two, so the composite sky is blue. The face is lightest in the red channel with some middle grays from the green channel. Red with a little bit of green make orange. The lips are dark everywhere except the red channel, so the lips are red.

Each channel contains 256 luminosity values—black, white, and the 254 shades of gray in between. When colored and mixed together, they produce as many as 16.8 million (256^3) unique colors. (For a less common scenario with even more colors, see "Exploring High Bit Depths" on page 302 of Lesson 9.)

You can access both the full-color composite and the individual channels in the Levels and Curves dialog boxes. To see what the grayscale channels in an image look like, choose **Window→Channels**, and click **Red**, **Green**, or **Blue** in the Channels palette. Click **RGB** to return to the full-color composite view.

Red channel Green channel Blue channel

Red channel Green channel Blue channel

© Auto Color @ 25% (RGB/8) *

25% © Doc: 13.4M/13.4M

Figure 6-22.

Figure 6-23.

2. **Duplicate the image.** I often find it helpful to give one of the Auto commands a try before resorting to Levels. (After all, if I can get away with being lazy, more power to me.) But rather than mess up the original image, it's better to modify a copy. So choose **Image→Duplicate** and name the new image "Auto Color."

> If you don't feel like naming the image, you can skip this part. Just press Alt (or Option) when choosing Image→Duplicate. Photoshop skips the dialog box and names the image *Washed out beauty copy.*

3. **Apply the Auto Color command.** Choose **Image→Auto Color** or press Ctrl+Shift+B (⌘-Shift-B). The result appears in Figure 6-22. The fact that Photoshop can retrieve this much contrast all by itself is flat-out amazing. But I'm afraid the Auto command has taken us from a pink cast to a decidedly unattractive greenish-blue one. We can do much better with the Levels command. So close this image and feel free *not* to save it.

4. **Return to the original image.** Click the title bar or tab (depending on how you're choosing to work) for the *Washed out beauty.jpg* image window to bring the uncorrected photo to the front.

5. **Create a Levels adjustment layer.** Levels are another one of those Photoshop adjustments that you can apply via an adjustment layer for greater flexibility. From the **Adjustments** panel, Alt-click (Option-click) the second icon in the top row, the one that looks like a jagged mountain range, as I'm doing in Figure 6-23. In the **New Layer** dialog box that appears (presented because you held down the Alt or Option key), name your new adjustment layer "Contrast and color," and press **OK.**

> You can also apply a Levels command directly by choosing Choose Image→Adjustments→Levels or pressing the shortcut Ctrl+L (⌘-L on the Mac). You will be presented with a dialog box that contains the same controls you see when you select the Levels option in the Adjustments panel and will be able to work through this exercise with the settings shown here.

The Adjustments panel switches to show the Levels Adjustments option (shown in Figure 6-24).

6. *Change the Adjustments panel to expanded view.* It will be easier to work with the Levels adjustment command if you take advantage of an option provided in the Adjustments panel flyout menu. Click the ▾≡ at the upper-right corner of the panel and choose the first option, **Expanded View**. This gives you better visual access to the following options:

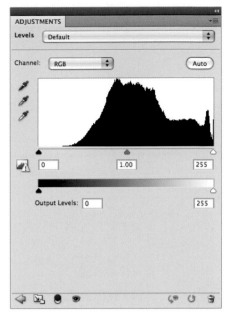

Figure 6-24.

- The Channel pop-up menu lets you edit the contents of each color channel independently. The default RGB setting lets you edit all channels at once. (Read the sidebar "The Nature of Channels," on page 196, if you haven't already.)

- The black blob in the middle is the *histogram*, which is a graph of the brightness values in your image. (See another sidebar, "How to Read and Respond to a Histogram," on page 200.)

- The three Input Levels values list the amount of adjustment applied to the shadows, midtones, and highlights. The default values—0, 1.00, and 255, respectively—indicate no change.

- The Output Levels values let you lighten the darkest color and darken the lightest one, thus reducing the contrast. Although useful for dimming and fading, they rarely come into play when correcting an image.

- The Levels preset pop-up menu (at top) lets you apply a predefined collection of settings or save your own.

- The Auto button applies the equivalent of the Auto Tone command, which you can modify as needed.

- See the three eyedropper tools alongside the histogram? You can select an eyedropper and then click in the image window to modify the clicked color. The black eyedropper makes the clicked color black; the white one makes it white; the gray one robs it of color, leaving it a shade of gray.

PEARL OF WISDOM

If you used the menu command rather than an adjustment layer, you'll have a Preview check box inside the dialog box that you can turn on and off to see your before and after effects. Since we're demonstrating the adjustment layer approach here, you can "preview" the effects by clicking the 👁 for the Contrast and Color layer in the Layers panel to turn on and off its visibility.

How to Read and Respond to a Histogram

In the world of statistics, a *histogram* is a kind of bar graph that shows the distribution of data. In the Levels dialog box, it's a bit simpler. The central histogram in the Levels dialog box contains exactly 256 vertical bars. Each bar represents one brightness value, from black (on the far left) to white (on the far right). The height of each bar indicates how many pixels in your image correspond to that particular brightness value. The result is an alternative view of your image, one that focuses exclusively on the distribution of luminosity values.

Consider the annotated histogram below. I've taken the liberty of dividing it into four quadrants. If you think of the histogram as a series of steep sand dunes, a scant 5 percent of that sand spills over into the far left quadrant; thus, only 5 percent of the pixels in this image are dark. Meanwhile, fully 25 percent of the sand resides in the big peak in the right quadrant, so 25 percent of the pixels are light. The image represented by this histogram contains more highlights than shadows.

One glance at the image itself (opposite page, top) confirms that the histogram is accurate. The photo so obviously contains more highlights than shadows that the histogram may seem downright redundant. But the truth is, it provides another helpful glimpse into the image. Namely, we see where the darkest colors start, where the lightest colors drop off, and how the rest of the image is weighted.

With that in mind, here are a few ways to work with the histogram in the Levels dialog box:

- **Black and white points:** Keeping in mind the sand dune analogy, move the black slider triangle below the histogram to the point at which the dunes begin on the left. Then move the white triangle to the point at which the dunes end on the right. (See the graph below.) This makes the darkest colors in the image black and the lightest colors white, which maximizes contrast without harming fragile details inside the shadows and highlights.

- **Clipping:** Take care not to make too many colors black or white. This will result in *clipping*, in which Photoshop renders whole regions of your image flat black or white. That's fine for graphic art but bad for photography, where you need continuous color transitions to convey depth and realism.

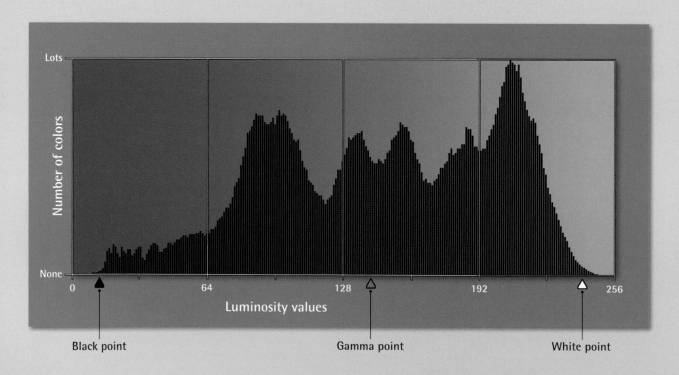

To preview exactly which pixels will go to black or white, press the Alt key (Option on the Mac) as you drag a slider triangle. When dragging the black triangle, any pixels that appear black or any color *except* white (as in the example at the bottom of this page) will be clipped. When dragging the white triangle, Photoshop clips the nonblack pixels.

- **Balance the histogram on the gamma:** When positioning the gray gamma triangle, think "center of gravity." Imagine that you have to balance all the sand in the histogram on a teetering board that is poised on this single gray triangle. If you position the gamma properly, you can distribute the luminosity values evenly across the brightness spectrum, which generally produces the most natural results.

Note that these are suggestions, not rules. Clipped colors can result in interesting effects. An overly dark image may look great set behind white type. Let these suggestions guide your experimentation, and you'll find yourself working more quickly and effectively in the Levels dialog box.

Figure 6-25.

Figure 6-26.

7. *Apply the Auto Tone function.* In the **Adjustments** panel, click the **Auto** button to apply the Auto Levels function. The histogram stretches to fill the center of the dialog box, but the numerical Input Levels values stay the same, as in Figure 6-25. (You'll see why in the next step.) As before, Photoshop's automated adjustment isn't perfect, but it's a good jumping-off point.

8. *Switch to the Red channel.* Choose **Red** from the **Channel** pop-up menu or press the shortcut, Alt+3 (Option-3). You now see the Red-channel histogram with adjusted Input Levels values, as shown in Figure 6-26.

9. *Expand the shadows.* Notice the black and white slider triangles directly below the histogram (highlighted red in Figure 6-26)? They correspond to the first and last Input Levels values, respectively. In my case, the black slider tells me that any pixel with a brightness of 80 or less will be made black in the Red channel; the white slider says any pixel 255 or brighter will be made white. (This is to be expected given the overall lightness of this particular image.) Your values may differ slightly. Remember, 0 is absolute black and 255 is absolute white.

If grabbing and moving those triangles doesn't suit your mood or manual dexterity, you can change the value by selecting the numerical value inside the box on the right and typing the new value. If you want even greater control, you can nudge the values with your arrow keys. Click inside any of those boxes and use the ↓ or ↑ key to move the sliders in 1-step increments. Holding down the Shift key with the arrow keys moves the sliders in 10-step increments.

Move the black triangle to the left to a value of 60 to send more of the pixels to black in the Red channel. This causes a little extra warmth, which we don't need, but it also improves the contrast, as you can see in Figure 6-27. We'll neutralize the color as we make adjustments in the other channels.

10. ***Switch to the Green channel and increase the shadows.*** Choose **Green** from the **Channel** pop-up menu or press Alt+4 (Option-4). Then move the black triangle to a value of 40.

11. ***Raise the midtones value.*** Increase the middle **Input Levels** value to 1.05, thus increasing the brightness of the midtones in the Green channel. Somewhat counterintuitively, this means moving the slider to the left. The results of both Green channel adjustments are shown in Figure 6-28.

Figure 6-27.

PEARL OF WISDOM

The middle Input Levels number (which corresponds to the gray slider below the histogram) is calculated differently than the black and white points. Expressed as an exponent, this *gamma value* multiplies all colors in a way that affects midtones more dramatically than shadows or highlights. The default gamma value of 1.00 raises the colors to the first power, hence no change. Higher gamma values make the midtones brighter; lower values make the midtones darker.

12. ***Switch to the Blue channel.*** Choose **Blue** from the **Channel** pop-up menu or press Alt+5 (Option-5).

13. ***Adjust the shadows and midtones.*** This time, change the first two **Input Levels** values to 35 and 1.05, respectively. The changes to the black value darkens the Blue channel, while the revised gamma value lightens the midtones. The result, as you can see in Figure 6-29 on the next page, is a pretty good neutralization of the pink color cast along with some fairly significant improvements to the contrast overall.

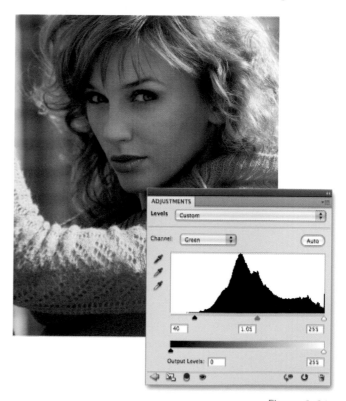

Figure 6-28.

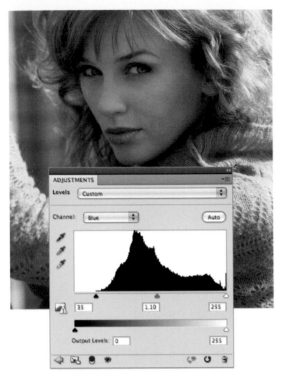

Figure 6-29.

14. **Add a Vibrance adjustment layer.** We've lost a bit of color along the way, so return to the **Adjustments** panel and press the ⇦ arrow at the bottom left. Alt-click (Option-click) the V-shaped icon (first from the left in the second row) to create a Vibrance adjustment layer. Name the layer "Color Up" or something equally descriptive and press **OK**. Then raise the **Vibrance** way up to +85 and set the **Saturation** to +20.

You can see the resounding success of the adjustments in Figure 6-30. On the left is our washed-out original image, and on the right is the result of our efforts with the Levels command.

You may be wondering how I arrived at the specific values that you entered during this exercise. The answer is trial and error. I spent a bit more time flitting back and forth between the channels and nudging values than the exercise implies, just as you will when correcting your own images. But as long as you keep your eye on the image preview, you can review each modification as you apply it. Of course, understanding how to read the histogram, constant companion to the Levels command, is a great way to learn where best to start. So I'll gently suggest once more that you take a look at the aptly named sidebar, "How to Read and Respond to a Histogram," which you'll find back on page 200.

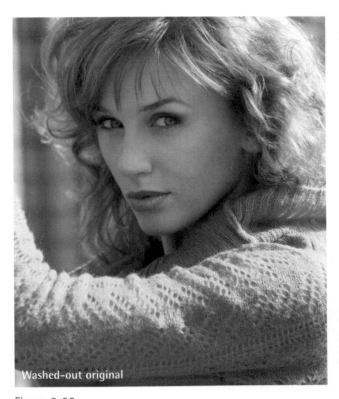

Washed-out original

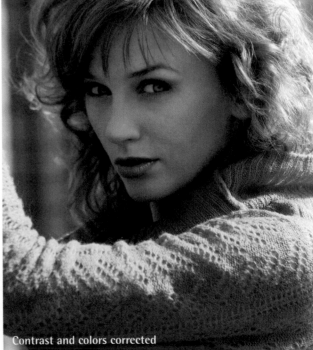

Contrast and colors corrected

Figure 6-30.

Correcting with Curves

As a rule, the Auto and Levels commands work best when you want to increase the contrast of an image, not decrease it. Granted, you can darken or brighten midtones. But what if you want to tone down a group of highlights or shine a bit of light into the shadows? To perform these kinds of adjustments, you need more control than the basic three divisions—shadows, midtones, and highlights—can provide. You need to divide shadows and highlights into their component parts. In other words, you need to establish your own brightness divisions.

This is precisely what the Curves command does. You can set and edit a dozen or more brightness points. Or you can set just three or four and modify them with a precision that Levels can't match. And now that Curves includes slider controls, clipping previews, and even a histogram and a targeted adjustment tool, it's more powerful than ever.

1. *Open an image.* Open *High-contrast elephant.jpg*, included in the *Lesson 06* folder inside *Lesson Files-PsCS5 1on1*. This is a relatively low-resolution image I captured years ago at the Denver Zoo. As you can see in Figure 6-31, the elephant is decidedly too warm, but more importantly, the entire image suffers from too much contrast. And as I've mentioned, reducing contrast is the Curves command's specialty.

Figure 6-31.

2. ***Create a Curves adjustment layer.*** Like the other adjustments we've applied so far, the Curves command can be applied as a static adjustment (by choosing Image→Adjustments→Curves) or via an adjustment layer, as we'll do here. To shake things up this time, create the adjustment layer by clicking the ⬤ icon at the bottom of the **Layers** panel and choosing **Curves** from the pop-up menu.

The Adjustments panel should still be in expanded view from the last exercise. This setting is "sticky," meaning it should persist even if you've closed Photoshop. If you didn't do the last exercise, press ▾☰ in the upper-right corner of the panel and choose Expanded View.

Pictured in Figure 6-32, the Curves option in the Adjustments panel contains many of the same options found in Levels, including the Channel pop-up menu, the Auto button, and the eyedropper tools. (For explanations of each, see Step 6 of the "Adjusting Brightness Levels" exercise on page 99.) But there are a few differences:

- The central element of the Curves panel is the *luminance graph*, in which you plot points along a line called the *luminance curve*. When editing an RGB image, the curve represents all brightness values in the image from black in the lower-left corner to white in the upper-right corner. Click the curve (initially a straight line) to add

Figure 6-32.

a point to it. Then drag the point up or down to make the corresponding brightness value lighter or darker.

- In the middle of the luminance graph is a gray histogram that's scaled vertically to fit the square graph. Note that this histogram is static; it always represents the image prior to your modifications.

- Near the bottom-left corner of the graph are two tools for directly editing the luminance curve. The first is the point tool. Click in the graph with this tool to add a point to the curve, and then drag the point to bend the curve. The second tool, the pencil, lets you draw freehand curves. For example, if the curve flexes in a way that you don't like, switch to the pencil tool and draw directly inside the graph.

Available only when the pencil tool is active, the Smooth button (the icon below the pencil tool) rounds rough corners in your graph. Smooth is especially useful after Shift-clicking with the pencil tool, which draws straight lines. If one click of the Smooth button doesn't do the trick, click the button again. In fact, clicking two or three times in a row is the norm, not the exception.

- Introduced back in CS4, the targeted adjustment tool lets you choose a spot on the image and move your mouse up or down to reset all equivalent luminance values in the image.

- When available, the Input and Output values show the coordinates of the chosen point in the graph. Located below the graph, Input tells the original brightness of the color; to the left, Output indicates what the brightness will be when you click OK. As with the Levels command, the brightness of an RGB image is measured from 0 to 255.

Now that we have the cursory introductions out of the way, let's see how these options fare in a real-world project.

3. *Choose the targeted adjustment tool.* Make sure the point tool is selected in the lower-left corner of the Adjustments panel, so that the targeted adjustment tool is available. Note that I call it the "targeted adjustment tool," but you won't see that name if you hover over the 🖐 icon. I stole the name from Adobe Lightroom, where the tool made its first appearance, because it's so darn appropriate. We'll use this tool to indicate input values that we want changed to lighter or darker luminance values in the image.

4. ***Click and drag an area on the elephant's forehead.*** Our pachyderm has some highlight areas in her forehead that will serve as good sample areas for reducing the brightest levels in the image. Hover your cursor over the forehead indicated in Figure 6-33. You can wiggle your cursor around to find an area similar to mine. Keep an eye on the **Input** value; when it reads very close to 235, click to add a point to the curve. Then drag downward until the **Output** value reads 220. You'll notice an overall darkening of the image as all the values that are 235 and brighter are pulled downward by the curve.

Figure 6-33.

5. ***Click a shadow area and drag it upward.*** Click an area in the elephant's belly that has an **Input** value of around 25, and this time drag upward until the **Output** value reads 35. You'll notice in Figure 6-34 on the facing page that this places a point on the curve in the lower-left quadrant and bends the curve into a subtle backward S shape. It also has the overall effect of lightening the shadows.

You don't need to click in the exact spots with the exact values I've used. And if you can't find those spots, you can always create points (with the targeted adjustment tool or the pencil tool) and move the points into place on the curve by clicking in the Output or Input value boxes and manipulating them manually, either by typing numbers or by using the ↑ or ↓ key.

Figure 6-34.

6. **Switch to the Red channel.** We've successfully reduced the contrast, but we've left behind a slight color cast in the image. In the preceding exercise, you saw how the Levels command allowed you to adjust luminance values in each of the color channels individually. The same is true for the Curves command. From the pop-up menu that currently reads RGB, choose **Red**. Alternatively, you can press Alt+3 (Option-3) to switch to the Red channel.

7. **Place a point in the center and move it manually.** Start by clicking once in the center of the graph, which should set your **Input** level to 128. Then press Shift-↓ three times to reduce the output for the midtones in the Red channel to 98. Your Adjustments panel should look like Figure 6-35.

8. **Switch to the Blue channel.** You can choose **Blue** from the pop-up menu, or easier yet, press Alt+5 (Option+5) to switch to the curve for the Blue channel.

9. **Add a point and raise it.** Click in the center of the graph at an **Input** and **Output** value of 128, and then press Shift-↑ twice to raise the Blue midtones to 148.

Figure 6-35.

Figure 6-36 shows the image we started with (above) and our final, properly gray, reasonably lit elephant (below). The Adjustments panel displays a line for each channel adjustment we made, as well as the composite image (press Alt+2 or Option-2 to return to the RGB view in the Adjustments panel).

Figure 6-36.

Compensating for Flash and Backlighting

Photography is all about lighting—specifically, how light reflects off a surface and into the camera lens. So things tend to turn ugly when the lighting is all wrong. One classic example of bad lighting is *backlighting*, where the background is bright and the foreground subject is in shadow. Every photographer knows that you adjust for backlighting by adding a fill flash, but even the best of us forget. An opposite problem occurs when shooting photos at night or in dimly lit rooms using a consumer-grade flash. You end up with unnaturally bright foreground subjects set against dark backgrounds.

Whether your subject is underexposed or overexposed, the solution is the Shadows/Highlights command, which lets you radically transform shadows and highlights while maintaining reasonably smooth transitions between the two. Here's how it works:

1. *Open an image.* Open *Rooster in shadows.jpg*, found in the *Lesson 06* folder inside *Lesson Files-PsCS5 1on1*. When I shot this image, I chose an exposure setting with the bright Key West sunlight in mind. As a result, the highlights are balanced but the shadows are not (see Figure 6-37). A fill flash might have helped, but alas, I didn't have my flash with me. So an unacceptably dark and murky rooster is what I got.

Figure 6-37.

Figure 6-38.

2. *Choose the Shadows/Highlights command.* Choose **Image→ Adjustments→Shadows/Highlights**. The resulting **Shadows/ Highlights** dialog box is simple compared to what we've seen so far, containing just two slider bars (see Figure 6-38). The Shadows option lets you lighten the darkest colors; the Highlights option darkens the lightest colors.

3. *Adjust the shadows and highlights.* By default, Photoshop is too enthusiastic about lightening the shadows and not enthusiastic enough about darkening the highlights. To temper the dark colors, reduce the **Shadows** value to 30 percent. Then raise the **Highlights** value to 10 percent, as in Figure 6-39.

Figure 6-39.

4. *Show the advanced options.* The Shadows/Highlights dialog box may appear a bit feeble—especially when compared with the likes of Levels and Curves—but it's got a tiger in its tank. To unleash that tiger, select the **Show More Options** check box. Photoshop unfurls the options pictured in Figure 6-40 on the facing page.

5. **Maximize the Radius values.** Left to its own devices, the Shadows/Highlights command tends to sharpen an image. To prevent an overly sharpened effect, raise both **Radius** values—one under **Shadows** and the other under **Highlights**—to 100 pixels. A large Radius value distributes the effect, resulting in the smoothest possible transitions between our friends the highlights, shadows, and midtones.

6. **Modify the Tonal Width values.** The two Tonal Width options control the range of brightness values that Photoshop regards as shadows or highlights. Because our image consists of slightly more shadows than highlights, we want to lightly narrow the definition of the former (the shadows) and barely widen the latter. So reduce the **Tonal Width** for **Shadows** to 40 percent and increase the **Tonal Width** for **Highlights** to 70 percent.

7. **Increase the amount of shadow.** Having tempered the shadows by decreasing the Tonal Width and increasing the Radius, the dark shades can tolerate a higher Amount value. Raise the **Amount** in the **Shadows** section from 30 to 60 percent to increase the brightness of the darkest colors in the photo.

8. **Lower the Color Correction value.** Much like the Saturation value in the Hue/Saturation command, the Color Correction option lets you adjust the intensity of colors. For the most part, the colors are fine in this image, though the reds in the rooster's beak are a bit too intense for my taste. Lower the **Color Correction** value to +10 and leave the other Adjustments values as they are. Figure 6-41 shows the Shadows/Highlights dialog box with the final values entered.

9. **Accept your changes.** Click the **OK** button or press Enter or Return to apply your changes and exit the Shadows/Highlights dialog box.

Figure 6-40.

Figure 6-41.

Shown in Figure 6-42, the before (top image) and after (bottom image) results are pretty impressive. Pressing Ctrl+Z (or ⌘-Z) a few times on your own image will show you how effectively the Shadows/Highlights command has improved it. We've successfully pulled a ton of detail from the shadows, all without blowing out the brighter areas, pushing the midtones into grays, or shifting the color balance (as Curves can sometimes do). This makes Shadows/Highlights the best one-stop method in all of Photoshop for correcting extremely high-contrast images.

Figure 6-42.

WHAT DID YOU LEARN?

Match the key concept in the numbered list below with the letter of the phrase that best describes it. Answers appear upside-down at the bottom of the page.

Key Concepts

1. Hue and Saturation
2. Brightness
3. Contrast
4. Highlights, Shadows, and midtones
5. Color cast
6. Color channel
7. Auto Tone
8. Histogram
9. Levels
10. Gamma value
11. Curves
12. Shadows/Highlights

Descriptions

A. A command that automatically corrects the shadows and highlights of each color channel independently.

B. The two ingredients in color: The first is the tint, from red to magenta, and the second is the purity, from gray to vivid.

C. This command lets you darken highlights and lighten shadows, just what you need when correcting flash photos.

D. The lightness or darkness of a group of colors.

E. A bar graph representation of all brightness values and their distribution in an image.

F. The three brightness ranges that you can edit independently using the Color Balance and Levels commands.

G. Expressed as an exponent, this value multiplies the brightness of an image to lighten or darken midtones.

H. An independent grayscale image that Photoshop colorizes and mixes with other such images to produce a full-color composite.

I. The one command that lets you pinpoint a specific color in an image and make it lighter or darker; best suited to reducing contract.

J. The best tool for manually adjusting the brightness and increasing the contrast of an image on a color-by-color basis.

K. The difference between light and dark colors.

L. When one color pervades an image to a degree that is unpleasant or unrealistic.

Answers

1B, 2D, 3K, 4F, 5L, 6H, 7A, 8E, 9J, 10G, 11I, 12C

LESSON

7

SHARPENING AND SMART OBJECTS

PHOTOSHOP OFFERS more than a hundred *filters*, some of which we've already encountered in earlier lessons. Some filters modify the contrast of neighboring pixels, others trace the contours of a photograph, and still others deform an image by moving pixels to new locations. (See Figure 7-1 for examples.)

Original photograph Filter→Blur→Surface Blur Filter→Artistic→Colored Pencil Filter→Distort→Shear

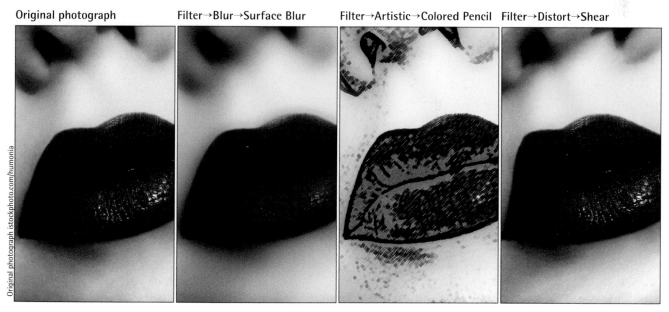

Original photograph istockphoto.com/humonia

Figure 7-1.

Arguably, the most useful filters are concerned with *sharpening* an image, that is, removing softness by increasing the contrast at the edges. Inevitably, every photograph needs some sharpening to bring out the detail that otherwise gets lost in translation between camera, computer, and print. Be warned, sharpening doesn't compensate for bad focus. No amount of filtering will make up for depth-of-field problems. But then, no perfectly focused image is going to "pop" without the appropriate amount of sharpening applied, either.

ABOUT THIS LESSON

Project Files

Before beginning the exercises, make sure you've downloaded the lesson files from *www.oreilly.com/go/Deke-PhotoshopCS5*, as directed in Step 2 on page xvi of the Preface. This means you should have a folder called *Lesson Files-PsCS5 1on1* on your desktop (or whatever location you chose). We'll be working with the files inside the *Lesson 07* subfolder.

In this lesson, I explain the intricacies of Photoshop's most useful filters and how to use smart objects to apply effects nondestructively. You'll learn how to:

Video Lesson 7: Introducing Filters

In a program that seems to pride itself on its crowded menus, Photoshop's Filter menu is the most jam-packed of them all. Its commands (known generically as *filters*) range from extremely practical to wonder-fully frivolous to just plain lame. We're not going to look at *all* the filters—that would be pointless—just the best ones. We'll get a sense for how they work as well as how to adjust their results

To find out about Photoshop's filters, visit *www.oreilly. com/go/deke-PhotoshopCS5.* Click the **Watch** button to view the lesson online or click the **Download** button to save it to your computer. During the video, you'll learn these shortcuts:

Command or operation	Windows shortcut	Macintosh shortcut
Undo application of static filter	Ctrl+F	⌘-F
Set colors to their default	D	D
Fade last-applied filter	Ctrl+Shift+F	⌘-Shift-F
Copy image to new layer and name it	Ctrl+Alt+J	⌘-Option-J
Reapply last filter (with different settings)	Ctrl+F (Ctrl+Alt+F)	⌘-F, (⌘-Option-F)
Apply Gaussian Blur filter*	Shift+F7	Shift-F7
Apply High Pass filter*	Shift+F10	Shift-F10

* Works only if you loaded the dekeKeys keyboard shortcuts (as directed in Steps 8 through 10, beginning on page xix of).

Unlike the adjustment layers you saw in Lesson 6, filter application is a destructive edit that alters pixels in an unchangeable way. One way to protect your image from this irreversible damage is to wrap it up in a *smart object,* a Photoshop feature that keeps the original image safe inside a virtual protective container.

You can put an image or a vector illustration inside this vessel, and no matter how much you scale, rotate, warp, or filter it, Photoshop always references the original art and re-renders it to achieve the best possible transformation. Admittedly, smart objects suffer the occasional limitations. If you want to paint or edit a smart object, you have to open it in a separate window. Even so, they're astonishingly powerful and a welcome addition to the application.

The Subterfuge of Sharpness

When an image is formed by the camera lens, the image's focus is defined. The moment you press the shutter, you accept that focus and store it as a permanent attribute of the photograph. If the photograph is slightly out of focus, it stays out of focus. No post-processing solution can build more clearly defined edges than what the camera actually captured. Although Photoshop can't reach back into your camera and modify the lens element for a better shot, it can compare neighboring pixels and enhance already existing edges. Your eyes think they see a differently focused image, but really they're seeing an exaggerated version of the focus that was already there.

Consider the photos in Figure 7-2. The first comes from an image that was shot to film and then scanned. This macro shot includes a generous depth of field, with the focus varying from dead-on in the eyes to soft as the creature's scales bulge toward us or recede away. The second and third images show variations imposed by Photoshop. (For the sake of demonstration, I applied the sharpening over the softening.) Softening blurs the pixels together; sharpening exaggerates the edges. Softening bears a strong resemblance to what happens when an image is out of focus. Sharpening is a contrast trick that exploits the way our brains

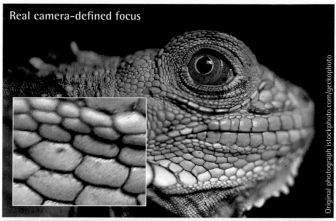
Real camera-defined focus

Original photograph istockphoto.com/geckophoto

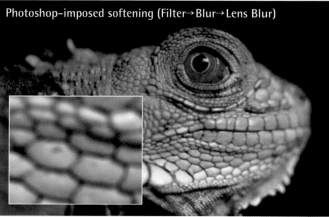
Photoshop-imposed softening (Filter→Blur→Lens Blur)

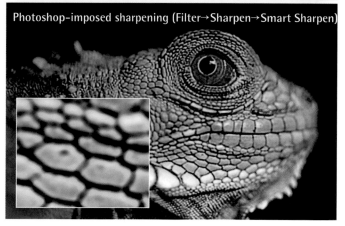
Photoshop-imposed sharpening (Filter→Sharpen→Smart Sharpen)

Figure 7-2.

perceive definition, particularly with respect to distant or otherwise vague objects. A highly defined edge with sharp transitions between light and dark tells us where an object begins and ends.

But so what if it's a contrast trick? After all, photography itself is a trick that simulates reality, specifically geared to human eyes and brains. If Photoshop's sharpening augments that trick, more power to it. I just want you to know what you're doing. After all, the magician who truly understands his bag of tricks is better equipped to perform magic.

Sharpening an Image

Of the five filters that reside in the Filters→Sharpen submenu, only two, the ancient Unsharp Mask and the more recent Smart Sharpen, let you control the amount of sharpening you apply to an image. As a result, they do everything the other three filters do—which isn't much, frankly—plus a whole lot more.

Unsharp Mask derives its name from an old and largely abandoned traditional darkroom technique in which a photographic negative is sandwiched with a blurred, low-contrast positive of itself and printed to photographic paper. Ironically, this blurred positive (the "unsharp" mask) accentuated the edges in the original, resulting in the perception of sharpness.

To see how Unsharp Mask's arcane origins translate to the way Photoshop's sophisticated sharpening functions work, read the upcoming sidebar "Using Blur to Sharpen" on page 224.

These days, Unsharp Mask takes a back seat to Smart Sharpen, which incorporates the best of Unsharp Mask's capabilities and adds a few of its own. This is why we'll focus exclusively on Smart Sharpen in the following tale of rodent romance.

1. *Open an image.* Go to the *Lesson 07* folder inside *Lesson Files-PsCS5 1on1* and find *Rodents in love.psd* (see Figure 7-3). Cute as this squirrely story is, the image suffers from a tiny amount of *lens blur*, meaning that it's a bit off from its ideal focus.

Figure 7-3.

2. *Choose the Smart Sharpen filter.* Go to the **Filter** menu and choose **Sharpen**→ **Smart Sharpen** to display the **Smart Sharpen** dialog box, complete with a cropped preview, as you can see in Figure 7-4. When the Preview check box is turned on, Photoshop applies the effect to the larger image window as well. Preview is turned on by default, and I can think of only two reasons to turn it off: First, you may want to compare before-and-after versions of an image, and second, you're working on a large image and the program just can't keep up with your changes.

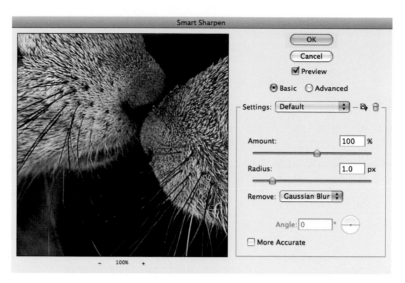

Figure 7-4.

Virtually every image you edit will require some amount of sharpening. This means you'll be choosing Smart Sharpen a lot. To save you some effort (the damn thing's in a submenu, after all), I've assigned it a shortcut. If you loaded dekeKeys, as I advised in the Preface, you can invoke Smart Sharpen by pressing Shift+F6. My logic? Smart Sharpen has two S's; Shift and 6 (of F6) do too. For whatever reason, that's been enough to stick it in my head.

3. *Set the zoom ratios for the image previews.* Press Ctrl+1 (⌘-1) to set the image window to the 100 percent view size. Then click a couple of times on the minus sign (–) below the preview in the **Smart Sharpen** dialog box to reduce that preview to 50 percent. Now you can gauge the results of your changes in two ways.

Why did I use 100 and 50 percent? Because the 100 percent view shows you every pixel in the image, and the 50 percent view more closely represents the image's appearance when printed, at which point more pixels are packed into a smaller space. But assuming that you have an OpenGL-compatible graphics card, you can use any zoom ratios you like. They all display smoothly (something that could not be said of Photoshop versions before CS4).

4. *Set Remove to Lens Blur.* The default setting for the **Remove** option—Gaussian Blur, which highlights edges in gradual, circular patterns—duplicates the one and only behavior of the Unsharp Mask filter. And although Gaussian Blur does a serviceable job, the **Lens Blur** setting enjoys a higher degree of accuracy and is better suited to reversing the effects of the soft focus, particularly in digital photography. Think of it as Photoshop's next-generation sharpening algorithm.

Lens Blur, Amount: 500%, Radius: 1.5 pixels

Radius: 3 pixels

Radius: 6 pixels

Figure 7-5.

5. *Increase the Amount value.* Set **Amount** to the maximum value, 500 percent. This is a temporary setting that exaggerates the effect and permits us to see what we're doing. We'll rein it in when we get to later steps.

6. *Specify a Radius value of 3 pixels.* Although Radius is the second value, we'll play with it first because it's really the linchpin of the sharpening operation. Like Unsharp Mask before it, Smart Sharpen simulates sharper transitions by drawing halos around the edges (see "Using Blur to Sharpen," page 224). The Radius value defines the thickness of those halos. Thin halos result in a precise edge; thick halos provide a more generalized, high-contrast effect. A few examples appear in Figure 7-5.

The best Radius value is the one you can barely see. What you will be able to see depends on how you will view your final image:

- If you intend to display the image on screen (say, as part of a Web page or PowerPoint presentation), enter a very small value, between 0.5 and 1.0 pixel.

- For medium-resolution printing, a Radius value of 1.0 to 2.0 pixels tends to work best.

- For high-resolution printing, I recommend a Radius between 2.0 and 4.0 pixels.

The examples in Figure 7-5 were printed at 356 pixels per inch, so a 3-pixel Radius delivers the best edges. (For more information on print resolution, read Lesson 12, "Print and Web Output.") A smaller Radius value will most likely look better on your screen, but for now, I'd like you to imagine that you're going to print, so enter a **Radius** value of 3.

Use the up and down arrow keys to nudge the selected value by its smallest increment: 0.1 in the case of Radius and 1 in the case of Amount. Add Shift to nudge 10 times that increment.

7. ***Lower the Amount value to 300 percent.*** The Amount value controls the degree to which the image gets sharpened. Higher values result in more edge contrast. The effects of the Amount value become more pronounced at higher Radius values as well. So where 400 percent might look dandy with a Radius of 1.5 pixels, the effect may appear excessive at a Radius of 3 pixels. An image exposed to too high an Amount value is said to be *oversharpened*, as is presently the case for our squirrels.

Press Shift+Tab to highlight the Amount value. Then experiment with the setting by pressing Shift+↓ a few times, which lowers the Amount in 10 percent increments. Figure 7-6 shows a few examples. The top image is too harsh, the bottom image is too soft, and the middle one is just right. (Forgive my storybook analogy, but this is a storybook tale, people.) So do like me and set the **Amount** value to 300 percent.

Lens Blur, Amount: 500% Radius: 3 pixels

PEARL OF WISDOM

Users accustomed to Unsharp Mask will notice one value conspicuously absent: Threshold. Meant to avoid the sharpening of grain, noise, and other artifacts, Unsharp Mask's Threshold option results in an either/or proposition—an edge gets sharpened or it doesn't—which may create pockmarks in an image. I for one am glad it's missing from Smart Sharpen.

Amount: 300%

8. ***Leave the More Accurate check box turned off.*** The Smart Sharpen dialog box ends with an improvement on Threshold called More Accurate. On first blush, you might assume you should turn on this option. After all, who doesn't want a more accurate sharpening effect? But it's a little more complicated than that:

- Turn on More Accurate to burrow into the image and extract all the edges the filter can find.

- Leave More Accurate turned off, as by default, to trace only the most pronounced edges.

Amount: 100%

Figure 7-6.

Using Blur to Sharpen

The "unsharp" that drives both Unsharp Mask and its successor, Smart Sharpen, is a function of the softly tapering halo that the Radius value applies. Once you understand this concept, you can master the art of focus in Photoshop.

Consider the line art in the figure below. The top-left image features dark lines against a light background. The other three are sharpened with increasingly higher Radius values. Throughout, the Amount value is 200 percent and the Reduce pop-up menu is set to Gaussian Blur. In each case, the sharpening filter traces the dark areas inside the lines (the brown areas) with a blurry dark halo and the light areas outside the lines (the green areas) with a blurry light halo. Regardless of the

Reduce setting—Gaussian Blur, Lens Blur, or Motion Blur—the thickness of these halos conforms to the Radius value.

Given that the Radius value is all about blurring, it's no surprise that this option also appears in the Gaussian Blur dialog box, where it once again generates halos around edges. In fact, if we were to trace the lineage of these filters, Gaussian Blur is Unsharp Mask's grandparent, which in turn witnessed the birth of Smart Sharpen. It's downright biblical, I tell you. The missing family member in between is an obscure command called High Pass.

Why should you care? Because Unsharp Mask's parent, High Pass, is in some ways a more flexible sharpening agent than its first- or second-generation progeny.

Try this: Open *Happy family.jpg* from the *Lesson 07* folder inside *Lesson Files-PsCS5 1on1*. Then press Ctrl+J (or ⌘-J) to copy the image to an independent layer. Now choose **Filter**→**Other**→**High Pass**. Or if you loaded dekeKeys, press Shift+F10. Pictured below, the High Pass dialog box contains a single option, **Radius**. Change this value to 4 pixels, the same Radius you applied in the exercise using Smart Sharpen. Then click **OK**.

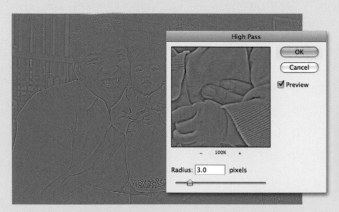

Looks like a big mess of gray, right? But tenuous edges are in there. To bring them out, press Ctrl+L (or ⌘-L) to display the **Levels** dialog box. Change the first and third **Input Levels** values to 75 and 180 brightness levels, respectively, as in the figure below. Then click **OK**.

Still looks terrible. But what you're looking at are the very same light and dark halos that Smart Sharpen creates. To apply those halos to the original photograph, go to the **Layers** panel and choose **Overlay** from the top-left pop-up menu. Just like that, Photoshop drops out the grays, blends in the edges, and makes it all better. The result is almost exactly what you'd get if you applied the Smart Sharpen filter with a Reduce setting of Gaussian Blur, a Radius of 4 pixels, and an Amount of 200 percent. (In other words, the current High Pass layer has more than twice the effect of a default application of Smart Sharpen.) You can now freely adjust the Amount by reducing the top layer's Opacity setting until you're satisfied. To my eyes, an **Opacity** setting of 80 percent looks just fine, as shown below.

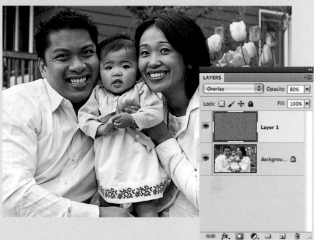

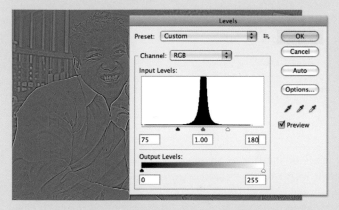

Why go through all this just to get the same effect we achieved in the exercise? Because now you have a floating layer of sharpness whose Amount you can change at any time by adjusting the layer's Opacity setting. This means you can change your mind well into the future, as opposed to being locked into the static result of Smart Sharpen. And because the layer is separate, you even have the option of limiting the area that you sharpen by adding a layer mask. It's an unusual approach—especially in light of smart filters (which we'll discuss in Lesson 11)—and it takes a bit of experience to get it down pat. But given the importance of sharpening in digital imaging, having a versatile filter like High Pass at your disposal helps.

Counterintuitive as it may seem, you usually don't want to enhance all edges, just the major ones. Two reasons for this: First, slight edges—such as those produced by film grain, noise, and skin blemishes—are often bad edges. Do you really want to sharpen someone's pores? Second, More Accurate more than doubles the amount of time it takes the filter to preview and apply an effect. When editing a high-resolution, noiseless product shot—in which you want to see every last detail—More Accurate can work wonders. But for portraits and day-to-day work, I generally recommend you leave it turned off.

9. **Save and apply your settings.** Because the Smart Sharpen options are so complex—even more so than we've seen thus far—it's a good idea to save your settings for later use:

- Click the tiny disk icon (▣), name the settings "Soft Squirrels" (see Figure 7-7), and click **OK**. Now your settings are ready and waiting for later use.

- To avoid overwriting the Default settings, choose **Soft Squirrels** from the **Settings** pop-up menu. Then click **OK** at the top of the dialog box to apply those settings to the image.

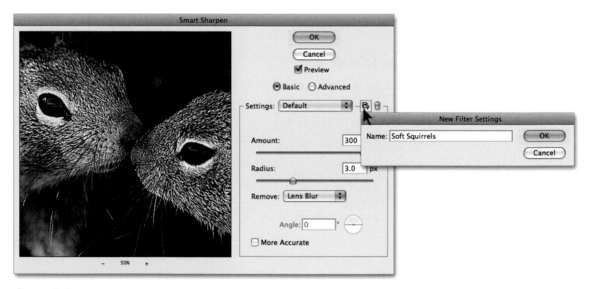

Figure 7-7.

Look closely at the side of the love-squirrel on the right and notice the bright bluish-purple striations woven into the fur. The filter can't distinguish color detail from luminosity detail, so it exaggerates the contrast of the hue, saturation, and brightness of an image in equal amounts. To return the colors to their previous appearance—free of purple—while retaining the sharpness, drop out the colors as explained in the next step.

10. **Fade the Smart Sharpen filter.** Choose Edit→ Fade Smart Sharpen or press Ctrl+Shift+F (⌘-Shift-F) to display the **Fade** dialog box. Then choose **Luminosity** from the **Mode** pop-up menu and click **OK**. Photoshop merges the new sharpness with the original colors, as illustrated in Figure 7-8. This technique is so extraordinarily useful that you may want to follow up every application of the Smart Sharpen filter with a preventative dose of the Fade command. Because whether you see the aberrant colors or not, they're there, just beyond view, ready to spring forth when you print the image.

Figure 7-8.

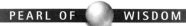

Working with Smart Objects

One of the main frustrations when working in a pixel-based image editor is, well, the pixels. In a vector-based program such as Illustrator or the program in which this document was laid out, InDesign, edits are nondestructive, meaning that no matter how much you reshape or transform a work of vector art, it remains razor sharp. But try the same thing in Photoshop—for instance, shrink a layer, rotate it, and then scale it way up—and you're faced with a soft, blocky mess. And, excepting Undo and history, a pixel that goes bad stays bad.

With smart objects, Photoshop offers a kind of pixel-protection plan. You can put an image or a vector illustration inside this protective container, and no matter how much you do to it, Photoshop holds the original in its pristine restorable original condition. Meanwhile, you can duplicate a smart object to create one or more *instances*. Change the original and all instances update in kind. And finally, you can place an Illustrator or a Camera Raw document and retain a dynamic link between the resulting layer and the original document data. (Photoshop embeds the original data inside the layered composition, so there's no chance of losing a linked file on disk.)

If all this sounds a bit abstract, no fear. Over the course of the next eight pages, abstraction will transform into brass-tacks practicality. In the next steps, you'll use smart objects to build a flexible project that responds easily and quickly to your edits. It's an exercise in workflow enhancement, and a fun one at that.

Figure 7-9.

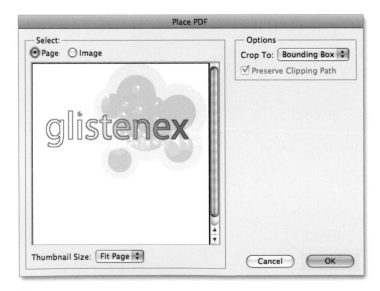

Figure 7-10.

1. *Open an image.* Open the layered composition *Glistenex ad.psd,* included in the *Lesson 07* folder inside *Lesson Files-PsCS5 1on1*. Pictured in Figure 7-9, this document contains the beginnings of an advertisement for a new antibacterial soap, which features an image from iStockphoto's Joshua Blake. We'll simulate the all-too-common ritual of designing an image for a client only to have the image returned with a list of corrections. Thankfully, we will have assembled the composition using smart objects, so our response will be a calm and cordial "No problem, boss."

2. *Place an Illustrator document.* To import a file as a smart object, choose **File→Place**. Then locate and select the vector-based Illustrator graphic *Glistenex logo.ai*, which you'll find in the *Lesson 07* folder inside *Lesson Files-PsCS5 1on1*.

 Click the **Place** button, and you'll see a dialog box titled **Place PDF** (for *Portable Document Format)*, as shown in Figure 7-10. (Note that I set the Thumbnail Size option to Fit Page.) By default, Illustrator saves its native AI files with PDF encoding, which Photoshop needs to process the drawing as a smart object. Besides alluding to that fact, this dialog box is not much use to us. It confirms cropping and lets you select a specific page inside a multipage PDF document. But the cropping is fine and this is a single-page document, so there's nothing for you to do besides click **OK**.

Another way to create a smart object from Adobe Illustrator is to use the clipboard. Select the paths you want to bring over, and press Ctrl+C (⌘-C on the Mac) to copy the artwork. Then switch to Photoshop and, with a document open, press Ctrl+V (⌘-V) to paste the artwork. In the ensuing dialog box, select Smart Object from the Paste As options and click OK.

Figure 7-11.

3. *Scale and position the logo art.* Photoshop automatically generates a smart object and centers it in your composition, as shown in Figure 7-11. Surrounding the illustration, you'll see a bounding box with a giant ✕ over it, which permits you to position and transform the illustration.

Just so we're in sync, I'd like you to manually enter the following values in the options bar, as I have in Figure 7-12. I found that I had the best luck when I entered the values slowly, waiting a beat after every digit for Photoshop to catch up. (It's irritating, but what is one to do?)

- Click the ⚮ icon to constrain the proportions of the logo, and then enter 50 percent for either the **W** or **H** scale value.

- Change the **X** value to 1250 pixels.

- Change the **Y** value to 970 pixels.

Figure 7-12.

Press the Enter or Return key twice to accept your changes and apply the transformation. Photoshop creates a new layer, names it automatically, and assigns its thumbnail a ⊡ icon to distinguish it from other, less smart layers.

4. *Add a drop shadow.* Smart objects support the parametric amenities available to other layers, including transparency, blend modes, and layer styles. This is fairly amazing, given that our Illustrator logo amounts to a foreign object, the appearance of which Photoshop has to calculate on-the-fly. To see for yourself, click the *fx* icon at the bottom of the **Layers** panel and choose **Drop Shadow**.

Accept the default settings, which are:

- A color of black and a **Blend Mode** of **Multiply**.

- An **Opacity** value of 75 percent.

- An **Angle** of 138 degrees (already established as the global light direction).

- **Distance** and **Size** values of 5 pixels.

Click the **OK** button to create a slight drop shadow. The foreign object fits right in.

Figure 7-13.

Figure 7-14.

5. *Place a Photoshop image.* Choose **File→Place** to import another file as a smart object. This time, instead of using vectors, we'll place a pixel-based cartoon by artist Jason Woliner. Select the file named *Germ.psd* in the *Lesson 07* folder and click the **Place** button. The germ enters our world big and scary, as in Figure 7-13.

6. *Scale and position the germ cartoon.* The germ looks frightening, but he's really too big to hurt anyone. Once again, we'll scale and position the layer from the options bar. Click the 🔒 icon to constrain the proportions and enter a **W** value of 25 percent. Change the **X** value to 250 pixels and **Y** to 350 pixels. Then press Enter or Return twice to complete the transformation. Again, Photoshop names the layer automatically and marks it as a smart object.

7. *Clone the Germ layer.* Now the germ is the right size, but there's just one of him. He needs some pals to form a proper infection. Good thing he's a smart object, the only function in Photoshop that can give birth to an army of clones that all reference a single source image. To clone the little fellow, press the Alt (or Option) key and drag the **Germ** layer onto the 🔲 icon at the bottom of the **Layers** panel, as in Figure 7-14. Or press Ctrl+Alt+J (⌘-Option-J on the Mac). Name the duplicate smart object "Germ 2" and click **OK**.

8. *Transform the Germ 2 layer.* With the **Germ 2** layer selected in the Layers panel, press Ctrl+T (or ⌘-T). Note that the options bar remembers the last values we entered, specifically, the 25 percent scaling. This may seem like a small thing, but where Photoshop is concerned, it borders on miraculous. It means that Photoshop knows that this image is set to 25 percent of its full size. Change the **W** value to –35 percent and the **H** value to 35 percent. This enlarges the image and flips it horizontally. And because Photoshop is referencing the original artwork, the transformation is nondestructive. Change the **X** and **Y** values to 1300 and 510 pixels, respectively, to move the germ to the other side of the fellow's head. Then press Enter or Return twice to accept the results, which appear in Figure 7-15.

Figure 7-15.

9. *Clone the Germ layer again.* Click the original **Germ** layer to select it. Then press Ctrl+Alt (⌘-Option on the Mac) and drag the germ down and to the left, to a comfortable position above the fellow's hand. This clones the germ to a new location. Next, double-click the new layer name in the Layers panel and call it "Germ 3." (There's no rule that says you have to clone from the first smart object; we did it just for placement.)

10. *Warp the Germ 3 layer.* We don't want our three germs to look identical—they're all individual infectors, after all—so let's use the Warp command to give the third germ some personality. Choose **Edit→Transform→Warp** or press my dekeKeys shortcut, Ctrl+Shift+R (⌘-Shift-R), to surround the newest germ with a *mesh*, a grid with four square corner handles, which let you stretch the image this way and that, and eight round control handles, which let you twist and bend the image. Drag any of the control handles to bend Germ 3 to your heart's desire. I found that pushing the middle of the germ's face up and to the right gave him a nice 3-D effect. You can duplicate my choices from Figure 7-16 if you want, but there are no rules. When you achieve an effect you like, press Enter or Return to accept the results.

Figure 7-16.

> Change your mind after you press the Enter key? No problem. The germ is a smart object, so you can always revisit the point where you last left off. Just choose the Warp command again to redisplay the warp mesh, with all lines and handles intact. To remove the warp entirely, choose None from the Warp pop-up menu in the options bar.

And there you have it—a compelling, expertly assembled advertisement. But imagine that the suits representing the soap company have demanded some crucial changes: They think that the logo is way too small and the germs aren't unappealing enough. (One guy called them "cuddly"!) And the germs can't be blue—that's the logo color. They have to be green. These eleventh-hour fixes might be cause for alarm for someone who used a traditional Photoshop composition. But let's see how smart objects save the day.

11. *Resize the logo.* Go to the **Layers** panel and click the vector-based **Glistenex Logo** layer. Then press Ctrl+T (⌘-T) to enter the Free Transform mode and do the following:

 - In the options bar, change the transformation origin to the bottom-right corner (▦, as in Figure 7-17).

 - Turn on the 🔒 icon to lock the proportions and increase the **W** value to 65 percent.

Figure 7-17.

 - Press the Enter or Return key twice to accept your changes.

Figure 7-18.

Back in the days before smart objects, one transformation would have been heaped upon the other, and the quality of the logo would have suffered considerably. But thanks to smart objects, Photoshop references the original Illustrator graphic and produces a razor-sharp transformation once again, as witnessed in Figure 7-18. But impressive as this new efficiency is, we've only begun to reap the benefits of working with smart objects. Let's keep reapin'.

12. *Edit one of the Germ smart objects.* To make all the germs look less cuddly, we'll need to access the original embedded contents of our linked Germ layers. Double-click the thumbnail for any one of the three **Germ** layers. Photoshop greets you with the alert message shown in Figure 7-19.

13. *Confirm the warning.* Photoshop lets you modify a pixel-based smart object by opening a temporary file that's extracted from the layered composition. Saving this file updates the composition. Why the warning? Because if you save the temporary file to a new location or under a different name, the entire process will fall apart. Now that you know, turn on the **Don't Show Again** check box and click **OK**. The germ appears in a new window, as in Figure 7-20.

Figure 7-19.

Figure 7-20.

14. *Liquify the germ.* In this window, all the limitations of smart objects drop away, permitting us to manipulate the germ just like any other layer. So we might as well push some pixels around. Choose **Filter→Liquify** or press Ctrl+Shift+X (⌘-Shift-X on the Mac) to bring up the massive **Liquify** dialog box. Along the left side of the dialog box, you'll see a set of tools you can use to push the pixels of this microbe around.

We'll learn more about the specifics of the Liquify command in the next lesson. For now, just experiment. For my part, I used the pucker tool to decrease the size of the eyes and the bloat tool to thicken the eyebrows. Then I used the warp tool to make the eyes angrier and the mouth snarlier, as in Figure 7-21.

Have fun with it. If you want to exactly match my outrageously vicious germ, click the **Load Mesh** button and choose the *Angry germ.msh* file, which I've placed in the *Lesson 07* folder, then click **Open**. When you get an effect you like, click the **OK** button to apply it.

Warp tool

Pucker tool

Bloat tool

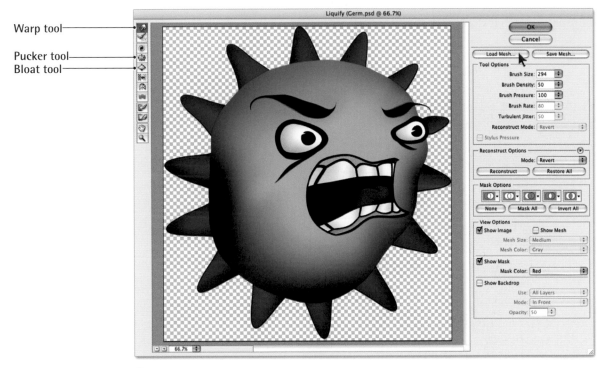

Figure 7-21.

Figure 7-22.

15. *Display the Hue/Saturation dialog box.* Now to make the angry germ turn green. Choose the classic color command **Image→Adjustments→Hue/Saturation** or press Ctrl+U (⌘-U).

16. *Replace the cyans with green.* We don't want to change the red of the tongue and the pink of the gums. So relegate your edits to the germ's flesh by choosing **Cyans** from the second pop-up menu. Enter a value of −50 into the **Hue** option box, which pushes the light blues into a more germy-looking green territory. When your settings match those in Figure 7-22, click **OK**.

17. ***Save your changes.*** Choose **File→Save** or press Ctrl+S (⌘-S) to save your changes to the smart object inside the layered composition. Then close the window that contains the mean green germ by clicking the ⊠ box in the title bar (◉ on the Mac) or by pressing Ctrl+W (⌘-W). A moment later, Photoshop updates the three germs—scaled, flipped, and warped to our specifications—without losing a smidgen of quality. Nice work! You finished the revision with time to spare.

18. ***Turn on the Extras group.*** Back in the **Layers** panel, click the empty box to the left of the group labeled **Extras** to turn on its 👁 icon and reveal a few additional lines of text that round out our advertisement, all visible in Figure 7-23.

Figure 7-23.

19. ***Export the contents of the Germ smart object.*** As I mentioned, Photoshop maintains no link to the original *Germ.psd* file on disk. So if you were to alter the original file after placing it as a smart object, none of your changes would affect the ad. But what if the clients are so happy with the modified germs that they want a version to use in other print material? The answer: Export the smart object.

Right-click (or Control-click) any one of the **Germ** layers in the **Layers** panel and choose **Export Contents**. Go ahead and accept the default filename and click **OK**.

I love smart objects, but they come at a price. Adding smart objects to a composition can have the undesirable effect of ballooning the file size and slowing the program. So while I encourage you to get in the habit of using them, I also recommend that you use them judiciously. Remember, be smart.

Nondestructively Editing a Photo with Smart Filters

As I alluded to at the outset of this lesson, *smart filters* provide a means of applying Photoshop's wide-ranging filter effects nondestructively and reversibly. Just as a live adjustment layer allows you to modify color adjustment settings any time you like, a smart object combined with a nondestructive smart filter lets you edit filter settings ad infinitum.

Smart filters are a recent by-product of smart objects. As a result, they don't have the same tried-and-true feeling as Photoshop's more mature functions. Their implementation is sometimes strange, so you may occasionally find yourself scratching your head trying to figure out how to pull off a specific effect. But while smart filters rely on a series of secret handshakes to get them up and running, the return on memorizing those handshakes—in the form of increased creative freedom—is well worth the commitment.

1. *Open a flat photograph.* In this exercise, we'll modify a basic (if beautiful) layer-free photograph. Go to the *Lesson 07* folder inside *Lesson Files-PsCS5 1on1* and open the file called *Soft portrait.jpg.* Provided to us by photographer Joey Nelson of iStockphoto, the image appears in Figure 7-24 on the facing page. In part due to the photographic process and in part thanks to my downsampling the photo with the Image Size command, the portrait is slightly soft. I want it to pop, so let's sharpen it with a smart filter.

PEARL OF ⬤ WISDOM

Because smart filters demand so much planning and jumping through hoops, this exercise keeps it fairly simple, employing smart filters to modify the contours and colors in a flat digital photograph. If you're looking for a glimpse into something more ambitious—such as, say, smart filters integrated into an elaborate layered composition and even applied to live type—check out the appropriately named sidebar "Smart Filters on Steroids," which begins on page 246.

Figure 7-24.

2. *Convert the layer to a smart object.* To add a smart filter, you need to convert the image to a smart object in one of the following ways:

- Choose **Layer→Smart Objects→Convert to Smart Object**. If you loaded dekeKeys back in the Preface (see Steps 8 through 10, page xix), you can press the shortcut Ctrl+⌐ (or ⌘-⌐).

- Right-click (or Control-click) the **Background** layer in the **Layers** panel and choose **Convert to Smart Object**.

- Choose **Filter→Convert for Smart Filters**. As shown in Figure 7-25, this method displays a message alerting you to the fact that the command makes a smart object. You already knew that, so turn on the **Don't Show Again** check box and click **OK**.

Photoshop names the new layer *Layer 0*. I suggest you rename it "Smart Object" or something equally meaningful.

Figure 7-25.

3. *Apply the first filter, Smart Sharpen.* Let's start the filtering process by firming the edges using Smart Sharpen (no relation). Choose **Filter→Sharpen→Smart Sharpen** and enter the following settings, all pictured in Figure 7-26:

- From the **Settings** pop-up menu, choose **Default.** (You don't really need to do this, but it will keep you from being confused by references to rodents from the last exercise.)

- Increase the **Amount** to 400 percent.

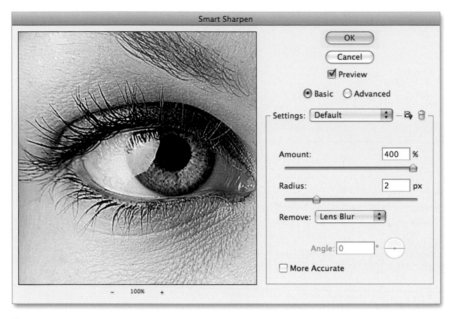

Figure 7-26.

- Change the **Radius** value to 2.0 pixels.

- Set the **Remove** pop-up menu to **Lens Blur**, generally the best setting for digital photographs like this one.

If the visible area in the preview window of the Smart Sharpen dialog box isn't to your liking, you can move the image around within that box by simply dragging within the preview. I moved the image to our model's right eye (left side of the image). Eyes are a good place to gauge the sharpening of portraits. You can also click your desired area in the main image window, and the preview will jump to the area you've indicated.

Figure 7-27.

Click the **OK** button to apply the filter. Photoshop adds not one but two items to the Layers panel. Pictured in Figure 7-27, they are an empty mask with Smart Filters on the right and Smart Sharpen below. If you turn off the ◉ icon for either of the new items, you temporarily disable the filter. But be sure to turn back on all ◉s before you proceed to the next step.

4. **Modify the filter settings.** Suppose you decide that the image is too sharp. Given that you can see the model's pores, bright edges around her hairs, and even a strong highlight line down the length of her nose, I think that's a wise conclusion. Adjust the Smart Sharpen settings like so:

- Reduce the **Amount** value to 300 percent. It's not a tremendous difference, but it helps.

- The edges are too thin for such a large image. So take the **Radius** value up to 4.0 pixels.

When your settings look like those in Figure 7-28, click the **OK** button.

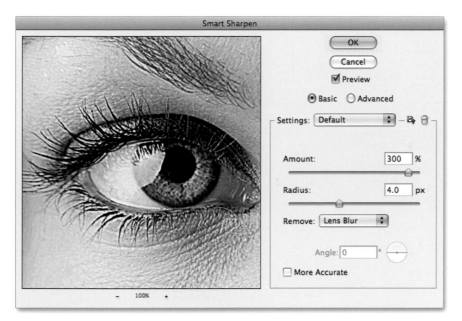

Figure 7-28.

5. **Open the Blending Options dialog box.** Smart filters allow you to change the opacity and blend mode assigned to a filtered image, free of the time constraints associated with Edit→Fade. To display the blend settings, do one of the following:

- Right-click (or Control-click) the **Smart Sharpen** entry in the **Layers** panel and choose **Edit Smart Filter Blending Options**.

- Double-click the tiny sliders (⇌) to the far right of the **Smart Sharpen** item.

Either way, Photoshop displays the **Blending Options** dialog box for the Smart Sharpen effect.

6. *Change how the filtered effect blends with the original.* If you look closely, you may see hot strands of yellow outlining the model's hair, a function of the blue channel drifting slightly out of registration with the other two. To get rid of the hot yellow strands and reduce the effects of the filter overall in the **Blending Options (Smart Filter)** dialog box:

• Change the **Mode** setting to **Luminosity**. As you may recall from the first exercise in this lesson (see Step 10, page 227), this setting eliminates any color artifacts associated with the sharpening effect.

• The image remains oversharpened, so take the **Opacity** value down to 40 percent.

As Figure 7-29 shows, the result is a more natural blend of sharpness and softness. Click **OK** to accept your changes. If you later change your mind, just double-click the ≑ icon again and Photoshop will once again display the Blending Options dialog box, with your last-applied settings intact.

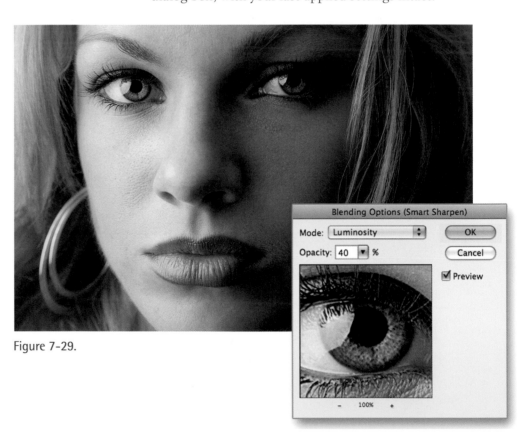

Figure 7-29.

7. *Apply the second filter, Median.* Now let's add another effect, this one designed to smooth over some of the choppier details in the image by averaging colors of neighboring pixels. Choose **Filter→Noise→Median**. In the **Median** dialog box, enter a high **Radius** value of 20 pixels and click **OK**. Thanks to the changeability of smart filters, you can start with a setting that you know is too high and dial it back with the Opacity setting or a blend mode.

PEARL OF WISDOM

As you can see in Figure 7-30, the Median entry sits above Smart Sharpen in the Layers panel. Although I question how much sense it makes for smart filters to be listed below the layer that they affect—if anything, the filtered effects are *in front of* the original image—the order of the individual smart filters is logical, with the most recent entry positioned at the top of the list and the oldest at the bottom. Feel free to drag a filter entry up and down the list to change the order in which it is applied.

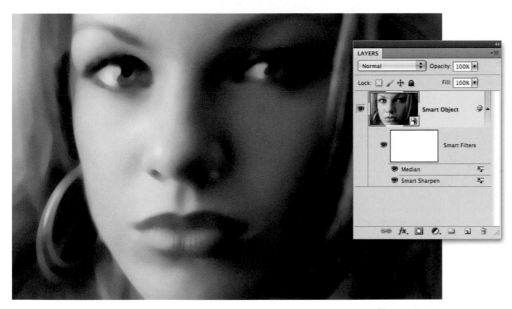

Figure 7-30.

8. *Change the blend settings for the Median effect.* Double-click the ⥮ icon to the right of **Median** in the **Layers** panel to bring up the **Blending Options** dialog box, and do like so:

 • Change the **Mode** setting from Normal to **Lighten**, which keeps the Median effect only where its pixels are lighter than they were in the Smart Sharpen version below.

 • Reduce the **Opacity** value to 50 percent to coat the photograph with a light, even haze.

Click **OK** to accept your changes. To get a sense of the way in which the Median effect smooths over and lightens the pores and other harsh, dark edges, click the 👁 icon in front of **Median** in the **Layers** panel to turn it off and on. Or check out Figure 7-31, which shows the two versions of the image side-by-side.

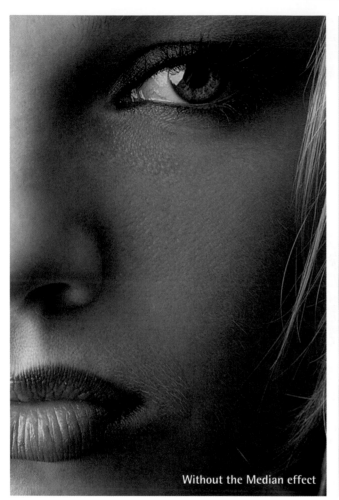

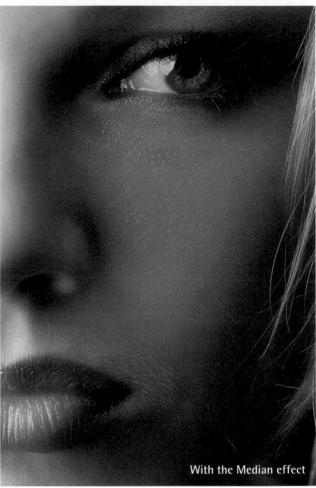

Without the Median effect

With the Median effect

Figure 7-31.

Now I want you to add another pass of sharpening to achieve a heightened contrast effect. I could apply the Smart Sharpen command again, but if I did, I'd get another Smart Sharpen entry in the Layers panel, and telling one Smart Sharpen from another could prove confusing. So better to apply a different filter, one just as suited to enhancing the contrast of an image: High Pass.

9. *Apply the third filter, High Pass.* Choose **Filter→Other→High Pass**. In the **High Pass** dialog box, enter a **Radius** value of 75 pixels and click **OK**. As shown in Figure 7-32 on the facing page, the image looks unnaturally gray; we'll solve that problem shortly.

10. *Move High Pass to the bottom of the stack.* High Pass appears at the top of the filter entries in the **Layers** panel because it was the last one applied. Under normal conditions, however, you're generally better off enhancing the contrast of an image before sharpening the edge detail and applying softening effects such as Median. To make it the first command in the smart filter pecking order, drag **High Pass** to the bottom of the **Smart Filters** list, as in Figure 7-32. After a moment's delay—as I mentioned earlier, smart filters are computationally intensive (which is to say, slow)—you should see a subtle shift on screen. As minor as this adjustment turns out to be, the simple act of reordering filters was not possible prior to smart filters.

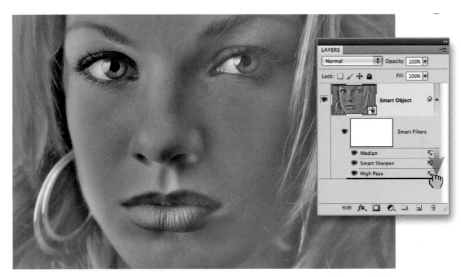

Figure 7-32.

11. *Edit the settings of Median and High Pass.* Given the relative newness of smart filters in Photoshop (they first sprung up in CS3), it's not surprising that they have their limitations. One example is the way Photoshop previews smart filter adjustments. Suppose you want to modify the blend settings associated with the Median (yes, again) and High Pass filters:

- Double-click the ⇄ icon for the **Median** entry to display the **Blending Options** dialog box, and raise the **Opacity** value to 65 percent. The image window and dialog box preview update to reflect your edit, just as you'd expect them to. Click **OK** to accept the revised setting.

- Now double-click the ⇄ for the **High Pass** item. Photoshop displays a warning, telling you that any filters on top of this

Figure 7-33.

one will not be previewed (see Figure 7-33). You'll be able to preview the results of the filter you're editing and anything below it. Nothing is below High Pass, so High Pass is all you see. As unfortunate as this is, you don't need to be reminded of it later, so turn on the **Don't Show Again** check box and click **OK**.

- Set the **Mode** option to **Overlay** and the **Opacity** value to 50 percent to blend the High Pass effect into the original image, as in Figure 7-34. Without seeing the other effects, you're working in the dark, but experience tells me that these settings should do the trick. Click **OK**. A few seconds later, Photoshop applies your changes to High Pass and restores the Smart Sharpen and Median filters.

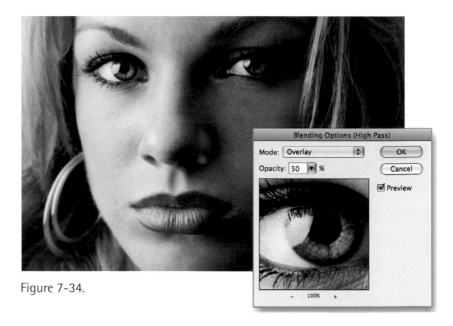

Figure 7-34.

12. *Load the Red channel as a selection.* To the left of the words Smart Filters in the **Layers** panel is an empty mask. You can use this *filter mask* to isolate the effects of your filters. I suggest that we focus the sharpening effects in particular to the darkest details by stealing a "natural" mask from the original image.

Here's how it works:

- Turn off all the smart filters by clicking the 👁 icon next to the **Smart Filters** mask. This restores the original image.

- Switch to the **Channels** panel. Since this is a portrait and thus rife with flesh tones, the Red channel is the brightest,

boasting the most contrast between highlights and shadows. Click the **Red** channel to view it in the image window, as in Figure 7-35. What you're seeing is called a *luminance mask* because you can use it just as it is to select the light regions of the image.

- Ctrl-click (or ⌘-click) the **Red** channel to load it as a selection outline. That's all it takes—your luminance mask is ready to roll.

13. ***Mask the effects of the smart filters.*** Return to the **Layers** panel. Turn on the filters by restoring the 👁 in front of **Smart Filters**, and click the filter mask to make it active. Ensure that the background color is black Then press Ctrl+Backspace (or ⌘-Delete) to fill the selection with black.

14. ***View the filter mask by itself.*** Press Ctrl+D (⌘-D on the Mac) to deselect the image. Next, Alt-click (or Option-click) the filter mask thumbnail to view only the mask. Pictured in Figure 7-36, this reverse version of the Red channel is known as a *density mask* because it reveals the darkest regions of the images, which in print are the areas of highest ink density. The upshot is that the effects of the smart filters are limited to the darkest areas of the photograph.

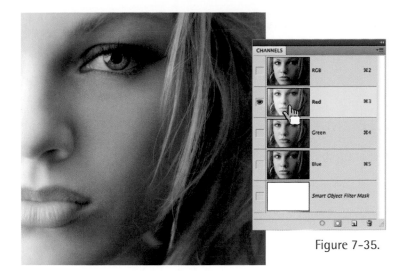

Figure 7-35.

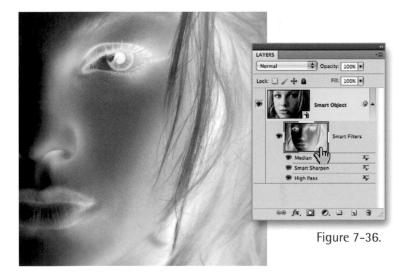

Figure 7-36.

Alt-click (on the Mac, Option-click) the layer mask thumbnail to return to the image. To compare the masked version of the filters to the unmasked one, Shift-click the filter mask thumbnail, which turns it on or off. By masking away the filters in the bright areas, we limit the sharpening and other effects to the dark details, which represent the real edges in the image, including the perimeter of the eyes, mouth, and nose. This is digital sharpening at its most subtle, not to mention its best.

Smart Filters on Steroids

During the step-by-step phase of our smart filter discussion, we stuck to the relatively prosaic task of applying corrective effects to a flat photograph. But in the right hands, smart filters can serve as radically creative tools as well. Only take care: As natural as it might seem to employ filters in a creative fashion, your artistic experimentation can turn into an unqualified efficiency pit as one filter after another fails to produce quite the desired effect. And if you already have experience losing track of time playing with filters, it only gets worse with smart filters. Not only can you stir a near-infinite variety of filter cocktails, garnished with different blend modes and opacity settings, but you can do it all nondestructively. This may lead you to ignore the obvious side effect of the parametric wonderland: your diminished capacity to get anything done. Few things are worse than wasting hours pilfering through filters only to wake up in the imaging equivalent of a foreign motel room with a severe hangover and a lampshade on your head. So as with other cocktails, pace yourself. Keep an eye on the clock. Avoid aimless wandering. And recognize when it's time to stop.

That said, you can accomplish some interesting stuff. By way of example, I started with the letterboxed composition below, comprising little more than another Joey Nelson photograph (already converted to a smart object) and some live text set against a black background. I then applied a labyrinthine combination of smart filters, adjustment layers, masks, and layer effects to achieve the movie poster at the bottom of the facing page.

I started by applying a sequence of effects filters to the smart object photograph. To follow along, open *Kill Jill art.psd* in the *Lesson 7* folder, select the **Model** layer, and try the following (all available from the **Filter** menu):

- **Artistic→Cutout**. Number of Levels: 6, Edge Simplicity: 1, and Edge Fidelity: 2. I changed the blend mode to Linear Light and the Opacity to 30 percent.

- **Sketch→Conté Crayon**. Default filter settings, with the blend mode set to Normal and 40 percent Opacity.

- **Noise→Add Noise**. Amount: 20 percent, Distribution: Gaussian, Monochrome: on. Opacity: 30 percent.

While I found the results intriguing (see the detail below), they didn't convey the effect I was looking for. So I decided to switch out a couple of the filters. Happily, you can swap any filter that calls up the big Filter Gallery, which includes Cutout and Conté Crayon. (To switch a non-Filter Gallery command such as Add Noise, you have to delete and reapply.)

After a bit of investigation, I decided to double-click Cutout and Conté Crayon (each) and replace them with Poster Edges and Reticulation, respectively. Here's how:

- **Artistic→Poster Edges**. Edge Thickness: 2, Edge Intensity: 1, Posterization: 5.

- **Sketch→Reticulation**. Density: 20, Foreground Level: 50, Background Level: 30.

Reticulation created enough noise for my tastes, so I turned off **Add Noise** by clicking its 👁. The result appears below.

The file includes a few dormant adjustment layers and layer effects. Go ahead and turn on all the 👁s in the **Layers** panel. Shift-click the **Eyes** layer mask to make it active. Set the Eyes layer to **Vivid Light** with a **Fill** value of 50 percent. Ctrl-click (⌘-click on the Mac) the **Eyes** mask to load it as a selection outline. Switch to the filter mask below the **Model** layer and press Ctrl+Backspace (⌘-Delete) to mask away the filters in the eyes. Then Alt-click (or Option-click) on the horizontal line between the Colorize and Model layers to combine the two into a clipping mask. Press Ctrl+D (⌘-D) to deselect the image. The finished poster shows the result.

Smart filters are also applicable to editable type. Select the **Kill Jill** layer, switch the blend mode to **Normal**, and choose **Filter→Convert for Smart Filters**. Then apply the following from the **Filter** menu:

- **Blur→Motion Blur**. Angle: 90 degrees, Distance: 200 pixels. I changed the Blend Mode to Linear Dodge (Add).

- **Other→Maximum**. Radius: 15 pixels. Changing the Blend Mode to Screen makes for letters inside letters.

For a bit more blur, I Alt-dragged (Option-dragged) the **Motion Blur** entry above Maximum to duplicate it. Then I double-clicked the ⇆ icon and reduced the **Opacity** to 20 percent.

Pictured below, the final movie poster includes some additional treatments assigned to the still editable Kill, Jill layer. You can check them out in *Finished movie poster.psd*, also included in the Lesson 7 folder. Admittedly, this is a whirlwind tour of the kinds of effects you can achieve when you combine Photoshop's parametric capabilities.

You may be feeling more than sufficiently enlightened after this first level of initiation into smart filters. If so, feel free to skip to the next exercise, "Making a Magical Pattern-Generating Smart Filters File," which begins on page 251. But if you're still craving mystery—and honestly, who isn't?—I have a puzzle for you: The Layers panel includes one filter mask that affects all filters applied to a single smart object. But what do you do if you want to apply different masks to different filters? Well, cue the *Twilight Zone* music: The only way to pull off this feat is to travel through another dimension, one where you can wrap one smart object inside another. That's the signpost up ahead—the next stop: Extra Credit.

In the case of our composition, the odd man out is Median. Much of its power is limited to the lightest regions in the image because you set Median to the Lighten mode (Step 8, page 241). Meanwhile, the mask limits the filters to the darkest areas. As a result, Median produces a very slight effect. We need to unmask the Median filter while leaving the sharpening effects masked, as outlined in the following steps.

15. *Duplicate the smart object.* Press Ctrl+J (or ⌘-J) to duplicate the Smart Object layer and all its filters. Rename the layer "Dummy." We'll come back to it in a moment.

16. *Put the original smart object inside a new smart object.* Click the **Smart Object** layer to select it. Then choose **Layer→Smart Objects→Convert to Smart Object** or press my keyboard shortcut, Ctrl+⌐ (or ⌘-⌐). This puts the smart object, complete with its smart filters, into another smart object container.

17. *Open the new smart object.* In the **Layers** panel, double-click the layer thumbnail (still called Smart Object, but now without the smart filters or filter mask) to bring up an image window titled *Smart Object.psb*, which includes the nested smart object and all your masked filters.

If you get the smart objects warning, it's because you didn't turn it off back in the "Working with Smart Objects" exercise (Step 13, page 233). Select the **Don't Show Again** check box and click **OK**.

18. *Turn off the Median filter.* This and the next couple of steps are devoted to the task of moving the Median filter from the smart object you duplicated in Step 15 to the newest "parent" object that you made in Step 16. This task, which sounds much tougher than it is, means we won't be needing the Median filter. Still in the Layers panel, click the 👁 icon in front of **Median** to turn it off.

19. ***Close the smart object and save your changes.*** Close the *Smart Object.psb* file by clicking the ⊠ box in the title bar (⊙ on the Mac). Then click the **Yes** (or **Save**) button to update the smart object and return to the *Soft portrait.jpg* composition.

20. ***Move the Median filter from Dummy to Smart Object.*** Again in the Layers panel, drag the **Median** entry from the **Dummy** layer to the thumbnail for the **Smart Object** layer. Click the ▼ to the right of the ⊚ icon for the Smart Object layer to expand the layer and reveal the smart filter items, which include Median and an empty filter mask, as shown in Figure 7-37.

21. ***Throw the Dummy layer away.*** You don't need it anymore. Nuke it with impunity.

 Next, I want to expand the shadows and downplay the highlights a bit using the Shadows/Highlights command. Naturally, we want to apply the command as a nondestructive edit. Unfortunately, Shadows/Highlights isn't available as an adjustment layer. Why not? Because even though Shadows/Highlights is organized with the color commands, it's actually a filter. Fortunately, you can now apply the command nondestructively as a smart filter.

22. ***Apply the fourth filter, Shadows/Highlights.*** Choose **Image→Adjustments** to reveal the filter disguised as a color adjustment function, Shadows/Highlights. Choose it to display the **Shadows/Highlights** dialog box. Make sure the **Show More Options** check box is turned on, and then do the following:

 • Press the Alt key (Option on the Mac) and click what is now the **Reset** button (formerly Cancel) to restore the default settings.

 • In the **Shadows** section, set the **Amount** value to 5 percent. Then set the **Tonal Width** and **Radius** values to 50 percent and 100 pixels, respectively.

 • For **Highlights**, take the **Amount** value slightly higher, to 15 percent. Again set **Tonal Width** and **Radius** to 50 percent and 100 pixels.

 • Leave the other values set to their defaults, which include +20 for Color Correction, 0 for Midtone Contrast, and 0.01 for the Clip values.

All settings appear in Figure 7-38. Assuming that you've entered everything correctly, click the **OK** button.

Figure 7-37.

Figure 7-38.

23. ***Change the blend settings for the Shadows/Highlights effect.*** The Shadows/Highlights command has a habit of dimming the colors in an image, regardless of the Color Balance value. To compensate, double-click the ⯮ icon for Shadows/Highlights in the **Layers** panel. Then change the **Mode** to **Luminosity** and the **Opacity** to 65 percent, which restores the original colors and backs off the effect, respectively. Click **OK** to accept.

The first two examples in Figure 7-39 compare the original image to the finished smart object. The changes are both subtle and precise. Even so, it may occur to you that you could have achieved the same goal with less chicanery using static filters. Very likely, but as with any parametric modification, the advantage of smart filters is changeability. If I wanted, say, a higher contrast effect with more brilliant colors, I'd simply double-click the ⯮ icon for the Shadows/Highlights filter, change **Mode** to **Overlay**, and reduce the **Opacity** to 35 percent, and I'd be rewarded with the last example in the figure below. Smart filters may be a bit overwrought, but it's hard to object to anything that so willingly adapts to your every creative whim.

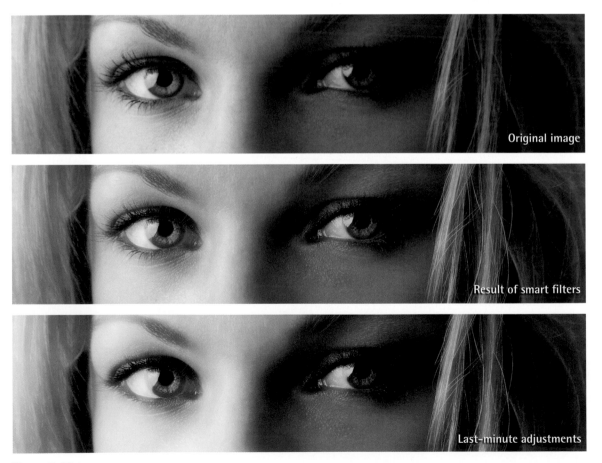

Original image

Result of smart filters

Last-minute adjustments

Figure 7-39.

Making a Magical Pattern-Generating Smart Filters File

In the preceding exercise, you saw how smart filters allow you to create subtle, nondestructive edits to a simple portrait. And if you read the sidebar on page 246, you've seen how you can go crazy with smart filters, making transformations to a portrait that are in no way subtle but nonetheless still reversible. Who's to say we need to start with any image at all, portrait or otherwise?

In this exercise, I'll show you how to create one of the most enlightening and flat-out practical files you've ever made. One moment a starfield, the next a wall texture, the next a bird's-eye view of landmasses. A file that requires no initial image and delivers one amazing result after another. The kind of file you'll find yourself revisiting again and again. Whether you're a novice or a seasoned pro, a designer or a photographer, I think you'll be duly impressed. And it's so very easy.

1. *Create a new image.* This exercise requires no image, no base photograph, nothing. Just Photoshop and a sense of adventure. Choose **File→New**. In the **New** dialog box, name the image "My Smart Filters File." Make the image as big as you want, say, 2000 by 2000 pixels. The resolution doesn't matter. Set the **Color Mode** to **RGB** and the **Background Contents** to **Transparent**, as in Figure 7-40. Click **OK**.

Figure 7-40.

2. *Rename Layer 1.* In the **Layers** panel, double-click **Layer 1** and rename it "Base." Then press Enter or Return.

3. *Fill the layer with gray.* Choose **Edit→Fill**. In the **Fill** dialog box, choose **Color** from the **Use** pop-up menu. Change the **H**, **S**, and **B** values to 0, 0, and 15, respectively, as in Figure 7-41. Click **OK**. In the **Choose a Color** dialog box, make sure the **Blending** option is set to **Normal**, the **Opacity** is 100, and the **Preserve Transparency** check box is turned off. Click **OK** again. You should see a field of dark gray.

Figure 7-41

4. *Convert the Base layer to a Smart Object.* In the **Layers** panel, right-click anywhere except the image thumbnail and choose **Convert to Smart Object**.

5. *Save your file.* Zoom the image to 100 percent so you can see the pixels in later phases. Then choose **File→Save**. Click the **Save** button. Congratulations. You have yourself a boring but beautiful base file.

The next phase is to turn this dark grayness into a field of random stars. The technique we'll use is old—one that was employed in the remastering of *Star Wars,* no joke—but the difference here is that we'll do it all with two smart filters and an adjustment layer. As if you're some kind of 21st-century Photoshop-wielding Jedi.

6. *Create some noise.* Visual noise, that is, nothing to rouse the neighbors. Choose **Filter→Noise→Add Noise**. In the **Add Noise** dialog box, set the **Amount** to 20. Then select **Gaussian** and **Monochromatic**. Click **OK**. Now you have some noisy garbage like that shown in Figure 7-42, on the facing page.

Figure 7-42.

7. *Add another filter effect.* First, right-click the white filter mask in front of the words Smart Filters in the **Layers** panel and choose **Delete Filter Mask** to help reduce clutter. Then, choose **Filter→Blur→Gaussian Blur**. In the **Gaussian Blur** dialog box, set the **Radius** to 2.0 and click **OK**. Now the noisy garbage is out of focus, as you can see in Figure 7-43.

Figure 7-43.

8. *Create a Levels adjustment layer.* Choose **Layer→New Adjustment Layer→Levels**. Name the new layer "Stars" and click **OK**.

9. ***Adjust the levels.*** In the **Adjustments** panel, set the first numerical value, on the far left, to 56. Press the Tab key twice and set the third value to 62. As you can see in Figure 7-44, you now have a starfield, like the one used in *The Empire Strikes Back* or the only slightly less famous Lesson 5 of this book.

Figure 7-44.

But better still, you can edit it. Some options:

- You can double-click the **Gaussian Blur** entry in the **Layers** panel, and adjust the **Radius** in the **Gaussian Blur** dialog box to make the stars bigger or smaller.

- Click the **Stars** layer and adjust the **Levels** settings in the **Adjustments** panel if you want to make the stars brighter and more plentiful or dimmer and more scarce.

When you have the stars the way you like, choose **File→Save** to update your file.

10. ***Create a new pattern.*** Stars aren't the only magic this new file can create. You can use the same two smart filters and turn them into a stucco pattern. Start by clicking the ☻ next to the **Stars** layer to turn it off. Click the **Base** layer to make it active. Choose **Filter→Stylize→Emboss**. In the **Emboss** dialog box, ignore the Angle value, set the **Height** to 3, and set the **Amount** to 300. Click **OK**.

11. ***Add a Hue/Saturation adjustment.*** Choose **Layer→New Adjustment Layer→Hue/Saturation**. Name the layer "Color" and click **OK**. In the **Adjustments** panel, turn on the **Colorize** check box, and set the **Hue** and **Saturation** values to whatever you like. I recommend 30 and 15, respectively, but you may have different tastes in imaginary digital paint.

Check out the results in Figure 7-45. That's a darn nice texture, friend. Some might even call it a bump map. To achieve different results, adjust the Gaussian Blur, Emboss, and Color (Hue/Saturation) settings.

Figure 7-45.

12. ***Add additional texture.*** Just for fun, let's enhance the stucco effect with some additional noise and texture. Click the **Base** layer again. Press the D key to make sure the foreground and background colors are black and white, respectively, and then choose **Filter→Render→Clouds**. This effect may look like smoke, but it's actually another style of noise called fractal noise, made from nothing but mathematical calculations. In the **Layers** panel, drag the **Clouds** item to the bottom of the smart filter stack, below Add Noise.

13. ***Add another filter.*** Choose **Filter→Sketch→Note Paper**. Accept the default settings and click **OK**. Can't you just imagine the palette knife that was dragged across that wall?

14. ***Further manipulate the filters.*** Turn off **Emboss** to make a series of inverted islands. Double-click **Note Paper** and reduce the **Relief** value to 6 in the filter's dialog box. Then play with the **Image Balance** value to change the size of the landmasses. I set mine to 25. Click **OK**. The result is the map of the imaginary land you see in Figure 7-46 on the next page.

15. ***Add yet another filter.*** Choose **Filter→Sketch→Plaster**. In the **Plaster** dialog box, set the **Image Balance** to 30 and click **OK**. Then, in back in the **Layers** panel, click the 👁 next to the **Note Paper** filter to turn it off.

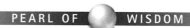

PEARL OF WISDOM

By now you get the idea. You can move filters around, turn on and off adjustment layers, and create an infinite variety of textures, patterns, and entire worlds from nothing but an image full of grayness.

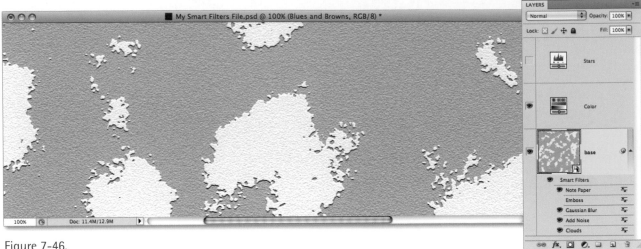

Figure 7-46.

16. **Add a gradient map adjustment layer.** Turn off the **Colorize** adjustment layer by clicking its 👁. Then choose **Layer→New Adjustment Layer→Gradient Map**. Name your new layer "Blue and Browns" and click **OK**. A gradient map takes a range of colors (the gradient) and maps them to the lightness and darkness values in your image. In the **Adjustments** panel, click the ▮ to the right of the gradient preview, and choose the gradient that starts with sky blue on the right and moves through light brown, as shown in Figure 7-47. Click **OK**, and you have a futuristic map for your imaginary isles.

Choose **File→Save** to save your changes. It's a 12MB file, hardly larger than the 11MB required to express a 2000-by-2000-pixel image. Put the file in a safe place. You may find yourself needing it, and many more of the variations it might supply, in the future.

Figure 7-47.

WHAT DID YOU LEARN?

Match the key concept in the numbered list below with the letter
of the phrase that best describes it. Answers appear upside-down
at the bottom of the page.

Key Concepts

1. Filters
2. Smart object
3. Focus
4. Sharpening
5. Radius
6. Warp
7. Liquify
8. Smart filter
9. High Pass
10. Median
11. Luminance mask
12. Gradient map

Descriptions

A. A method of layer transformation that allows you to move points on a mesh to reshape and stretch an image.

B. The clarity of the image formed by the lens element and captured by the camera, whether digital or film.

C. The thickness of the effect applied by a filter, often expressed as a softly tapering halo.

D. Commands from the Filter menu or the Adjustments panel that can be applied nondestructively to a smart object.

E. A filter with a massive dialog box that allows you to warp, bloat, pinch, stretch, and generally swirl around pixels.

F. A mask created by selecting just the lightest areas of an image.

G. Removing softness in a photograph by increasing edge contrast.

H. A special variety of layer that wraps the original content of an image inside a protective container, allowing pixel modifications to be made without damaging or changing the original contents

I. An effect that applies a range of colors based on the lightest and darkest areas of an image.

J. A varied set of Photoshop commands that apply effects to an entire image.

K. A filter that mimics the functionality of Unsharp Mask by retaining areas of high contrast and sending low-contrast areas to gray.

L. A simple filter that averages the colors of neighboring pixels in sweeps defined by the radius value.

Answers

1J, 2H, 3B, 4G, 5C, 6A, 7E, 8D, 9K, 10L, 11F, 12I

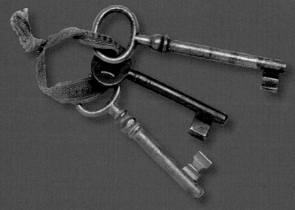

TRANSFORM AND DISTORT

MOST OF THE SKILLS we've covered in this book have been about enhancing or refining images—taking them to a final destination in which they are arguably improved yet still recognizable versions of their original selves. Up until this point, we haven't done a great deal of what Photoshop is notorious for, transforming an object into something noticeably different. Oh sure, we've encountered an unrealistically large cartoon germ and the odd dinosaur posing as a trusty steed. But even when my compositional creativity has run amok, for the most part we've been working with objects that have come out of our Photoshop machine in much the same shape and form as when they went in.

And yet, Photoshop is lauded and cursed for its ability to distort and mislead. And when people wring their hands over not being able to trust their own eyes anymore, they are more than likely concerned with the work of the Photoshop tools we'll cover in this lesson.

You can see why people would be disturbed. Just look at what a modern imagination such as my own can do to the work of one of the masters of the Italian Renaissance. In Figure 8-1, I've taken Raphael's masterpiece, *Portrait of Maddalena Doni* (top image), and turned her from a distinguished 16th-century merchant's wife to a doe-eyed 21st-century starlet who just landed a choice role in a historical epic about a 16th-century merchant's wife (bottom image). Armed with the Liquify tool, I've enlarged her eyes, plumped her lips, toned her shoulders, and given her a nose job. Basically, she's gone Hollywood. You can call it my interpretive modernization of the feminine ideal or a boorish—if not downright offensive—attack on classic culture, but one thing is certain, with Photoshop's distortion tools, nothing is sacred.

Whether you want to simply scale or skew an item to make it fit your composition or completely bend or squish an object in your image, Photoshop has a small but powerful set of tools to help you.

Raphael's Maddalena

After visit to Dr. Deke, A-List Plastic Surgeon

Figure 8-1.

ABOUT THIS LESSON

Project Files

Before beginning the exercises, make sure you've downloaded the lesson files from *www.oreilly.com/go/Deke-PhotoshopCS5*, as directed in Step 2 on page xvi of the Preface. This means you should have a folder called *Lesson Files-PsCS5 1on1* on your desktop (or whatever location you chose). We'll be working with the files inside the *Lesson 08* subfolder.

This lesson teaches you how to use Photoshop's distortion tools to bend, bloat, nip, tuck, squish, and reposition the subjects of your images. You'll learn how to:

Video Lesson 8: Liquify in Motion

To get your bearings with Photoshop's powerful distortion tools, it's best to watch them in action. So in this video lesson, I demonstrate the Liquify tool that you'll see later in the book-based exercise. There's nothing quite like watching the occasionally wacky, always entertaining pixel-squishing and pixel-stretching power of Photoshop transformations in motion. I'll review all the tools you have at your disposal in Liquify, from the straightforward Warp to the surreal Turbulence.

To experience Liquify live, visit *www.oreilly.com/go/deke-PhotoshopCS5*. Click the **Watch** button to view the lesson online or click the **Download** button to save it to your computer. During the video, you'll learn these shortcuts:

Operation or Tool	Windows shortcut	Macintosh shortcut
Apply Liquify	Ctrl+Shift+X	⌘-Shift-X
Warp tool	W	W
Undo last distortion in Liquify	Ctrl+Z	⌘-Z
Increase brush size in Liquify	Ctrl+⬚	⌘-⬚
Decrease brush size in Liquify	Ctrl+⬚	⌘-⬚

And the hand-wringers will have even more to worry about with Photoshop CS5 and its addition of puppet warp, which allows for easy repositioning of specific parts of humans, inanimate objects, and even text. When you can't even trust the letters of the alphabet to go undistorted, you know that anything goes.

The Shape of Things to Come

The tools in this lesson are ultimately concerned with reshaping. You've already seen how the Transform command (obtained by choosing Edit→Transform), allows you to change the proportions or rotation of your image. But Transform can be used also to skew and slant angles, in effect stretching and squishing the content that is delineated by those angles, as in the top *shape* in Figure 8-2. Items transformed this way are still more-or-less recognizable even after the transformation is complete.

But the real stretching and squishing—not to mention outright twirling and bending—power comes from three Photoshop features that let you do much more than change the box that bounds your content. With these tools, your images can be manipulated until even their own mothers don't recognize them:

- The Liquify filter, accessed via Filter→Liquify, is not really a filter at all but an independent program that runs inside Photoshop. Liquify lets you brush with a variety of tools that distort an image in a multitude of ways. You can warp (as we did in the preceding lesson), pinch, bloat, and generally push your pixels around inside Liquify, as I did to the letters in the second entry in Figure 8-2.

- Content-aware scaling (applied via Edit→Content-Aware Scale) allows you to stretch one part of an image (say, the background) while leaving other parts (like foreground objects) unscathed, as in the third entry in the figure. Content-aware scaling is great for changing the relative scale of items in a composition without having to add a bunch of layers.

- New to Photoshop CS5, the Puppet Warp command (employed by choosing Edit→Puppet Warp) lets you place pins in an image and then drag to change the distance between those pins, thus stretching, bending, and twisting specific areas. If you've ever wanted people or text to do your bidding, as I did to the letters in the last entry in Figure 8-2, puppet warp is what you've been waiting for.

Transform

Liquify

Content-Aware Scale

Puppet Warp

Figure 8-2.

Figure 8-3.

Figure 8-4.

Applying Free Transform to Scale and Align Perspective

As powerful as Photoshop is, little about the program is obvious. For instance, how do you rotate a layer? Sure, we've seen the Rotate command way back in Lesson 2, but that feature turns the entire image, so it doesn't solve the problem of rotating and scaling one layer to make it fit into the rest of a composition. For this common problem, the solution is the Free Transform command, which allows you to rotate and scale one layer independently of the rest of the image in one encompassing operation.

Case in point: I was creating an opening graphic for a lesson in this book's little brother, *Photoshop Elements 8 One-on-One*. The sign-toting robot in Figure 8-3 was the perfect subject for the scenario I wanted to create, but his sign was blank in the original image. My goal was to create some robot-appropriate text that would make this charming little automaton the perfect ambassador for a discussion of the auto commands in Elements. In the following lesson, I'll show you how the Free Transform command let me and my little robot friend express ourselves appropriately and proportionally.

1. *Open the robot image.* Navigate to the *Lesson 08* folder inside *Lesson Files-PsCS5 1on1* and open the file called *Automation Boy.psd*. The model in this image is a charming 3-D illustration from Fotolia.com artist Leo Blanchette. Our green-and-white representative of robot-kind has a blank sign that is just waiting for the appropriate message to be displayed.

2. *Turn on the text layer's visibility.* I've already created a layer for you with the message I want to display on the robot's sign. In the **Layers** panel, click the space to the left of the **I ♥ Automation** layer to turn on its 👁 and make it visible. The robot mantra flashes across the screen. As you can see in Figure 8-4, it's not going to fit its intended destination in its current state. We need to change the angle, size, and distortion (*perspective* in faux 3-D) of the text to match the sign.

3. ***Apply Free Transform to the text layer.*** Ensure that the text layer is active by clicking it in the Layers panel if necessary. Choose **Edit→Free Transform** or press Ctrl-T (⌘-T). In Figure 8-5, you can see that the Transform bounding box that Photoshop creates around the text has room for descenders, should any of the letters happen to have them. Because we're working with all caps, the extra space below the text doesn't need to fit on the sign.

Figure 8-5.

You may have noticed that the command just below Free Transform in the Edit menu, called simply Transform, has a flyout menu that contains a variety of transformation options such as Scale, Rotate, and Skew, all of which sound like they would be useful in this example. But once you choose a command from this list, you are locked into that specific kind of transformation. Since we have to make multiple tweaks, the Free Transform command offers the flexibility we need.

4. ***Drag in the handles to make the text layer narrower.*** Hover over the handle in the middle of the left side of the bounding box. When you get a double-headed arrow, drag the side inward, as in Figure 8-6. Then do the same with the right side. Adjust the sides so that the width of the layer is roughly the width of the sign. We'll do a better job of lining up the angle in the next step, so for now, just approximate the width you need.

Figure 8-6.

5. ***Rotate the layer.*** Hover over the handle in the left corner of the bounding box until you get a curved double-headed arrow, like the one in Figure 8-7, and then drag the corner upward so that the angle of the text aligns as closely as possible with the angle of the sign. Click anywhere inside the box to reposition the layer as you transform it. If necessary, and it probably will be, grab each of the side handles again to readjust the width. Remember: Use the text, not the bottom of the box, as your reference.

Figure 8-7.

6. **Abandon the transformation.** You'll notice that you can get the angle of the text fairly close to the angle of the sign, but matching the perspective requires skewing the sides of the text. We can't properly accomplish this on a text layer, so we'll need to start over.

Anytime you need to escape a transformation, you can press the Esc key or click the ⊘ in the options bar to abandon your change. Select one of those options now.

7. **Change the text into a shape.** To change the text into a shape that can undergo the transformation we're looking for, right-click any empty area in the **I ♥ Animation** layer in the Layers panel and choose **Convert to Shape** from the context menu. You'll notice that Photoshop turns the text into a vector mask, which can now be manipulated more exactly. The outlines you see around the text will disappear as soon as you deselect the vector mask in the Layers panel by clicking another part of the layer.

Once you convert the text to a shape, you can no longer edit the contents (for example, you can't change *Automation* to *Girl Robots*). The text is now a drawing of type rather than actual type.

8. **Re-evoke the Free Transform command.** Press Ctrl-T (⌘-T) to once again start the Free Transform operation. This time, the bounding box better fits the layer. Because Photoshop no longer understands the contents of the layer as text, it's no longer leaving room for descending letters. Reposition, resize, and re-angle the layer, as you learned to do in Steps 4 and 5. Extend the sides all the way to the edges of the sign. We'll want to add a small margin later, but for now, seeing how the edges of the Transform bounding box and the sign line up is helpful.

9. **Skew the text layer to change the perspective.** Hold down the Ctrl key (⌘ key on the Mac) and choose one of the four corners of the bounding box. (I found it easiest to start with the upper-left corner.) When you press the Ctrl (⌘) key, your cursor changes to a gray arrow and Photoshop allows you to move the corners independently. Move the upper-left and lower-right corners in, and keep adjusting the corner points until the text appears to be at the same perspective as the sign, as shown in Figure 8-8. You can see that leaving the text slightly wider than how we ultimately want it is helpful for gauging the relationship between the text layer and the sign.

Figure 8-8.

10. *Drag in the sides to create a margin.* Once you get the corners positioned where you like them and align the layer's edges with the sign's edges, drag in the sides to add some white space around the text. When you get everything just so, press Enter (Return) or click ✔ in the options bar to accept your transformation.

11. *Add an inner shadow to the text.* Now that the message is in the right place, let's integrate the letters into the sign a little better. Start by clicking the *fx* icon at the bottom of the Layers panel and choosing **Inner Shadow**. In the **Layer Style** dialog box, drop the **Opacity** to 45 percent but otherwise leave the default settings. Click **OK** and you'll see how the text embeds slightly into the material of the sign, as in Figure 8-9.

Figure 8-9.

12. *Create a new layer for a shading effect.* To give the text the highlight and shadow appropriate to its new orientation, we're going to create a gradient-style effect. Start by Alt-clicking (Option-clicking) the ◻ icon at the bottom of the **Layers** panel to create a new layer. Name the layer "Shading" and click **OK**.

13. *Paint white across the top.* Press B to get the brush tool and use the bracket keys to size your brush so it's about half the height of the sign. Right-click and set your brush hardness to about 50 percent. Press the D key to make sure your colors are set to their defaults, and then press the X key to make white the foreground color. Paint with white across the top half of the sign.

14. *Paint black across the bottom.* Press the X key again to switch the foreground and background colors. Then paint the bottom half of the sign black. Your image should look as defaced as mine is in Figure 8-10.

15. *Clip the shading layer to the text layer.* Choose **Layer→Create Clipping Mask.** When you do so, the shading you've painted will clip the layer beneath it, limiting the shading effect to just the letters, as in Figure 8-11, on the next page.

Figure 8-10.

Figure 8-11.

16. **Adjust the Shading layer.** Set the blend mode to **Overlay** and reduce the **Opacity** of the **Shading** layer to 30 percent.

You can see the final result in Figure 8-12. I took artistic license and turned off some of the layer. The robot's message is now fully integrated into his sign, thanks to the power of the Free Transform command.

Figure 8-12.

Using Liquify to Fix Posture and Appearance

In the last lesson, we saw some of Photoshop's most practical filters, but the award for the most powerful filter goes to Liquify. Well, Photoshop calls it a filter, and it lives in the Filter menu, but it's really an independent utility that runs inside Photoshop. The Liquify dialog box has a vast array of tools that give you the power to melt, pinch, swirl, smush, and much more. These tools make Liquify ideally suited to cosmetic surgery.

The Liquify filter is one of Photoshop's great destructive retouching tools. Meaning that it permanently modifies pixels in the name of making the subject of your photograph look her or his best. Notice that I positioned the feminine pronoun first; that was not by accident. These days, Liquify is used to tweak virtually every professional glamour shot on the planet. But despite Liquify's almost Dali-esque powers, it needn't be used to create unrealistic depictions. In the following exercise, we'll use the tool to fix some unfortunate side effects of our model's posture, undoubtedly bringing her a little bit *closer* to how her mother would assert she looks in real life.

1. *Open an image that you want to distort.* Begin by opening the image *Head tilted.jpg*, which you'll find in the *Lesson 08* folder inside *Lesson Files-PsCS5 1on1*. As you'll notice in Figure 8-13, this image (from Fotolia.com contributor Serg Zastavkin) shows an attractive woman whose position, posture, and wardrobe are doing less than conventionally flattering things to various parts of her body.

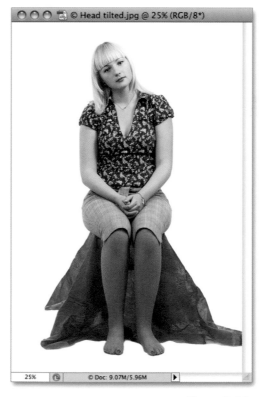

Figure 8-13.

2. *Choose the Liquify command.* Choose **Filter→Liquify** to display the **Liquify** window, which appears in Figure 8-14. The window, which we first saw in the previous lesson, sports twelve tools on its left edge and a slew of options on the right. The rest of the window is devoted to the image itself.

Many of the navigation techniques that work outside the Liquify window work in it as well. You can zoom in or out by pressing Ctrl+⊡ or Ctrl+⊡ (⌘-⊡ or ⌘-⊡ on the Mac), respectively. Press the spacebar and drag to pan the image.

Figure 8-14.

3. **Select the warp tool.** Click the topmost tool in the Liquify window or press the W key to select the warp tool, which lets you stretch or squish details in an image by dragging them. (Photoshop calls the warp tool forward warp, as if there were any such thing as backward warp.) Of all Liquify's tools, the warp tool is the most consistently useful.

4. **Set the zoom to 100 percent.** Set the zoom to 100 percent by pressing Ctrl-1 (⌘-1). Alternatively, you can set the zoom by hand using the pop-up menu in the lower-left corner of the Liquify dialog box. Then press the spacebar for an on-the-fly hand tool in Liquify (as well as in Photoshop proper) and drag so that the top half of the model's body fills the image preview.

5. **Adjust the brush settings.** Okay, here's where the inexactness of my instruction that I warned you about begins. You want a nice big brush, so press Shift+⬚ until your brush size covers her entire torso, somewhere around 750 pixels.

6. **Drag each elbow upward.** Note that our model's elbows are uneven. Start by clicking near her elbow on the left side, as I've indicated in Figure 8-15, and gently push the pixels upward so that her hips elongate, her elbow rises, and her posture (on her right side, at least) improves dramatically. Err on the side of moving inward rather than outward. Move her right shoulder (the left side of the image) up to match the other side. Don't worry about smushing her face. Then do the same for her right elbow. Try to ignore the other aspects of her posture, and get her elbows roughly in alignment. You can see the results of my brushstrokes in the preview window of the figure.

My general advice for using the Liquify tool is to apply as slight a modification as you can. That is, work as slowly and carefully as your patience and time allotment allow. I usually start big and move into smaller adjustments as I work.

Start at her elbow and gently push upward

Figure 8-15.

7. **Decrease the brush size.** To work on her hips, reduce the brush size by pressing and holding the Shift and ⬚ keys until you reach about 375 pixels.

8. **Pull her thighs and hips upward and inward.** The stool our lovely model is sitting on is having an unfortunate effect on her thighs and hips. Press and hold the spacebar and drag so that her lower body is visible. Start at the point I've indicated in Figure 8-16 and restore a more flattering look to her lower body by moving upward and slightly inward, elongating the hips. Remember the following as you work:

 - Keep your strokes very short. I used three strokes on the left side and four on the right, moving bulging areas in and up.

 - Evaluate each brushstroke as you apply it. Remember you can Undo any stroke and use the Step Backward command to go back more than one step if necessary.

 - Generally, you want to drag *on* the detail that you want to move. In this case, we want those areas that are being smushed out by the stool to move, so start your drag near the outer edge of her pants.

 - When you're compressing one area, you're stretching another. In this case, the background is white, so it's forgiving. If we had a busier background, you'd need to watch for pixel stretching outside her body.

 My results are shown in Figure 8-16.

9. **Reduce the brush size again and drag in her arms.** Moving her elbows upward can cause her arms to look too wide. Press the ⬚ key until your brush is about 150 pixels. Then choose some key spots along her arm and pull them inward. If you like, you can actually pull down her cap sleeves slightly to cover the top of her arms a bit. (I think a longer sleeve looks nicer in this case. Call me not-a-slave-to-fashion.)

Choose key spots on the outer edge, where the stool has caused a bulge, and move inward and upward

Figure 8-16.

10. ***Switch to the pucker tool.*** The pucker tool is great for areas that need to be constricted. It's particularly useful when the use of the warp tool has caused some lumpiness. In my case, her arm on the right side of the image is looking a little bumpy from my attempts to squish it inward.

Grab the pucker tool from the toolbox (it's the fourth one down, as you can see in Figure 8-17). Press the ⬚ key several times to reduce the brush size to around 50 pixels. Click at the top of the outer edge of her arm where the sleeve starts, and then Shift-click at the outer edge near her elbow to draw a line of pucker down the side (both areas are indicated in Figure 8-17). This should smooth out any lumps you may have caused with the warp tool. Do the same on the other arm if necessary.

You can change the brush size by pressing a bracket key, just like with other brush tools in Photoshop. But the shortcut behaves a bit differently. Press the ⬚ or ⬚ key to scale the brush by 2 pixels. Press and hold the keys to scale more quickly. Press Shift+⬚ or ⬚ to scale the brush in 20-pixel increments.

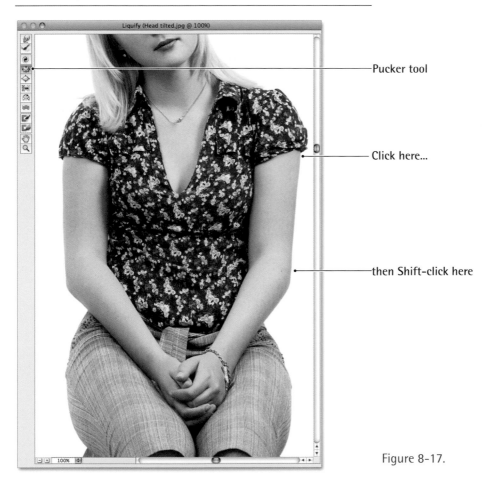

Pucker tool

Click here...

then Shift-click here

Figure 8-17.

11. **Employ the pucker tool on her midsection.** Increase the **Brush Size** to around 350 pixels and click a few times on the model's belly to reduce the bulging that's caused by her posture and blowsy shirt. You don't need to perform major digital liposuction surgery (although the pucker tool is great for that); just make her tummy appear as it would if she were sitting up straight.

12. **Apply a freeze mask.** Our next step is fairly drastic: We'll attempt to turn her head upright. Before we start, we'll use the Liquify tool to protect areas that we don't want affected by our "liquifications." Select the freeze mask tool from the Liquify toolbox, and paint a protective shield over everything below the model's neck, as I did in Figure 8-18. You don't need to be pretty about it, just quickly cover the entire area.

Freeze mask tool

Area to be protected

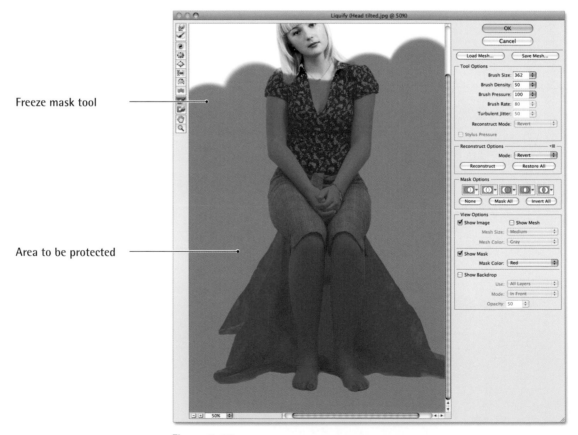

Figure 8-18.

13. *Select the twirl clockwise tool.* We'll employ the handily named twirl clockwise tool to rotate the model's head. As opposed to subtle clicks with the pucker tool, this will be a radical modification. Set your **Brush Size** to its maximum of 1500 pixels.

The clockwise nature of the tool is convenient for this image, but as you might have guessed, you can twirl counterclockwise too. Just hold down the Alt key (Option key) while you click.

14. *Rotate her head.* Place your cursor at the base of her neck, which will become the fulcrum of the rotation. Then click about 10 times to rotate her neck to almost upright. The problematic results are shown in Figure 8-19. When you're finished, click the **None** button in the **Mask Options** section of the dialog box to remove your freeze mask.

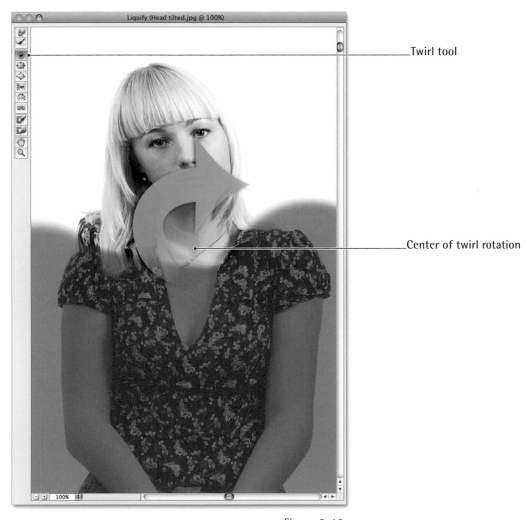

Twirl tool

Center of twirl rotation

Figure 8-19.

15. **Restore the shoulder.** Obviously, our twirling has wreaked havoc with the shoulder on the left side of the image. The reconstruct tool can sometimes restore previous pixel states to amend for such damage. Set your brush to about 50 pixels, and click a few times in an area in the shoulder to bring back some reality. You may have to switch to the warp tool again to lift the shoulder back up. The effect of my attempt is shown in Figure 8-20.

Reconstruct tool

Click gently to restore the shoulder

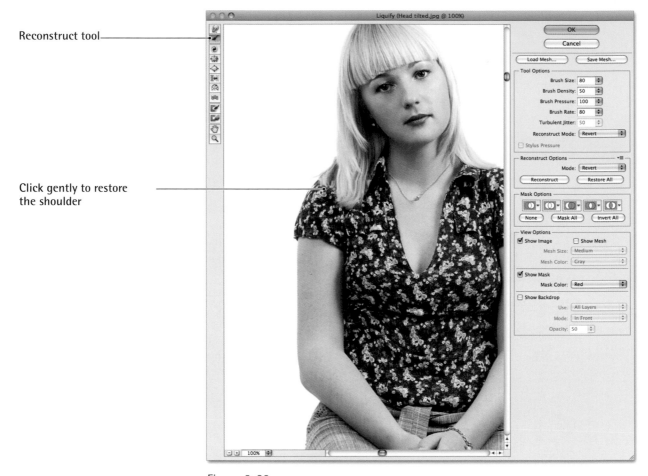

Figure 8-20.

The directive is called Save Mesh because the adjustments you made to the image are governed by an invisible (usually) mesh that overlays the image. If you'd like to see the mesh and what you've done to it so far, turn on the Show Mesh check box in the View Options area.

16. **Save your adjustments in progress.** You've made decent progress, but you may want to come back and tweak this set of modifications further. Were you to cancel out of the Liquify dialog box now and come back to it, all your work would be gone. So save this work by clicking the **Save Mesh** button. Name your collection of Liquify settings "My Liquify Mesh" and click **OK**. Once your changes have been safely stored, click **OK** again to return to Photoshop proper.

17. ***Load a preexisting mesh.*** Once you've saved a mesh, you can load it on your next visit to the Liquify dialog box and resume your work. This useful feature also provides me with a way to share with you my particular adjustments for this project. Press Shift-Ctrl-X (Shift-⌘-X) to once again open the Liquify dialog box. Click the **Load Mesh** button, navigate to the *Lesson 08* folder, and select the file called *Head Upright.msh*. Click **Open**, and give Photoshop a moment to implement the settings.

You'll see that I made some further adjustments to her face, pushing it more upright after straightening her neck. I also used the pucker tool on her ankles, and extended her pants down a bit on her knees with the warp tool. While these kinds of transformations are undoubtedly a matter of taste, you can see that the Liquify command can take you wherever your particular whims suggest. Figure 8-21 shows how the Liquify command has taken our model from frumpy to perky.

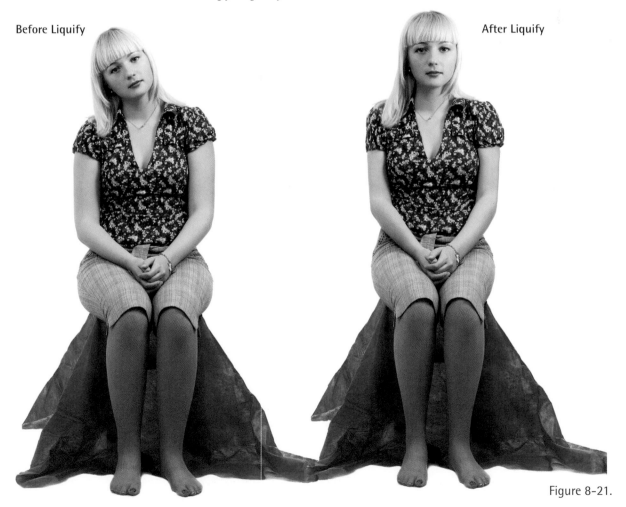

Before Liquify

After Liquify

Figure 8-21.

Manipulating with Puppet Warp

As I mentioned, Photoshop is famous, if not downright notorious, for its ability to distort reality. But we've pretty much been limited to Liquify and to the content-aware scaling added in CS4. However, this current edition of Photoshop introduces us to puppet warp, which allows you to assign points, known as *pins*, in an image and then stretch or squish the geographic relationship of those pins to effect distortion. This is easily the most entertaining new feature in Photoshop CS5, and it's powerful too. If you thought you couldn't believe your eyes before, just wait until you see puppet warp.

In this exercise, I'll show you how to use puppet warp in one of its most obvious ways, manipulating the limbs of a human model. We'll also use it in a slightly less obvious way, distorting individual characters of type.

Figure 8-22.

1. **Open an image.** Open the image *Jump Puppet.psd*, located in the *Lesson 08* folder inside *Lesson Files-PsCS5 1on1*. This image, by the photographer with the handle U.P. Images, comes from Fotolia.com. As you can see in Figure 8-22, it features an obviously exuberant dude who's clearly just waiting to fulfill his destiny as a human puppet. There's also a text layer imparting my personal directive to our model, which will also become puppet warp fodder before we're finished with this exercise.

2. **Select the subject.** The first task at hand is to move our would-be Pinocchio to his own layer, so we can manipulate his arms and legs independently of the sky behind him. I've made it relatively easy to do so. Click the tab for the **Channels** panel, and you'll see that I've created an alpha channel in which the background is black and the subject is white, meaning that he'll be selected. Ctrl-click (⌘-click) the **Mask** channel to load it as a selection. Then switch to the **Layers** panel.

3. *Jump the selection to a new layer.* Press Ctrl+Alt+J (⌘-Option-J) to jump the jumper to a new layer. Name the layer "Jumping Puppet" in the **New Layer** dialog box and click **OK**. Now that you've created the layer, turn off its visibility temporarily by clicking its 👁, as I did in Figure 8-23. We'll work on filling in the Sky & Grass layer first in the next few steps.

4. *Reload the selection.* We have two jumpers on two different layers, and we want to remove the bottom one so he won't show through when we modify the Jumping Puppet layer. Return to the **Channels** panel and once again Ctrl-click (⌘-click) the **Mask** channel to load it as a selection. Then return to the **Layers** panel for good measure.

5. *Create some wiggle room around the selection.* You want to be sure you're capturing all the pixels associated with our jumper, so give yourself a safety zone. Choose **Select→Modify→Expand**, and set **Expand By** to 20 pixels. Click **OK**. You'll see the selection line move outward, as in Figure 8-24.

Figure 8-23.

Figure 8-24.

6. *Fill in the background.* Since we'll be repositioning our puppet-boy's limbs, we want his background to be solid sky, rather than his doppelganger. Click the **Sky & Grass** layer to make it active. Then choose **Edit→Fill**. In the **Fill** dialog box, choose **Content-Aware** from the **Use** pop-up menu and click **OK**. Photoshop assesses the surrounding pixels to decide how to fill in the selection. Press Ctrl+D (⌘-D) to deselect; as you can see in Figure 8-25, content-aware fill did a fairly good job for a one-step operation.

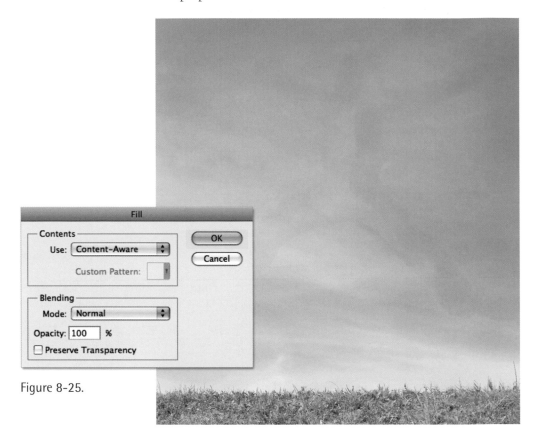

Figure 8-25.

7. *Heal the haloes with the healing brush.* Yes, content-aware fill is pretty cool, but you can see in this case that it's not perfect. (Especially when you know what to look for: the outline of the removed object that you know was there.) To fix those haloes left behind by our jumping subject, select the healing brush from the toolbox. Alt-click (Option-click) in a suitably similar area to set the source point, and smooth over the shadow effect that Jumper left behind. Choose a few random source points (Alt-clicking or Option-clicking) as you work to get good texture variation in the sky.

We're going to be putting puppet boy and his wild puppet limbs over this background in a distracting way, so don't worry about your healing being perfect. Just remove any areas of the background that you might still find noticeable *despite* the presence of flailing limbs.

8. *Convert the Jumping Puppet layer to a smart object.* Click the column to the left of the **Jumping Puppet** layer to turn its 👁 back on. To leave a trail of reversability before you enter the puppet warp mode, right-click the layer and choose **Convert to Smart Object**. This not only gives you a trail back but also allows you to modify your puppet warp in the future.

9. *Choose the Puppet Warp command.* Choose **Edit→Puppet Warp**. At first, you'll see a distracting mesh cover your subject. For now, turn off the **Show Mesh** check box in the options bar. You'll also notice that your cursor changes to a pushpin icon with a plus symbol (📌+), which indicates that you'll be adding pins as you click with it.

10. *Set two pins along the arm on the left.* Make your first click at the subject's right shoulder (the left side of the image). Then set another pin by clicking at his elbow on the same arm, as in Figure 8-26.

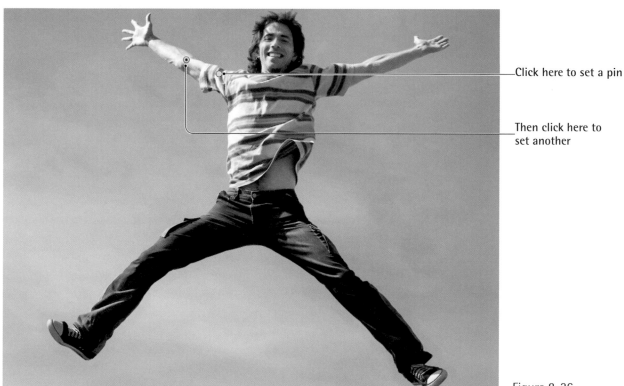

Click here to set a pin

Then click here to set another

Figure 8-26.

11. ***Drag the outer pin further outward.*** Hover over the outer-most pin on the elbow and you'll notice that the cursor now changes to an arrow plus pin icon. The arrow indicates that you'll be moving that pin rather than adding a new one. If you drag outward, you'll see that the jumper's arm stretches out in a disturbing way, but the rest of the image rotates around your set pins as well, as in Figure 8-27.

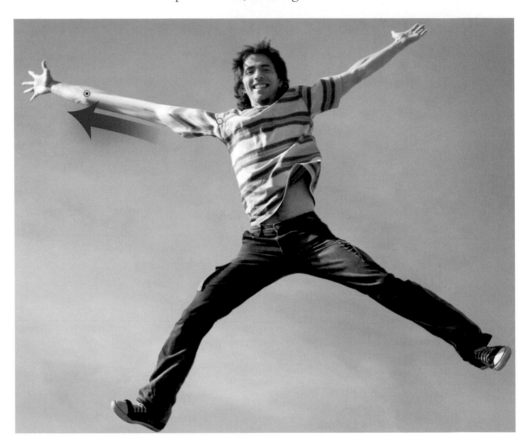

Figure 8-27.

Interesting, but not exactly what I had in mind. So press Ctrl+Z (⌘-Z) to undo that modification.

12. ***Set additional pins to stabilize the image.*** Turns out that each puppet warp pin not only serves as a point of stretching but also locks down its designated portion of the image when you stretch. So, to retain some control over how things move (or don't), you'll want to set pins at key points around the image. In Figure 8-28, I've set pins along each limb and down the center of the figure starting at his head. Click with your pushpin cursor to do the same.

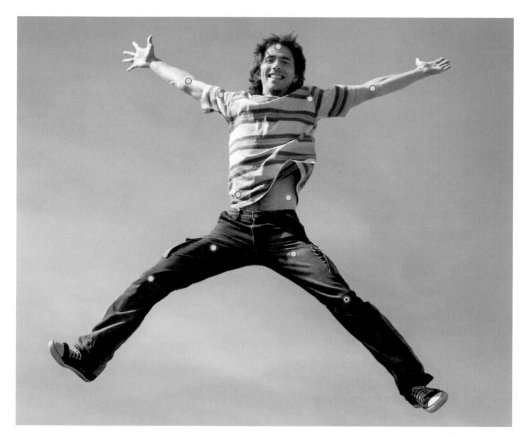

Figure 8-28.

13. ***Move the pins to stretch the puppet.*** Once you get all the pins in place, the fun begins. The goal is to stretch this guy out in an almost cartoonish way. You'll see where my pins ended up shortly, but for now, here are a few things to keep in mind when you're setting and working with puppet warp's pins:

- The selected pin (the one that's going to move) has a black dot in the center.

- You can move two or more pins simultaneously. To see an amusing example, select the pin on one elbow and Shift-click the opposite one. Then drag one of the pins up and down to make puppet boy wave his arms like a maniac. Be sure to press Ctrl+Z (⌘-Z) to undo when your amusement wanes.

- If you press and hold the Alt key (Option key) and then hover over a pin, you get a scissors icon. Click, and you delete that pin.

• If you hold down the Alt key (Option key) in the vicinity of a pin (rather than over a pin), you'll see a rotation indicator around the pin, as in Figure 8-29. If you subsequently drag, you'll rotate your image (any part that's not "pinned down," so to speak) around that pin. For instance, by Alt-dragging (Option-dragging) down in the example in Figure 8-29, I was able to pivot the forearm into that unnatural position. (If you try it, be sure to undo when you've finished playing puppet master.)

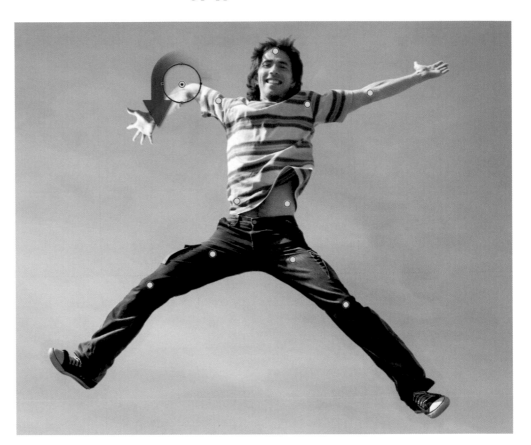

Figure 8-29.

• The pins have a depth assigned, meaning that if you drag a "deeper" pin (one that was created earlier) past those that you set later, the section of the image that the deeper pin controls will appear behind the rest of the image. Try dragging the arm all the way down, and notice that it goes behind the thigh. You can change the order in which Photoshop prioritizes the pin depth (which pin drags material behind the other) in the Pin Depth settings in the options bar. Ctrl+Z (⌘-Z) to undo. You gotta admit that it's weird that you can distort an image so that it's behind itself.

- If you're curious about the underlying infrastructure that Photoshop is using to create these distortions, turn on the Show Mesh check box in the options bar. I find it distracting and leave it off.

 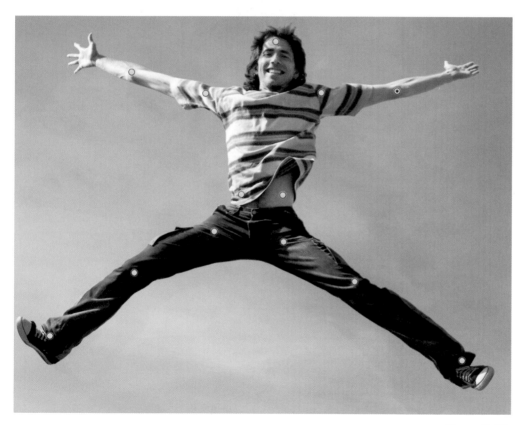
Ultimately, I set the pins where you see them in Figure 8-30. Note that while I was working, I added additional pins to the feet to elongate the calves.

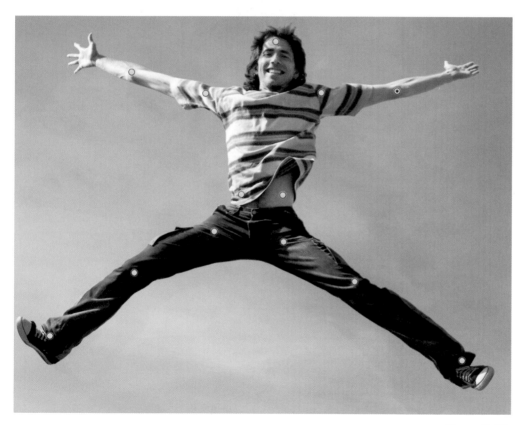

Figure 8-30.

14. *Apply the puppet warp effect.* Once you get the puppet positioned the way you want it (or copy my pin placement), you can either click the ✔ in the options bar or simply press Enter (Return) to accept your changes.

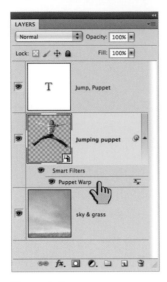

Figure 8-31.

The Jumping Puppet layer now has a Puppet Warp entry, as you can see in Figure 8-31. It's accompanied by an automatically created filter mask, which allows you to mask certain parts of your distortion. In this case, I prefer to delete the mask (by dragging it to the trash can icon) to tidy up. You can click the 👁 next to the Puppet Warp entry to turn on or off the effects and get a before-and-after view. Finally, you can adjust your warp effect at any time by double-clicking the Puppet Warp entry itself to reenter the puppet warp mode and gain access to all your pins once again.

15. *Turn the Type layer into a smart object.* Applying puppet warp to type is almost more fun than applying it to people. But before you can apply the distortion to the type layer, you need to rasterize the type (convert the type to pixels) or turn it into a smart object. We'll choose the latter. Right-click the **Jump, Puppet** type layer in the **Layers** panel, and choose **Convert to Smart Object**.

16. *Reinvoke puppet warp and apply to the letter* **P.** Once again, choose **Edit→Puppet Warp**. Place pins at the top and bottom of the spine of the second letter *P* in of the word *Puppet*, and then stretch the upper pin upward as in Figure 8-32.

Figure 8-32.

17. ***Manipulate the other letters.*** In Figure 8-33, you can see the pins I set for distorting the other letters in the text layer. For letters like the *U* and the *M*, I pulled up the tops of each stroke separately and made sure to anchor the lower points with pins of their own.

As you move between letters, you'll notice that the pins in the previous letters become gray. So in Figure 8-33, only my last letter, the *J*, has active yellow pins. Photoshop treats each noncontiguous letter as an independent objects. If you want to remanipulate another letter, simply activate one of its pins by clicking it, and all the pins that you've placed within that letter become yellow and active.

Figure 8-33.

18. ***Move and then stretch the comma.*** Place a single pin in the middle of the comma, and then drag it upward so that the bottom of the comma is right on the edge of the grass. When you add only one pin, you can move the entire element by moving that pin. Once you have the comma where you like, click to add another pin at the bottom of the comma to anchor it. Finally, grab the top pin in the comma and give it a stretch as well.

19. **Accept your modification.** Press Enter (Return) to accept your distortions to the letters. Again, if you want to change any of these modifications after examining the effect, simply double-click the Puppet Warp entry under the Jump, Puppet layer.

If you'd like to make any of the letters more wiggly, simply add extra click points at midpoints along the letter strokes and have a ball.

The final results of the puppet warp effect are shown in Figure 8-34.

Figure 8-34.

If you happen to be sending a puppet warped file to someone with an earlier version of Photoshop, be sure to flatten the image. Puppet warp modifications can "fall out" in earlier versions under some conditions, like a changed resolution.

Content-Aware Scaling

Photoshop CS4 introduced a handful of "advanced compositing" features that applied a high degree of automation to the task of merging, blending, and transforming images. Far and away the sexiest and most practical of these features is the Content-Aware Scale command, which transforms areas of low contrast while protecting areas of high contrast. The upshot is that, in many cases, you can scale an image's background while leaving the foreground unharmed.

Content-aware scaling does not require elaborate multilayered compositions, nor does it work on multiple layers at a time. In fact, its only relationship to layers is that it happens to work best when applied to an image that you've first isolated to an independent layer. Here's how the command works, best approach and all.

1. ***Open an image that you want to scale.*** Go to the *Lesson 08* folder inside *Lesson Files-PsCS5 1on1* and open the file called *Jumper.jpg.* Captured by Andrzej Burak of iStockphoto, the image in Figure 8-35 features clearly distinguishable, high-contrast foreground objects—the leaping woman and the foreground grass—set against medium-contrast clouds and a low-contrast sky. These features make it a perfect test project for content-aware scaling, as we keep our theme of jumping subjects. This is a small file, which means less work for Photoshop. (Larger images take more time to process and may overwhelm the command.) But the final result may look a bit stretched out of shape.

Figure 8-35.

2. ***Convert the image to a floating layer.*** Like any transformation function, the Content-Aware Scale command needs a selection or an independent layer to work. Give it the latter by double-clicking the **Background** item in the **Layers** panel. In the **New Layer** dialog box, name the layer "Jumper" and click **OK**.

3. ***Add some height to the canvas.*** Let's be ambitious and convert the image from horizontal to vertical. We'll start by making the canvas square, which will give us more headroom. Choose **Image**→**Canvas Size**. Turn off the **Relative** check box, set the **Height** value to 1440 pixels (to match Width), and select the bottom **Anchor** option, as in Figure 8-36. Then click **OK** to add a healthy amount of empty space to the top of the image.

Figure 8-36.

4. *Choose the Content-Aware Scale command.* Choose **Edit→Content-Aware Scale**, which is featured in Figure 8-37. If you did *not* load my dekeKeys shortcuts, you can invoke the command with Ctrl+Shift+Alt+C (⌘-Shift-Option-C). Otherwise, I reassigned that shortcut to the more frequently used Image→Crop. In any event, Photoshop surrounds the image with eight scale handles, just as if you were working in the free transform mode.

5. *Scale the image as tall as it will go.* Go ahead and scale the image window to give yourself some extra gray pasteboard so you have enough room to work. Then drag the top handle all the way to the top of the canvas. If you drag slowly, you'll see that Photoshop focuses most of its efforts on the background sky. But after a point, it can't help but engage the leaping woman to a lesser extent. Lesser or not, the command still manages to make an absolute mess of things, as witnessed in Figure 8-37.

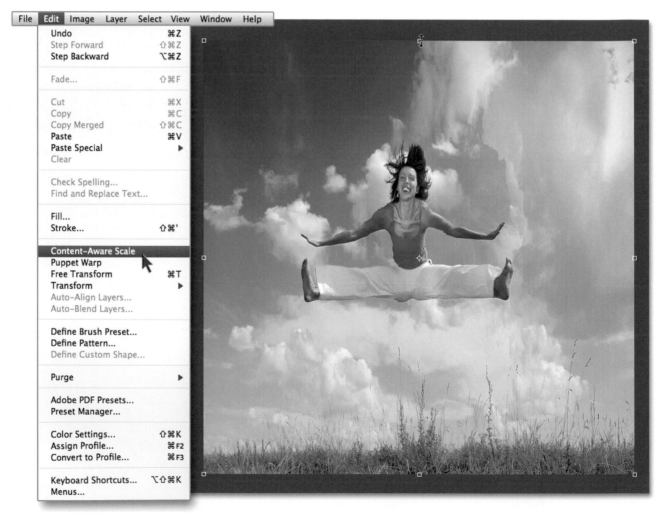

Figure 8-37.

6. **Protect the skin tones.** Go up to the options bar and click the little ⚡ icon. That little dude protects the skin tones by ruling out all warm colors from the scaling equation, which eliminates the stretching in the woman's skin, shirt, and brilliantly scarlet hair. But it leaves her white slacks scaled more disproportionately than ever, producing the tragic MC Hammer pants pictured in Figure 8-38.

7. **Make the image shorter and skinnier.** Drag the top handle down until the thighs return to their original dimensions, which I found to be about midway between the fully stretched image and the original one. Then drag the left handle to the right as far as you can without reducing the length of the woman's arms or legs. Once the image looks more or less like the one in Figure 8-39, press Enter or Return to apply your edits.

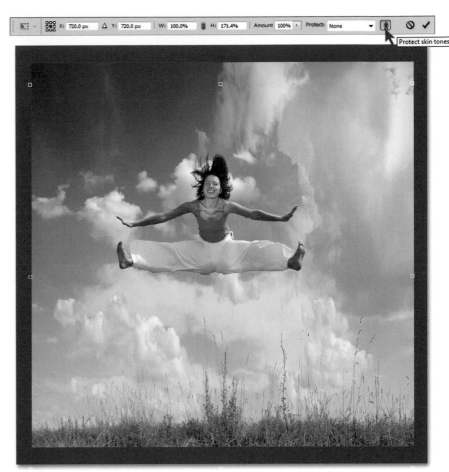

Figure 8-38.

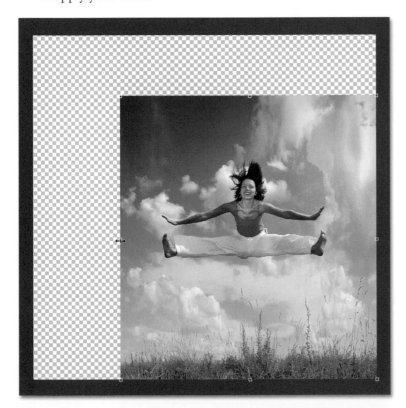

Figure 8-39.

8. **Choose Content-Aware Scaling again.** Like all transformations, content-aware scaling rewrites pixels, so by definition it's a destructive modification. Were it a typical transformation, you shouldn't apply it multiple times in a row. But content-aware scaling actually produces *better* effects if you apply it in multiple passes. So choose **Edit→Content-Aware Scale** to do just that.

9. **Scale the image as desired.** Make the image the full height of the canvas and skinnier still. Assuming that the ⋔ icon remains on, you'll find it difficult to harm the woman. When you're finished, press Enter or Return to apply the change.

Figure 8-40 compares the content-aware scaling to an identical nonproportional stretch applied via the Free Transform command. The differences are so obvious as to render any description I might offer altogether redundant.

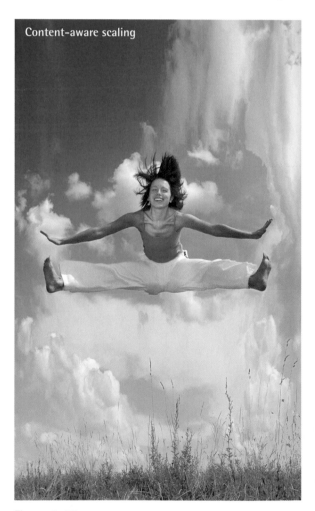

Figure 8-40.

WHAT DID YOU LEARN?

Match the key concept in the numbered list below with the letter
of the phrase that best describes it. Answers appear upside-down
at the bottom of the page.

Key Concepts

1. Free Transform
2. Convert to Shape
3. Clipping mask
4. Liquify filter
5. Pucker
6. Bloat
7. Freeze mask
8. Twirl clockwise tool
9. Load Mesh
10. Puppet warp
11. Pins
12. Content-Aware Scale

Descriptions

A. A mask applied to protect parts of an image that you want to remain unaffected by the Liquify tools.

B. A mask created by attaching one layer to another to limit the effects of the first layer to just the layer beneath.

C. A tool in Liquify that you use to suck the edges of an area inward.

D. A command that allows you to reinstate a previous Liquify modification.

E. A tool in Liquify that allows you to spin an area around a center point.

F. Set points in the puppet warp that serve as fixed points and points of stretching.

G. An independent environment in Photoshop where you can squish and stretch pixels.

H. A command that allows you to turn text into a vector-based shape.

I. This advanced compositing function is capable of stretching low-contrast areas of an image without affecting high-contrast areas.

J. A command that allows you to rotate, resize, and rescale one layer independently of the rest of a composition.

K. A tool in Liquify that puffs out areas of an image.

L. A tool that allows you to distort a subject by changing the relationship between set points.

Answers

1J, 2H, 3B, 4G, 5C, 6K, 7A, 8E, 9D, 10L, 11F, 12I

LESSON
9

PRO PHOTOGRAPHY TOOLS

PHOTOSHOP BEGAN ITS LIFE back when few people, even professional photographers, possessed digital cameras. Most of the folks using the application then were like me, graphic artists who were either working with scanned film images shot by someone else or creating pieces of our own from scratch. Usually, the photographer was more or less out of the loop by the time the Photoshoppery happened. As taking your own digital photos became more common, however, the Photoshop phase of the process started much earlier. Nowadays, if you have a digital camera, chances are you want to create and enhance your photographs yourself. Photoshop has become a digital darkroom, where the photographer makes early decisions about the way an image is developed, both literally and expressively.

As Photoshop has matured, we began to see tools that were tailored for photographic work. The most overarching of these tools is Adobe Camera Raw (ACR), a plug-in that comes with Photoshop CS5 and allows you to process your own digital negatives right from the get-go. In this lesson, we'll look at both the global edits you can create in ACR as well as the localized modifications you can make to specific parts of an image.

We'll also discuss two powerful features that are particularly appealing to photographers. Both involve combining multiple frames or exposures into one image. Using Photoshop's Photomerge technology, you can, among other things, stitch a bunch of images into one large, expressive piece that captures an entire horizon, like the one in Figure 9-1.

Figure 9-1.

Before beginning the exercises, make sure you've downloaded the lesson files from *www.oreilly.com/go/Deke-PhotoshopCS5*, as directed in Step 2 on page xvi of the Preface. This means you should have a folder called *Lesson Files-PsCS5 1on1* on your desktop (or whatever location you chose). We'll be working with the files inside the *Lesson 09* subfolder.

This lesson examines the Photoshop tools and features that are of particular use to professional photographers or serious amateurs who want professional results. In this lesson, you'll learn how to:

- Use Adobe Camera Raw to adjust white balance and other exposure settingspage 296

- Perform selective edits in Adobe Camera Raw. . . . page 313

- Change hue, saturation, and luminance in raw files. .page 317

- Stitch images together to create a panorama.page 322

- Use HDR Pro's power to create striking photos that capture extreme shadows and highlights page 328

Video Lesson 9: Exploring Camera Raw

Adobe Camera Raw is a separate utility that allows you to process images captured in the raw format by sophisticated cameras. In this video lesson, I'll develop a raw file right before your eyes, bringing out detail and color that don't appear to be there at the beginning. I'll also demonstrate some of the newer features in Camera Raw: automatic noise adjustment, targeted adjustments, and the ability to save multiple variations as snapshots.

To see camera raw in action, visit *www.oreilly.com/go/deke-PhotoshopCS5.* Click the **Watch** button to view the lesson online or click the **Download** button to save it to your computer. During the video, you'll learn these shortcuts:

Video Lesson 9: Exploring Camera Raw

Operation	Windows shortcut	Macintosh shortcut
Open in Camera Raw	Ctrl+R	⌘-R
Move to next numerical value field	Tab	Tab
Move in Preview window	spacebar-drag	spacebar-drag
Get target adjustment tool	T	T
Open Saturation subpanel	Ctrl+Alt+Shift+S	⌘-Option-Shift-S
Open Luminance subpanel	Ctrl+Alt+Shift+L	⌘-Option-Shift-L

Photoshop CS5 also has a new, improved engine for creating High Dynamic Range (HDR) photos that allows you to combine multiple frames of the same subject shot at different exposures. Using HDR, you can combine a wider range of highlight and shadow detail than a single frame might be able to capture (which I've also simulated in Figure 9-1). Both Photomerge and HDR require some planning at the moment you click the shutter, so you have to be thinking like a photographer way before you get to Photoshop.

The Raw Power of Adobe Camera Raw

As far as processing digital photographs in Photoshop goes, Adobe Camera Raw is the flagship tool. ACR'S primary purpose is to be the digital darkroom for photographs captured by a midrange or professional-level digital camera and saved in the camera's native format, known as its *raw format*. These raw files represent the unprocessed data captured by a camera's image sensor, represented in its unprocessed state in Figure 9-2. You have to process the files to see the benefits of capturing raw, but you get to work with a much wider range of luminance data. All this adds up to a lot more flexibility when you're correcting images. Figure 9-3 was created from the same capture data (the same click of the shutter) as Figure 9-2, but you can see all the shadow and highlight detail and color that I was able to extract using ACR.

Inside Camera Raw (a third way people refer to this plug-in), you can adjust white balance, fix the exposure, correct the contrast, enhance the colors, and straighten or crop as needed. Camera Raw also allows something Photoshop doesn't: You can apply adjustments to multiple images at a time. And although it was designed specifically for processing raw format files, it also works with TIFFs and JPEGs.

Figure 9-2.

Figure 9-3.

PEARL OF WISDOM

Photoshop supports raw files from a slew of digital cameras, including those sold by Nikon, Olympus, and Canon. The problem is, virtually every manufacturer uses a different file format (Nikon's NEF, Olympus's ORF), and some have more than one (Canon's CRW and CR2). To rein in the proceedings, Adobe developed the DNG (Digital Negative) format, a royalty-free, documented standard with lossless compression and editable metadata that Adobe promises to support well into the future. The list of manufacturers whose cameras capture DNG files include Hasselblad, Leica, and Samsung, and the list is likely to grow. If your camera shoots to another format, as most do, not to worry. You can convert your images directly from your camera's memory card using Adobe's DNG Converter, which you can download for free from *www.adobe.com/dng*. We will be using DNG files throughout this exercise.

Amazingly, every adjustment with ACR is *parametric*. That is, the changes are saved as a set of parameters, temporary instructions that are applied to your image only at output. So your work is safe, your "digital negatives" (i.e., your original files) are protected, and you can rethink and readjust your photos at any time.

Whether a raw image file is saved to DNG or to one of the many proprietary camera formats, ACR supports it directly—without the need to preprocess the file using your camera's software. Photoshop CS5 comes with Camera Raw 6, a plug-in so vast and sophisticated that I could devote an entire book to the topic (and many have). Even with two full exercise to work with, we'll focus only on Camera Raw's most essential capabilities and recent innovations.

Adjusting White Balance in ACR

Even though a raw image may not look as good as a JPEG equivalent when it first comes off a memory card, it represents much more potential. A raw image is much like a film negative, containing all the information needed to bring out all the luminance data that your camera captured. Although JPEGs can be adjusted in ACR, and quite effectively so, some processing has been handled on board your camera by the time you pull a JPEG file off your card. With raw files, you have more control. And ACR is the environment you need to assert it.

Adobe is continuously updating ACR to keep up with file formats employed by new cameras. If your proprietary raw format image doesn't open in ACR, make sure you've updated to the most recent release of ACR. Choose **Help**→**Updates** from either the Bridge or Photoshop.

In these ACR exercises, I've provided a set of DNG files for you to work on. My colleague shot them with a Canon camera, but rather than supply you with the proprietary Canon CR2 files, I've converted them to DNG, Adobe's manufacturer-neutral raw format. DNG has some nice advantages, one of which is that your adjusted settings travel with your image (instead of in a *sidecar* file, which other formats use to convey edits to raw files).

1. *Locate and select four raw images.* We'll start things off in the Bridge, which you first saw way back in Lesson 1, so that we can select multiple images simultaneously. If you're in Photoshop, switch to the Bridge by choosing **File**→**Browse in Bridge** or by clicking the Br icon in the application bar. Then do the following:

- Assuming that you followed my advice in Lesson 1 (see Organizing and Examining Photos" Step 13, page 16), click **Filmstrip** in the upper-right corner of the window to switch to the Filmstrip workspace, which we left in a vertical configuration.

- Navigate to the *Lesson 09* folder inside *Lesson Files-PsCS5 1on1*. Then double-click the *Raw Images* subfolder, which contains a collection of images from the aforementioned colleague, pro photographer and fellow lynda.com trainer Chris Orwig.

- Wait a few seconds for the thumbnails to generate. Then scroll down the **Content** panel until you come to the four *Heart_art* photographs. Click *Heart art_01.dng* and then Shift-click *Heart art_04.dng* to select a range of four images, as pictured in the Preview panel in Figure 9-4.

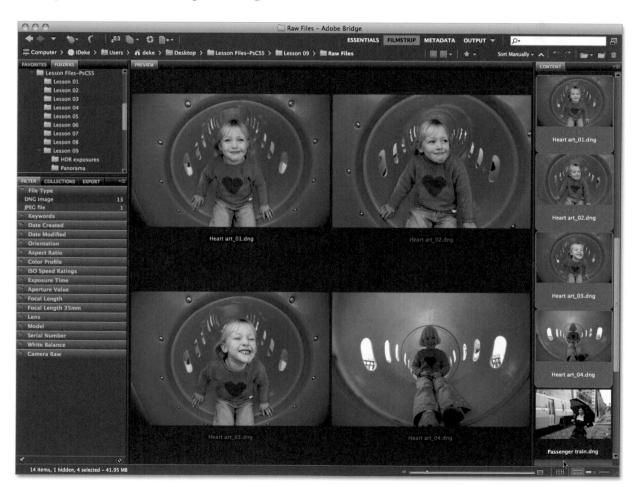

Figure 9-4.

Figure 9-5.

Captured with a Canon EOS 5D and converted from the CR2 format to DNG, each of these 12-megapixel photos weighs in at around 10MB, or somewhere between two and four times the size of an equivalent image saved as a high-quality JPEG file. The theoretical color range includes more than a billion possible variations, 64 times as many as a JPEG image. To distill these billion or so colors to the best 16 million (as explained in the sidebar, "Exploring High Bit Depths" on page 302), the Bridge requires the image to pass through the Camera Raw plug-in.

2. *Open the images in Camera Raw.* From the Bridge, you get to Camera Raw in one of two ways:

 • Choose File→Open or double-click any one of the selected thumbnails to switch to Photoshop and display the Camera Raw interface.

 • Choose File→Open in Camera Raw or press Ctrl+R (⌘-R) to load the Camera Raw interface directly inside the Bridge.

Although either method is fine, the latter is a bit more flexible, permitting you to examine one or more raw photos while keeping Photoshop free to perform more complex modifications. So choose **File→Open in Camera Raw** as you see me doing in Figure 9-5 or press Ctrl+R (⌘-R) to display Camera Raw in the Bridge. As witnessed in Figure 9-6 on the facing page, Camera Raw includes a high-resolution preview of the selected image, a vertical filmstrip of thumbnails (visible only when adjusting multiple images), and a full-color histogram, all of which update as you adjust the color settings. The title bar lists the model of camera used to shoot the photo.

If you want to devote 100 percent of your attention to Camera Raw, you can fill the screen with the interface by clicking the ⊞ icon to the left of the histogram or by pressing the F key.

Directly below the histogram, you'll see the ISO, exposure, aperture, and shutter speed. This EXIF data helps Camera Raw establish some of its automatic settings.

Below the EXIF data is a panel that contains the Camera Raw controls for developing your images. The contents of this panel change depending on which tab you have selected from the ten displayed directly above the panel. Camera Raw opens by default to the Basic tab, which contains the most essential and often-used adjustment tools.

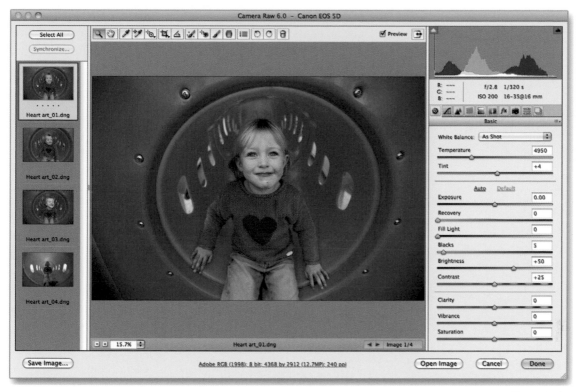

Figure 9-6.

3. **Select all four images.** Even though Camera Raw is a plug-in (meaning it has to run in a host program), it's an independent utility with its own tools, options, and benefits. One of the features that sets it apart from the rest of Photoshop is its ability to apply corrections to multiple images at a time. The vertical filmstrip displays the four images you selected in the Bridge as in Figure 9-7. To modify all four images at the same time, first click the **Select All** button at the top of that filmstrip or use the Select All shortcut, Ctrl+A (⌘-A).

Figure 9-7.

PEARL OF ⬤ WISDOM

The colors captured by a camera (as well as those we see in real life) are typically a function of light reflecting off the surfaces of objects. (The exceptions are objects that emit light, such as, well, lights.) As a result, those reflected colors are informed by the color of the light source. This source defines the color of white because no light-reflecting object can be whiter than the source. Hence, the color cast of the image is the direct result of the color of the light source. This relationship between the color cast of the scene and the color of the light source is known as *white balance*. I explain how you address white balance in the next step.

4. ***Adjust the White Balance controls.*** You can neutralize a color cast using the White Balance controls, found in the Basic panel on the right side of the interface. (If you see a different panel of options, click the ⊛ tab below the histogram.) Here's how the White Balance functions work:

- By default, the White Balance pop-up menu is set to As Shot, which loads the white balance information conveyed by the camera. You can override this setting by choosing a lighting condition from the pop-up menu or entering your own Temperature and Tint values.

- The Temperature value compensates for the color of the light source, as measured in degrees Kelvin. Low-temperature lighting such as tungsten produces a yellowish cast, so Camera Raw "cools" the image by making it more blue. High-temperature light such as shaded daylight produces bluish casts, so Camera Raw "warms" the image by tilting it toward yellow. The closest thing to neutral light is direct sunlight, which hovers around 5500 degrees.

- Tint compensates for Temperature by letting you further adjust the colors in your image along a perpendicular color axis. Positive values introduce a magenta cast (or remove a green one); negative values do the opposite.

This series of images seems to require some warming, perhaps because Chris's daughter is climbing out of a cool blue tube or because the images were shot on a cold, gray day. Either way, the White Balance pop-up menu offers a series of predefined light sources, one of which is called Cloudy. Note that this setting is not designed to add a cloudy day effect but rather to compensate for the coolness of the light on an overcast day. In other words, choosing Cloudy makes the image warmer. Choosing a preset that refers to a warmer light source—say Tungsten—would cool down the image. Just remember that these settings are about compensation.

The Temperature and Tint sliders are color-coded. For example, raising the Temperature value makes an image more yellow and lowering the value shifts it toward blue. But these sliders are easier to use if you think not about the color you want to add but the color you want to remove. If you reference "The Visible-Color Spectrum Wheel" (page 185), you can see that less orange equates to more cobalt, a near cousin to blue, which means we need to reduce the Temperature value.

With all that in mind, start by choosing **Cloudy** from the **White Balance** pop-up menu. You'll see that it has the immediate effect of warming the skin tones, perhaps a little too much.

I suggest that you cool the photos just a bit by lowering the **Temperature** value to 6150 degrees. Then remove some of the magenta from the images by moving the **Tint** slider to the left (toward green) to a value of –5 or thereabouts. As you can see in Figure 9-8, the adjustment accurately accounts for the lighting conditions under which the preview image was shot.

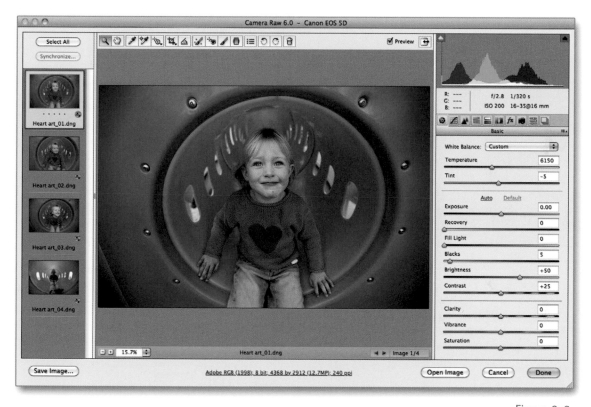

Figure 9-8.

You can correct a color cast also by using the white balance tool in the horizontal toolbar. Select the ✏ icon near the top of the window and click a color in the image that should be a light neutral gray—try clicking the white inside-out pocket on the right side of the image. ACR sets the Temperature and Tint values as needed. In my case, this method gets pretty close to the settings I chose manually. If necessary, you can tweak from that point with the sliders. (Your results will vary depending on the exact spot you click.) If you don't like the results, try again or adjust the sliders slightly. Double-click the eyedropper icon to restore the As Shot values, but remember that puts you back at square one.

Exploring High Bit Depths

To understand how color works in an image, you have to start at the very beginning, at the assembly-language level: Your computer is a binary machine. It thinks and communicates entirely in the binary digits 0 and 1, known as *bits*. Pixels began life as single bits, either 0 or 1, black or white. Hence the earliest black-and-white images were called *bitmaps*.

Nowadays, a typical RGB image contains no fewer than 256 luminosity values per color channel, which means a whole

A 24-bit image shown head-on, the way we users see it

The same image with
colors mapped into the third dimension

lot of bits. For example, a pixel with 2 bits can be any of 4 colors—00, 01, 10, or 11. Each additional bit doubles the potential of the pixel, so you quickly progress from 8 colors to 16, 32, 64, and so on. A total of 8 bits gets you $2^8 = 256$ colors. Hence, a typical digital photograph is said to be an 8-bit-per-channel image. Three channels times 8 bits each is 24 bits, which means $2^{24} = 16.8$ million colors.

The name given to the number of bits assigned to a pixel is *bit depth*. So in addition to the height and width of an image, Photoshop sees a third dimension of bit depth associated with each and every pixel, as illustrated on the left.

Various digital cameras and scanners support higher bit depths. A typical digital SLR supports 10 bits per channel, or 30 bits in all, which translates to $2^{30} = 1.1$ billion colors. Other devices capture 12 bits per channel, 36 bits in all, for $2^{36} = 68.7$ billion colors. Meanwhile, Photoshop supports two even higher bit depths: 16 bits per channel (which translates to $2^{48} = 281.5$ trillion colors) and 32 bits per channel (or $2^{96} = 79.2$ octillion colors).

The benefit of so many colors is somewhat theoretical. First, your computer's operating system cannot display more than 16.8 million colors. Second, even an extremely large image—such as one captured with a professional-quality drum scanner—might contain at most 100 to 200 million pixels, and most images contain a fraction of that. Given that each pixel can display just one color, that leaves at the very least billions of colors unused.

The advantage: So many potential colors are lying fallow that you can apply multiple radical color transformations without harming your image. It's like a game of musical chairs in which each contestant has a million chairs. No one comes within miles of each other, let alone sits in an occupied chair.

Consider the examples in the upper-right figure on the facing page. (Hey, it's an advertisement—the product name is *supposed* to be misspelled.) I start with a photo from a stock image library. Then I choose the Levels command and adjust the Output Levels values to dramatically reduce the contrast of the image so it can serve as

the background for a perfume ad (top middle). Now let's say I lose the original image and the lightened background copy is all I have. If I apply the Auto Color command to restore the highlights and shadows, I can revive a semblance of the original image. But you can see how few colors remain (top right). The corrected image is rife with color banding as well as flat highlights and shadows.

This would not have been a problem if I had chosen the Image→Mode→16 Bits/Channel command *before* creating the perfume ad (the command doesn't do me any good after the colors are lost!). Choosing Auto Color would have restored the image to nearly its original coloring, as demonstrated by the lower-right example. It would have also produced a much healthier histogram. When you're working with 8 or 16 bits per channel, the histogram shows you just 256 levels of brightness. But when you stretch out a squished histogram, the 8-bit histogram reveals gaps and the 16-bit histogram is smooth, as the examples on the right show.

If you convert to 32 bits per channel (also known as *high dynamic range,* or *HDR*), you gain still more theoretical wiggle room. Suddenly, you are no longer bound by the conventional histogram. Colors can float outside the boundaries of the visible range, permitting you to regain blown highlights and flat black shadows.

What does all this have to do with Camera Raw? By default, Camera Raw reduces the bit depth to 8 bits/channel when opening an image in Photoshop. That makes sense given that the major benefit of a higher bit depth is the freedom it gives you when applying color adjustments, and chances are you'll do most of the destructive work in Camera Raw before setting foot in Photoshop. However, if you plan on applying a few more dramatic color adjustments, or you're merely keen on

protecting every single color that you can, click the blue link below the image preview in the Camera Raw interface. This displays the Workflow Options dialog box. Set the Depth option to 16 Bits/Channel and then click OK. From now on (or until you restore the default Depth setting), all your raw photos will open in Photoshop's 16 bits/channel space.

Original photograph **Lightened using Levels** **Auto Color produces banding**

Radically lightened image **Auto Color in 8-bit/channel** **Auto Color in 16-bit/channel**

5. ***Check how the adjustments work for other images.*** However great our settings may look on the *Heart art_01.dng* photo, we're editing three other images as well. So let's see how our changes affect those images:

- Use the ↓ key to move to the *Heart art_02.dng* image. By using the arrow keys, you can switch between images in the filmstrip without deleting them. You can also Alt-click (Option-click on the Mac) to view other images without deselecting any of them.

- Both *Heart art_02.dng* and *Heart art_03.dng* appear to have responded well to the adjustments we made with *Heart art_01* as the visual reference. But the last one, *Heart art_04.dng,* clearly needs some personalized attention, which we'll make happen in the next step.

When switching images, you may see a yellow ⚠ icon in the top-right corner of the preview, as in **Figure 9-9.** Don't fret; nothing's wrong with your image. The ⚠ merely means that Camera Raw is applying its adjustments, so don't make any decisions until the ⚠ goes away.

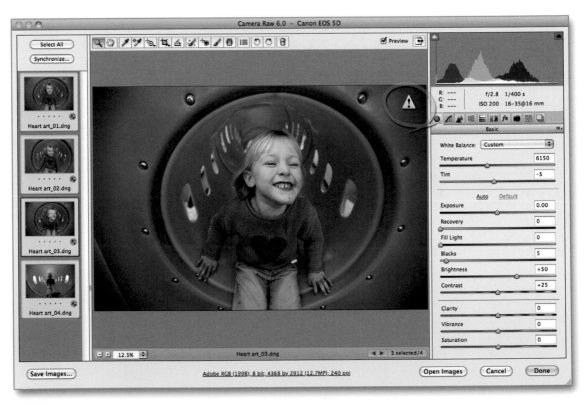

Figure 9-9.

6. *Adjust an image independently.* Since our little subject is exiting the tube in the first three shots, a certain amount of natural light is on her face. But the last image captures her in what has to be the coolest (colorwise) environment possible, while she's still in the blue light of the tube. So it's hardly surprising that the fourth photo in our group requires individual attention.

Click the fourth thumbnail in the filmstrip area, *Heart art_04. dng,* to select that one image. Press the Tab key to select the **Temperature** value, and then significantly warm up the image by pressing Shift+↑ until you reach 25150 (holding the Shift key moves the value in 500-degree increments). That's a little too far, so release the Shift key and press the ↓ key three times to reach a value of 25000. (Without the Shift key, the value moves in 50-degree increments.)

7. *Adjust the tint.* Once you've changed the temperature, you'll notice a slight magenta cast in her skin tone (previously obscured by the unrelenting blue). Press the Tab key to jump down to the **Tint** value, and compensate for the magenta by pressing Shift+↓ once to move the Tint slider to −15. You can see the results in Figure 9-10.

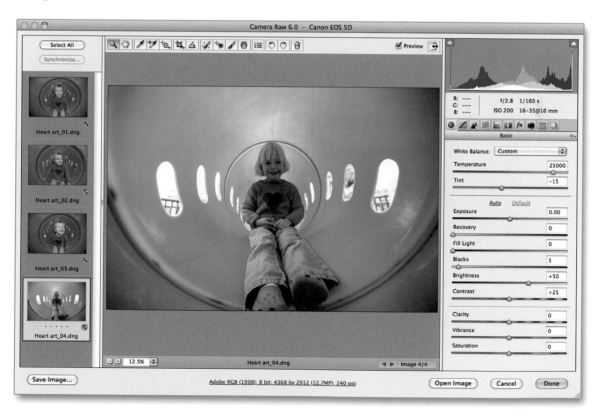

Figure 9-10.

8. **Save your changes.** When you're happy with your white balance settings, you'll want to save your work. But how you do this may surprise you. First, let's review the buttons along the bottom of the interface:

- Open Images opens all the selected images inside Photoshop, where you can perform further edits.

Press and hold the Shift key to change Open Images to Open Objects. Clicking this button opens the raw image as a smart object, thus permitting you to modify your Camera Raw settings well into the future. For more information about smart objects, see "Working with Smart Objects," which begins on page 227 of Lesson 7.

- The Cancel button abandons all the adjustments you've made during the session.

- On the far left, Save Images allows you to save the processed images to a different file format and a different location on your hard drive .

- Done saves your changes as metadata instructions (which are stored with the original DNG files), closes Camera Raw, and returns you to the Bridge.

We don't need to work in Photoshop, so click **Done**. A moment later, you should see the Bridge thumbnails update dynamically to reflect your changes, as in Figure 9-11. (If the images don't update—it can take a few seconds—choose Tools→Cache→Purge Cache For Folder "Raw Images" to rebuild the cache and generate new thumbnails.) The slider icon (⊜) in the top-right corner of each thumbnail (circled in the top image in Figure 9-11) tells you that the corresponding file has been altered. These changes will be understood by any application that reads Camera Raw metadata, including (but not limited to) the Bridge, Photoshop, and Lightroom.

Figure 9-11.

PEARL OF ●WISDOM

Note that while each DNG file has been updated, not a single pixel in these files has been harmed or otherwise changed. All the adjustments have occurred parametrically, meaning you can revisit your settings, make additional changes without penalty, and even go back to the image's original state. You cannot permanently alter an image in Camera Raw.

Luminance, Crop, and Color

In addition to white balance, the Basic tab of Camera Raw gives you efficient control over the exposure and color intensity of your image. This is where the real power of working with raw files shines, bringing back detail in shadow and highlight areas that would be totally lost in a JPEG file. The luminance-related sliders are similar to those we saw in the Levels dialog box, but the sliders in Camera Raw are specifically designed to bringing back the immense amount of data that our raw capture possesses within.

We'll also take a look at some familiarly named sliders that help fine-tune the color and contrast of an image, sliders that are progenitors of the Vibrance and Saturation adjustments we saw back in Lesson 6. And finally, we'll use the wonderfully efficient crop and straightening tools in Camera Raw to level the corrected photo.

1. *Open a new image.* Let's select a suitable photo. In the Bridge, select the *Checkers.dng* file in the *Raw Images* folder (which is inside the *Lesson 09* folder inside *Lesson Files-PsCS5 1on1*), and press Ctrl+R (⌘-R) to open the file in Camera Raw. The charming if overly bright photo of my friend Megan Anderson Read is shown in Figure 9-12.

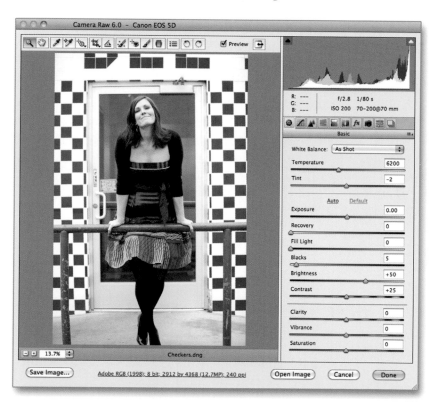

Figure 9-12.

In time, you may find that you prefer to double-click a thumbnail and have it open in Camera Raw in the Bridge. If so, press Esc to return to the Bridge, choose **Edit→Preferences** (**Adobe Bridge CS5→Preferences** on the Mac), click **General**, and turn on the **Double-Click Edits Camera Raw Settings in Bridge** check box. Now click **OK**, double-click the *Checkers. dng* thumbnail, and watch the image open in Camera Raw in the Bridge.

2. *Adjust the highlights, shadows, and midtones.* The Basic panel includes a collection of sliders that allow you to control the exposure and overall brightness of your images. Very briefly, here's how the options work:

 • Exposure gives you control over the highlights of an image, much like the white slider triangle in the Levels dialog box but with two big differences. First, Exposure is computed in f-stops. For example, raising the Exposure to +0.50 simulates opening the lens aperture of the camera a half-stop wider. Second, because a raw image includes colors beyond those rendered in the preview, you can sometimes use Exposure to recover blown highlights, as we will shortly.

 • Recovery allows you to darken your highlights, reining them in from the extremes without affecting the exposure of the entire image.

 • Fill Light brightens the shadows independently of the highlights. Recovery and Fill Light work much like the Amount values in the Shadows/Highlights dialog box.

 • Blacks sets the black point of your image, permitting you to set the clipping point for shadows. It works just like the black slider triangle in Photoshop's Levels dialog box.

 • The Brightness value controls the midtones. It's computed as a percentage of an image's original linear luminance data. This data requires lots of darkening, which is why the default value is 50 percent. Values below 50 percent compress shadows and expand highlights, thereby lightening an image. Values over 50 percent do just the opposite, darkening the image.

 • Increase the Contrast value to exaggerate the difference between shadows and highlights, creating a valley in the center of the histogram. Decrease the value to converge shadows and highlights into the midtones, so the histogram looks more like a central mountain.

It's a good idea to keep an eye on the histogram as you adjust the various exposure and brightness values. Unlike its counterparts in Photoshop, this histogram comprises three overlapping graphs, one for each color channel. As you move the sliders, the histogram lets you predict how your colors will develop when the image is rendered in Photoshop. As usual, shadows are on the left and highlights are on the right. Spikes on the extreme ends of the graph tell you that you've clipped the shadows or highlights.

For our image, let's do the following:

- Begin by lowering the **Exposure** value to –1. You'll immediately see that you've recovered the highlight detail throughout the image.

- Raise the **Recovery** value to 20. This lightens the highlights of the image without further changing the overall exposure.

- Skip the Fill Light value for the moment and set the **Blacks** slider value to 10 to bring out the shadow detail.

- Change the **Fill Light** value to 10 to bring back some of the details that were lost in the shadows, restoring some of the shape detail in her black-stockinged legs.

- Darken the midtones by reducing the **Brightness** value fairly precipitously to –15. This is an unusually drastic modification, but the image is very bright. Reducing the Brightness has the effect of making the image too dark overall, so return to the **Exposure** setting and increase it to 20. (When using these sliders in Camera Raw, you'll want to go back to previous settings and reconsider them in light of the overall effect.)

- Decrease the **Contrast** value to +20.

The final settings appear in Figure 9-13.

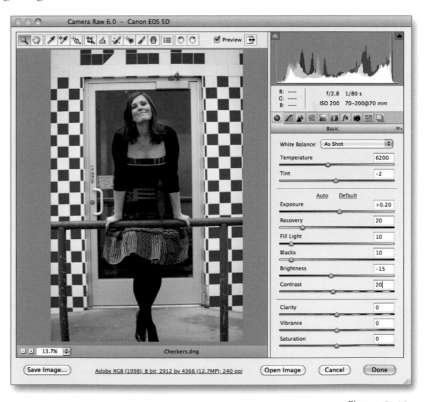

Figure 9-13.

You may have noticed the Auto button above the Exposure slider. Use Auto to have Camera Raw assign its best-guess values to the six exposure settings. (To apply Auto from the keyboard, press Ctrl+U or ⌘-U.) Like Photoshop's Auto Color command, the Auto button fails about as often as it succeeds. You can always try the Auto settings first and then make your adjustments.

3. *Sharpen the image with the Clarity slider.* Clarity increases the contrast along edges. In other words, areas of rapid contrast become more rapid still, which has the effect of sharpening the image. For this image, a **Clarity** setting of +50 provides nice edges without going overboard.

4. *Adjust the Vibrance and Saturation settings.* The final two sliders in the Basic panel let you modify the intensity of colors in an image. In reverse order:

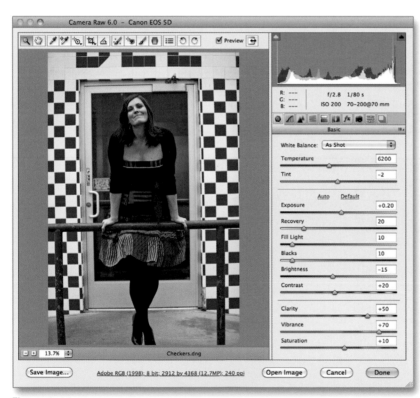

Figure 9-14.

- The Saturation value increases or decreases the intensity of all colors across the entire image—the flesh, the fabric, the background, everything. Overdoing it with the Saturation slider can result in garish colors, especially in the skin tones.

- Vibrance changes color intensity more selectively, affecting the low-saturation colors more than the high-saturation ones. A heavy hand with the Vibrance slider can give you rough transitions because not all the colors are boosted evenly.

For this image, set the **Vibrance** value to +70 to bring out the lovely red shade of Megan's hair and play up the purple in her sash. Then set the **Saturation** to +10 to pump up the colors without overplaying them. The results are displayed in Figure 9-14.

5. *Choose the straighten tool.* Because a handy checkerboard grid appears on either side of the subject of this image, it's fairly obvious that the image is slightly crooked. Camera Raw has you covered for fixing this problem. Start by selecting the straighten tool in the toolbar across the top of the window (highlighted in Figure 9-15) or pressing the A key.

Figure 9-15.

6. *Draw a level horizon line.* The straighten tool in Camera Raw works similarly to the one we saw in Photoshop in Lesson 2, except that once you release the mouse, the image will automatically go into crop mode. Carefully drag a horizontal line across the image, using the checkerboard tiles of the building as a reference. When you release, Camera Raw will create a crop bounding box showing you which parts will be cut away.

Take this cropping opportunity to improve the composition. Grab the handle at the top of the bounding box and move it down below the cutoff tile lettering at the top. Then move the right boundary halfway into the outer row of tiles to match the tiles on the left, as in Figure 9-16.

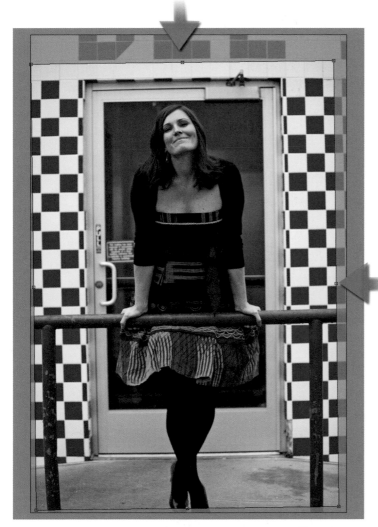

Figure 9-16.

Consider the following features of the crop tool in Camera Raw:

- If you don't like your crop, you can abandon it by clicking outside the image in the gray area of the interface.

- You can change the aspect ratio of your crop on-the-fly by choosing one of the preset ratios or setting custom dimensions. Press and hold the crop tool icon to see a pop-up menu of your choices.

- If you'd like to see a preview of your crop, simply change to a different tool. To readjust your crop, choose the crop tool again.

- Finally, like every other thing you do in Camera Raw, this edit is temporary, even after you close the file. Anytime you open the image in Camera Raw, your crop is readjustable by simply clicking the crop tool.

7. **Return to the Bridge** Click the **Done** button to return to the Bridge. The Preview window displays your image with all its changes, as in Figure 9-17.

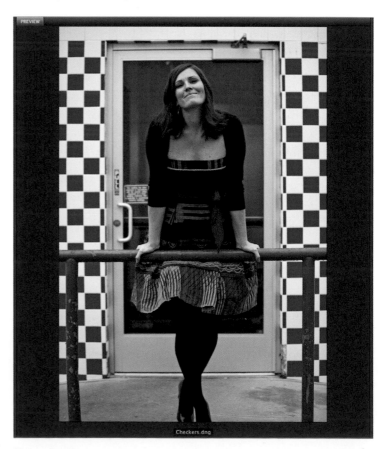

Figure 9-17.

Selective Editing and Spot Removal

Way back, oh, before CS4 came along, the edits you made in Camera Raw could be applied only to the entire image. You couldn't specifically limit your modifications to a particular part of a photo that was in need of special consideration. You also couldn't deal with pesky little flaws unless you opened the image in Photoshop proper. But all that changed with the previous update of ACR and Photoshop.

Selective edits come in handy when you have an image like the one pictured in Figure 9-18. I balanced this shot in advance to accommodate the sky. But the low-angle foreground is a bit too cool as a result. Wouldn't it be great it you could adjust different regions of an image differently? Well, as of Camera Raw 5, you can. The plug-in provides two tools (both labeled in the figure) that let you adjust colors selectively:

- The *adjustment brush* (keyboard shortcut: K) lets you paint in brightness and color adjustments.

- The *graduated filter tool* (G) creates a gradual transition between one area of color adjustments and another.

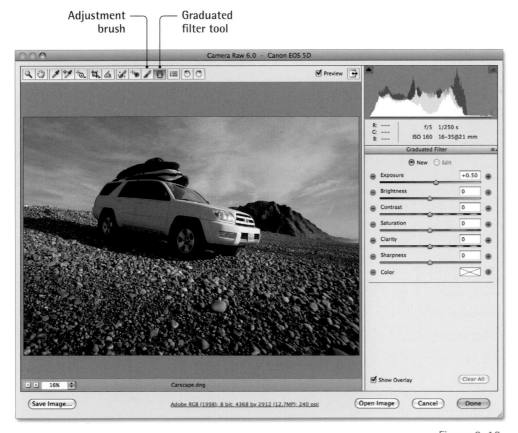

Figure 9-18.

Both are great features, but I find the graduated filter tool easier to control. Which is why I advocate on its behalf in this next exercise.

1. *Open an image.* From the Bridge, navigate to the *Lesson 09* folder inside *Lesson Files-PsCS5 1on1*. Then double-click the *Raw Images* subfolder, select the image called *Carscape.dng*, and press Ctrl+R (⌘-R) to open it in Camera Raw.

2. *Select the graduated filter tool.* Select the graduated filter tool from the top of the Camera Raw interface. Or press the G key.

3. *Define the size and angle of the graduated adjustment.* Drag from the bottom-left corner of the image up and to the right, to about a half inch above the horizon line. A green circle marks the beginning of your drag, and a red one marks the end, as in Figure 9-19. If your circles and lines look less like those in the figure than you would like, no worries. Just drag the green and red circles, or the dashed line between them, to make adjustments. You have now isolated the bottom half of the photograph.

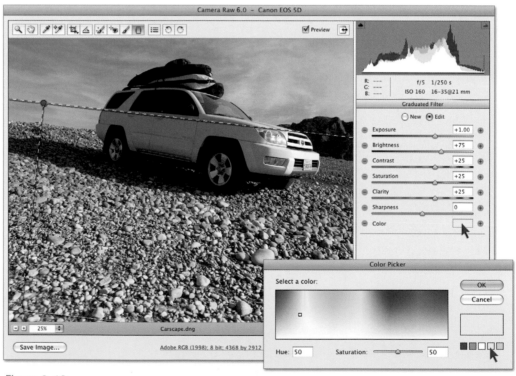

Figure 9-19.

4. *Apply a few adjustments.* The right side of the window now sports a **Graduated Filter** window, which includes a sampling of the options we've seen so far. Here are the settings I recommend (subject to your interest in applying them, of course):

- Raise the **Exposure** value to +1.00 to brighten the rocks and other foreground objects.

- Increase the **Brightness** value to +75.

- Take the **Contrast**, **Saturation**, and **Clarity** values up to +25. Any reason for this parity? Easy to replicate and the result looks great.

- Finally, click the swatch to the distant right of the word **Color**. This brings up the **Color Picker** pictured in the bottom-right corner of Figure 9-19. You can select any color you like. But for the sake of simplicity, click the light yellow swatch in the bottom-right corner—just to the right of white—and then click **OK**. The result is the warmed up image shown in the figure's Preview window.

To get a sense of just what a difference you've made, turn off and on the Preview check box or press the P key. Turn off the Show Overlay check box or press V to hide the interface folderol.

5. *Accept your changes.* Click **Done**. The Bridge updates to reflect your changes, and the *Carscape.dng* thumbnail receives a ⊕ to show that the Camera Raw metadata has been modified.

6. *Open an image with specks and blemishes.* The spot removal tool allows you to retouch defects and unwanted details in a digital photograph, a quick and easy alternative to the power-healing we did in Lesson 4, "Retouch, Heal, and Enhance." Start by selecting the thumbnail *Boat & beach.dng* in the *Raw Images* folder and press Ctrl+R (or ⌘-R) as we have so many times before.

7. *Automatically adjust the exposure settings.* Click the **Auto** button in the Basic panel to instruct Camera Raw to automatically correct the brightness and contrast of the image. Although subject to the whims of a robot mind, the adjustments work well enough for this image. My only manual imposition is to raise the **Recovery** value to 30 to suit my taste, as in Figure 9-20 on the next page.

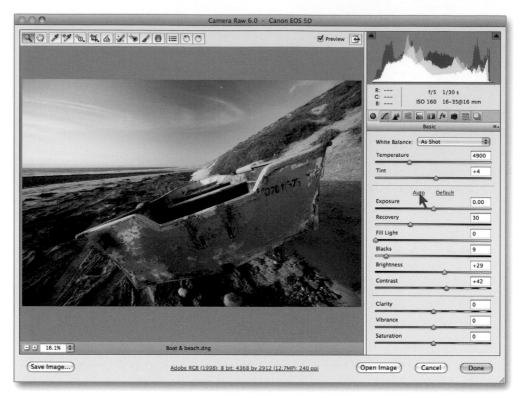

Figure 9-20.

8. *Zoom in on the dust spots.* With the zoom tool, click in the image to magnify the dust spots far above the boat at the top of the sky. At the 100 percent view size, you can see that the dust spots aren't dust spots at all, but blurry gulls, out beyond the focal range of the camera.

9. *Select the spot removal tool.* Click the eighth icon (✋) along the top of the interface (shown in Figure 9-21) or press B (for blemish) to select the spot removal tool. The moment you do, Camera Raw displays a panel of options, empty except for Type, Radius, and Opacity. Check to make sure **Type** is set to **Heal** and **Opacity** is 100 percent; otherwise, you're good to go.

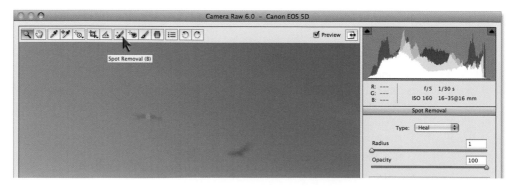

Figure 9-21.

10. *Draw circles around the blemishes.* Position your cursor at the center of one of the blurry gulls and drag outward to create a circle around the bird. When you release, Camera Raw not only makes the seagull disappear—it's officially an ex-spot— but also shows you two circles, one red and one green, as in Figure 9-22. The green circle shows you the portion of the image that has been cloned, known as the *source*. The red circle is the area that the source has been cloned onto, called the *destination*. (These terms should be familiar from Lesson 4.) You can move either circle by dragging it. If the retouch radius (i.e., the circle) turns out to be too large or too small, you can scale it using the Radius slider in the options bar.

11. *Gauge the quality of your edits.* Retouch away as many seagulls as you like. (There are a lot of them, so I leave it up to you to decide how thorough you want to be.) After a while, you'll have several circles in the works. Problem is, the very circles that are miraculously erasing the birds are interfering with your ability to gauge the quality of your edits. To hide them temporarily, turn off the **Show Overlay** check box or press the V key. With any luck, you shouldn't see a ripple in the sky. If you do, turn on the check box and edit the circles as needed. (Click a circle to select it; press Backspace or Delete to delete it.)

12. *Accept your changes.* As always, when you click **Done**, Camera Raw saves your changes as part of the image file. Again, no pixels are modified; Camera Raw achieves its magic with metadata. Programs that support this variety of metadata see it; those that don't, don't.

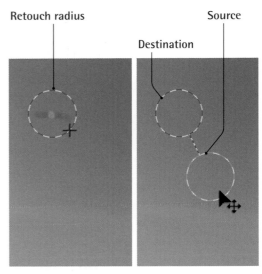

Figure 9-22.

Having lived through the bad old days, it's fairly miraculous to me that Camera Raw can create these localized edits so easily and so reversibly.

HSL and Grayscale

The tabs across the Basic panel give you access to a variety of other types of adjustments in Camera Raw. One of the more useful of these is the fourth one over, the HSL/Grayscale tab.

HSL stands for Hue, Saturation, and Luminance, and the sliders in this panel allow you to address all three adjustments on a color-by-color basis. In this exercise, we'll take a look at three situations where such control is very useful. (For a look at the grayscale part of HSL/Grayscale, see the sidebar back in Lesson 6, "Converting an Image to Black and White.")

1. *Open another trio of images.* Back in the Bridge, select *Big sky.dng*, *Flowers.dng*, and *Wing.dng*. When sorted alphabetically, the files are nonadjacent, so click one and Ctrl-click (or ⌘-click) the other two. For the sake of variety, right-click one of the selected thumbnails and choose **Open in Camera Raw**.

2. *Switch to the HSL/Grayscale panel.* This time, we'll edit each image independently. Click the *Flowers.dng* thumbnail in the vertical filmstrip. Then click the ☰ icon below the histogram to switch to the **HSL/Grayscale** panel. You'll find yourself automatically in the **Hue** subpanel, shown in Figure 9-23. As in the Hue/Saturation dialog box, the options permit you to adjust one set of colors independently of another. But instead of sticking to the six evenly spaced primaries, Camera Raw presents you with eight subjective color groups. Where's Cyans? Who cares when you have such old chums as Oranges and Purples in its stead?

Figure 9-23.

3. *Modify the hues of the flowers.* As I mentioned, when working in the Hue subpanel, you can change one range of colors independently of another. Let's say that you want to make the flowers redder. The flower is primarily orange, so move the

Oranges slider to the left toward red. A value of −70 produces the effect shown in Figure 9-24. Everything orange changes to red; other colors remain untouched.

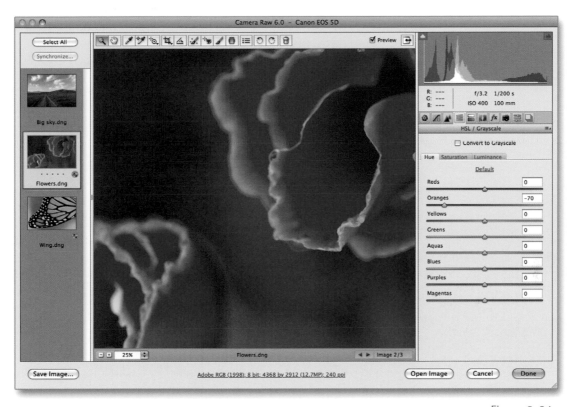

Figure 9-24.

Notice that your range for modifying any hue is limited. For example, I can rotate the hues of the flowers between red and yellow, but I can't make them purple. The other sliders in the Hue subpanel don't help because each slider operates on the original colors, not the modified ones.

4. *Change the hues behind the wing.* Case in point: Click the close-up shot *Wing.dng* in the vertical filmstrip. The background is a yellowish green but I want it to be blue. Change the **Greens** value to its absolute maximum, +100. The background becomes bluer, falling more or less in the aqua range. It's tempting to increase the Aquas value, but the base raw image has no aquas, so the Aquas slider has no effect. I could get clever and heap on more color adjustments using Temperature, Tint, and the options in the Camera Calibration panel. But if I really have my heart set on a blue background, I'm better off opening the image in Photoshop and applying the Hue/Saturation command.

5. *Increase the saturation of the wing.* Fortunately, I don't have my heart set on a blue background; I'm more concerned about lifting the saturation of the insect's wing. Click the **Saturation** tab to make it active. You'll see the same slider bars as before. But instead of drifting from one color to another, each slider progresses from gray to full saturation. To modify the saturation of the wing independently of its background, do like so:

- The wing is orange, so raise the **Oranges** value to +100.

- That's not enough. Luckily, the wing contains a good deal of yellow, so increase the **Yellows** value to +100 as well.

- To settle down the background a bit, you might reason that Aquas is the proper choice. But as far as the HSL/Grayscale panel is concerned, the background is still green. Back off **Greens** to −50 to achieve the effect in Figure 9-25.

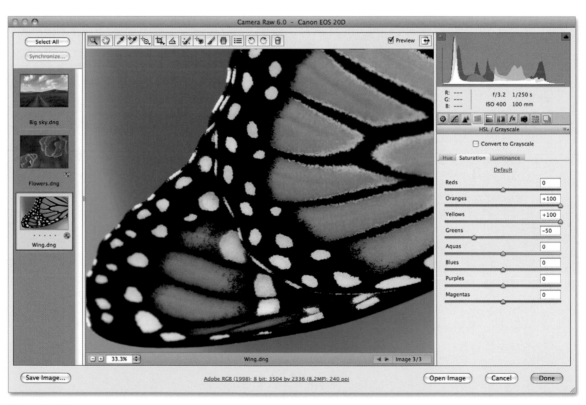

Figure 9-25.

You've managed to increase the saturation of one part of the image and decrease the saturation of another, something you can't do with the Vibrance and Saturation sliders we saw earlier.

6. *Switch to the Luminance subpanel.* To appreciate the amazing powers of the final set of options in the HSL/Grayscale panel, we need a great big sky. So click the *Big sky.dng* thumbnail in the left-hand filmstrip. Then click the **Luminance** tab to call up eight more sliders, which vary from one brightness extreme to the other.

7. *Darken the sky.* The photograph has a stark elegance, but the texture is a bit flat. To heighten the drama, I suggest we deepen the sky by moving the **Blues** slider down to −80. The before and after versions of the image in Figure 9-26 show the dramatic difference this one simple change makes. You can see it for yourself by toggling the **Preview** check box off and on.

8. *Click Done, because, well . . .* on so many levels, we are done.

Unaltered sky

Luminance, Blue: −80

Figure 9-26.

Figure 9-27.

Creating Panoramas with Photomerge

If you want to capture the grandeur of a sweeping horizon or an iconic structure, nothing quite does it like a *panorama*, which allows you to combine multiple frames into one single powerful image. From the earliest days of photography, artists were assembling individual photos to create a wider view than their lenses could capture in a single shot. In the digital age, where you can shoot until you run out of memory card space and then allow a tool like Photoshop to do the blending and merging, creating panoramas has become almost miraculously easy.

Photomerge, the command in Photoshop that automatically combines images to form panoramas, invokes a combination of the Auto-Align Layers command and its companion, Auto-Blend Layers, the latter of which automatically adjusts and masks images so they merge seamlessly. Amazingly, just by applying Auto-Align Layers and Auto-Blend Layers in sequence, Photomerge is able to create panoramas of astonishing quality. We'll perform such a feat in this exercise.

1. **Select the photos in the Bridge.** Even though Photomerge is a Photoshop function, it is most efficiently invoked from the Bridge so that you can choose your images with the aid of thumbnails. If you're still in the Bridge from the last exercise, great. If not, from Photoshop, click the ⊞ icon on the right side of the options bar to switch to the Bridge. Then navigate to the *Panorama* subfolder in the *Lesson 09* folder inside *Lesson Files-PsCS5 1on1*.

 Click *Theatre Ancient_01.jpg* and then Shift-click *Theatre Ancient_14.jpg* to select a series of images (represented in Figure 9-27) that I took at the best-preserved Roman theater in the world, the Theatre Ancient d'Orange in Southern France. Given my love of both Roman antiquities and the *I, Claudius* PBS miniseries, I wanted to capture the overwhelming feeling of being in the midst of such an amazing structure in a way that a single shot from too far away never would have captured.

PEARL OF ⬤ WISDOM

Although I did not use a tripod, I took care to shoot every image from a single vantage point by pivoting my head and camera, keeping my feet and hips fixed. This is the key to shooting a successful Photomerge composition: Rotate left and right, tilt up and down, but keep your point of perspective fixed. Overlap the individual shots by about 30 percent or more to ensure complete information.

2. *Begin the merge process.* From the Bridge, choose **Tools→Photoshop→Photomerge**. The Bridge switches back to Photoshop and displays the dialog box in Figure 9-28, which lists all the images you selected in the Bridge. On the left side of the dialog box, you'll see a list of Layout options, which allow you to define the variety of distortions to use to align the merged photographs. Here's how these options work:

- Select Auto to let Photoshop apply one of the next five Layout options according to its own internal calculations. This option sometimes works great, other times not.

- The next option, Perspective, flares the images to create an exaggerated bow-tie pattern. The result simulates the effect of images at the perimeter of the panorama wrapping around your head. Again, rarely the best solution.

- Cylindrical wraps each image around the outside of a virtual cylinder, so that they bulge in the center and map into alignment at the outside edges. It sounds weird but works great.

- If Cylindrical doesn't produce the effects you're looking for, try Spherical instead. It can distort both the horizontal and vertical edges inward or outward, as needed, to make the images match up.

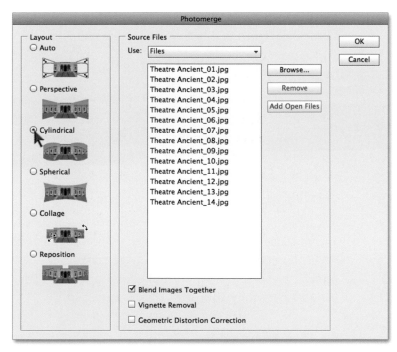

Figure 9-28.

- Collage is capable of scaling and rotating images, but it will not distort them.

- Reposition Only moves the images into alignment but does not distort them. Select this option only if you plan on applying the Auto-Align Layers command manually at a later point.

For our purposes, go ahead and select **Cylindrical**—even though Photoshop would probably opt for it if we selected Auto—and click **OK**. Then sit back and watch as Photomerge assigns each photo to its own layer. Shortly thereafter, you'll see progress bars for the Auto-Align and Auto-Blend functions.

3. *Enjoy the miracle of the Photomerge calculations.* It may take a while (a long while on older machines), but as you can see in Figure 9-29, Photoshop does a spectacular job of merging the pieces. Each component image is represented on its own layer with its own layer mask.

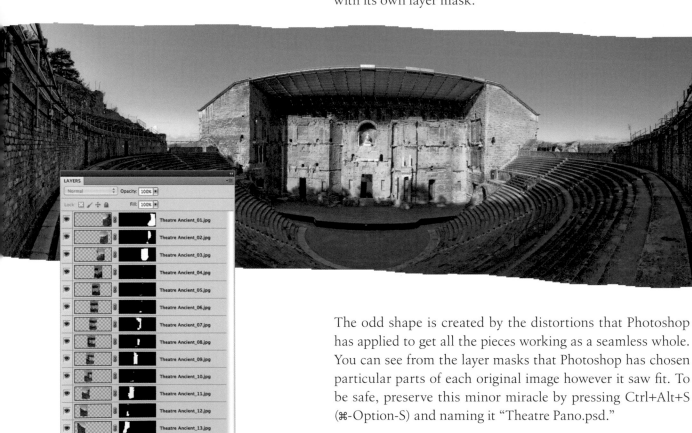

Figure 9-29.

The odd shape is created by the distortions that Photoshop has applied to get all the pieces working as a seamless whole. You can see from the layer masks that Photoshop has chosen particular parts of each original image however it saw fit. To be safe, preserve this minor miracle by pressing Ctrl+Alt+S (⌘-Option-S) and naming it "Theatre Pano.psd."

4. *Flatten the image.* The multiple layers may be interesting and all, but we really don't need them and having them will make the next steps problematic. So click the ▾≡ at the top right of the **Layers** panel and from the pop-up menu choose **Flatten Image**.

5. *Crop the image.* Ultimately, we want to get rid of the irregular edges, so press C to obtain the crop tool. Draw a crop boundary that represents the largest rectangle possible that still fits within the photograph, as shown in Figure 9-30. When you have it where you like it, press Enter or Return.

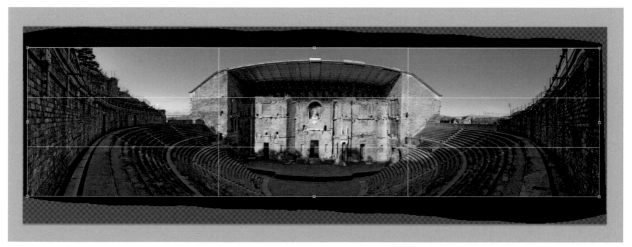

Figure 9-30.

6. *Open the Mini Bridge.* To demonstrate the enormity of this structure, I think adding a human figure would be helpful. I have just the guy for the job. We'll put me in the figure with the assistance of a feature new to CS5, the Mini Bridge. The purpose of this tool is self-explanatory: You get access to the file browsing capabilities of the (full) Bridge encased in a panel in the Photoshop interface. You can open the Mini Bridge in no less than four ways, perhaps the easiest of which is to click its icon in the options bar, as I'm doing in Figure 9-31.

If you haven't used the Mini Bridge before, it opens to the Home panel, as shown in the figure. Click the icon to the left of Browse Files (the one that looks like a photo of a sailboat, for reasons known only to Adobe) to do just that, browse files as you would in the Bridge proper.

Figure 9-31.

Figure 9-32.

The real Bridge needs to be running for the Mini Bridge to work. If you didn't already have the Bridge open, the Mini Bridge would warn you that it was "disconnected" and present you with the appropriate button to launch the Bridge.

7. *Browse to the I Deke file.* When you evoke browsing in the Mini Bridge, you'll see a dual-pane Navigation pod (as Adobe calls it). The Favorites, Recents, and Collections entries on the right (as in Figure 9-32) are determined by what you have been doing in the Bridge proper. Click **Recent Folders** in the right-hand pane. Since you began this exercise with the **Panorama** folder, you should be able to find and click said folder in the list of recently viewed folders on the left. (Oddly, they are listed alphabetically.) When you do so, the Content panel displays the thumbnails from that folder. Click the **I Deke.psd** thumbnail to select it.

You can reset the Recent Folders and Recent Files list only from the main Bridge. The Mini Bridge will sync accordingly. (If you want to reset either Recent Folders or Recent Files in the Bridge, go to the full application, click the fourth icon in the top row, and choose either of the Clear Recent options from the pop-up menu).

8. *Drag me into the panorama.* One of the great features of the Mini Bridge is that you can drag-and-drop to place files from the Mini Bridge's Content panel into an existing Photoshop document. Drag *I Deke.psd* into the panorama. The default behavior when placing from the Mini Bridge is to bring in the new image as a smart object, so you'll be presented with the familiar smart object box shown in Figure 9-33. Press Enter (Return) to accept the placement.

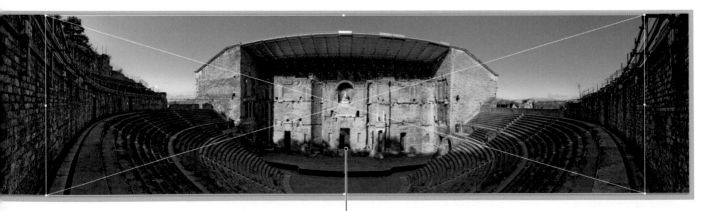

Figure 9-33.

Tiny me on a panoramic stage

The default placement from the Mini Bridge plops me down center stage, a place I occasionally assert I belong. But you can move me around at will by pressing the V key to grab the move tool. I'm your own personal dekePuppet. If you move me downward from the default placement, you'll find that perfect spot (where the photo of me was actually taken after I finished shooting my panorama frames) and see the masking job around tiny me blend seamlessly.

9. *Save the panorama.* After all this work, you'll want to save the results. Choose **File→Save** or press Ctrl+S. Name the file "Emperor Deke" or something equally clever and trademarkable. Then click the **Save** button.

In the end, I decided to revisit the precrop *Theatre Pano.psd* file I saved in Step 3 and recrop the image so that more of the sky and less of the side structures were visible. (There's no rule that panoramas have to be that long and skinny; their real benefit is your ability to capture detail over a large visible span.) I repositioned the I Deke layer so that I was back in my original spot as a tourist rather than an orator. Then I warmed the image considerably (one of my notorious tendencies) with a Levels adjustment and sharpened to taste.

My final interpretation is revealed in Figure 9-34.

Figure 9-34.

Figure 9-35.

High Dynamic Range (HDR)

HDR Pro is another tool in Photoshop CS5 that allows you to combine information from multiple frames to create something you can't capture in a single shutter click. HDR stands for *high dynamic range*, meaning that the results capture both ends of the shadow-to-highlight continuum. HDR Pro lets you combine multiple frames of the same subject shot at different exposures, which allows a wider range of luminance information to be combined into one image. So instead of just exposing for either shadow or highlight, you can shoot a succession of images that capture both. The result is a compilation that in some ways more closely mimics the way our eyes—rather than our camera sensors—are able to take in a broad range of light information.

On a practical level, HDR Pro, which has been vastly improved in this version of Photoshop, works similarly to Photomerge. First, you shoot a set of photographs at various exposure stops (preferably with a tripod, and varying in either shutter speed or ISO). Then you point Photoshop at that collection and the magical calculations go to work creating a single image. The new HDR Pro feature in CS5 then allows you to assert all kinds of creative control over that output.

1. *Select eight images that represent a wide range of exposure settings.* For this exercise, we'll use a series of photos I took with an Olympus E-30 in Steamboat Springs, Colorado. I shot them from the dark interior of a ramshackle barn, looking out through cracks in the walls and door into bright sun reflecting off a snowy landscape. I used a tripod and an identical aperture setting for each shot, simply varying the shutter speed to create different exposures. On one end of the luminance range, an exposure with a shutter speed of 0.5 seconds captures highlight detail without blowing out completely (although there are spectral highlights); on the other end, an exposure of 20 seconds is enough exposure to record the texture of the old wood in the dark recesses of the interior.

 If the Mini Bridge isn't still open from the last exercise, choose **File→Browse in Mini Bridge**. The *Lesson 09* folder should still be available in your **Recent Folders** pane. Click *Lesson 09*, and then double-click the *HDR Exposures* folder in the **Content** panel. Finally, open the *DNG* subfolder by double-clicking it. Click *Exposure 0.5 sec.dng* and then scroll down the Content panel and Shift-click the *Exposure 20.0 sec.dng* file, thus grabbing all the images in between, as I've done in Figure 9-35.

I've provided the same images in JPEG format, which you can use if the larger DNGs slow your computer too painfully. You'll get similar results, although some detail may be lost. Even if you stick with DNGs, Photoshop may warn you that HDR Pro prefers raw files (which DNGs are, of course). Just click OK either way.

2. *Evoke HDR Pro.* Click the tools icon at the top right of the Content panel, and choose **Photoshop→Merge to HDR Pro**, as shown in Figure 9-36. (You'll note that Photomerge is available from this Mini Bridge menu as well. Analogously, you could access HDR by choosing Tools→Photoshop→Merge to HDR Pro in the Bridge proper.)

Much like when you launched Photomerge, Photoshop goes to work calculating how it's going to combine the images. After a noticeable amount of time, you'll be presented with the Merge to HDR Pro window, as shown in Figure 9-37, which displays your combined preview in the large window, your component images across the bottom, and an array of slider controls along the right side.

Figure 9-36.

Figure 9-37.

3. **Adjust the sliders.** You can see back in Figure 9-37 that HDR Pro's initial preview reveals a successful fusing, bringing out details in the wood and reining in some of the highlights, like those along the pipe on the ground. But the real fun of Merge to HDR Pro comes from using the new sliders, which allow you creative control over the output. The fact is we're working with a through-the-looking-glass 32-bit image and seeing a preview of what our 16-bit output will look like. So things can be unpredictable, not entirely intuitive, and subject to healthy trial-and-error. In our case, here are the settings (shown in Figure 9-38) I chose:

Figure 9-38.

- The Edge Glow controls help you create the effect of bounced light that has become synonymous with HDR. Set the **Radius**, which controls the size of the glow, to 200. Set the **Strength**, which controls the interpretation of what exactly is an edge by comparing pixel contrast, to 3.00.

- The next few sliders can be thought of as analogous to those in the Levels command. The Gamma slider controls midtone contrast. If you move it to the right, midtones are increased. If you move it to the left, where somewhat unintuitively the value gets bigger, the shadows and highlights are emphasized. In this case, move the **Gamma** slider to the right to .50.

- The **Exposure** slider represents just that, the theoretical f-stop of the compiled image. For this image, reduce it to –1.00.

- The **Detail** slider will have a sharpening effect. For this image, I like taking it way up to 150. To me, playing in HDR makes no sense if you don't create some impact.

- The Shadow and Highlight sliders control those areas of greatest darkness and greatest lightness, respectively. In this case, leave the **Shadow** set to 0, but move the **Highlight** slider all the way to the left, to –100, to get as much detail as possible from around the spectral highlights (which aren't recoverable themselves).

- The Vibrance and Saturation sliders work like the ones we saw in Camera Raw. I increased the **Vibrance** to 70 and the **Saturation** to 25 to bring out the warm glow of the sun against the wood.

4. *Switch to the Curve panel.* Click the **Curve** tab, which sits behind the Color tab that houses Vibrance and Saturation. Although the graph looks familiar to those of you who followed Lesson 6—with its input and output values and the ability to set points along a curve—it doesn't work quite the same way. This is another moment where trial and error will serve you well when you're working on your own images. The next step shows you my settings.

5. *Load an HDR preset.* HDR Pro comes with a collection of preset effects that you can apply from the Preset pop-up menu. You can also save and load your own combinations of custom settings. Let's exploit that feature for the curve adjustment. At the top of the window, click the icon to the right of the **Preset** pop-up menu to bring up your **Preset Options**, and choose **Load Preset**, as in Figure 9-39.

In the **Open** window that appears, navigate to the *Dark interiors.hdt* setting in the *Lesson 09* folder. Click it, and then click **Open**. The curve adjustment that I created (after some experimentation) to further compress some of those very bright areas appears in the Merge to HDR window. You can see the results in Figure 9-39.

Figure 9-39.

6. *Address the ghostly artifacts.* One reason why using a tripod is recommended when taking a series of HDR exposures is that Photoshop needs to align the individual frames to fuse them. The slightest movement in your scene from one frame to the next will cause a shift and most likely create *ghosting* in your combined image, meaning some movement or change between frames creates a luminance aberration in the photograph. Even in the case of our seemingly deserted barn, with no wind or creature in sight, our scene is still subject to the rotation of the earth. So the angle of sun moved slightly while I was capturing my various exposures, thus creating an artifact along the rafters in the upper-right corner, as you can see (zoomed to 200 percent) in Figure 9-40.

Luminance "ghosts" left by shifting light from the sun

Figure 9-40.

Turn on the **Remove Ghosts** check box at the top of the panel (circled in Figure 9-41 on the facing page). You won't notice any immediate change to the problem area. You will, however, see a green stroke around the leftmost frame in the filmstrip at the bottom. This is Photoshop's way of telling you that it is using that lightest exposure as the source for determining how to address the aberration, which doesn't do us much good in this case. Instead, click the fourth exposure from the left in the filmstrip to move the green indicator stroke and set that exposure as the source for fixing the problem area. You can see improvement in the preview window on the facing page.

7. *Click the OK button.* We're done with our HDR adjustments, so click the **OK** button at the bottom of the Merge to HDR window. You'll be treated to a parade of progress bars as Merge to HDR cooks up a 16-bit image and ultimately hands off the merged composite to Photoshop. Press Ctrl+Alt+S (⌘-Option-S) and save the image as "Dark Interiors HDR.psd."

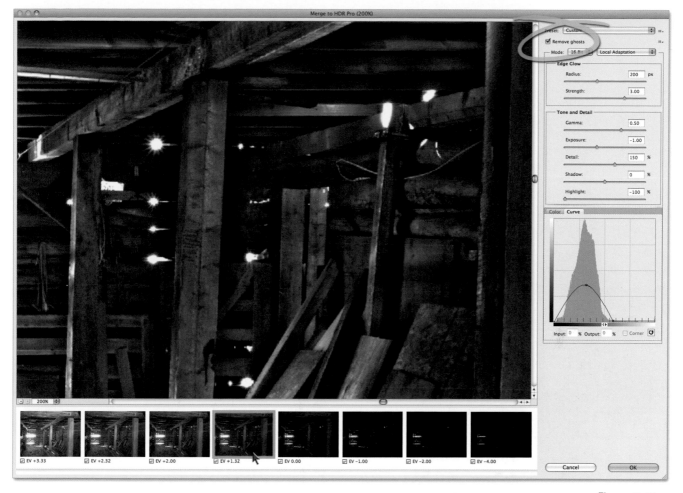

Figure 9-41.

8. *Create a levels adjustment layer.* Now that we're in Photoshop proper, we can make further adjustments to our HDR composite. I'd like to tweak a few things, starting with Levels. Click the ⊘ at the bottom of the **Layers** panel, and choose **Levels**. In the **Adjustments** panel, set the black point value (under the black triangle below the histogram) to 5 and the gamma (below the gray triangle) to 1.2, as in Figure 9-42.

9. *Add a Vibrance adjustment.* Unbelievably, I know, I want to raise the vibrance a little further to bring up the rich tones. Click the ⊘ icon at the bottom of the **Layers** panel and choose **Vibrance**. Then, in the **Adjustments** panel, move the **Vibrance** slider up to 60.

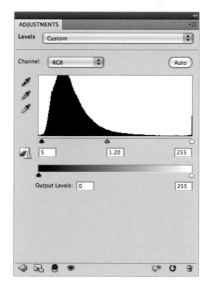

Figure 9-42.

10. *Sharpen the image.* Finally, let's sharpen the image a little further. Click the **Background** layer to make it active. Then choose **Filter→Sharpen→Smart Sharpen**. Set the **Amount** to 200, the **Radius** to 3px, and the **Remove** pop-up to **Lens Blur**. Click **OK**.

11. *Save as final.* Congratulations. You've persevered through astounding mathematical calculations to arrive at an almost otherworldly result. Press Ctrl+S (⌘--S) to save your work.

The final miraculous work of HDR Pro is shown in Figure 9-43.

Figure 9-43.

WHAT DID YOU LEARN?

Match the key concept in the numbered list below with the letter of the phrase that best describes it. Answers appear upside-down at the bottom of the page.

Key Concepts

1. Camera Raw
2. Raw format
3. Sidecar file
4. White balance
5. Bit depth
6. Exposure
7. Graduated filter
8. Panorama
9. Photomerge
10. Mini Bridge
11. HDR (High Dynamic Range)
12. Ghosting

Descriptions

A. Adjusting for the predominant color of neutral white, usually off as the result of an uncorrected light source.

B. A single image that represents a view wider than a traditional camera lens can capture.

C. A photographic compilation that allows for the combination of luminance data from different exposure values.

D. The appearance of luminance aberrations, caused in HDR photos by an element moving or changing appearance between individual frames.

E. A file that contains the instructions for modifications made to a raw file.

F. A tool that lets you adjust one region of an image independently of another inside Camera Raw

G. Photoshop's tool that allows you to align and blend multiple frames.

H. Measured in f-stops, this Camera Raw option corrects the brightness of highlights.

I. A camera's native format for which no on-board camera processing has occurred.

J. A new feature in CS5 that allows you to access the Bridge's photo organizing features.

K. The number of digits required to express a single pixel, which in turn determines the number of colors in an image.

L. A Photoshop plug-in that allows for the development of unprocessed native image files.

Answers

1L, 2I, 3E, 4A, 5K, 6H, 7F, 8B, 9G, 10J, 11C, 12D

CREATING AND APPLYING MASKS

IF YOU'RE LIKE most Photoshop users, you've at least heard of *masks*. Or perhaps you've heard them called *mattes* or *alpha channels* or any of a half dozen other terms. But whatever you call them, their purpose is the same: to block out one portion of an image and reveal another, as illustrated in Figure 10-1.

Essentially, what I did in Figure 10-1 was select the woman's face and move it into the mirror. But I never could have achieved such an accurate selection if I had relied exclusively on the lasso, wand, and pen tools. Masking lets you use the colors and luminosity values inherent in the image to define a selection outline. In effect, you use the image to select itself. You can do this in a myriad of ways in Photoshop. Masking takes some getting used to, but once you do, no selection tool is as accurate or efficient.

Seeing through Photoshop's Eyes

In real life, we have a natural sense of an object's boundaries. You may not be able to make out an individual flower in a crowded garden from a distance, but get close enough, and you can trace the exact border in your mind (see Figure 10-2, page 339). So why does Photoshop have such a hard time with it? Why can't you just say, "Choose the flower," instead of painstakingly isolating every single leaf, stem, and petal?

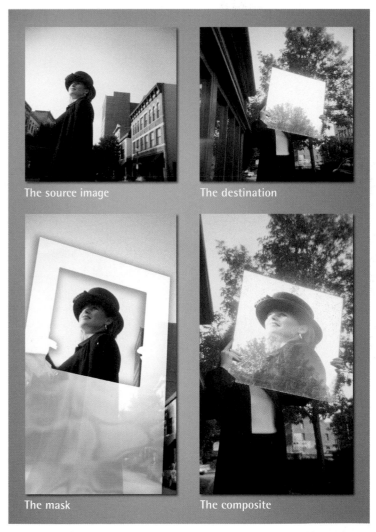

The source image

The destination

The mask

The composite

Figure 10-1.

ABOUT THIS LESSON

Project Files

Before beginning the exercises, make sure you've downloaded the lesson files from *www.oreilly.com/go/Deke-PhotoshopCS5*, as directed in Step 2 on page xvi of the Preface. This means you should have a folder called *Lesson Files-PsCS5 1on1* on your desktop (or whatever location you chose). We'll be working with the files inside the *Lesson 10* subfolder.

In this lesson, you'll wade slowly (at first) into the world of masking, starting with automated techniques and then moving on to calculations and defining precision masks via the pen tool. You'll learn how to:

 ## Video Lesson 10: Masking

A mask is a way of creating a highly accurate selection outline, using the image to select itself. When you're crafting a mask, you can bring a wide range of Photoshop features to bear on fine-tuning that selection process. In fact, the most accurate masks require the combined use of more than one of the tools in Photoshop's sophisticated arsenal. In this video, you'll see how I created the alpha channel you used for our jumping puppet friend from back in Lesson 8. I'll show you Color Range, the Quick Mask mode, and the new improved Refine Edge command.

To begin your mastery of masks, visit *www.oreilly.com/go/deke-PhotoshopCS5*. Click the **Watch** button to view the lesson online or click the **Download** button to save it to your computer. During the video, you'll learn these shortcuts:

Previous Video Lesson 10: Masking Next ▶

Operation or Tool	Windows shortcut	Macintosh shortcut
Color Range*	Ctrl+Alt+Shift+O	⌘-Option-Shift-O
Add color values to Color Range selection	Shift-click	Shift-click
Lift multiple colors with Color Range	Shift-drag	Shift-drag
Refine Edge	Ctrl+Alt+R	⌘-Option-R
Choose Brush tool	B	B

* Works only if you loaded the dekeKeys (as directed in Steps 8 through 10, beginning on page xix of the Preface).

Well, the truth is, you can, provided you know how to speak Photo-shop's language. A long conversation may be required, and you might have some misunderstandings along the way. But with a little time, a bit more patience, and a lot of experience, you'll learn to translate your vision of the world into something that Photoshop can recognize as well.

When you see a flower, you know precisely where it begins as well as where it ends.

Figure 10-2.

As you may recall from Lesson 6 (see "The Nature of Channels," page 196), Photoshop never actually looks at the full-color image. Assuming that you're working in the RGB mode, the program sees three independent grayscale versions of the image, one for each color channel. A mask is just another kind of channel, one in which white pixels are selected and black pixels are not. So if any one of those channels contains a very light foreground subject against a very dark background, you've got yourself a ready-made mask.

More likely, however, each channel contains some amount of high-lights, some amount of shadows, and lots of midtones in between. But that's okay because the strengths of one channel can compen-sate for the weaknesses of another. Take the sunflower, for example. If you inspect the individual color channels, you'll find that each highlights a different portion of the image.

The petals are brightest in the Red channel, the stem is well-defined in the Green channel, and the sky is lightest in the Blue channel (see the colorized views in Figure 10-3).

High contrast, light petals and head Uniform brightness, great detail Generally dark with bright sky

Figure 10-3.

Duplicating the Blue channel and inverting it makes the sky dark and other portions of the image light, a step in the right direction. Combining channels with Image→Calculations permits you to emphasize portions of the image, such as the flower (see Figure 10-4, left) or stem (middle). From there, it's just a matter of selecting the pieces you like, splicing them together, and adjusting contrast values. After a few minutes of tinkering—a process that I explain in detail later in this lesson—I arrived at the rough mask shown on the right side of Figure 10-4. Five to ten minutes later, I completed the mask and used it to select the flower.

Invert Blue, combine with Red Invert Blue, combine with Green 5 minutes of hacking pieces together

Figure 10-4.

Photoshop gives you the raw information you need to accurately define the edges in the image. Then it's up to you to figure out how to assemble the pieces. Fortunately, you can do so using not just a few selection tools but virtually every function in Photoshop's arsenal. And because a mask is a channel that can be saved as part of a TIFF or native PSD file, you can recall or modify the selection outline any time you like.

Using the Color Range Command

Photoshop's Color Range command uses a masking metaphor to generate selection outlines. In this regard, it serves as a bridge between the worlds of selections and masks, not to mention as a wonderful introduction to our lesson.

Essentially a sophisticated version of the magic wand, Color Range lets you adjust the range of colors you want to select until you arrive at an acceptable, if not perfect, selection outline. And it does so dynamically, so there's no need to start a selection over, as you sometimes must with the wand. Color Range also interprets luminosity values in a more sophisticated manner than the wand, which results in smoother, more credible selection outlines.

1. *Open an image.* Open the file *Superlips.psd* which is located in the *Lesson 10* folder inside *Lesson Files-PsCS5 1on1*. This striking image, displayed in Figure 10-5, comes from photographer Lvenl of the Fotolia.com image library. In the course of this exercise, we'll not only change the color of these lips to a nice cherry red but successfully mask them against a new black background.

2. *Press the D key.* By now, you know this resets the foreground color to black. But what you might not know is that the Color Range command uses the foreground color as the basis of a selection. You don't always have to start with black; doing so merely assures that you and I start on the same foot.

Figure 10-5.

3. **Create a Hue/Saturation adjustment layer.** Our goal is to turn the colored area of her lips red, so Hue/Saturation will come in handy. If the Adjustments panel isn't open, press F10 (if you loaded dekeKeys as instructed in the Preface). Hold down the Alt key (Option key) and click the ⥮ icon in the **Adjustments** panel (second row, second icon). Name your new layer "Cherry red" and press **OK**.

By default, when you create an adjustment layer, Photoshop automatically creates what it thinks is a handy, ready-to-use layer mask. The mask is harmless, but oftentimes you don't need it and it clutters up your Layers panel. To turn off this behavior, you have to go to the main Adjustments panel (the one from which you can choose the various types of adjustments), click the ⥮ at the upper-right corner of the panel, and turn off Add Mask by Default. If Photoshop gave you an automatic mask before I told you how to turn it off, simply drag that empty mask to the trash can at the bottom of the Layers panel.

4. **Redden the lips.** In the Adjustments panel, which now displays the Hue/Saturation sliders, set the **Hue** to −10 to redden the color, and then move the **Saturation** slider all the way to 80. This results, as you can see in Figure 10-6, in some awesomely radioactive red lips.

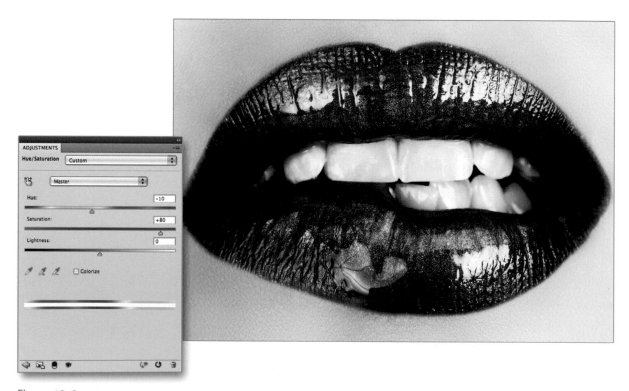

Figure 10-6.

5. *Choose the Color Range command.* We ultimately want to select the lips independently of the skin and teeth. Choose **Select→Color Range**. Alternatively, if you installed the custom dekeKeys shortcuts I recommend in the Preface (Step 9, page xix), you can press Ctrl+Shift+Alt+O (⌘-Shift-Option-O). Either way, you get the **Color Range** dialog box, shown in Figure 10-7.

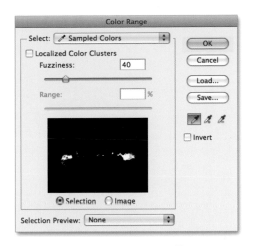

Figure 10-7.

The central portion of the dialog box features a black-and-white preview, which shows you how the selection looks when expressed as a mask. The white areas represent selected pixels, the black areas are deselected, and the gray areas are somewhere in between. This might seem like a weird way to express a selection outline, but it's actually more precise than the marching ants, which we saw back in Lesson 3. Whereas marching ants show the halfway mark between selected and deselected pixels, a mask shows the full range of a selection, from fully selected to not selected.

6. *Click in a dark area of the lips.* When you move the cursor into the lips image window, it changes to an eyedropper. Click in a dark area of the lips, like the one I've designated in Figure 10-8, to create a base for the selection. You can see that the Color Range preview changes to reflect a selection that includes all the areas with a similar color value.

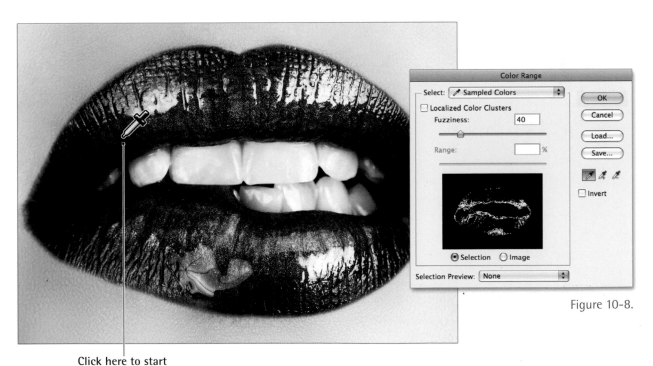

Click here to start

Figure 10-8.

7. **Add some more samples to the Color Range selection.** To add base colors to the selection, press the Shift key and click or Shift-drag inside the image window. For our purposes, Shift-click in other shadow areas of the lips (like the outer corner), then Shift-drag along the inner lower lip. You can watch the selection grow in the preview inside the Color Range dialog box. Figure 10-9 documents where I've clicked and the subsequent progress I've made in the Color Range preview.

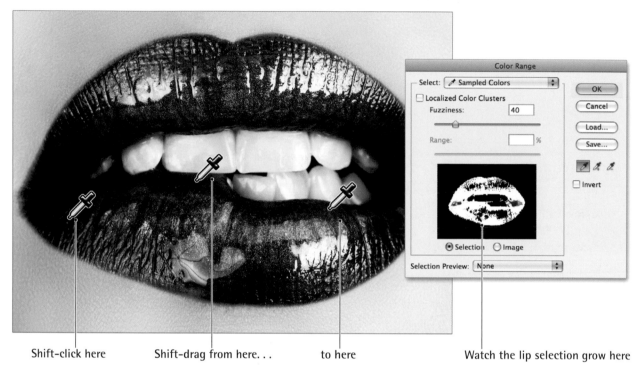

Shift-click here Shift-drag from here. . . to here Watch the lip selection grow here

Figure 10-9.

Avoid clicking the highlight areas where the light is reflecting dramatically off her lip gloss. Clicking one of those spots would not only select that area of the lip but also the lighter areas in the teeth and face that have the same luminance value, thus adding those areas to the selection and defeating the purpose. If you go too far, consider these two options:

- Press Alt (or Option) and click a color in either the image window or preview to deselect a range of related colors. As often as not, this technique overcompensates and deselects too much of the image.

- Choose Edit→Undo Color Sample or press Ctrl+Z (⌘-Z) to restore the previous selection. Great feature, but note that

you have just one level of undo inside the Color Range dialog box. Use it wisely. And immediately.

8. *Change the Fuzziness value.* Like the magic wand's Tolerance value you saw in Lesson 3, the Fuzziness value spreads the selection across a range of luminance levels that neighbor the base color. Lowering the value contracts the selection; raising the value expands the selection. Change the **Fuzziness** value to 60.

Fuzziness improves on Tolerance in two important ways. First, whereas the static Tolerance value modifies the next selection, the dynamic Fuzziness value changes the selection in progress. Second, the magic wand selects all colors that fall inside the Tolerance range to the same degree, but Color Range gradually fades the selection over the course of the Fuzziness range. As a result, Fuzziness produces gradual, organic transitions.

9. *Check your mask in the image window.* The mask preview in the Color Range dialog box is helpful, but its dinky size makes it hard to accurately gauge a selection. To better judge the quality of your work, choose **Grayscale** from the **Selection Preview** pop-up menu, as in Figure 10-10. Photoshop fills the image window with the mask preview, permitting you to zoom in (Ctrl+⊡ on the PC or ⌘-⊡ on the Mac) and see every little detail of your prospective selection.

To see the mask preview and image at the same time, click the Image radio button directly under the preview. The preview box switches from a thumbnail of the mask to a thumbnail of the full-color image (again, see Figure 10-10).

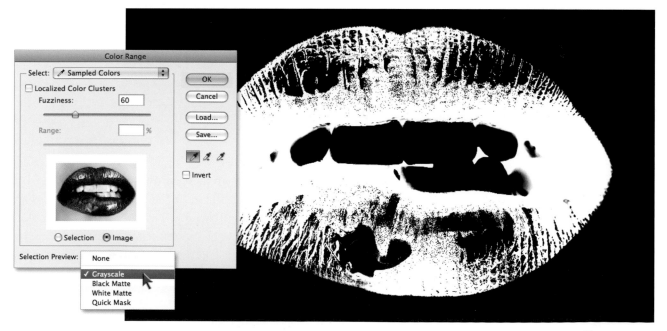

Figure 10-10.

10. ***Close the Color Range dialog box.*** At some point, you'll find that adding more click points has a diminishing return in terms of making a useful mask. When you've taken the lip selection as far as it can go in Color Range, click **OK**. Color Range adds a selection outline to the image window. Not a mask. A standard marching-ants-style selection ready for immediate use.

11. ***Add a layer mask.*** Our immediate use for the selection will be to create a layer mask that limits the cherry red adjustment to only the lips. So make sure you are on the **Cherry Red** layer, and click the ⬚ icon at the bottom of the **Layers** panel. Immediately, you'll see that the skin area returns to its original desaturated color, as in Figure 10-11, and the lips remain red. But the mask still needs work to let all the red come through.

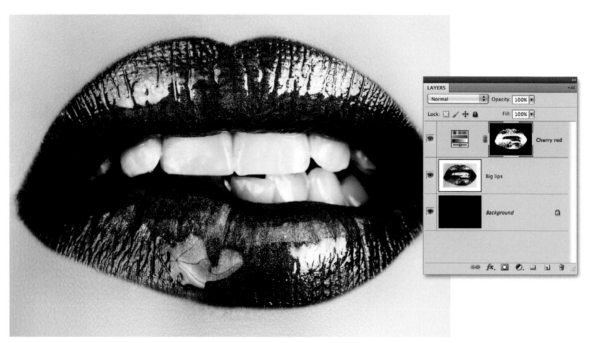

Figure 10-11.

12. ***Refine the mask.*** Although the teeth and skin are nicely masked so that they aren't affected by the red adjustment, the lips are still masked too much and therefore not red enough. To let more red come through, we'll need to refine the mask. Start by Alt-clicking (Option-clicking) on the layer mask thumbnail in the Layers panel to load the mask into the main preview window so you can work on it directly.

13. *Paint the highlight areas in the mask.* You can add to the masked area by simply painting with white inside the current lines created by the mask. Press the B key to choose the brush tool, and set the **Size** to 200 pixels and the **Hardness** to 100 percent (because you don't want to add any fuzziness around the edges of your mask). Press the X key to make white the foreground color, and paint away the dark areas inside the lips (avoiding the teeth). Remember, you can Shift-click to paint a straight line from your last click point. Leave the nice crunchy edges around the outer areas of the lips. Your mask should end up looking roughly like Figure 10-12.

Figure 10-12.

14. *Finesse the edges with the smudge tool.* In the **Layers** panel, Alt-click (Option-click) the layer mask thumbnail to return to your full color image. You can see, especially on the right side, that the edges of the lips are still dark in some places. By trying to maintain the nice soft transitions provided by the Color Range command, we haven't gone quite far enough with the mask. This presents one of the few instances where the smudge tool can be really useful. From the toolbox, click and hold on the blur tool (which looks like a big drop of water) and then choose the smudge tool from the flyout menu (as shown in Figure 10-13).

Figure 10-13.

Even though we're working in the full color image for reference, your mask is still selected in the Layers panel, so you'll still be adding to it as you paint with white. Press the] key several times until your brush is 200 pixels. Carefully brush from the interior outward, smudging to finesse any of the remaining dark edges, especially those around the right corner of the mouth, as I'm doing in Figure 10-14. The effect extends the red adjustment subtly outward.

Figure 10-14.

15. ***Clean the teeth with the brush.*** Just as you can extend the mask by smudging with white, you can subtract from it by painting with black. Press the X key to make the foreground color black, and then press the B key to return to the brush. Reduce the brush size to something manageable by pressing the [key three or four times, and carefully click over any areas of the teeth that appear to have a pinkish film. You may also find that switching back to the smudge tool and smushing from the teeth outward is helpful. Don't forget you can Alt-click (Option-click) the mask thumbnail in the Layers panel to get a close-up look if you want to find any stray areas.

PEARL OF ● WISDOM

As you can see, masking isn't an exact science. Your results reflect the amount of time and patience you put into them as well as your mastery of tools. For me, creating a great mask is one of the most satisfying feats in Photoshop.

16. *Duplicate the mask.* Having gone to so much painstaking work creating the mask on the Cherry Red layer, we'll reuse it as a starting point for a new mask, the purpose of which will be to move the entire mouth to a new black background. Start by Alt-dragging (Option-dragging) the layer mask thumbnail from the **Cherry Red** layer to the **Big Lips** layer in the Layers panel to duplicate it, as in Figure 10-15.

Figure 10-15.

17. *Paint in the teeth area.* To return the teeth to their rightful place in the mouth, we'll need to expand the Big Lips layer mask. Click that layer mask thumbnail to make it active. Press the D key to return to the default masking foreground color (white). Choose the brush tool, and paint over the mouth area. You don't have to worry about being subtle since you've already fine-tuned the outer edges of the lips. Just paint the teeth back in using broad strokes. At any time, you can Alt-click (Option-click) the layer mask thumbnail to view the mask in the main image window and check for any stray black areas that you might have missed.

18. *Soften the edges of the lips.* Although the lips are now floating nicely in space, the edges could use a little more softening. We'll fix that with a layer effect rather than disturb the mask. Click the *fx* icon at the bottom of the Layers panel and choose **Inner Glow**. In the **Layer Style** dialog box, click the color swatch. Set

it to black by clicking in the lower-left corner of the **Color Picker,** and then click **OK**. Set the **Blend Mode** to **Multiply,** the **Opacity** to 100 percent, and the **Size** value to 35. Then click **OK** again to exit the Layer Style dialog box.

19. *Save your image.* Press Ctrl+Shift+S (⌘-Shift-S) and save your work as *Lips in Space.psd*. Click **OK**. The wonderful results of our double-masking Color Range endeavor are shown in Figure 10-16.

Figure 10-16.

Masking with the Calculations Command

Over the course of the next three exercises, we'll be working with the same image, demonstrating how a powerful set of Photoshop features can be used together to overcome an extremely problematic masking problem.

As you can see in Figure 10-17, this image by photographer Stas Perov, from the Fotolia.com image library, presents a couple of significant masking challenges. First, we're working with that quintessential masking bugaboo, wild hair. Added to that, we have very low-color information to work with, given the predominance of low-saturation blues in the hair, the background, and the dress.

Figure 10-17.

We'll begin this masking odyssey with the Calculations command, one of the more sophisticated, mathematical, not-exactly-intuitive tools in all of Photoshop. Calculations compares the information in two different color channels, lets you designate a blend mode, and comes up with a mathematical extrapolation that it expresses as an alpha channel. You can then use that channel as the basis for a mask. It sounds daunting, but stick with me and you'll see how useful it can be.

1. *Open the notorious image.* Navigate to the *Lesson 10* folder inside *Lesson Files-PsCS5 1on1* and open the aforementioned file, *Hair assault.jpg*.

Red Channel

Green Channel

Blue Channel

Figure 10-18.

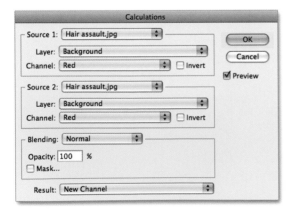

Figure 10-19.

2. **Survey the color channels.** Go to the **Channels** panel and click the individual channel names **Red**, **Green**, and **Blue**. Or press the keyboard shortcuts Ctrl+3, Ctrl+4, and Ctrl+5 (⌘-3, -4, and -5 on the Mac). Now you can peruse the channels and decide which ones are the best candidates for building a mask. The three channels appear slightly colorized in Figure 10-18.

PEARL OF WISDOM

You're looking for the two channels that represent the biggest extremes—that is, extreme contrast between shadows and highlights as well as extreme contrast between each other. In our case, the differences are subtle. But you can see that the skin tones are brightest in the Red channel (as you can expect for human flesh tones in general) and the hair is also darkest there. The hair seems to be the lightest in the Blue channel, and as expected the blue background is lightest in the Blue channel. So we'll proceed with Red and Blue channels as our choices for the Calculations command.

3. **Return to the RGB composite view.** Now that we've decided on our channels, click **RGB** at the top of the **Channels** list or press Ctrl+2 (⌘-2) to make the full-color image active.

4. **Choose the Calculations command.** Go to the **Image** menu and choose **Calculations** to display the **Calculations** dialog box, as in Figure 10-19. Calculations lets you mix two channels to form a new alpha channel using a blend mode and an Opacity value. In the days before layers, the Calculate commands (there were many of them back then) were your primary tools for mixing and merging images. Although today's Calculations command is more powerful, it's relegated almost exclusively to the creation of masks.

The dialog box is elaborate, so it's a good idea to turn on the Preview check box, if it's not turned on already. With Preview on, you can observe the results of your changes in the full-image window. Unfortunately, the preview function can be a tad buggy, occasionally refusing to update when you make a change. If this happens to you, just turn the check box off and then back on to refresh the preview.

5. **Select the desired Source channels.** You can think of the Calculations dialog box as layering one channel on top of another. Source 2 is the background channel; Source 1 is the channel in front. Source 1 is in a position of emphasis and should therefore contain the channel with the highest contrast.

Accordingly:

- Make sure the **Source 1** and **Source 2** pop-up menus are set to **Hair Assault.jpg**.

- This is a single-layer document, so both Layer options are automatically Background. No need to change them.

- Set the first **Channel** option to **Red**. Set the second one to **Blue**, as I have in Figure 10-20.

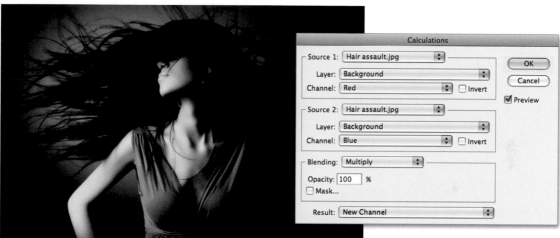

Figure 10-20.

6. *Change the Blending.* As you can see in the figure, the results so far are unhelpful in terms of selecting the hair. Choosing the Blending mode is the least predictable step in the process because the ideal settings vary radically depending on the composition of your image. Bear in mind, the goal is to select the foreground subject by making her white against a deselected black background. Of all the Blending options in the pop-up menu, you'll usually find that Add and Subtract are your best bets. So start by choosing **Add** from the **Blending** pop-up menu.

7. *Invert the blue channel.* Since we want to work with the highest degree of contrast between our two source channels, it might help to invert one of them to increase that difference. Turn on the **Invert** check box in the **Source 2** section of the dialog box. Unfortunately, the image is still way to bright. Even if you change the **Offset** value to −100, as I did in Figure 10-21 on the next page, we're still swimming in a sea of gray on gray.

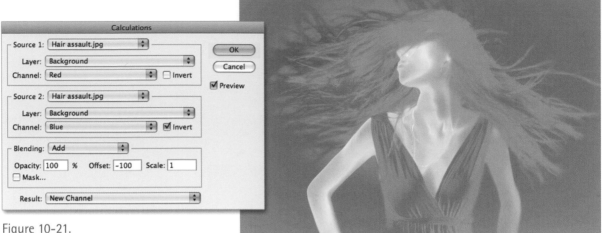

Figure 10-21.

8. *Change the Blending mode.* If the Add blend mode is creating very little difference, it makes sense to try its opposite. From the **Blending** pop-up menu, choose **Subtract**. The results, as you can see in Figure 10-22, are ideal for masking the hair, which is now white against a dark background with great detail throughout the hair section. (The arms, unfortunately, will need to wait for the next exercise.)

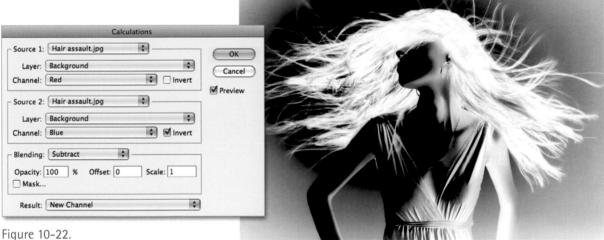

Figure 10-22.

9. *Check your Result setting.* Make sure your **Result** setting is set to **New Channel**. This tells Photoshop to add an alpha channel to hold your mask. Then click **OK**. Photoshop adds a new channel to the Channels panel and displays the contents of that channel in the image window.

10. *Name the new channel.* Double-click the new **Alpha 1** item at the bottom of the **Channels** panel and rename it something clever like "Mask" (shown in Figure 10-23). Press Ctrl+Shift+S (⌘-Shift-S) and save your image as *My Calculated Hair.psd*. We'll be using it in the next exercise, where we'll work to select the body.

Using the Pen Tool to Select Smooth Contours

Many of the masking tools available in Photoshop rely on information within the image to help make a selection, but the pen tool is an exception. The pen tool allows you to draw meticulous, painstaking outlines, one point and control handle at a time, much as you would do in Adobe Illustrator. Although these outlines, or *paths*, don't have any pixel information associated with them, they can be converted to selections that will help you create masks when there's not enough information for any other tool to be useful.

The pen tool isn't easy to master, but it's worth the effort to learn how to draw around any object you'll encounter in a digital image. Case in point, our mask-in-progress that we began in the last exercise. We'll use the pen tool to trace the organic, smooth curves of our model's body, and add it to the successful job the Calculations command did on her hair.

1. *Open your file from the previous exercise.* Continue working with your *My Calculated Hair.psd* image. If you didn't do the previous exercise, I've created a file in the *Lesson 10* folder called *Calculated Hair.psd* for you to work with. We've got a great mask going for the hair, thanks to the Calculations command, but Calculations did an abysmal job on the arms and dress regions.

2. *Display the Paths panel.* When you use the pen tool to trace an image, you're leveraging the power of vectors in Photoshop. A *vector* has no content of its own, but rather is a mathematically defined path that controls pixels but isn't controlled by them. These paths live inside their own panel, which is housed by default with the Layers and Channels panels. Click the **Paths** tab to bring the panel into view (or if the Paths tab isn't available, choose **Window→Paths**). You'll see in your panel (and in Figure 10-24) that I've already created and saved a path called Body Path (as well as a spare Deke's version for your reference). Click the **Body Path** entry in the panel to make it active.

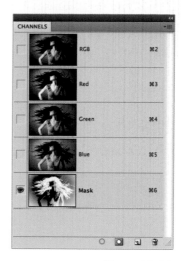

Figure 10-23.

Figure 10-24.

3. **Select the path.** When you activate the path in the panel, you'll see a solid outline appear around the arms and torso. Press the A key to get the black arrow tool (officially called the path selection tool, but I like to call it what it is). Click with the black arrow tool on that outline, and you'll see a series of anchor points come to life along the path, as in Figure 10-25. These points and their frequent companions, the control handles (which you'll see in a moment), define the outline of the path. At the moment, all points appear as solid squares to show that they're selected.

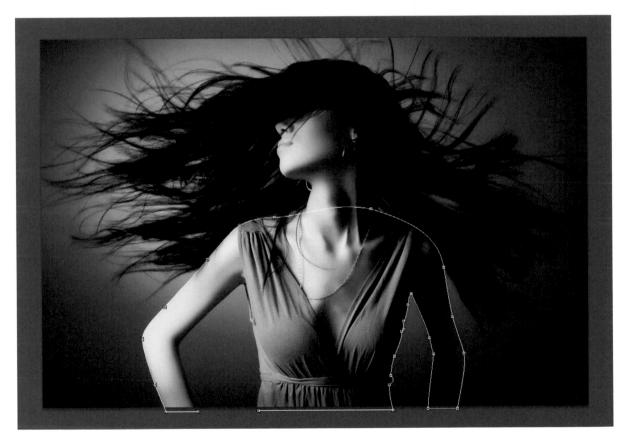

Figure 10-25.

4. **Examine the unfinished path.** If you zoom into the lower-left quadrant of the image, you'll notice that the prebaked path I created for you isn't quite finished. I haven't traced the area under her right arm (on the left side of the image). We'll complete this path in the first part of this exercise, and then load it as a selection to add to our working mask.

5. **Test drive the white arrow tool.** Switch to the white arrow tool by pressing the A key (or Shift+A if you skipped the Preface). Then do this:

- Click anywhere off the path outline to deselect the path and all its points.

- Click a segment in your path. You'll again be able to see the anchor points, but they are now open squares, indicating that they are not selected.

- Select the point indicated in Figure 10-26 by clicking it with the white arrow tool. The point becomes solid, showing that it's selected.

Why two arrow tools? Because they serve different purposes. The black arrow tool selects and moves entire paths at a time. The white arrow tool lets you select an element of a path, such as an anchor point, a segment, or a collection of points and segments.

Click this point

Figure 10-26.

You could now drag the selected point to move it or use the arrow keys to nudge it a screen pixel in any direction. If you want to give it a try, do so, but press Ctrl+Z (⌘-Z) or Ctrl+Alt+Z (⌘-Option-Z) as necessary to get back to this starting point.

Note that the extra line with the circle on the end (rather than a square) coming out of the point is a control handle and not part of your path. Control handles determine the curve of your path. We'll see how control handles work as we progress.

6. **Set up the pen tool.** Get the pen tool by clicking the ✎ icon in the toolbox (as in Figure 10-27) or by pressing the P key. Then confirm the following settings in the options bar:

- Create a path by clicking the 🖾 in the first group of icons. This is, wisely, the default setting.

- Turn on the **Auto Add/Delete** check box.

- Check that the first icon, 🖿, is active in the last icon group. The preferred settings appear in the figure (below).

Figure 10-27.

7. **Resume the path from its endpoint.** Note that if you move the cursor into the image window but away from the path outline, the cursor gets a little × next to it, like this: ✎ₓ. If you were to start clicking, you'd draw a new path that would appear as a sub-path in your Body Path entry in the Paths panel. Don't do that.

Instead, move the cursor over the open anchor point you selected in Step 5, until you get the ✎ₒ cursor. (That tiny square with the two nodes is supposed to be a path going into and out of an anchor point.) Then, click the endpoint to make it ready to receive more points.

8. **Add a point to the path.** Slightly inside the skin area, about two-thirds up the visible part of her lower arm, click and hold; then continue dragging upward toward the crook of her elbow. What you've just done is create a *smooth point* and it's corresponding control handles, as shown in Figure 10-28 on the facing page.

When you click and then drag with the pen tool in this manner, Photoshop creates a pair of round *control handles* that sit on a slightly inclined seesaw-style lever through the anchor point. These handles will attract and repel the segment in a magnet-like way as you adjust them, allowing you to manipulate the curvature of your path outline

Before you release the mouse button, try twirling the control handles. See how they move symmetrically about the point? This is a function of a smooth point, which guides the path outline through a continuous, even arc. Release the mouse button when your handles are in the positions shown in Figure 10-28.

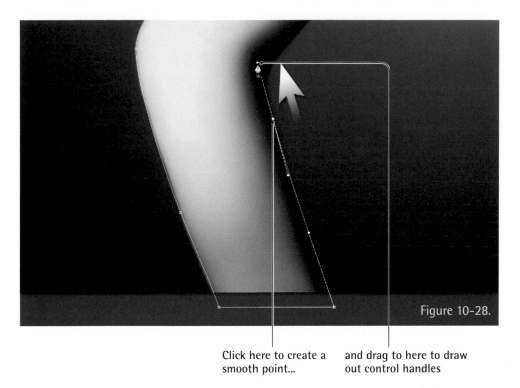

Figure 10-28.

Click here to create a
smooth point...

and drag to here to draw
out control handles

9. **_Reposition the upper control handle._** As we try to make that curve around the crook of her elbow, the upper control handle will affect the curve of the next segment we're about to draw. We probably don't want the control handle up quite so high. Press and hold the Ctrl key (⌘-key) to grab the white arrow tool on-the-fly. With it, you can reposition any anchor point or control handle. Move that top control handle down to about half its original length.

10. **_Create two more points further up her arm._** Click and drag to make your next anchor point in the crook of her elbow, then add another one further up her arm. Now that you've established a clockwise direction, keep moving and dragging that way. You can see my placement of anchor points and control handles for the inside of her arm in Figure 10-29.

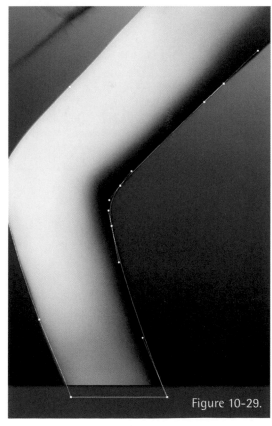

Figure 10-29.

Or you can switch to my Deke's Body Path entry in the Paths panel, and click along it with the white arrow tool to get hands-on information about where I placed my points. Note that to see the control handles for any given anchor point, you need to select it specifically with the white arrow tool. To resume your working path, simply switch back to the Paths panel, reselect the path, and resume with the pen tool.

Inevitably, every path drawn with the pen tool is constructed differently. As you set the control handles and anchor points, keep in mind the *one-third rule*: Each control handle should extend about one-third the total length of its line segment. Another rule says that two opposing handles can extend different lengths if together they add up to two-thirds of the segment.

Once you've made a few segments in your line, you can begin to see how its curvature is affected by the handles. See how the segment begins and ends at an anchor point and bends toward each of the opposing control handles? The path has no choice but to pass through each and every anchor point—hence the word *anchor.* In contrast, the path approaches but never touches the control handles. The points demand; the handles attract.

Remember, you can adjust an anchor point or a control handle while drawing a path by pressing the Ctrl (or ⌘) key to get the white arrow tool on-the-fly and then dragging the points around as you want. Err on the side of keeping the path inside the edge of the model's shoulder to help avoid fringing when we turn the path into a mask.

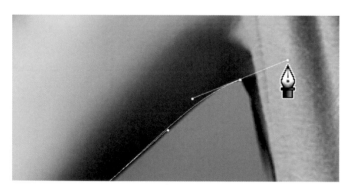

Figure 10-30.

Figure 10-31.

11. ***Create a smooth point under the model's arm.*** Turning the corner under her arm is a two-point process. First, click at the point indicated in Figure 10-30, and drag out the control handles as shown. You really only care about the position of the left control handle because we're going to move the right one independently in the next step.

12. ***Convert the smooth point into a cusp.*** Still armed with the pen tool, press the Alt (Option) key and hover your cursor over the last anchor point. Your pen cursor displays a tiny caret symbol, as in ♦ₙ, to show that it's poised to convert the point from a smooth point to a *cusp point*, which joins one or more curved segments at a corner. With Alt (or Option) down, click and drag out a new control handle at a new angle, as in Figure 10-31. The second handle now moves independently of the one on the other side of the anchor.

13. **Make another point and lop off the lower control handle.** Make your next anchor at the point where the dress material juts out farthest, and drag as in Figure 10-32 to draw out the control handles. We want the next segment to be a *straight segment*, i.e., no curvature created by a control handle's magnetic power. Not only can you change the angle of a control handle independently of its partner by Alt-dragging (Option-dragging) out a new one, you can also get rid of a control handle altogether. Alt-click (Option-click) the anchor point to lop off the bottom control handle, as in Figure 10-33.

Figure 10-32.

Figure 10-33.

14. **Click to create a tiny straight segment.** Now that we got rid of that control handle so we could make a tiny segment with no curve, click (no dragging) at the next corner along the edge of her dress. The result is the aforementioned straight segment, unaffected by any control handles, as in Figure 10-34.

15. **Make two more points to reach her belt.** Drag from the newest corner point, and a control handle emits as you drag downward along the dress. Make two more smooth points to reach the top of her belt. Alt-click (Option-click) on the last point to convert it to another cusp point.

Figure 10-34.

16. **Draw a simple series of straight segments.** Click (without dragging) to make a series of straight segments around her sash, as you can see in Figure 10-35.

17. **Complete the shape.** After you create the final point at the base of the belt, hover over the first point in the path down on the pasteboard. Your cursor should look like ♦₀. The circle next to the pen cursor indicates you'll be closing a path, and thus completing the shape. When you click with that close path cursor on the original anchor point (see Figure 10-35), drag downward (and slightly to the right) to create an *upper* control handle that will give the last segment a nice curve around her skirt. This isn't intuitive. You need to drag downward to create the upper control handle. It's as if you're creating a pair of control handles, but you've already lopped off the bottom one (because that original point was already a cusp).

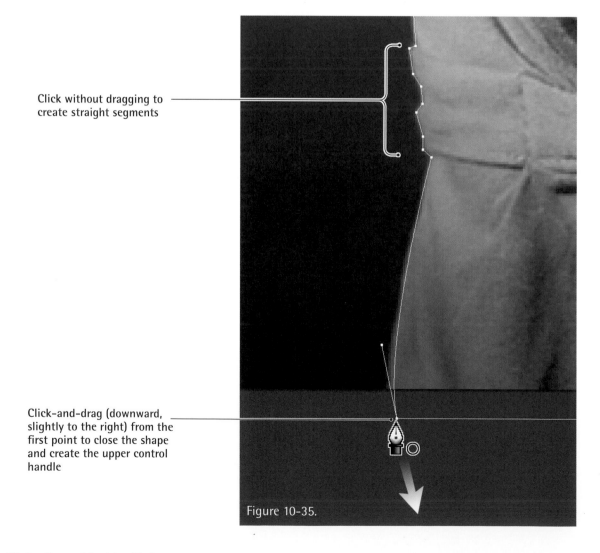

Click without dragging to create straight segments

Click-and-drag (downward, slightly to the right) from the first point to close the shape and create the upper control handle

Figure 10-35.

18. ***Turn the completed path into a selection outline.*** Now that we have a completed shape, grab the black arrow tool and click the path to make it active. Then, in the **Paths** panel, click the ⭕ icon at the bottom of the panel, as indicated in Figure 10-36, to load the path as a selection.

19. ***Add the new selection area to the existing mask.*** To add our latest contribution to the mask that we started in the previous exercise, start by moving to the **Channels** panel. Click the **Mask** entry to make it active. Make sure your foreground color is still white (remember, we're working to get a white model outline on a black background), and press Alt-Backspace (Option-Delete) to fill the selected area with white. You can see the results of our progress in Figure 10-37.

20. ***Save your work.*** We'll finish this mask in the next exercise. For now, press Ctrl+Shift+S (⌘-Shift-S), save your file as *My hair with body.psd*, and click **OK**.

Figure 10-36.

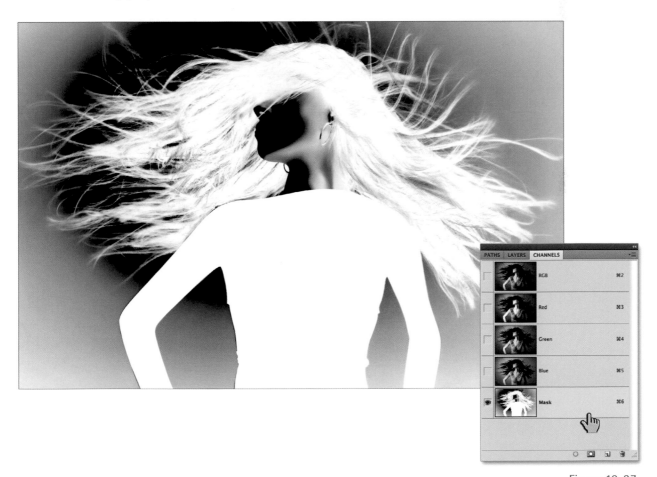

Figure 10-37.

Finessing a Mask with Overlay Brushing

In the previous two exercises, we made significant progress in isolating our model and all her loose locks from her low-contrast background. Now that we've addressed the hair with the mathematical power-lifting of the Calculations command, and approached the arms and body with the precision selecting power of the pen tool, what remains will require a tool of more versatility and subtlety— the trusty brush tool. The brush tool, particularly when set to the Overlay blend mode, is a great contrast-enhancement tool ideally suited for the clean-up work we have left on this project.

Remember, the goal here is to increase the contrast of the mask so that the model is perfectly white and the background is perfectly dark. Once we've completed this long awaited mask, I'll show you how to load it as a selection and move our tempestuously tressed model to a less boring background.

1. *Open the image.* Either continue with the image you saved at the end of the last exercise, or navigate to the *Lesson 10* folder in *Lesson Files-PsCS5 1on1* and open the catch-up file I created for you, *Hair with Body.psd*.

2. *Switch to your working mask.* If you don't have the mask open, click the **Mask** channel in the **Channels** panel to view our masking work-in-progress. You can see in Figure 10-38 that the remaining obstacles include the gradient-like background, the areas of transition around her hair, and the face and neck. We'll start with the last one first, since it's the most straightforward.

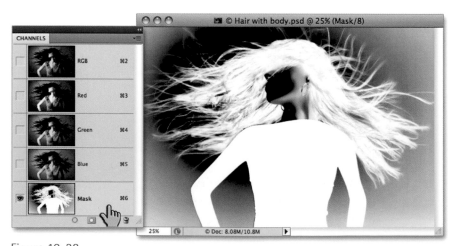

Figure 10-38.

3. *Obtain the brush tool.* We'll start by using the brush tool in its normal free-form painting capacity. Make sure your foreground color is set to white (and press the D key to restore the default colors if it isn't). Then press the B key to choose the brush tool. Right-click in the image window and set the brush **Size** to 60 and the **Hardness** to 100 percent.

4. *Paint in the model's face with white.* First, we need to fill in her face, which will require more patience than finesse. Zoom into the unwanted dark areas of her face and neck, and then carefully paint over them with white, closely tracing the edges as you get close to the hair. You can think of this as the paint-by-numbers phase of the endeavor. When you're done, the image should look something close to Figure 10-39.

Remember that you can click and then Shift-click with the brush to create straight lines, which can help you quickly navigate edges.

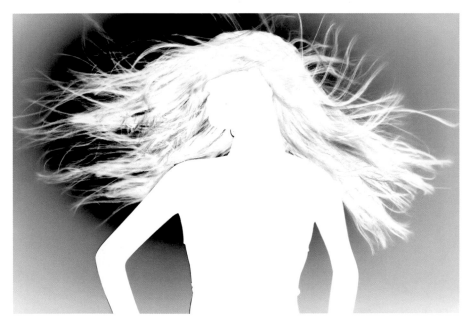

Figure 10-39.

5. *Change the brush mode to Overlay.* Next, we're going to approach darkening the background. For this we'll need a brush with a little more subtlety. Start by setting the **Mode** to **Overlay** in the options bar. Leave the **Opacity** at 100 percent. Then press the ⊡ key nine times to increase the brush size to 250 pixels. Finally, click the ⊡ to the right of the size value in the options bar, and set the **Hardness** to 0 percent, as shown in Figure 10-40 on the next page.

6. **Paint the dark areas with black.** Press the X key to switch your foreground and background colors, so that you're painting with black. Paint around the edges of the mask. Because you're painting with black in Overlay mode, the white areas will be protected from your painting. You may have to go over some areas more than once or start a new brushstroke.

PEARL OF WISDOM

When you start working around the edges of the flailing hair, you're going to start to lose strands here and there, which is okay. No one is going to look at the final composition and say that she doesn't have enough hair. When I'm masking, I generally like to err on the side of too much rather than too little; better to let the edges of your mask intrude a little on your subject rather than leave behind areas likely to cause fringing.

When you've finished painting the dark areas, your mask should look something like Figure 10-40.

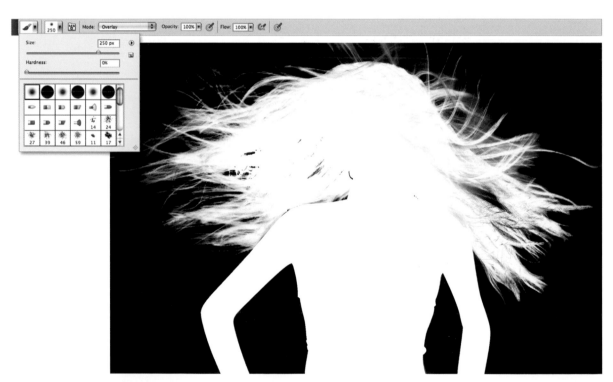

Figure 10-40.

7. **Paint the light areas with white.** The light areas can benefit from an Overlay pass as well. Press the X key to switch foreground and background colors, and paint over the light areas, as I did in Figure 10-41.

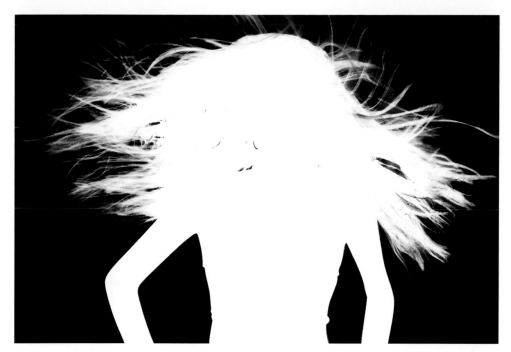

Figure 10-41.

8. *Lasso the earring.* That one stubborn area near her face is her earring, which is going to remain dark no matter how often you paint over it. Often the easiest thing is just to grab the lasso tool, draw a selection around the area, as in Figure 10-42 (with artificially cyan-colored marching ants for visibility), and press Alt+Backspace (Option-Delete) to fill the area with white (the foreground color). Deselect when you're done by pressing Ctrl+D (⌘-D).

Figure 10-42.

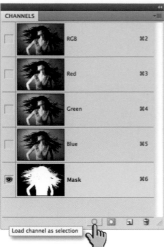

Figure 10-43.

9. **Save the mask.** Now that you've gone to all the trouble to get the mask to this stage, take my word for it and save the file. You haven't really altered anything in the overall composition, but saving the mask allows you to come back to it later and rethink it, should you want to.

10. **Load the mask as a selection outline.** We finally get to put the mask we've been working on for three exercises to work. With the Mask channel still selected, click the ○ icon at the bottom of the **Channels** panel to load the channel as a selection (as in Figure 10-43). Then press Ctrl-2 (⌘-2) to return to the full RGB image.

11. **Convert the background to a floating layer.** To give our model and her nicely masked hair a new background, we'll need to turn her (and it) into a floating layer. Switch back to the **Layers** panel, and double-click the **Background** layer. Name the new layer "Model" and click **OK**.

12. **Add layer mask.** To turn the current selection into a layer mask, click the ▢ icon at the bottom of the Layers panel. The visual result is a view of the model masked against the transparency grid, as dramatically depicted in Figure 10-44.

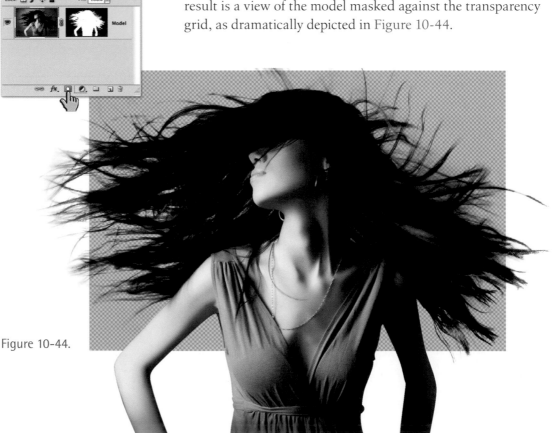

Figure 10-44.

13. ***Open another image*** Press Ctrl-O (⌘-O) and navigate to the *Blue sky with clouds.jpg* image in the *Lesson 10* folder of the *Lesson Files-PsCS5 1on1* folder. This image, shown in Figure 10-45, is by photographer Ribeiro Rocha and comes from the Fotolia.com image library.

Figure 10-45.

14. ***Paste the blue sky image into the hair image.*** Select the entire *Blue sky with clouds.jpg* image by pressing Ctrl+A (⌘-A), and then copy it by pressing Ctrl+C (⌘-C). Move back to your *Hair with Body.psd* image window, hold down the Shift key, and press Ctrl+V (⌘-V) to drop the sky into place.

15. ***Make the Blue sky image your background layer.*** From the **Layers** menu, choose **New→Background from Layer** to set the sky image as the Background layer. The fairly respectable results are shown in Figure 10-46. But we can use a new feature in Photoshop CS5 to improve some of the crunchy effects on the left side of the image.

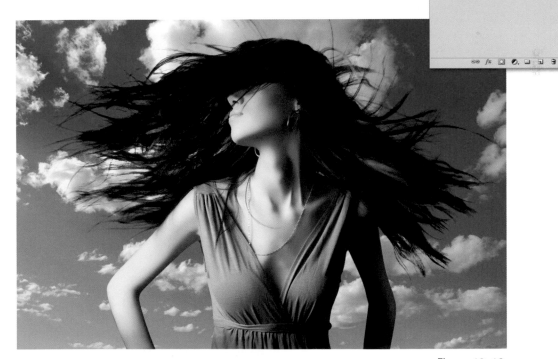

Figure 10-46.

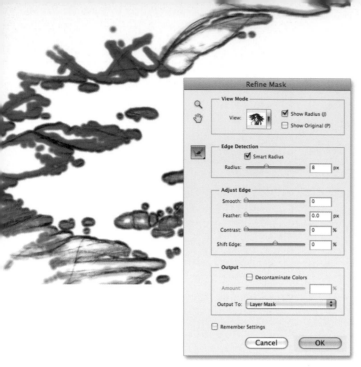

Figure 10-47.

16. *Refine the mask.* In the **Layers** panel, click the layer mask to make it active. Then right-click and choose **Refine Mask** from the context menu. Alternately, you can press Ctrl+Alt+R (⌘-Option-R). You'll be presented with the Refine Mask dialog box pictured in Figure 10-47.

17. *Increase the Radius.* In the Edge Detection section of the **Refine Mask** dialog box, set the **Radius** to 8 pixels. This defines the area into which the Refine Mask can work its automatic luminance detection. The bigger the radius, the more radical the effect. Turn on the **Smart Radius** check box. Smart Radius contracts the edge radius around smooth areas (like arms) and leaves the rough areas of your mask at your maximum value (in this case, 8). To see the edges Photoshop is working with (as in the figure), turn on the **Show Radius** check box at the top of the dialog box.

18. *Click OK.* When you click **OK**, Photoshop calculates its automatic improvement to your mask edges. The improved results, and satisfying finale to our three-exercise excursion, are revealed at long last in Figure 10-48.

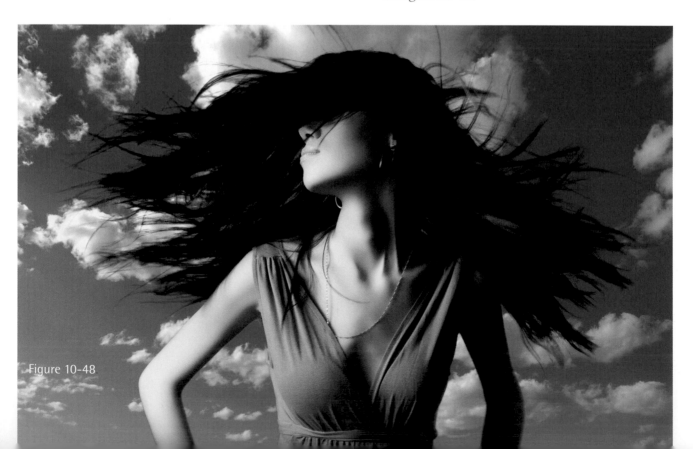

Figure 10-48

WHAT DID YOU LEARN?

Match the key concept in the numbered list below with the letter
of the phrase that best describes it. Answers appear upside-down
at the bottom of the page.

Key Concepts

1. Alpha channel
2. Color Range
3. Fuzziness
4. Smudge tool
5. Calculations
6. Paths
7. Smooth point
8. Control handle
9. Cusp point
10. Straight segment
11. Refine Mask
12. Smart radius

Descriptions

A. An anchor point along a path that has two control handles to allow for creating a continuous, even arc.

B. Analogous to the magic wand's Tolerance setting, this feature spreads a Color Range selection out to neighboring color values beyond those specifically chosen

C. A Photoshop command that allows you to create masks based on a mathematical comparison of the luminance values in two of the color channels.

D. A point along a path that joins two segments at a corner.

E. A lever-like device that allowed you to control the curve of a path through a smooth point.

F. A new feature in Photoshop CS5 that allows you to fine-tune your mask by setting a prescribed radius for edge calculation.

G. This otherwise fairly useless tool is handy for finessing mask edges by smushing edge pixels in one direction or another.

H. This advancement on the magic wand tool allows you to select given colors in your image and turn them into a selection outline.

I. A feature of the Refine Edge command that tells Photoshop to adjust the radius based on the smooth or jagged nature of your mask.

J. Also known as a mask, this special channel selects white pixels and deselects black ones, allowing you to hide or reveal corresponding parts of your image.

K. Outlines described by vectors that contain no pixel information but can be used to control the pixels within their boundaries.

L. Part of a path that is unaffected by control handles and is thus a direct path between points.

Answers

1J, 2H, 3B, 4G, 5C, 6K, 7A, 8E, 9D, 10L, 11F, 12I

LESSON
11

TEXT AND SHAPES

AS YOU'VE NO doubt discerned by now, Photoshop's primary mission is to correct and manipulate digital photographs and scanned artwork. (If this comes as a shock, I'm afraid you're going to have to go back and re-read—gosh how should I put this?—*the entire book!*) But there are two exceptions. The culprits are text and shapes, two features that have nothing whatsoever to do with correcting or manipulating digital photos, scanned artwork, or pixels in general.

Where text and shapes are concerned, Photoshop is more illustration program than image editor. You can create single lines of type or set type inside columns. You can edit typos and check spelling. You have access to all varieties of formatting attributes, from those as common as typeface to those as obscure as fractional character widths. You can even attach type to a path. In addition to type, you can augment your designs with rectangles, polygons, and custom predrawn symbols—the kinds of geometric shapes that you take for granted in a drawing program but rarely see in an image editor.

All this may seem like overkill, the sort of off-topic largess that tends to burden every piece of consumer software these days. But although you may not need text and shapes for *all* your work, they're incredibly useful on those occasions when you do. Whether you want to prepare a bit of specialty type, mock up a commercial message as in Figure 11-1, or design a Web page, Photoshop's text and shape functions are precisely the tools you need. If you have any doubts, they'll be allayed as soon as you watch the video that accompanies this lesson.

If I could save thyme *in a bowler...*

This text acts as a label to the above graphic. If only I had something to say.

Figure 11-1.

ABOUT THIS LESSON

Project Files

Before beginning the exercises, make sure you've downloaded the lesson files from *www.oreilly.com/go/Deke-PhotoshopCS5*, as directed in Step 2 on page xvi of the Preface. This means you should have a folder called *Lesson Files-PsCS5 1on1* on your desktop (or whatever location you chose). We'll be working with the files inside the *Lesson 11* subfolder.

In this lesson, I show you how to use Photoshop's text and shape tools, as well as ways to edit text and shapes by applying formatting attributes and transformations. You'll learn how to:

Video Lesson 11: Creating Vector Art

We think of Photoshop as a pixel-based image editor, and normally, we're right. But Photoshop provides two exceptions, text and shapes, which are treated as vector-based layers. As long as these layers remain intact, you can edit them to your heart's content. And because they're vectors, you can transform them without degrading their quality. After this video lesson, Photoshop just might be your favorite tool for this kind of project, especially after I show you how to prepare it for a commercial printer.

To view Photoshop's vector art capabilities, visit *www. oreilly.com/go/deke-PhotoshopCS5*. Click the **Watch** button to view the lesson online or click the **Download** button to save it to your computer. During the video, you'll learn these shortcuts:

Tool or operation	Windows shortcut	Macintosh shortcut
Type tool	T	T
Cut	Ctrl-X	⌘-X
Paste	Ctrl-V	⌘-V
Accept changes to a text layer	Enter on keypad (or Ctrl+Enter)	Enter on keypad (or ⌘-Return)
Copy layer effects to a new layer	Ctrl-drag	⌘-drag
Load channel as selection	Ctrl-click	⌘-click

The Vector-Based Duo

Generally speaking, Photoshop brokers in pixels, or *raster art*. But the subjects of this lesson are something altogether different. Photoshop treats both text and shapes as *vector-based objects* (or just plain *vectors*), meaning that they rely on mathematically defined outlines that can be scaled or otherwise transformed without any degradation in quality.

For a demonstration of how vectors work in Photoshop, consider the composition shown in Figure 11-2. The *Q* is a text layer with a drop shadow. The black crown and the orange fire are shapes. The background is a pixel-based gradient. The artwork looks jagged because it contains very few pixels. The image measures a scant 50 by 55 pixels (less than 2800 pixels in all) and is printed at just 15 pixels per inch!

Clearly, you'd never create such low-resolution artwork in real life. I do it here to demonstrate a point: If this were an entirely pixel-based image, we'd be stuck forevermore with jagged, indistinct artwork. But because the *Q*, crown, and fire are vectors, they are scalable. In other words, unlike pixel art, vectors become smoother when you make them bigger.

One way to scale the vectors is to print them to a PostScript-compatible printer, which automatically scales the artwork to the full resolution of the device. The result is a breathtaking transformation. Believe it or not, the low-resolution, jagged artwork from Figure 11-2 prints to a PostScript output device as shown in Figure 11-3. All pixel-based portions of the composition—namely, the gradient and drop shadow—print just as they look on screen. But Photoshop conveys the text and shapes as true PostScript vectors; therefore, they render at the full resolution of the printer.

Few people own PostScript printers; most of us are stuck with standard raster printers. (Your everyday average inkjet device prints just the pixels you see on screen, as

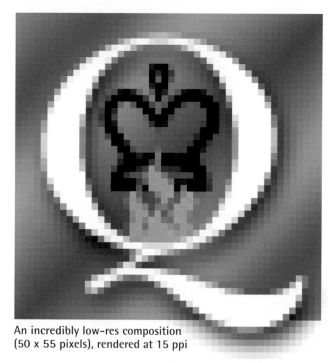

An incredibly low-res composition (50 x 55 pixels), rendered at 15 ppi

Figure 11-2.

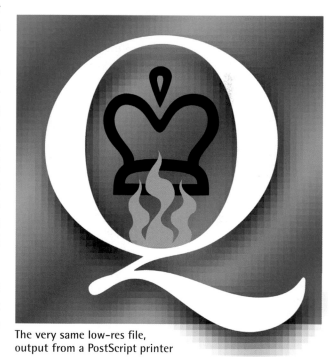

The very same low-res file, output from a PostScript printer

Figure 11-3.

The Vector-Based Duo 375

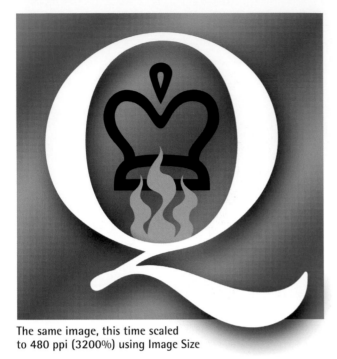

The same image, this time scaled
to 480 ppi (3200%) using Image Size

Figure 11-4.

in Figure 11-2.) So fortunately, there's a second, arguably better way to scale vectors—the Image Size command. To achieve the result pictured in Figure 11-4, I chose Image→Image Size and turned on the Resample Image check box. (Scale Styles and Constrain Proportions were also turned on.) Then I increased the Resolution value to a whopping 480 pixels per inch. The result looks every bit as good as the PostScript output, except for the drop shadow, which looks even better. (The Image Size command can scale drop shadows, whereas PostScript printing can't.) Now I can print this artwork to any printer—Post-Script, inkjet, or otherwise—and it'll look just as it does in Figure 11-4.

The upshot is that vectors are a world apart from anything else inside Photoshop, always rendering at the full resolution of the image. To see more on this topic, watch Video Lesson 11, "Creating Vector Art in Photoshop," introduced on page 374).

Creating and Formatting Text

Text inside Photoshop works a lot like it does inside every major publishing application. You can apply typefaces, scale characters, adjust line spacing, and so on. However, because Photoshop isn't well suited to routine typesetting, we won't spend much time on the routine functions. Instead, we'll take a look at some text treatments to which Photoshop is very well suited, as well as a few functions that are exceptional or even unique to the program.

In this exercise, we'll add text to an image and format the text to fit its background. We'll also apply a few effects to the text that go beyond anything you can accomplish outside Photoshop.

1. *Open an image.* Not every image welcomes the addition of text. After all, text needs room to breathe, so your image should have ample dead space. Such is the case with *TV movie ad.psd* (see Figure 11-5 on the facing page). Found in the *Lesson 11* folder in *Lesson Files-PsCS5 1on1*, this image is the foundation for an advertisement for a made-for-TV movie starring some of basic cable's brightest names. In reality, it's an amalgam of a few images from PhotoSpin, which is apparently a great resource for photos of people smirking or shrugging. I already did the compositing; now we need to insert the copy (industryspeak for blather).

When you open this document, you may see the following alert message: "Some text layers might need to be updated before they can be used for vector based output." If you do, click the **Update** button to make the one live text layer in this document editable.

Figure 11-5.

2. *Make sure the guidelines are visible.* You should see three cyan *guidelines*—two horizontal and one vertical—in the image window. If not, choose **View→Show→Guides** to make them visible. Also make sure a check mark appears in front of **View→Snap**, which makes layers snap into alignment with the guides.

PEARL OF WISDOM

As we saw in Lesson 5, guidelines are nonprinting elements that ensure precise alignment in Photoshop. They are especially useful for positioning text layers, as we'll see in upcoming steps.

3. *Click the type tool in the toolbox.* Or press the T key. Photoshop provides four type tools in all, but the horizontal type tool—the one that looks like an unadorned T (see Figure 11-6)—is the only one you need.

Figure 11-6.

4. *Establish a few formatting attributes in the options bar.* The options bar provides access to a few of the most common *formatting attributes*, which are ways to modify the appearance of live text. Labeled in Figure 11-7, they are:

- **Font family.** Click the second-from-left ⦿ arrow to see a list of typefaces available on your system. I prefer the term *font families* (or just plain *font*) because, technically speaking, most typefaces include multiple stylistic alternatives, such as bold and italic.

Figure 11-7.

If you purchased the full Adobe Creative Suite, select **Adobe Caslon Pro** (look under the Cs). If you don't have this Caslon, select **Times**, **Times New Roman**, or a similar font.

- **Type style.** The type style pop-up menu lists all stylistic alternatives available for the selected font. Change the style to read **Bold**.

- **Type size.** If using Caslon Pro, set the type size to 33 points. For Times or Times New Roman, set the value to 38 points.

- **Antialiasing.** The next menu determines the flavor of antialiasing (edge softening) applied to the text. We'll examine this option a bit more in Step 21 (page 365), but for now, either **Crisp** or **Sharp** will suffice.

- **Alignment.** The alignment options let you align rows of type to the left, center, or right. Click the middle icon (▤) to create center aligned text.

- **Text color.** The color swatch determines the color of the type. For the moment, press the D key and then the X key to make the swatch white.

- **Character panel.** Click the rightmost of the type tool icons to display the **Character** panel, which offers access to several more formatting attributes. We'll need this panel a few steps from now.

You can change every single one of these formatting attributes after you create your text. Getting a few settings established up front merely saves a little time later.

5. *Click in the image window.* Click somewhere in the lower-middle portion of the image. For now, don't bother trying to align your cursor with the guidelines. Better to get the text on the page and align it later.

6. *Enter some text.* Type "chief executive." Lowercase letters are fine. Then press the Enter or Return key to advance to a new line and type "nephew." You should see white type across the bottom of your image, as in Figure 11-8. If the Layers panel is visible, you'll also notice a new layer marked by a T icon (also in the figure). This T indicates that the layer contains live text.

Figure 11-8.

7. *Select all the text.* Press Ctrl+A (⌘-A on the Mac) to highlight all three words. Now you can modify the type.

8. *Capitalize the letters.* Click the TT icon in the **Character** panel, as in Figure 11-9 on the next page. This switches the lowercase letters to capitals using a temporary style option. You can also press Ctrl+Shift+K (⌘-Shift-K). If you decide later to restore lowercase letters, turn off the TT or press the shortcut again.

Figure 11-9.

9. **Drag the text into alignment with the guides.** Press the Ctrl (or ⌘) key and drag the text until the left and bottom edges of the letter *C* in *CHIEF* snap into alignment with the vertical guideline and the higher of the two horizontal guides.

10. **Select the last word of type.** With the text still active, double-click the word *NEPHEW* in the image window to select it.

11. **Adjust the type size and leading.** In the Character panel, click the T̵T icon and change the type size to 67 points. Then press Tab, change the next-door ᴬᴵᴬ option to 55 points, and press Enter or Return. The ᴬᴵᴬ value sets the *leading* (pronounced *ledding*, for the strips of lead used in hand-set printing days to space lines of type), which is the amount of vertical space between the selected word and the line of type above it. The new value shifts the text up, as pictured in Figure 11-10.

12. **Accept your changes.** Press the Enter key on the keypad (not the one above the Shift key) to exit the type mode and accept the new text layer. You can also press Ctrl+Enter (or ⌘-Return).

At this point, Photoshop changes the name of the new text layer in the Layers panel to Chief Executive Nephew. The program will even update the layer name if you make changes to the type. If you like, you can rename the layer just as you would any other layer (especially helpful when the layer name becomes too long), but doing so will prevent Photoshop from automatically updating the layer name later.

Figure 11-10.

13. **Select and show the Body Copy layer.** Click the **Body Copy** layer in the **Layers** panel and then turn on its 👁 to make it visible. This layer contains a paragraph of type set in the world's ugliest font, Courier New. (For you, it may appear in some other Courier derivative, but rest assured, they're all dreadful.) The only reason the layer is here is to spare you the tedium of having to enter the type from scratch. But that doesn't mean there's nothing for you to do. Much formatting is in order.

This particular variety of text layer is called *area text*. To create such a layer, drag with the type tool to define the bounding box around the area text, also known as a *text block*. As you enter text, Photoshop wraps words down to the next line as needed to fit inside the block.

14. **Assign a better font.** As long as a text layer is active, you can format all type on that layer by adjusting settings in the options bar or **Character** panel. For starters, click the word **Courier** in either location. This highlights the font name and provides you with a couple of options:

 • Press the ↑ or ↓ key to cycle to a previous or subsequent font in alphabetical order. This permits you to preview the various fonts installed on your system, handy if you have no idea what fonts like *Giddyup* or *Greymantle* look like. (Those are just examples; your strange fonts will vary.)

 • Enter the first few letters of the font you'd like to use.

For example, type "Ver." This should switch you to Verdana as in Figure 11-11, which is included on all personal computer systems. Then press Enter or Return to apply the font and see how it looks.

Figure 11-11.

15. ***Make the first three words of the paragraph bold.*** Zoom in on the words *What a situation!* at the beginning of the paragraph to better see what you're doing. Then with the type tool still selected, do the following:

- Select all three words by double-clicking *What* and dragging over *a situation!*

- Choose **Bold** from the type style menu in the options bar, as shown in Figure 11-12. You can do the same from the keyboard by pressing Ctrl+Shift+B (⌘-Shift-B on the Mac).

16. ***Make the words*** the hard way ***italic.*** Find the phrase *the hard way* in the eighth line of the paragraph and drag over it to select it. Then choose **Italic** from the type style menu in the options bar or press Ctrl+Shift+I (⌘-Shift-I).

PEARL OF WISDOM

Even if a font doesn't offer a bold or italic style (called a *designer style* because it comes from the font's designer), the keyboard shortcuts still function. In place of the missing designer style, press Ctrl+Shift+B (⌘-Shift-B) to thicken the letters for a *faux bold*; press Ctrl+Shift+I (⌘-Shift-I) to slant them for a *faux italic.* Beware: Faux styles don't always look right or even good.

Figure 11-12.

17. ***Show the rulers and the Info panel.*** The Body Copy text is looking better, but its placement is for the birds. Before we size and position the text block, it helps to lay down a few guidelines. And before we can do that, we have to do the following:

 - Guidelines come from the rulers, so choose **View→Rulers** or press Ctrl+R (⌘-R) to display them.

 - To track the coordinate position of your guides, press F8 or choose **Window→Info** to display the **Info** panel.

18. ***Add three guidelines.*** Drag from the left ruler to create vertical guides, and drag from the top ruler to create horizontal guides. As you do, you can track the location of the guidelines by watching the X and Y values in the Info panel. With that in mind, create the following guides:

 - Drag a vertical guide to the coordinate position **X**: 80.

 - Next, drag another vertical guide very close to the right edge of the document, to the coordinate position **X**: 860.

 - Finally, drag a horizontal guide to **Y**: 30.

Figure 11-13 shows me in the process of creating the last guide. Note that these values assume your rulers are set to pixels (as we established when setting preferences in Step 10 of "One-on-One Installation and Setup," page xxii). If your rulers are set to some other unit of measurement, right-click (or Control-click) either ruler and choose **Pixels**.

Here's a helpful tip: As you drag, press the Shift key to snap the guideline to the tiny tick marks in the ruler (also known as *ruler increments*). If you drop a guideline at the wrong location, you can move it by pressing Ctrl (or ⌘) to get the move tool and then dragging the guide. To delete a guide, Ctrl-drag (or ⌘-drag) it back into the ruler.

Figure 11-13.

19. *Scale the text block to fit within the guides.* We're finished with the rulers, so press Ctrl+R (⌘-R) to hide them. With the type tool selected and some portion of the body text block still active (if the words *the hard way* are still highlighted, that's fine), move the cursor over the upper-left corner handle. The cursor should change to a bidirectional arrow, indicating that it's ready to scale. Drag the handle until it snaps to the intersection of the topmost and far-left guides. Similarly, drag the lower-right corner handle until it snaps to the far-right guideline, as shown in Figure 11-14 on the facing page.

Figure 11-14.

20. ***Hide the guides.*** At this point, you're finished with the guidelines. To hide them so you can focus on your composition, choose **View→Show→Guides**. Or better yet, press Ctrl+⌸ or ⌘-⌸ (the semicolon key, to the right of the L). The guidelines will no longer be visible, nor will they snap.

21. ***Change the antialiasing to Strong.*** Now comes one of Photoshop's subtlest formatting options. Located in the center of the options bar (as labeled in Figure 11-7 on page 378), the antialiasing setting controls the way the outlines of characters blend with their backgrounds. Your options are:

- Sharp, which manages to antialias the type while maintaining sharp corners. This preserves the best character definition, especially when applied to small letters with serifs (the flourishes at corners and ends of letters).

- Crisp, which rounds the corners slightly.

- Strong, which shores up small type by expanding the edges very slightly outward, thus resulting in bolder characters.

- Smooth, which supposedly rounds corners even more than Crisp. In practice, the two settings are virtually identical.

- None, which turns off antialiasing and leaves the jagged transitions. For Web work, this is a terrible setting. But for high-resolution print work, it helps reduce some of the blur that can result from antialiasing.

The examples in Figure 11-15 show all settings except Smooth applied to a magnified detail from the Body Copy layer. The differences verge on trivial, but for this particular layer, I would argue that **Strong** helps thicken the characters and boost legibility. So choose it.

Sharp

**What a situation! E
suburban teen found
bodies with his 57-ye
be none other than Te
maceutical giants in t**

Crisp

**What a situation! E
suburban teen found
bodies with his 57-ye
be none other than Te
maceutical giants in t**

Strong

**What a situation! E
suburban teen found
bodies with his 57-ye
be none other than Te
maceutical giants in t**

None

**What a situation! E
suburban teen found
bodies with his 57-ye
be none other than Te
maceutical giants in t**

Figure 11-15.

22. *Turn on Fractional Widths.* This next option is likewise subtle but, in my estimation, much more important. By default, Photoshop spaces characters by whole numbers of pixels. This is essential when working with jagged type (as when antialiasing is set to None) but otherwise results in inconsistent letter spacing. To better space one letter from its neighbor, click the ▾≡ in the top-right corner of the **Character** panel and choose **Fractional Widths**. This calculates the text spacing for the entire layer in the same way other design programs do, in precise fractions of a pixel. You'll see the text tighten up slightly.

23. ***Turn on the every-line composer.*** Flush left type is sometimes said to be ragged right, and the body text in this composition is nothing if not a case in point. To even out the choppy edges, switch to the **Paragraph** panel by clicking its tab in the Character panel cluster. Then click the ▾≡ in the top-right corner of the panel to bring up the panel menu and choose **Adobe Every-line Composer**. Photoshop better aligns the right edges of the type, as in Figure 11-16.

Photoshop's *single-line composer* (active prior to Step 23) analyzes each line of type on its own, in a vacuum. The *every-line composer* (shown in Figure 11-16) examines the entire text layer as a whole and spaces the text to give it the most even appearance possible.

Single-line composer

What a situation! Ever wonder what would happen if a hip, edgy suburban teen found a magic talking squirrel that let him switch bodies with his 57-year-old uncle? And what if that uncle happens to be none other than Ted Hutchinson, CEO of one of the largest pharmaceutical giants in the world? Well, Scott Stevens is about to find out—*the hard way*. Tune in this fall for an adventure that's sure to knock your socks off! Scott has only 72 hours to find the potion to change him back, win FDA approval for a controversial asthma medicine, and save the local orphanage. Meanwhile, Uncle Ted needs to survive in Scott's body—and he just might rediscover what it means to have fun. It's a guaranteed rollercoaster of laughs for nearly the entire family!

Every-line composer

What a situation! Ever wonder what would happen if a hip, edgy suburban teen found a magic talking squirrel that let him switch bodies with his 57-year-old uncle? And what if that uncle happens to be none other than Ted Hutchinson, CEO of one of the largest pharmaceutical giants in the world? Well, Scott Stevens is about to find out—*the hard way*. Tune in this fall for an adventure that's sure to knock your socks off! Scott has only 72 hours to find the potion to change him back, win FDA approval for a controversial asthma medicine, and save the local orphanage. Meanwhile, Uncle Ted needs to survive in Scott's body—and he just might rediscover what it means to have fun. It's a guaranteed rollercoaster of laughs for nearly the entire family!

Figure 11-16.

24. ***Justify the type.*** Less ragged text is great, but let's say you want both the left and right edges to be flush. Click the fourth icon (▤) in the top row of the Paragraph panel to justify the paragraph and leave the last line flush left, as shown in Figure 11-17. You can also press Ctrl+Shift+J (⌘-Shift-J).

Figure 11-17.

Even after justifying the paragraph, the every-line composer remains in effect, thus ensuring more evenly spaced words from one line of type to the next.

25. ***Select the entire paragraph, except the first three words.*** Let's change all but the first three words, the bold *What a situation!*, to a light blue hue that matches a color in the clothing of our shrugging actors. Start by double-clicking the fourth word, *Ever*. Then press Ctrl+Shift+↓ (⌘-Shift-↓ on the Mac) to extend the selection to the end of the paragraph.

26. ***Change the color to a bluish cyan.*** Click the white color swatch in the options bar to display the **Select Text Color** dialog box. Then move the cursor into the image window and click in one of the lighter blue areas inside the nephew's shirt, as shown in Figure 11-18. You should end up with a color in the approximate vicinity of **H**: 200, **S**: 20, **B**: 100. When you do, click the **OK** button to recolor the text.

If you don't get a shade of blue when you click with the eyedropper, here's what you do: Click the Cancel button. Select the eyedropper tool. Go to the options bar and change Sample to All Layers. Then repeat Steps 25 and 26.

Figure 11-18.

27. ***Accept your changes.*** Press the Enter key on the keypad or press Ctrl+Enter (⌘-Return) to exit the type mode and accept the changes to the Body Copy layer.

All this editing and formatting is fine and dandy, but it's the kind of thing you could accomplish in a vector-based program (such as Illustrator or InDesign), which is better designed for composing and printing high-resolution text. For the remainder of this exercise, we'll apply the sort of text treatment that's possible only in Photoshop. Due to the length of this exercise, I've marked these steps as Extra Credit. But between you and me, you won't want to miss them.

28. *Turn on the Style Holder layer in the Layers panel.* A tiny orange suitcase appears next to the CEO's head. This layer holds some of the attributes we'll be applying to the large *CHIEF EXECUTIVE NEPHEW* text.

29. *Eyedrop the orange suitcase.* Press the I key to select the eyedropper tool, and then click the little suitcase to make its orange the foreground color.

30. *Fill the Chief Executive Nephew layer with the sampled orange.* Click the **Chief Executive Nephew** layer in the **Layers** panel to make it active. Then press Alt+Backspace (Option-Delete on the Mac) to fill the text with orange, as shown in Figure 11-19. When filling an entire text layer, this handy shortcut lets you recolor text without visiting the Select Text Color dialog box.

Figure 11-19.

A Dozen More Ways to Edit Text

I couldn't begin to convey in a single exercise, even a long one, all the wonderful ways Photoshop permits you to edit and format text. So here are a few truly terrific tips and techniques to bear in mind when working on your own projects:

- Double-click a T thumbnail in the Layers panel to switch to the type tool and select all the text in the corresponding layer.

- Armed with the type tool, you can double-click a word to select it. Drag on the second click to select multiple words. Triple-click to select an entire line; quadruple-click to select a paragraph.

- To increase the size of selected characters in 2-point increments, press Ctrl+Shift+⧉. To reduce the type size, press Ctrl+Shift+⧉. (That's ⌘-Shift-⧉ and ⌘-Shift-⧉ on the Mac.)

- In the design world, line spacing is called *leading*. By default, the leading in Photoshop is set to Auto, which is 120 percent of the prevailing type size. To override this, click the ⍗A icon in the Character panel to highlight the leading value (Auto), and then replace the value with a number. In the figure below, I changed the leading to 16 points. Note that the new leading value affects the distance between the selected text and the text above it.

- After you enter a manual leading value (something other than Auto) in the Character panel, you can increase or decrease the leading using keyboard shortcuts. Press Alt+↓ (or Option-↓) to increase the leading; press Alt+↑ (Option-↑) to tighten it.

- Click between two characters and press Alt+←· (Option-←·) to move them together or Alt+·→ (Option-·→) to move them apart. This is called *pair kerning*.

- You can apply those same keystrokes to multiple characters at a time. For example, in the figure below, I selected a line of type and pressed Alt+←· to move the characters together; this wrapped another word onto that line. Photoshop calls this *tracking*. In this example, the Adobe every-line composer has shifted letters above the selected area to space the text as expertly as possible.

- When text is active, press Ctrl (or ⌘) and drag inside the text to move it.

- Also when text is active, press Ctrl+T (⌘-T) to display or hide the Character panel. Press Ctrl+M (⌘-M) to do the same with the Paragraph panel.

- The Color panel does not always reflect the color of highlighted text. But if you change the Color panel settings, any highlighted text changes as well.

- To change the formatting of multiple text layers at a time, first select the layers. Then choose a typeface, style, size, or other formatting settings. All selected text layers change at once.

- When editing text, you have one undo, which you can exercise by pressing Ctrl+Z (or ⌘-Z). If you need more undos, press the Esc key to abandon *all* changes made since you entered the type mode. But be careful when using this technique. If you press the Esc key in the midst of making a new text layer, you forfeit the whole thing. Esc can't be undone. Esc is forever.

31. ***Determine the angle of our shadow.*** The next trick is to add a *cast shadow*—that is, a shadow cast by the letters in the opposite direction from the light source. In this case, we can gauge the light source based on the shadow behind the nephew. Our new shadow should extend up and leftward in the area behind the letters.

32. ***Transform and duplicate the text layer.*** Press Ctrl+Alt+T (or ⌘-Option-T). This does two things: It duplicates the layer and enters the free transform mode. But for the moment, you'll have to take this on faith; the Layers panel doesn't show you the new layer until you begin editing it.

33. ***Scale and position the duplicate layer.*** I have a few instructions for you here:

 - Drag the top handle upward and stretch the duplicate vertically until you've reached a **Height** of about 130 percent.

 - In the options bar, change the **Y** value to 1090 pixels so that the bottom edges of both the original layer and its duplicate line up exactly. (The Δ icon should be off.)

The final position of the duplicate text appears in Figure 11-20. When your screen matches mine, click the ✔ or press Enter or Return to accept the transformation.

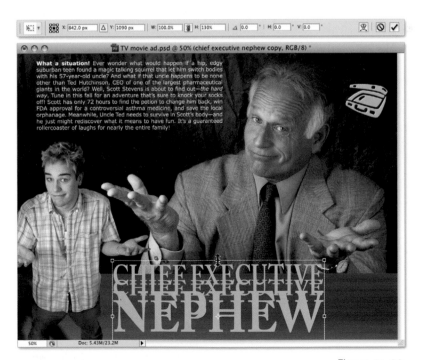

Figure 11-20.

34. *Rename the layer and move it one layer down.* Double-click the name of the new layer in the **Layers** panel and change it to "Cast Shadow." Then press Ctrl+⬚ (⌘-⬚ on the Mac) to move it behind the chief executive nephew layer.

35. *Adjust the color of the layer.* Press the D key to make sure our default colors are selected. Then press Alt+Backspace (or Option-Delete) to fill the layer with black.

36. *Apply the Gaussian Blur filter.* To create a soft shadow, you need to choose **Filter→Blur→Gaussian Blur**. But because Photoshop's filters were originally designed to modify pixels, the program alerts you that you must first *rasterize* the type—that is, convert it to pixels. This means two big sacrifices: You'll no longer be able to edit the text and you'll lose access to the type's high-quality vector outlines. Fortunately, there's a better way. Here's what I want you to do:

 • Click **Cancel** to avoid rasterizing the type.

 • Choose **Filter→Convert for Smart Filters**. Discussed at length in Lesson 7, the smart filter feature permits you to apply dynamic effects to live objects, such as type.

 • Photoshop may display a message, letting you know that by choosing Convert for Smart Filters, you are converting the text to a smart object. That's just fine, so click **OK**, as you see me doing in the none-too-understated Figure 11-21.

 • Again choose **Filter→Blur→Gaussian Blur**. Photoshop displays the **Gaussian Blur** dialog box.

 For a full refresher on smart objects and smart filters, check back with Lesson 7, "Sharpening and Smart Objects."

37. *Change the Radius value.* Enter a **Radius** value of 6 pixels and click **OK**. If you look at the **Layers** panel, you'll see that the Cast Shadow layer now includes an editable Gaussian Blur item, which I've circled in Figure 11-22 on the facing page.

38. *Reduce the layer's opacity.* Press 4 to reduce the **Opacity** value in the Layers panel to 40 percent.

Figure 11-21.

39. **Skew the blurry type.** Now let's give the shadow some directional perspective so it looks more realistic. Choose **Edit→Transform** or press Ctrl+T (⌘-T) to again enter the free transform mode. An alert message tells you that the Gaussian Blur filter will be disabled during the transformation process. Don't worry; it'll come back when you're done. For now, click **OK** to accept the news.

Inexplicably, the options bar lacks skew options when working with a smart object. So you have to slant the type by hand, as follows:

- Press the Ctrl key (⌘ on the Mac) and drag the top handle to the left. Photoshop slants the type.

- Keep dragging until you reach the inside of the two buttons on the older gentleman's exposed cuff, as indicated by the area circled in light green in Figure 11-23.

When you're satisfied that your shadow looks like mine—or is more to your liking than mine—press the Enter or Return key to apply the skew and restore the Gaussian Blur effect.

40. **Send the shadow backward.** In the Layers panel, click the ▶ in front of **Background Composition** to twirl open the group. This reveals the parts and pieces that make up the rest of our advertisement. Drag the **Cast Shadow** layer down the stack and drop it between the Uncle Ted and Blurred Background layers. Now the shadow exists inside the brown motion-blurred desktop. It doesn't extend out into the weird, hammy uncle, nor does it overlap the weird, hammy nephew.

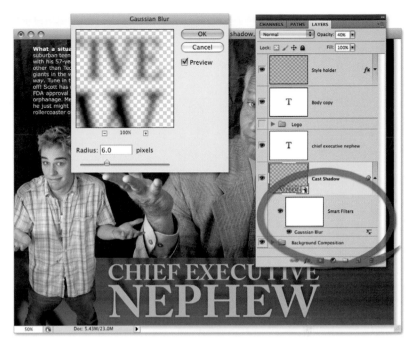

Figure 11-22.

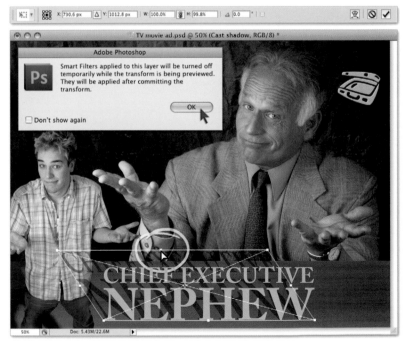

Figure 11-23.

Figure 11-24.

41. *Reveal the network logo.* In the Layers panel, click the empty gray square to the left of the **Logo** group to display the 👁 icon and reveal our network's distinctive logo. This group also includes some obligatory promo information about the movie.

42. *Move the effect from the Style Holder layer.* Let's finish by adding a bevel effect to the main title. In the Layers panel, drag the *fx* belonging to the **Style Holder** layer and drop it on the **Chief Executive Nephew** layer, as in Figure 11-24. Once upon a time, moving a style would copy it onto the new layer while leaving the original intact. But nowadays, dragging a style shifts it entirely from one layer to another, which works great here.

If you want to copy a style from one layer to another while leaving the original layer intact, hold down the Alt (or Option) key as you drag.

43. *Delete the Style Holder layer.* Drag the **Style Holder** layer to the trash can icon at the bottom of the Layers panel or press Backspace or Delete. The finished artwork appears in Figure 11-25.

44. *Choose File→Save As.* Give the file a different filename and click **Save**. If you decide to visit the file later, the live text remains editable. To change the text in a smart object, double-click the smart object's thumbnail in the Layers panel.

Figure 11-25.

Drawing and Editing Shapes

Photoshop's shape tools allow you to draw rectangles, ellipses, polygons, and an assortment of prefab dingbats and symbols. On the surface, they're a pretty straightforward bunch. But when you delve into them a little more deeply, you quickly discover that the applications for shapes are every bit as wide-ranging and diverse as those for text.

If you have even a modicum of experience using the marquee tools (you may recall the elliptical marquee tool from pages 69 and 70 of Lesson 3), you know how to draw rectangles and ellipses in Photoshop. So in the following exercise, we'll focus on the shapes we haven't yet seen—polygons, lines, and custom shapes—as well as ways to blend vectors and images inside a single composition.

1. *Open an image.* For simplicity's sake, we'll start with a more or less neutral background. Open the file *Election.psd* located in the *Lesson 11* folder in *Lesson Files-PsCS5 1on1.* After a possible "Update" alert message, you'll be greeted by what appears to be a couple of text layers set against a white fabric background, as in Figure 11-26. But in fact, the word *ELECTION* is a shape layer. I had originally set the text in the Copperplate font—a popular typeface but one you may not have on your system. To avoid having the letters change to a different font on your machine, I converted the letters to independent shapes. This prevents you from editing the type, but you can scale or otherwise transform the vector-based shapes without any degradation in quality.

Figure 11-26.

2. *Convert the 2084 layer to shapes.* Let's say we want to similarly prevent the text *2084* from changing on another system. Right-click (or Control-click) the **2084** layer in the **Layers** panel and choose **Convert to Shape** midway down the context menu. Photoshop converts the characters to shape outlines, which will easily survive the journey from one system to another.

3. *Display the guidelines.* This image contains a total of eight guides—four vertical and four horizontal. If you can't see the guides, choose **View**→**Show**→**Guides** or press Ctrl+□ (⌘-□). The guides will aid us in the creation of our shapes.

Figure 11-27.

4. *Select the polygon tool in the toolbox.* Click and hold the rectangle tool icon, below the arrow tool, to display the flyout menu pictured in Figure 11-28. Then choose the polygon tool, which lets you draw regular polygons—things like pentagons and hexagons—as well as stars.

5. *Click the shape layers icon in the options bar.* Highlighted on the far left in Figure 11-29, this icon tells the polygon tool to draw an independent shape layer.

Figure 11-28.

Figure 11-29.

6. **_Set the Polygon Options to Star._** Our image is an election graphic, so naturally one feels compelled to wrap the composition in stars and stripes. Click the ▾ arrow to the left of the **Sides** value in the options bar (labeled _Shape geometry options_ in Figure 11-29) to display the **Polygon Options** pop-up menu:

 - Select the **Star** check box to make the tool draw stars.

 - Make sure both **Smooth** check boxes are turned off so the corners are nice and sharp.

 - Set **Indent Sides By** to 50 percent to make opposite points align with each other, as is the rule for a 5-pointed star.

7. **_Set the Sides value to 5._** This is the default value, so it's unlikely you'll have to make a change. But if you do, here's a trick:

 To raise the Sides value in increments of 1, press the ⬚ key. To lower the value, press the ⬚ key. Add the Shift key to change the value by 10. This trick works for any value that occupies this space in the options bar.

8. **_Draw the first star._** Press D and then X to make the foreground color white. If you can see outlines around the numbers _2084_, press Enter or Return to dismiss them. Then draw the star. The polygon tool draws from the center out, so drag from the guide intersection marked by the yellow ⊕ to the one marked by the dark green ✚, as in Figure 11-30. Make sure you end your drag on the vertical guide just above the left half (not the middle) of the _4_. Photoshop matches the attributes of the 2084 layer, giving the star a white fill and a drop shadow.

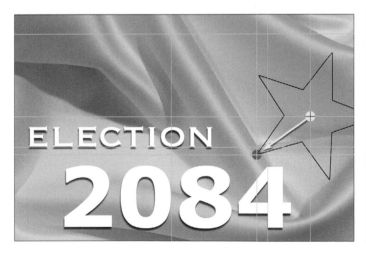

Figure 11-30.

9. **Carve a second star out of the first.** Press the Alt key (Option key on the Mac) and draw another star from the same starting point (marked by the yellow ⊕ in Figure 11-31) to the next guideline intersection (the dark green ● in the figure). Because the Alt or Option key is down, Photoshop subtracts the new shape from the previous one. The result is a star-shaped white stroke.

Figure 11-31.

10. **Click the arrow tool in the toolbox.** Or press the A key to select the black arrow, which Photoshop calls the path selection tool. As you saw in Lesson 10, it permits you to select and modify path outlines. Here, we'll use it to select the path that defines our shape layer

11. **Select both inner and outer star paths.** Click one of the star paths to select it. Then press the Shift key and click the other star. Photoshop selects both paths.

12. **Transform and duplicate the star.** Press Ctrl+Alt+T (⌘-Option-T on the Mac) to duplicate the selected star paths and enter the free transform mode. As usual, you have to take on faith that you've duplicated the star because, for the moment, the cloned paths exactly overlap the originals.

13. **Scale, rotate, and move the duplicate star.** At this point, I need you to make some precise adjustments:

- In the options bar, click the ⚙ icon between the W and H values to scale the star paths proportionally. Then change either the **W** or **H** value to 80 percent.

- Tab to the rotate value (△) and change it to –16 degrees. This tilts the star counterclockwise.

- Drag the star until what used to be the upper-left handle of the now-tilted bounding box clicks into alignment with the intersection of the topmost and leftmost guidelines, as shown in Figure 11-32.

When the new star appears in the proper position, press the Enter or Return key to confirm the transformation.

Figure 11-32.

14. **Repeat the previous transformation three times.** Press Ctrl+Shift+Alt+T (or ⌘-Shift-Option-T) to repeat all the operations performed in the preceding step. This tells Photoshop to duplicate the second star group, scale it proportionally to 80 percent, rotate it –16 degrees, and move it to the left. Press Ctrl+Shift+Alt+T (⌘-Shift-Option-T) twice more to further repeat the operations. The result is the arcing sequence of five stars shown in Figure 11-33 on the next page.

This succession of duplicate, transform, and repeat (similar to what we saw in Lesson 5) is known as *series duplication*. In Photoshop, it invariably begins with the keyboard shortcut Ctrl+Alt+T (⌘-Option-T) and ends with several repetitions of Ctrl+Shift+Alt+T (⌘-Shift-Option-T). Set up properly, series duplication helps automate the creation of derivative paths and shape patterns.

15. ***Name the new layer.*** By default, the layer full of stars is called Shape 1. Double-click the layer name in the **Layers** panel and enter the new name "Stars."

If you find that the names of some of your layers are getting truncated, the Layers panel is too narrow to display them. Move the panel away from the right edge of your screen, and then drag the lower-right corner of the panel to expand it.

Figure 11-33.

16. ***Turn on the Field layer.*** Click in front of the **Field** layer in the Layers panel to turn on its 👁 and display a slanted blue shape. I created this layer by drawing a rectangle with the rectangle tool and then distorting the shape in the free transform mode.

17. ***Set the Field layer to Hard Light.*** In the Layers panel, click the **Field** layer to select it and choose the **Hard Light** blend mode. Or press Shift+Alt+H (Shift-Option-H). If you chose the blend mode manually, press the Esc key to deactivate it. Then press 8 to lower the **Opacity** value to 80 percent. Even though Field is a vector shape layer, it's subject to the same blend modes and transparency options available elsewhere in Photoshop.

18. ***Turn on the Stripes layer.*** Click the 👁 icon in front of the **Stripes** layer to display a sequence of red stripes. I created the top stripe by distorting a rectangle. Then I used series duplication to make the other four.

19. ***Set the Stripes layer to Multiply.*** Select the **Stripes** layer by clicking it and then press Shift+Alt+M (or Shift-Option-M) to burn the stripes into the background image. The result appears in Figure 11-34. (Note: Your guides will still be cyan. I left mine white so you could see them more easily in the colorful image.)

By now, you may have noticed Photoshop's penchant for showing you the outlines of your paths whenever you view a shape layer. To hide the paths, click the vector mask thumbnail to the right of the color swatch in the Layers panel. Alternatively, if the arrow tool or one of the shape tools is active, you can press Enter or Return.

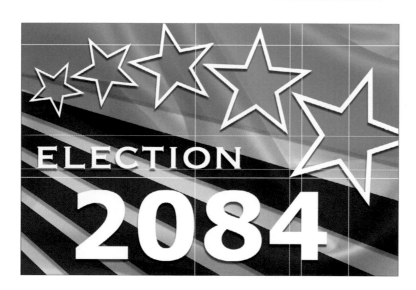

Figure 11-34.

Now suppose we want the stripes to vary in opacity, from nearly transparent on the left to opaque on the right. One solution is to fill the layer with a transparent-to-red gradient (Layer→Change Layer Content→Gradient). But a more flexible solution is to add a layer mask. This may seem like an odd notion, given that the layer already has a vector mask. But any kind of layer in Photoshop—even a text layer—can include one vector mask *and* one pixel-based layer mask, thus permitting you to blend the best of both worlds.

Figure 11-35.

Figure 11-36.

If adding a layer mask to a vector shape doesn't sound like a regular barrel of monkeys to you, skip to the "Bending and Warping Type" exercise, which begins on page 388. Then again, if it sounds like more fun than you've had in years, enjoy the remaining steps.

20. **Add a layer mask.** With the Stripes layer still active, click the small ◻ icon at the bottom of the Layers panel. Photoshop adds another mask thumbnail, as shown in Figure 11-35.

21. **Click the gradient tool in the toolbox.** If the paint bucket is active, Alt-click (Option-click) it to switch to the gradient tool. Or just press the G key. Also, confirm the following settings:

 • Press the D key to set the foreground color to white and the background to black (the masking defaults).

 • Make sure the gradient bar on the left side of the options bar displays a white-to-black gradient. If it does not, press Shift+⌷ (that's Shift+comma) to reset it.

 • Select the first style icon in the options bar (the one labeled Linear Gradient in Figure 11-36).

 • The other options should be set to their defaults: **Mode**: **Normal**, **Opacity**: 100 percent, **Reverse**: off, and the last two check boxes on.

22. **Draw the gradient mask.** Drag in the image window from the top of the 4 to just beyond the left edge of the image window, matching the angle of the neighboring stripe, as illustrated in Figure 11-37 atop the facing page. The result is that the stripes fade as they progress from right to left.

If you don't like the result of the gradient mask, just redraw it. Because the gradient is opaque, it replaces any previous gradient you've drawn; no undo needed.

Figure 11-37.

23. ***Select the line tool.*** The next step is to draw a rule under the word *ELECTION*. The best tool for this job is the line tool. You can select it in either of the following ways:

 • Select the line tool from the shape tool flyout menu, just as you chose the polygon tool back in Step 4.

 • Click the current occupant of the shape tool slot. Then click the line tool icon in the options bar, as shown in Figure 11-38.

Line Tool

Figure 11-38.

24. ***Increase the Weight value to 12 pixels.*** The **Weight** value determines the thickness of lines drawn with the line tool. You can modify the value directly in the options bar, or press Shift+⬚ to raise the value by 10 and ⬚ to raise it by another 1.

25. ***Click the Stars layer in the Layers panel.*** Be sure to click the vector mask to make it active. By selecting this layer and its mask, you do two things: First, you tell Photoshop to create the next shape layer in front of the Stars layer. Second, you tell it to match the Stars layer's color and style attributes.

26. *Draw a line under the word* **ELECTION**. Because we want the rule to extend beyond the left edge of the canvas, it's easiest to draw from right to left. So begin your drag just to the right of the *N* in *ELECTION* and between the two horizontal guides, as demonstrated in Figure 11-39. (If you find yourself snapping to one guideline or the other, zoom in and try again.) *After* you begin dragging, press and hold the Shift key to constrain the rule to precisely horizontal. (If you press Shift before starting to drag, you'll add the line to the existing star layer.) Drag beyond the edge of the canvas before releasing the mouse button, and then release Shift.

Figure 11-39.

You can adjust the position of the line as you draw it or after you finish. To move the line as you draw it, press and hold the spacebar. To move the line after you draw it, press Ctrl (or ⌘), click the path outline to select it, and press the appropriate arrow key (↑, ↓, ←, or →).

27. *Name the new layer.* Again, the layer is called Shape 1. Double-click the layer name and enter the new name "Underscore."

28. *Select the custom shape tool.* Now to draw the final shape, which will be a crown over the letter *T*. Photoshop permits you to draw prefab graphics using the custom shape tool. To select this tool, click the ✿ icon, the one to the right of the line tool in the options bar. Or press the U key.

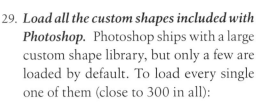

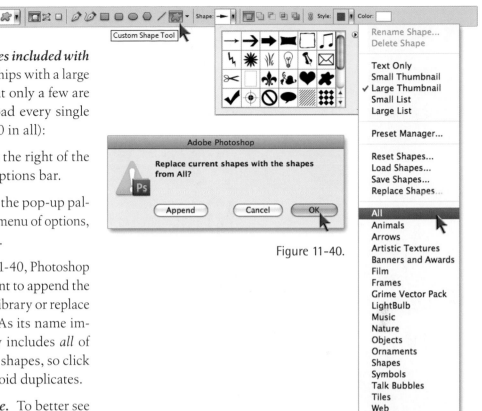

29. **Load all the custom shapes included with Photoshop.** Photoshop ships with a large custom shape library, but only a few are loaded by default. To load every single one of them (close to 300 in all):

- Click the ⬎ arrow to the right of the word **Shape** in the options bar.

- Click the ⊙ arrow in the pop-up palette to display a long menu of options, and then choose **All**.

- As shown in Figure 11-40, Photoshop asks whether you want to append the shapes from the All library or replace the current shapes. As its name implies, the All library includes *all* of Photoshop's custom shapes, so click the **OK** button to avoid duplicates.

Figure 11-40.

30. **Select the Crown 2 shape.** To better see the shapes, choose **Large Thumbnail** from the pop-up palette's menu. Photoshop's shape collection includes five crowns. Scroll down, and double-click the second one (♕), which I've outlined in red in Figure 11-41.

31. **Draw the crown shape.** Draw the crown above the letter *T*, as demonstrated in Figure 11-42 on the next page. As you do, press and hold the Shift key to constrain the crown to its original aspect ratio, so it appears neither stretched nor squished. (Again, be sure to press Shift *after* you begin dragging, not before.) Don't forget that you can press the spacebar to position the crown on-the-fly.

32. **Name the new layer.** Double-click the newest layer's name in the **Layers** panel and enter "Crown" instead.

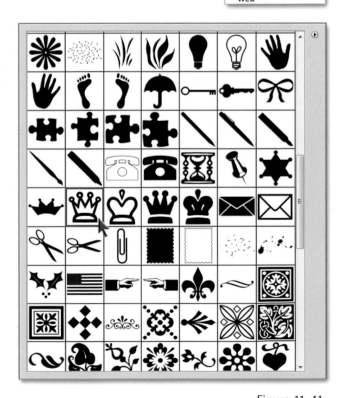

Figure 11-41.

Figure 11-42.

33. ***Switch to the Background layer.*** That takes care of all the shapes. My remaining concern with the design is that the word *ELECTION* is too close in color to its background. So I'd like to add a gradient just above the Background layer to create more contrast. Click **Background** to make it active.

34. ***Change the foreground color.*** Press D to call up the default foreground and background colors and select black. The active foreground color influences the gradient we're about to create.

35. ***Add a gradient layer.*** Press the Alt key (Option on the Mac) and click the ◑ icon at the bottom of the Layers panel. Then choose the **Gradient** command. This forces the **New Layer** dialog box to appear. Enter the settings shown in Figure 11-43 and described below:

 • Name the new layer "Shading."

 • Set the **Mode** option to **Multiply**. You can always change this later directly in the Layers panel, but we might as well set it up properly in advance.

 • Lower the **Opacity** value to 50 percent.

 Then click the **OK** button.

36. ***Set the angle to 50 degrees.*** Photoshop next displays the **Gradient Fill** dialog box (see Figure 11-44), which shows a black-to-transparent gradient, perfect for our needs. (The black comes from the foreground color, as set in Step 34.) Change the **Angle** value to 50 degrees and click **OK**. The result is an independent gradient layer that you can adjust later by double-clicking its thumbnail in the Layers panel.

Figure 11-43.

37. ***Hide the guidelines.*** Choose **View**→**Show**→**Guides** or press Ctrl+⬚ (⌘-⬚). The final artwork appears in Figure 11-45.

Remarkably, virtually everything about this design is scalable. To turn it into a piece of tabloid-sized poster art, choose **Image**→**Image Size** and change the **Width** value in the **Document Size** area to 17 inches. Make sure all three check boxes at the bottom of the dialog box are selected and click **OK**. Every shape, drop shadow, and gradient scales to fit the new document size, as shown in Figure 11-46. The background image gets interpolated, but given the dominance of the foreground elements, it's not something that anyone's going to notice.

Figure 11-44.

Figure 11-45.

Figure 11-46.

407

Bending and Warping Type

Back in Step 39 of the "Creating and Formatting Text" exercise (see page 393), we skewed some text backward using the Edit→Free Transform command. But what if we wanted to apply a more elaborate distortion? When working on text, Distort and Perspective are dimmed in the Edit→Transform submenu. But that doesn't mean distortions are applicable only to images. Photoshop offers two ways to distort live text layers:

- You can combine a text layer with a shape outline to create a line of type that flows along a curve, commonly known as *text on a path*.

- If that doesn't suit your needs, you can warp text around a predefined shape. This feature is similar to the Warp command that we used in Lessons 7 and 8, except that you can't apply a custom distortion. For that, you have to convert the text to shapes.

This exercise shows you how the two features work. First, we'll wrap text around the perimeter of a circle. Then we'll stretch and distort letters inside the contours of a text warp shape. All the while, our text layers will remain live and fully editable.

1. **Open two images.** The files in question are *Space radio.psd* and *Space text.psd*, both in the *Lesson 11* folder in *Lesson Files-PsCS5 1on1*. If Photoshop complains that some layers need to be updated, click the **Update** button. The first file contains a handful of text, shape, and image layers, many of which I've assigned layer styles. The second file contains two lines of white type against a black background. Our first task is to take the text from the second file and flow it around the black circle in the first file. So click the title bar for *Space text.psd* to bring it to the front, as shown in Figure 11-47.

Figure 11-47.

2. **Copy the top text layer.** In the **Layers** panel, double-click the **T** in front of the layer named **Everyone (top line)**. Photoshop switches to the type tool and selects all the type in the top line. (If it does not, it's probably because you double-clicked the layer name instead of the T. Try again.) Choose **Edit→Copy** or press Ctrl+C (⌘-C on the Mac).

3. **Switch back to the Space radio.psd composition.** Press the Esc key to exit the text-editing mode. Then click the title bar of the image that contains the microphone.

4. **Display the guidelines.** If you can already see the guidelines, super. If not, choose **View→Show→Guides** or press Ctrl+⌷ (⌘-⌷ on the Mac).

5. **Select the ellipse tool in the toolbox.** To create text around a circle, we need to draw a circle for the text to follow. Click and hold the shape tool icon and choose the ellipse tool, as shown in Figure 11-48.

6. **Click the paths icon in the options bar.** You can set text around any kind of path outline, whether it's part of a shape layer or stored separately in the Paths panel. But given the number of circles in this document, it'll be easier to see what's going on if we work with the Paths panel. So in the options bar, click the icon highlighted in Figure 11-49.

Figure 11-48.

Figure 11-49.

7. **Draw a big circle.** Drag from one guide intersection to the opposite intersection. Figure 11-50 illustrates the correct and proper left-hander's view. Those of you cursed with the popular blight of right-handedness can drag from left to right instead.

Speaking of Figure 11-50, the cyan lines are the guides, the black circle is the new path. The beginning of my drag appears as an orange ⊕; the end appears as a violet ✦. The actual image is dimmed so you can better see what's going on.

8. **Name the new path.** Strictly speaking, you don't *have* to name the path. But you might as well be organized and save your work as you go along. So with that in mind, switch to the **Paths** panel, double-click the **Work Path** item, and rename it "Big Circle."

9. **Hide the guidelines.** The sole purpose of the guides was to help you draw the big circle. Now that we're finished with that, choose **View→Show→Guides** or press Ctrl+⌷ (or ⌘-⌷) to make them go away.

Figure 11-50.

10. **Click the type tool in the toolbox.** Or press the T key. As I mentioned, the horizontal type tool is the only text tool you'll ever need. It creates point text, area text, and now, text on a path.

11. **Click at the top of the big circle.** When you move your cursor over the circular path, the cursor changes slightly to include a little swash through its center. This indicates that you're about to append text to the path. Click the center-topmost point in the path to set the blinking insertion marker on the path, as shown in Figure 11-51.

12. **Paste the text.** Choose **Edit→Paste** or press Ctrl+V (or ⌘-V). Photoshop pastes the text you copied back in Step 2 along the circumference of the path. The copied text was centered, so the pasted text is centered as well, exactly at the point at which you clicked in the preceding step. The result is a string of characters that rest evenly along the top of the circle, centered between the red ⊘s, as shown in Figure 11-52.

Figure 11-51.

Figure 11-52.

If your text is not quite evenly centered as in Figure 11-52, you may need to reposition it slightly. Press the Ctrl key (or ⌘ on the Mac) and move the cursor over the letters to get an I-beam with two arrows beside it. Then drag the text to move it around the circle until the first *E* and the last *A* are equidistant from the two red ⊘s. Small drags usually produce the best results.

When you have the type where you want it, press the Enter key on the keypad (or Ctrl+Enter or ⌘-Return) to accept the new text layer and move on.

13. ***Copy the second line of type.*** Now to create the text along the bottom of the circle. Switch to the *Space text.psd* window. Double-click the **T** in front of the layer named **Except (Bottom Line)** in the **Layers** panel to select the text. Then choose **Edit→Copy** or press Ctrl+C (⌘-C).

14. ***Select the next layer down in the composition.*** Press Esc to deactivate the text. Then return to the *Space radio.psd* composition. Press Alt+⬚ (or Option-⬚) to select the **Radio-Free Space!** layer. We're doing this for two reasons: First, I want the next layer you create to appear in front of this one. Second, it'll allow us to start with a fresh circle path instead of repurposing the one used in the top layer.

15. ***Click along the bottom of the big circle.*** Go to the **Paths** panel and click the **Big Circle** item to once again display the circle in the image window. Still armed with the type tool, click at the center of the bottom of the circular path. Photoshop displays a blinking insertion marker, this time emanating down from the circle.

16. ***Paste the text.*** Again, choose **Edit→Paste** or press Ctrl+V (⌘-V). As before, Photoshop pastes the text along the perimeter of the circle. But this time, the text comes in upside-down, as shown in Figure 11-53.

Figure 11-53.

17. ***Flip the text to the other side of the path.*** Press and hold the Ctrl key (⌘ on the Mac) and hover the cursor over the bottom of the text (roughly the *O* in *COMPLETE*) to get the I-beam with the double arrow. Then drag upward. Photoshop flips the text to the other side of the path, turning it right-side-up, as shown in Figure 11-54.

18. ***Select all the type.*** Next we need to nudge the type down using a function called *baseline shift*, which raises or lowers selected characters with respect to their natural resting position, the *baseline*. Press Ctrl+A (or ⌘-A) to select all the characters in the new text layer.

A Wholly Owned Subsidiary of The Bounded Frontiers of Journalism Society of The United Earth, LLC

Figure 11-54.

19. ***Bring up the Character panel.*** Click the Character tab if it's already on screen. Otherwise, choose **Window→Character** or press the shortcut Ctrl+T (⌘-T).

20. ***Set the baseline shift.*** In the **Character** panel, click the icon that looks like a capital letter paired with a superscript one (**A^a**) to select the baseline shift value, highlighted in Figure 11-55. Then enter −8.5 to shift the letters down 8.5 points, which translates to about 18 pixels inside this 150 ppi image.

You can also nudge the baseline shift value incrementally from the keyboard. Press Shift+Alt+↓ (or Shift-Option-↓) to lower the characters 2 points at a time. Shift+Alt+↑ (or Shift-Option-↑) raises the characters.

Press Enter on the keypad to accept your changes. (If the baseline shift value is selected, you may have to press Enter twice.) This completes the text on the circle. Now let's move on to warping some text.

A Wholly Owned Subsidiary of The Bounded Frontiers of Journalism Society of The United Earth, LLC

Figure 11-55.

21. *Select the Radio-Free Space! layer.* Press Alt+⬇ (or Option-⬇) to drop down to the layer. Right now, the text treatment is almost comically bad. Cyan letters, wide leading—how much worse could it get? We'll start by spicing up the text with some layer styles, and then we'll warp the text for a classic pulp fiction look.

22. *Turn on the layer styles.* In the **Layers** panel, click the ▼ to the right of the **Radio-Free Space!** layer name to twirl open the layer and reveal a list of three styles I applied in advance: Outer Glow, Bevel and Emboss, and Stroke. Click in front of the word **Effects** to display the three styles.

23. *Set the blend mode to Overlay.* Select **Overlay** from the blend mode pop-up menu at the top of the Layers panel. Or press the shortcut Shift+Alt+O (Shift-Option-O). The result appears in Figure 11-56.

24. *Click the warp icon in the options bar.* The type tool should still be active. Assuming that it is, look to the right side of the options bar for an icon featuring a skewed T above a tiny path (highlighted in Figure 11-57). Click this icon to bring up the **Warp Text** dialog box.

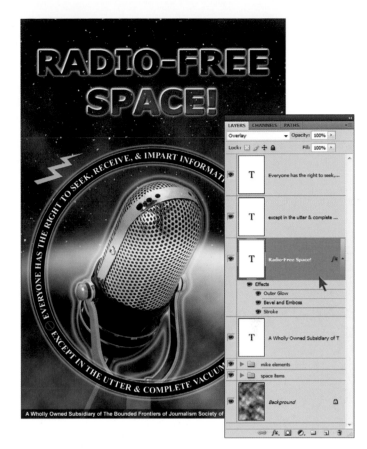

Figure 11-56.

Figure 11-57.

25. *Apply the Arc Lower style.* The Warp Text dialog box features the following options:

 • Select the shape inside which the text bends from the Style menu. The icons provide hints as to what the effect will look like. But if in doubt, choose an option and watch the preview in the image window.

 • Change the angle of the warp by selecting the Horizontal or Vertical radio button. Assuming Western-world text like we're working with here, Horizontal bends the baselines and Vertical warps the individual letters.

- Use the Bend value to determine the amount of warp and the direction in which the text bends. You can enter any value from −100 to 100 percent.

- The two Distortion sliders add perspective-style distortion to the warp effect.

For example, Figure 11-58 shows four variations on the Arc Lower style. The icon next to the style name shows that the effect is flat on top and bent at the bottom. Assuming Horizontal is active, this means the warp is applied to the bottom of the text. A positive Bend value tugs the bottom of the text downward (first image); a negative value pushes it upward (second).

To achieve a strict perspective-style distortion, choose any Style option and set the Bend value to 0 percent. Examples of purely horizontal and vertical distortions appear in the last two images in Figure 11-58.

For this exercise, choose **Arc Lower** from the **Style** pop-up menu. Then set the **Bend** value to −40 percent. The resulting effect looks awful—easily the worst of those in Figure 11-58—but that's temporary. Have faith that we'll fix it and click **OK**.

Figure 11-58.

26. ***Increase the size of the word SPACE!*** With the type tool, triple-click the word *SPACE!* to select both it and its exclamation point. Press Ctrl+Shift+⊡ (⌘-Shift-⊡) to increase the type size incrementally until the width of the selected text matches that of the text above it. (To resize faster, press Ctrl+Shift+Alt+⊡ or ⌘-Shift-Option-⊡.) Or just click the ᵀT icon and change the type size value to 88 points, as in Figure 11-59.

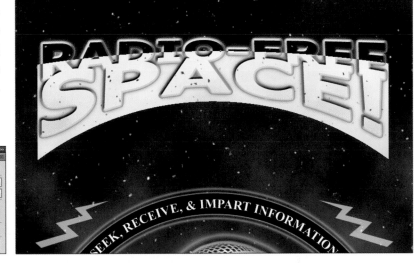

Figure 11-59.

27. ***Increase the vertical scale of all characters.*** One of the by-products of warping is that it stretches or squishes characters, thus requiring you to scale them back to more visually appealing proportions. In our case, the text is *really* squished, so some vertical scaling is in order. Press Ctrl+A (or ⌘-A) to select all type on the active layer. In the **Character** panel, click the ⫯T icon to select the vertical scale value, which I've highlighted in Figure 11-60. Enter 167 percent to make the letters taller but not wider, and then press the Enter or Return key. The text should remain active.

Figure 11-60.

Figure 11-61.

28. ***Increase the leading.*** Press Alt+↓ (or Option-↓ on the Mac) to incrementally increase the leading. Press Ctrl+Alt+↓ (or ⌘-Option-↓) to increase the leading more quickly. I eventually arrived at a leading value of 126 points (see Figure 11-61).

29. ***Press Enter to accept the warped text.*** Remember to press Enter on the keypad. The final composition appears in Figure 11-62.

It's important to note that throughout all these adjustments, every single text layer remains fully editable. For example, to change the text from *RADIO-FREE SPACE!* (indicating a space free of radio) to *RADIO FREE SPACE!* (which implies that the radio is dedicated to freedom in space), simply replace the hyphen with a space character. The layer effects are likewise live. To change the style of warp, simply select the text layer and click the text warp icon in the options bar.

Figure 11-62.

A Wholly Owned Subsidiary of The Bounded Frontiers of Journalism Society of The United Earth, LLC

WHAT DID YOU LEARN?

Match the key concept in the numbered list below with the letter
of the phrase that best describes it. Answers appear upside-down
at the bottom of the page.

Key Concepts

1. Raster art
2. Vector-based objects
3. Formatting attributes
4. Point text
5. Area text
6. Fractional character widths
7. Every-line composer
8. Pair kerning
9. Indent Sides By
10. Series duplication
11. Text on a path
12. Warp Text

Descriptions

A. Font family, type style, size, leading, alignment, and a wealth of other options for modifying the appearance of live text.

B. This numerical value lets you adjust the sharpness of points in a star drawn with the polygon tool.

C. A column of type created by dragging with the type tool, useful for setting long sentences or entire paragraphs.

D. Digital photographs and scanned artwork composed exclusively of colored pixels.

E. A special kind of text layer in which text is attached to a path outline to create a line of type that flows along a curve.

F. The best means for calculating text spacing, which permits Photoshop to move a character by a fraction of a pixel.

G. A succession of duplicated objects, scaled, rotated, and otherwise transformed in equal increments.

H. Mathematically defined text and shapes that can be scaled or otherwise transformed without any degradation in quality.

I. An option that spaces all lines of type in a selected layer by similar amounts to give the layer a more even, pleasing appearance.

J. A text layer that has no maximum column width and aligns to the point at which you clicked with the type tool.

K. This dialog box bends and distorts live text to create wavy, bulging, and perspective effects.

L. The adjusted amount of horizontal space between two neighboring characters of type.

Answers

1D, 2H, 3A, 4J, 5C, 6F, 7I, 8L, 9B, 10G, 11E, 12K

PRINT AND WEB OUTPUT

AT SOME POINT, I presume, you'll want to get your carefully crafted images out of Photoshop and into a medium that's meant for display. The most likely destinations are the Internet or the printed page. Of course, Photoshop has the tools to help you present your images to the world, whether that world is composed of electrons or ink or both.

For example, the image in Figure 12-1 appears in both the electronically delivered video for this lesson and here on the opening page of the printed chapter. Yes, friends, *Adobe Photoshop CS5 One-on-One "The Complete Experience"* (as I like to think of it when I'm feeling grandiose) lives in both worlds. So I've taken the opportunity to divide this output discussion according to appropriate media. In the video lesson, I'll show you how to prepare images for the Web. Here on paper, we'll cover the nuances of printing with Photoshop.

Figure 12-1.

ABOUT THIS LESSON

Project Files

Before beginning the exercises, make sure you've downloaded the lesson files from *www.oreilly.com/go/Deke-PhotoshopCS5*, as directed in Step 2 on page xiv of the Preface. This means you should have a folder called *Lesson Files-PsCS5 1on1* on your desktop (or whatever location you chose). We'll be working with the files inside the *Lesson 12* subfolder.

This final lesson covers topics related to inkjet printing, professional output, and CMYK color conversion. You'll learn how to:

Video Lesson 12: Exporting for the Web

When you decide to put your images on the Web, you'll need to make different decisions than you would if they were intended for printed paper. Photoshop's got you covered with a handy feature called Save for Web and Devices. In this video lesson, I'll cover all the choices you need to make when using that feature, and show you how to take the same file that's at the outset of the book-based lessons and make it work for Web delivery.

To see how to work your images for Web compatibility, visit *www.oreilly.com/go/deke-PhotoshopCS5*. Click the **Watch** button to view the lesson online or click the **Download** button to save it to your computer. During the video, you'll learn these shortcuts:

Video Lesson 12: Preparing Images for the Web

Tool or operation	Windows shortcut	Macintosh shortcut
Image Size	Ctrl+Alt+I	⌘-Option-I
Save for Web and Devices	Ctrl+Alt+Shift+S	⌘-Option-Shift-S
Print	Ctrl+P	⌘-P

Some could argue that Photoshop isn't a printing program at all. Rather, it's designed to prepare images that you plan to import into programs that are designed to amass and print pages, such as Adobe InDesign and QuarkXPress. For example, I prepared the images in this book in Photoshop; but I laid out this and every other page in InDesign.

Printing from Photoshop is at once a primitive and a sophisticated experience. On the primitive side, there's no way to print multipage documents. Even if you open multiple files, you can't print them all in one fell swoop; you must print each image in turn. You can't even print independent layers; the program always prints all visible layers. And you can print just one copy of a file per page. So if you want to double up images, you have to repeat the image inside the file before choosing Print.

So what's the sophisticated part? Well, what Photoshop lacks in page control, it makes up for in real-world acumen. First, it realizes that you have different output destinations. Sometimes you want to print a full-color page to a printer in your home or office. Other times, you want to print several hundred copies of your artwork for mass distribution. Second, Photoshop understands that regardless of your destination, you want the colors that you see on your screen to translate accurately onto the printed page. Most programs don't give either of these very important aspects of printing much attention. Yet for Photoshop, these are the only printing issues that matter. And as you'll discover in this lesson, Photoshop happens to be right.

PEARL OF WISDOM

The terms *local printing* and *commercial reproduction output* both refer to the act of getting something you see on screen onto a piece of paper; it's just a matter of scale and important-sounding words. The irony is that printing from a modern inkjet printer can produce better results than professional commercial output. In fact, an inkjet print can look every bit as good as a photographic print from a conventional photo lab. But inkjets are simply not affordable for large-scale reproduction. For example, printing a single copy of a 100-page glossy magazine would cost $50 to $100 in ink and paper. Commercially outputting that same magazine requires you to lay down more cash up front, but the per-issue costs are pennies per page. So when you want to make just a few copies, local printing offers the advantages of convenience and quality. But if you're planning a big print run, commercial output is the way to go.

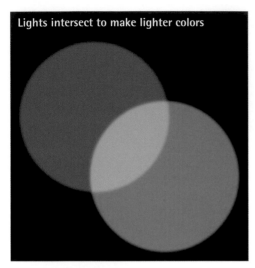

Lights intersect to make lighter colors

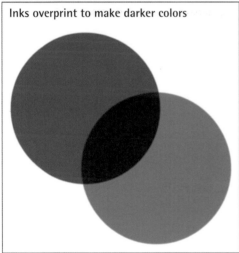

Inks overprint to make darker colors

Figure 12-2.

RGB Versus CMYK

Whether an image is bound for inkjet or imagesetter, it must make the transition from one color space to another. And that presents a problem because monitors and printers use opposite methods of conveying colors. Whereas images on a monitor are created by mixing colored lights, print images are created by mixing inks or other pigments. As illustrated in Figure 12-2, lights mix to form lighter colors, inks mix to form darker colors. Moreover, the absence of light is black, while the absence of ink is the paper color, usually white. Just how much more different could these methods be?

Given that monitors and printers are so different, it's not surprising that they begin with different sets of primary colors. Monitors rely on the *additive primaries* red, green, and blue, which make up the familiar RGB color space. Printers use the *subtractive primaries* cyan, magenta, and yellow, known collectively as CMY. The two groups are theoretical complements, which means that red, green, and blue mix to form cyan, magenta, and yellow—and vice versa—as illustrated in Figure 12-3. The intersection of all three additive primaries is white; the intersection of the subtractive primaries is a very dark, sometimes brownish gray that is nearly but not quite black. Therefore, a fourth primary ink, black, is added to create rich, lustrous shadows. Hence, the acronym CMYK for cyan, magenta, yellow, and the "key" color black.

Fortunately, Adobe and most printer vendors are aware of the vast disparities between RGB and CMYK. They are equally aware that you expect your printed output to match your screen image. So they've come up with a two-tiered solution:

- When printing an image directly to an inkjet printer or other personal device, leave the image in the RGB mode and allow the printer software to make the conversion to its native color space automatically.

- When preparing an image for commercial *color separation*—in which the cyan, magenta, yellow, and black inks are each printed to separate plates—convert the image to the CMYK color space inside Photoshop. Then save it to disk with a different filename to protect the original RGB image.

I provide detailed discussions of both approaches in the following exercises. And I'll provide insights for getting great looking prints with accurate colors along the way.

Printing to an Inkjet Printer

When it comes to printing full-color photographic images, your best, most affordable solution is an inkjet printer. Available from Epson, Hewlett-Packard, and a cadre of others, a typical inkjet printer often costs less than a hundred dollars. In return, it's capable of delivering outstanding color and definition (see the sidebar "Quality Comes at a Price," on page 480), as good as or even better than you can achieve from your local commercial print house. But you can't reproduce artwork for mass distribution from a color inkjet printout. Inkjet printers are strictly for personal use.

In the following exercise, you'll learn how to get the best results from your inkjet device. If you don't have a color inkjet printer, you won't be able to achieve every step of the exercise, but you can follow along and get an idea of how the process works.

Assuming you have an inkjet device at your disposal, please load it with the best paper you have on hand, ideally a few sheets of glossy or matte-finish photo paper, readily available at any office supply store (again, see "Quality Comes at a Price" for more information). If you don't have such paper, or if you simply don't feel like parting with the good stuff for this exercise, go ahead and load what you have. Just remember what kind of paper you loaded so you can address it properly in Steps 15 and 16 on page 478.

1. ***Open the test image.*** Look in the *Lesson 12* folder inside *Lesson Files-PsCS5 1on1* and you'll find a file called *The Joy of Color.psd*. Pictured in Figure 12-4 on the next page, it's a color-matching file I created with help from the photographic contribution of Jason Stitt from image vendor Fotolia.com. The image is sized at 7.5-by-5 inches with a resolution of 300 pixels per inch. But as you'll discover, print size can be changed on-the-fly to fit the medium.

2. ***Choose the Flatten Image command.*** This file contains a handful of layers, including a text layer that's currently turned off. (If you get a warning about updating text go ahead and click Update.) As you may recall from Lesson 11, text and shape layers can be output at the maximum resolution of a PostScript-compatible printer, but very few inkjet devices include PostScript processors (and those that do are expensive). So the layers won't help the image's print quality. Layers also require more computation and thus slow down the print process. Best solution: Get rid of them by choosing **Layer→Flatten Image**.

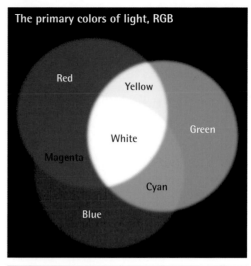

The primary colors of light, RGB

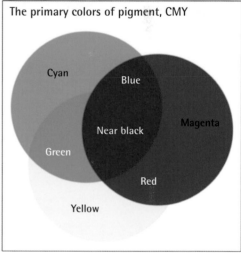

The primary colors of pigment, CMY

Figure 12-3.

Figure 12-4.

3. *Save the image under a new name.* Naturally, you don't want to run the risk of harming the original layered image, so choose **File→Save As**. As long as you save the image under a different name, you're safe. But here are the settings I recommend:

- In the **Save As** dialog box, choose **TIFF** from the **Format** pop-up menu.

- Make sure the **ICC Profile** check box is on (that's **Embed Color Profile** on the Mac).

- Click the **Save** button.

- In the **TIFF Options** dialog box, turn on the **LZW** option to minimize the file size without changing any pixels.

- From **Byte Order**, select the platform that you're working on, **PC** or **Mac**.

- Click the **OK** button to save the file.

The original layered file is safe and the flat file is ready to print.

4. **Choose the Print command.** Choose **File→Print** or press Ctrl+P
(⌘-P on the Mac) to display the **Print** dialog box, pictured in
all its enormity in Figure 12-5. This one-stop print station is
designed to provide everything you need to output an image
in one convenient location. Granted, it's a little daunting to the
uninitiated. But it's entirely in keeping with Photoshop's under-
lying credo: When in doubt, overwhelm the user with options.

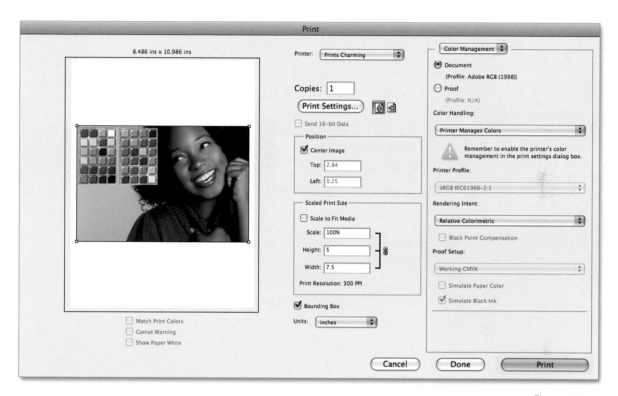

Figure 12-5.

5. **Select your printer model.** You may be working on a personal
computer cabled to a single USB printer. Or you may be work-
ing on a network with a dozen or more shared printers. In either
case, select the model of printer that you want to use from the
Printer pop-up menu, positioned top and center in the dialog
box (see Figure 12-6).

6. **Click the Print Settings button.** I would call Photoshop's Print
dialog box comprehensive were it not for the omission of one
essential option: You can't specify the size of the paper that you
want to print to. For that, you have to click the **Print Settings**
button to display your operating system's **Page Setup** dialog box.

Figure 12-6.

7. **Choose the desired paper size.** If you're using special photo paper, consult the paper's packaging to find out the physical page dimensions. In the case of my Premium Glossy Photo Paper, each piece of paper measures 8-by-10 inches, slightly smaller than the letter-size format.

 • Under Windows, click the **Advanced** button and choose your option from the **Paper Size** pop-up menu. Then click **OK** twice to exit the Advanced and Printer Settings dialog boxes.

 • On the Mac, choose your printer from the **Printer** pop-up menu. Next, select the page size from the **Paper Size** pop-up menu. Then click the **OK** or **Save** button.

 You should end up back in the comprehensive **Print** dialog box.

8. **Change the paper orientation.** Since we're working with an image that is wider than it is tall, it makes sense (and saves paper) to change the paper orientation to match. Make sure the paper orientation option next to the Print Settings button is set to landscape mode (as it is in Figure 12-7) so that the image prints horizontally.

9. **Scale the print size.** Speaking of maximizing paper real estate, we continue to have too much white area around the image. Enter a **Scale** value of 120 percent, which will expand the printed dimensions of the image to 6-by-9 inches. Note that Photoshop does not resample the image; it merely lowers the resolution value so that the pixels print larger. In Figure 12-7, for example, Photoshop has automatically reduced the resolution to 250 ppi. (You may need to close and reopen the Print dialog box to get an updated preview that reflects this resolution.

Paper orientation icons

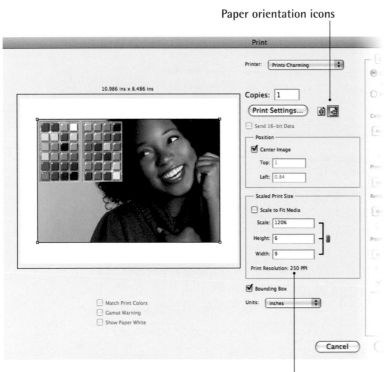

Figure 12-7.

Print resolution

10. **Choose the Color Management option.** The right side of the dialog box greets you with one of two groups of options: Output, which includes a bunch of PostScript printing functions applicable to commercial reproduction, or Color Management, which is what we want. (If you see buttons marked Background, Border, Bleed, and the like, you're in the wrong area.) Make sure the top-right pop-up menu is set to **Color Management**.

Color Management—much like printing in general—is a very context-sensitive proposition, so it's difficult for me, not knowing what make and model printer you're using, to tell you the best settings for your printer. Given that, I'm going to show you a couple of options, and let you decide for yourself which works better.

11. *Confirm the source and method options.* To print the colors in an image as accurately as possible, you must identify the *source space*—the color space used by the image itself—and the method by which Photoshop translates the colors to the *destination space* used by the printer.

- Select the radio button labeled **Document (Profile: Adobe RGB (1998))**. This source space is the variety of RGB employed by the image file *The Joy of Color.psd*.

- Start with the **Color Handling** option set to **Printer Manages Colors**. This setting conveys the source space and leaves the printer software in charge of the color conversion process. You'll be reminded to enable your printer's color management settings. To find this option, you'll have to poke around in the Print Settings options, which vary by printer and operating system.

- Rendering Intent specifies how you want Photoshop to deal with out-of-gamut colors (i.e., the colors in your digital image that aren't reproducible by your printer). Set the **Rendering Intent** option to **Relative Colormetric**, which preserves the widest range of colors by shifting each of the possible millions of colors in your image to the closest available color in the destination color space.

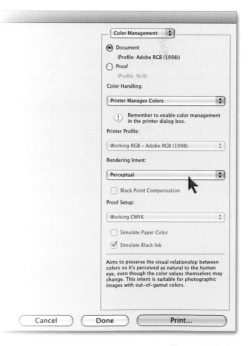

Figure 12-8.

PEARL OF ⬤ WISDOM

The only other option I'd ever recommend for the Rendering Intent setting is Perceptual. It maintains the smoothest transitions when converting colors because it tries to preserve the perceptual relationship (vis-a-vis the human eye) between colors. Perceptual is the best solution for photographic images. But since we have those two panels of colored Chiclet-like swatches in this image, Relative Colorimetric is preferable in this case.

Hover over a Color Management option to see an explanation of the active setting in the Description area in the bottom-right corner of the dialog box. Figure 12-8 shows the settings as they should appear at this point.

12. **Click the Print button.** This closes Photoshop's Print dialog box and may or may not deliver you to the operating system's **Print** dialog box. If such a box appears, just click **Print** again. (This dialog box is essentially the same one you poked around in when you clicked the Print Settings button back in Step 7.)

Because of the large number of printer vendors, your options in the Print Settings dialog box may vary significantly. You may even encounter additional options. For example, on the PC, Hewlett-Packard includes an ICM Method option (best set to **Host**) and an ICM Intent (best set to Picture). If none of the options I've mentioned so far are available for your printer, you'll need to experiment to find the settings that work best.

13. **Label your output.** When the newly printed document spits out of your printer, examine the reproductive quality. Then grab a pen and write "Printer Manages Colors—Relative Colorimetric" on it so that you can remember which settings led to this result.

If you made any decisions in the proprietary parts of the Print Settings dialog box, you'll want to note those variables too. The key here is to use a well documented trial-and-error method so that you can repeat the settings that finally work.

14. **Initiate a second print.** Press Ctrl+P (⌘-P) to bring back the Print dialog box once again. Your orientation and Scaled Print Size should be where you last left them. This time, change the **Color Handling** option to **Photoshop Manages Color**s, as I've done in Figure 12-10. You'll see that the **Printer Profile** option is no longer dimmed like it was when the printer was in charge (because Photoshop is now in control). From the pop-up menu, choose **sRGB-IEC61966-2.1** (sRGB for short, and there should be only one setting that starts with those letters, so don't waste brain cells comparing the latter digits). Leave everything else the same.

When you set the Color Handling to Photoshop Manages Colors, you'll get a reminder to disable your printer's color management settings, which you'll likely find once again in the Print Settings dialog box. You're welcome to try ignoring that directive. Just document as such when the print comes out.

Figure 12-9.

15. ***Click the Print button again.*** Wait and compare. When the print job finishes, grab your pen again and write "Photoshop Manages Colors—Relative Colorimetric" on the print. Compare it and the previous print to the image on the screen. Assuming that your printer is functioning properly (no missing lines, no paper flaws, all inks intact), the colors in the printout should bear a close resemblance to those in the screen image. Decide for yourself which of the two print settings does a better job.

Figure 12-10 shows two versions of the same image printed to photo-grade paper from a Stylus Photo 1280. The only differences are the computer and the method of color management used to print the image.

PEARL OF WISDOM

If the output doesn't match the screen image to your satisfaction, try experimenting with your printer-specific options until you arrive at a better result. After you do, write down the settings—or save them if you can—and use them in the future.

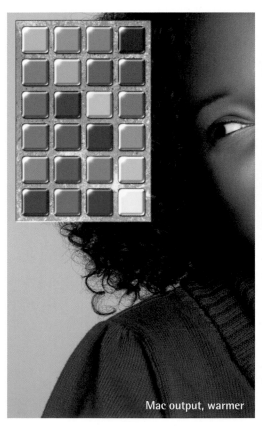
Mac output, warmer

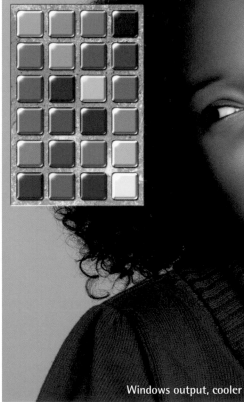
Windows output, cooler

Figure 12-10.

Quality Comes at a Price

Inkjet printers are cheap, often sold at or below cost. But the *consumables*—the paper and the ink—are expensive, easily outpacing the cost of the hardware after a few hundred prints. Unfortunately, this is one area where it doesn't pay to pinch pennies. Simply put, the consumables dictate the quality of your inkjet output. Throwing money at consumables doesn't necessarily ensure great output, but scrimping guarantees bad output.

Consider the following scenario:

- For purposes of illustration, my sample printer is an Epson Stylus Photo 1280. It's not a new printer (I've had it for several years), but it works great, the software mostly makes sense, it can print as many as 2880 dots per inch, and it well represents a standard consumer printer.

- The Stylus Photo 1280 requires two ink cartridges, pictured below. The first cartridge holds black ink; the second contains five colors: two shades of cyan, two shades of magenta, and yellow. (As the reasoning goes, the lighter cyan and magenta better accommodate deep blues, greens, and flesh tones.) Together, the cartridges cost about $60.00 and last for 45 to 120 letter-sized prints, depending on the quality setting you choose. The higher the setting, the more ink the printer consumes. So the ink alone costs 50¢ to $1.33 per page.

- You can print to regular photocopier-grade paper. But while such paper is inexpensive, it's also porous, sopping up ink like a paper towel. To avoid overinking, you have to print at low resolutions, so the output tends to look substandard—about as good as a color photo printed in a newspaper.

- To achieve true photo-quality prints that rival those from a commercial photo lab, you need to use *photo-grade paper* (or simply *photo paper*), which increases your costs even further. For example, 20 sheets of the stuff in the packet shown below costs $13.50, or about 67¢ per sheet.

The upshot: a low-quality plain-paper print costs about 50 cents; a high-quality photo-paper print costs about 2 bucks. Although the latter is roughly four times as expensive, the difference in quality is staggering. The figure below compares details from the two kinds of output magnified to six times their printed size. The plain-paper image is coarse, riddled with thick printer dots and occasional horizontal scrapes where the paper couldn't hold the ink. Meanwhile, the photo-paper image is so smooth, you can clearly make out the image pixels. Where inkjet printing is concerned, paper quality and ink expenditure are the great determining factors.

360 dpi, plain paper, 50¢ 2880 dpi, glossy photo paper, $2^{00}

Preparing a CMYK File for Commercial Reproduction

We now move from the realm of personal printers to the world of commercial prepress. The *prepress* process involves outputting film that is burned to metal plates (or output directly from computer to plates), which are then loaded onto a high-capacity printing press for mass reproduction. (Hence the *pre* in *prepress*.) Each page of a full-color document must be separated onto four plates, one for each of the four *process colors*: cyan, magenta, yellow, and black. By converting an image to CMYK in advance, you perform the separation in advance. All the page-layout or other print application has to do is send each color channel to a different plate, and the image is ready to output.

Converting an image from RGB to CMYK in Photoshop is as simple as choosing Image→Mode→CMYK Color. This one command separates a three-channel image into the four process colors. For insight into how this happens, read the sidebar "Why (and How) Three Channels Become Four," on page 492. Converting the image properly, however, is another matter. If you don't take time to *characterize* the output device—that is, explain to Photoshop how the prepress device renders cyan, magenta, yellow, and black inks—the colors you see on screen will not match those in the final output.

Photoshop gives you two ways to characterize a CMYK device:

- Ask your commercial print shop if they have a ColorSync or ICM *profile* for the press they'll be using to output your document. (They might also call it an ICC profile—same diff for our purposes.) Such profiles are entirely cross-platform, so the same file will work on either the PC or the Mac. Just make sure that the filename ends with the three-letter extension *.icc* or *.icm*. You can then load the profile into Photoshop.

- Wing it. Every print house should be able to profile its presses. But you'd be surprised how many won't have the vaguest idea what you're talking about when you request a profile or will proffer an excuse about why profiling isn't an option. In this case, you'll have to create a profile on your own through trial and error. It's not the optimal solution, but I have done it more often than not and generally manage to arrive at moderately predictable output.

The following exercise explores both options. You'll learn how to load a CMYK profile, should you be so lucky as to procure one. I'll also show you how to edit the CMYK options to create your own profile. And finally, you'll see how to convert the image to CMYK and save it in a format that either QuarkXPress or Adobe InDesign can read.

1. **Open the test image.** For consistency's sake, we'll be using the same composition we used in the preceding exercise. So open *The Joy of Color.psd* from the *Lesson 12* folder in *Lesson Files-PsCS5 1on1*. Make sure to open the original PSD file, not the TIFF file that you saved in Step 3 on page 474.

2. **Choose the Color Settings command.** Choose **Edit→ Color Settings** or press Ctrl+Shift+K (⌘-Shift-K) to display the **Color Settings** dialog box, pictured in all its gruesomeness in Figure 12-11.

3. **Click the Fewer Options button.** If you see a button in the dialog box labeled **Fewer Options** (instead of **More Options**), click it. Although not an essential step, this will help to simplify things a bit by reducing the number of options shown in the dialog box.

4. **Load the CMYK profile provided by your commercial print house.** In this exercise, your print house happens to be the highly esteemed and completely fictional Prints-R-Us. Click the words **U.S. Web Coated (SWOP) v2** to the right of the first **CMYK** option to display a pop-up menu of CMYK profiles. As in Figure 12-12, choose **Load CMYK** to load an ICC profile from disk. Locate the file called *Prints-R-Us profile.icc* in the *Lesson 12* folder in *Lesson Files-PsCS5 1on1*. Then click the **Load** or **Open** button to make the profile part of Photoshop's color settings.

5. *Click the OK button.* Photoshop closes the Color Settings dialog box and accepts your new CMYK settings.

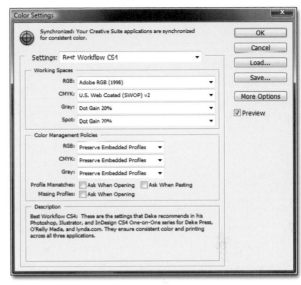

Figure 12-11.

Figure 12-12.

Figure 12-13.

6. *Choose the CMYK Color command.* Choose **Image→Mode→CMYK Color**. When Photoshop asks you whether you want to merge the image, as in Figure 12-13, click the **Merge** button to reduce the image to a single layer. Blend modes are calculated differently in CMYK than in RGB, so retaining layers can result in severe color shifts. Very likely you'll see a second alert, this time reminding you that you have the option to choose a different profile. Yes, we are aware of that. Turn on the **Don't Show Again** check box and click **OK**.

7. *Flatten the image.* Flattening isn't always the ideal solution, but there's no harm in this case, so we might as well. Choose **Layer Flatten Image** or press Ctrl+Alt+Shift+F (⌘-Option-Shift-F on the Mac).

8. *Save the image under a new name.* You should never save over your original layered image, and you should never *ever* save a CMYK image over the original RGB. CMYK is a more limited color space than RGB, less suited to general image editing. So choose **File→Save As** and do the following:

 • In the **Save As** dialog box, choose **TIFF** from the **Format** pop-up menu. TIFF is a wonderful format to use when handing off CMYK files because it enjoys wide support and prints without incident. Name the image "Joy of Color CMYK.tif."

 • Turn on **ICC Profile: Prints-R-Us profile** (or **Embed Color Profile: Prints-R-Us profile** on the Mac).

 • Click the **Save** button.

 • Inside the **TIFF Options** dialog box, turn on **LZW** under **Image Compression**. Every once in a while, a print house will balk at this setting. They can always open the file and resave it with this option off. Select the platform that your print house will be using from the **Byte Order** options.

 • Click the **OK** button to save the file.

9. *Hand off the TIFF file to your commercial print house.* The only way to judge the success of the profile supplied to you by the print house is to put it to use. When you get the printed output back, you can decide whether changes are in order or not. For the purposes of this exercise, we'll imagine that the overly light Figure 12-14 on the facing page represents the final output provided to us by Prints-R-Us.

Figure 12-14.

10. ***Compare the output to the CMYK file on screen.*** To see how the two images compare in my case, look at Figure 12-15 on next page. Overall, there is a big difference in brightness. The printed image is significantly lighter and the shadows are weak. The colors, especially in the swatches group on the left, differ radically from the original. Specifically, we're missing the richness in the reds of the flesh tones, the sweater, and the red color swatches—anywhere red is a factor. In fact, the warm colors in the output suffer from a slightly yellow-green cast. These issues must all be resolved.

PEARL OF 🔘 WISDOM

To fix the CMYK image, you need to modify the Prints-R-Us CMYK profile. The best way to judge the results of our modifications is to apply them on-the-fly to the open image and compare the resulting screen image to the output. This means releasing the image from the grips of the existing CMYK profile. Admittedly, this step is not particularly intuitive, but it is necessary. So here we go.

The CMYK output

The CMYK image as it looks on screen

Figure 12-15.

11. **Disable color management for the current document.** Choose **Edit→Assign Profile**. Dismiss the warning by clicking **OK**. Then in the **Assign Profile** dialog box, select the **Don't Color Manage This Document** option, as in Figure 12-16, and click the **OK** button. From now on, the open image, *Joy of Color CMYK.tif*, will respond dynamically to the changes you make to the CMYK color profile.

Figure 12-16.

12. **Again, choose the Color Settings command.** Choose **Edit→Color Settings**. Or simplify your life and press Ctrl+Shift+K (⌘-Shift-K). Photoshop redisplays the **Color Settings** dialog box.

Be sure that the dialog box doesn't entirely block your view of the image window. If that means dragging the dialog box most of the way off screen so only the Working Spaces options are visible, so be it. You can also zoom out from the image to view more of it by pressing Ctrl+⊟ (⌘-⊟ on the Mac).

13. **Confirm that the Preview check box is turned on.** Your job will be to make the screen image look like the CMYK output. After all, the CMYK output is, by its very existence, the accurate representation of the printer's CMYK space; if the screen image doesn't match, Photoshop's CMYK display space must be wrong. Only with the **Preview** check box turned on can you judge the effects of the changes you're about to make.

Note that I'm *not* suggesting that you somehow adjust the brightness and contrast of your monitor to make it match the CMYK output. That would alter everything you see on the screen, in Photoshop and out, and it wouldn't solve your problem. An incorrect adjustment to your monitor would alter your impression of future RGB images and thus further compound your problems. The aim here is to make sure Photoshop's understanding of the CMYK space matches that of the printer, and nothing more.

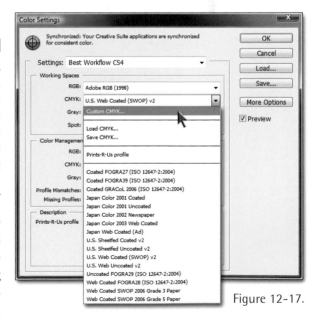

14. **Choose the Custom CMYK option.** Click the words **Prints-R-Us profile** to the right of the first **CMYK** option and choose **Custom CMYK**, as in Figure 12-17. Photoshop displays the little-known **Custom CMYK** dialog box, which allows you to change how the program converts colors to CMYK and displays them on the screen.

Figure 12-17.

15. ***Adjust the Dot Gain value.*** With very few exceptions, commercial presses use small circles of colored ink, called *halftone dots,* to impart different shades of color. Dark areas get big dots; light areas get small dots. Illustrated in Figure 12-18, the term *dot gain* refers to how much the halftone dots grow when they're absorbed into the paper. The Prints-R-Us profile includes a Dot Gain value of 35 percent, which means the print house anticipates that its halftone dots will grow 35 percent when printed on a specific grade of paper. Obviously, there's a mistake here; if the dot gain were really 35 percent, the image would tend to print dark, not overly light, as it did for us. So the current Dot Gain value is overcompensating.

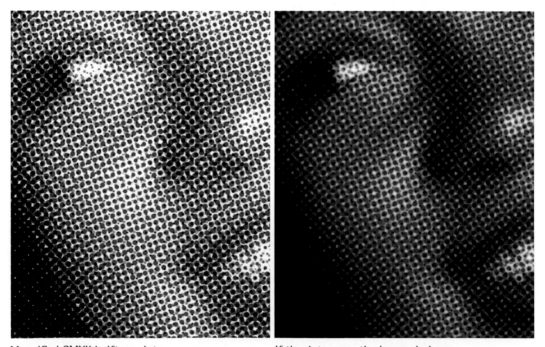

Magnified CMYK halftone dots If the dots grow, the image darkens

Figure 12-18.

The rules of thumb for adjusting the Dot Gain:

- If the printed image looks lighter than your screen display, as in this example, nudge the Dot Gain value down by pressing the ↓ key.

- If the printed image appears darker than your screen image, raise the value by pressing the ↑ key.

Small changes result in significant adjustments, so give the screen a moment to refresh between each press of the ↑ or ↓ key. I found that a **Dot Gain** value of 22 percent provides a pretty close match.

16. ***Choose Curves from the Dot Gain pop-up menu.*** The problem with adjusting the Dot Gain value is that it lightens or darkens all color channels at once. So while the brightness of the screen image roughly matches the output in Figure 12-14, on page 487, the reds don't appear washed out enough. To adjust each channel independently, choose the **Curves** option from the **Dot Gain** pop-up menu (see Figure 12-19). Photoshop responds with the Dot Gain Curves dialog box.

17. ***Adjust the Dot Gain Curves values for each channel.*** If the **All Same** option on the right side of the **Dot Gain Curves** dialog box is checked, turn it off. Use the **Cyan**, **Magenta**, **Yellow**, and **Black** options to switch between the four color channels and modify their luminosity values independently. This lets you correct the colors of the CMYK screen display one ink at a time.

To keep things as simple as possible—and by my reckoning, we could dearly use a bit of simplicity right about now—I modified only the 50 value for each channel. As shown in Figure 12-20 on the next page, I lowered the values for the **Cyan**, **Magenta**, **Yellow**, and **Black** channels to 70, 66, 70, and 72, respectively.

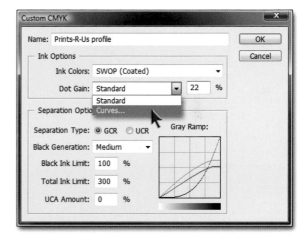

Figure 12-19.

Why (and How) Three Channels Become Four

If this were a perfect world, cyan, magenta, and yellow would be all the colors you'd need to print an RGB image. But alas, the world is perfect only in its lack of perfection. Thus, it's the job of the key color, black, to set the world straight. In fact, you could argue that the fourth channel, Black, is the most important ink in CMYK output.

In the world of RGB, black exists naturally; in CMYK, it has to be generated. Let's start with RGB. Here, black is the default color, the one that appears if no other color is present. As pixels are turned on, the black goes away. As illustrated in the figure directly below, light pixels in the Red channel add red, those in the Green channel add green, and those in the Blue channel add blue. Any one channel is very dark on its own; only by combining channels can they overcome the darkness, as the middle and bottom rows of the figure show.

By contrast, color printing is about overcoming the lightness. In the collection of images below this column, we see the results of converting the RGB channels from the previous figure into cyan, magenta, yellow, and black using the CMYK profile that you created in "Preparing a CMYK File for Commercial Reproduction" (page 484). Assuming you output to white paper, the default color of printing is white, and therefore it's the job of the inks to make the white go away. The channels start out very light, as in the top row of the figure; but as one layer of ink mixes with another, the photograph becomes progressively darker, as in the middle and bottom rows. (To help you navigate through the figure, samples with three or more inks include a black outline.)

The CMY channels are derived in large part from their RGB complements. But because every printer subscribes to

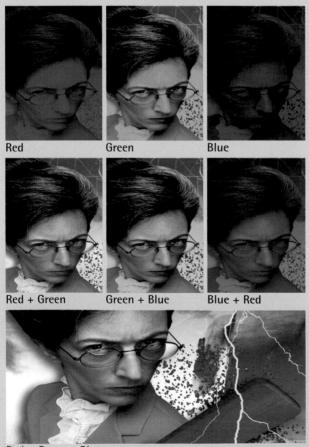

Red Green Blue

Red + Green Green + Blue Blue + Red

Red + Green + Blue

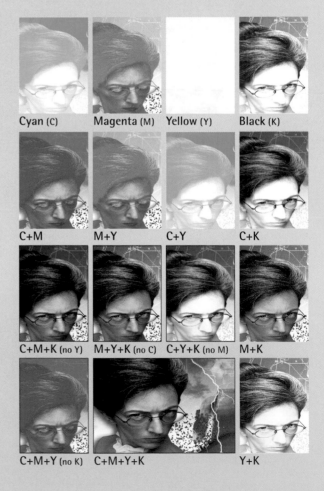

Cyan (C) Magenta (M) Yellow (Y) Black (K)

C+M M+Y C+Y C+K

C+M+K (no Y) M+Y+K (no C) C+Y+K (no M) M+K

C+M+Y (no K) C+M+Y+K Y+K

different standards, there is no one hard-and-fast formula. Rather, channels are mixed together in varying degrees according to the recipe outlined in the CMYK profile. So, for example, the Cyan channel is mostly a duplicate of the Red channel, but it also mixes in bits of the Green and Blue channels to account for the idiosyncrasies of a given press.

Looking at the figure below, however, you might find this hard to believe. The top row shows grayscale versions of the RGB channels; the middle row shows their CMY complements. The CMY channels bear a passing resemblance to the ones above them, but it's as if the darkest levels have been replaced with light gray. And that's precisely what has happened. Photoshop generates the contents of the Black channel by leeching shadows from the Cyan, Magenta, and Yellow channels. When we add the Black channel, as in the bottom row of the

figure, the CMY channels more closely match the brightness of the RGB channels in the top row. (Yellow + Black appears lighter than Blue only because yellow is such a light ink.)

The most popular method for transferring dark pixels to the Black channel is called *gray component replacement*, or *GCR*. The idea is that paper can absorb only so much ink, after which point the ink begins to smear. Suppose that a press subscribes to a *total ink limit* of 300 percent. This means that the percentages of cyan, magenta, yellow, and black ink can add up to no more than 300. GCR makes sure the total ink limit never goes higher, even in the darkest shadows in the image. Photoshop steals the shadows from the CMY channels, puts them in the Black channel, and then darkens the old CMY shadows until the total ink limit is met. And so it is that black restores the darkness at the heart of the RGB image.

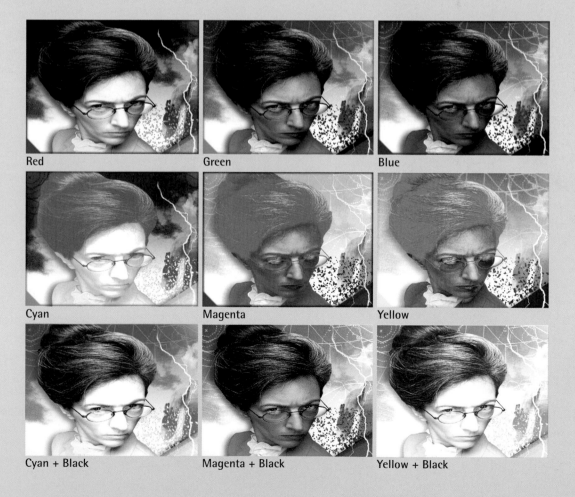

Red

Green

Blue

Cyan

Magenta

Yellow

Cyan + Black

Magenta + Black

Yellow + Black

Figure 12-20.

18. **Click the OK button three times in a row.** You are exiting the Dot Gain Curves, Custom CMYK, and Color Settings dialog boxes and updating the definition of the Prints-R-Us CMYK profile.

19. **Undo the last two operations.** Before you can apply the new color profile, you must first undo the effects of the previous one. So press Ctrl+Alt+Z (or ⌘-Option-Z) twice in a row to undo the operations performed in Steps 11 and 7, respectively, first reinstating CMYK color management and then restoring the layered RGB image.

Be sure to press Ctrl+Alt+Z (⌘-Option-Z), and *not* Ctrl+Z (⌘-Z)! The latter will undo all the work that you've achieved in the Color Settings dialog box, everything from Step 12 through and including Step 18. If you do accidentally press Ctrl+Z, press Ctrl+Z again to restore the color settings, and *then* press Ctrl+Alt+Z twice. I know it's weird, but that's how it works.

20. **Again, choose the CMYK Color command.** Choose **Image→Mode→CMYK Color** and click the **Flatten** button when asked to do so. The result doesn't look all that different from the CMYK image we created in Step 8. But now that you've improved the accuracy of the CMYK color space, you can trust what you see on the screen a bit more.

21. **Save the improved CMYK image.** Because you renamed the image *Joy of Color CMYK.tif* back in Step 8, there's no harm in saving over it. Choose **File→Save** or press Ctrl+S (or ⌘-S) to update the file on disk.

22. **Hand off the revised file to your commercial print house.** This time, the image prints much more accurately. In fact, as demonstrated in Figure 12-21, it's difficult to tell the CMYK output from the CMYK image we see on the screen. The reds are still a tad weaker than I'd like, but the output is close enough to qualify as a successful conversion. (For proof beyond a shadow of a doubt, compare Figure 12-25 to Figure 12-15, on page 487.)

Mind you, it's not always possible to create such accurate color conversions by winging it with Photoshop's Dot Gain controls. But given the uniformity of process inks and the fact that most domestic presses are calibrated to relatively common standards, it's worth a try. And there's nothing so empowering as successfully tweaking Photoshop's color settings so that your images output reliably to a commercial printing press.

The new and improved CMYK output . . . better matches the image on screen

Figure 12-21.

Packaging Multiple Images from the Bridge

Our final exercise is a cakewalk compared with the others in this lesson. In it, I'll show you how to package multiple photos onto a single page to create a contact sheet, perfect for documenting the contents of a folder on a CD or hard drive.

The Bridge has a feature that can scale and align images into regular rows and columns and then export one or more pages as a printable, distributable, widely compatible PDF file. This feature is available not in Photoshop but rather in the Bridge. Here's how it works:

1. *Go to the* **Mural Renamed** *folder.* Assuming that you're working in Photoshop, click the Br icon in the application bar or press Ctrl+Alt+O (⌘-Option-O) to launch the Bridge. Then navigate your way to the *Lesson 12* folder inside *Lesson Files-PsCS5 1on1*. Therein, you'll find a subfolder called *Mural Renamed*. Click it to see the group of a dozen images that show my progress in painting Max's mural, all renamed according to my instructions in the "Batch Renaming" exercise that began way back on page 32 of Lesson 1.

2. **Sort the images in the proper order.** Choose **View→Sort**. Then choose the last command, **Manually**. The pencil sketches should rise to the top, as in Figure 12-22. If they don't, drag the two *MaxBedroomPencil* images to the lead position. The images will now print in the proper order.

Figure 12-22.

3. **Display the Output panel.** This step is fairly tricky. Not because it's hard, but because the Bridge is so intent on concealing its packaging feature. Notice the application bar at the top of the window, the one that begins with the back and forward arrows and ends with ⬚⁺⁻? Click the ⬚⁺⁻ icon and choose **Output to Web or PDF**, circled in blue in Figure 12-23 on the facing page. The Bridge switches to a filmstrip view with an Output panel on the right. (I've hidden the left-side panels by double-clicking the vertical divider between those panels and the Preview panel.)

The Bridge also offers a preset workspace called Output. Choose it to switch to the view you see in Figure 12-23. If you've been following my instructions over the course of this book, the Output workspace has the shortcut Ctrl+F5 (⌘-F5). By default, it's Ctrl+F4 (⌘-F4). It's off the list of shortcuts if you've made more than three custom workspaces.

4. **Select all thumbnails.** The Bridge prints only those thumbnails that are selected. So choose **Edit→Select All** or press Ctrl+A (⌘-A) to select—and thereby print—everything. The Preview panel does its best to display all twelve images.

5. **Elect to create a PDF document.** The Output panel permits you to create a PDF document or a Web gallery, based on Flash or HTML. We'll be creating a PDF document, so click the **PDF** button at the top of the **Output** panel.

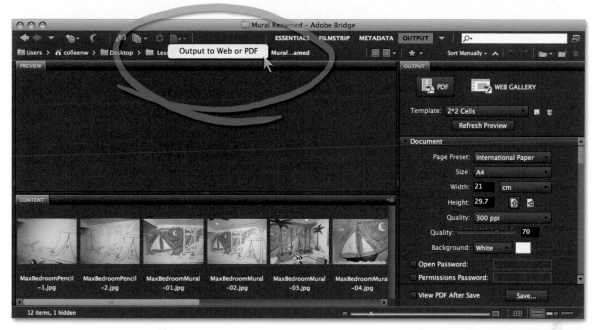

Figure 12-23.

6. *Select a letter-sized page.* I'm assuming you live in the States and you want to print to a standard letter-sized page. (That said, if you live elsewhere or have other needs, you can easily modify these instructions to suit your tastes.) Drop down to the **Document** area and change the **Page Preset** option to **U.S. Paper**. Then set **Size** to **Letter**, as in Figure 12-24.

If you're printing a CD or DVD insert, ignore the Size option and set both the Width and Height values to 4.75 inches.

7. *Specify the image resolution.* Make sure the **Quality** option is set to **300** ppi, which resamples images, well, to 300 ppi, thus ensuring sharp, legible output.

8. *Preview your PDF document.* Click the **Refresh Preview** button at the top of the Output panel to check on your progress so far. The Bridge displays an alert message that tells you it's generating a temporary PDF document. A few moments later, a new **Output Preview** panel appears, complete with the first four images on a letter-sized page.

9. *Set the rows and columns.* Let's say we want all twelve images to appear on a single page. Go down to the **Layout** area of the **Output** panel and set the **Columns** value to 3 and the **Rows** value to 4.

Figure 12-24.

10. ***Adjust the spacing values.*** Where contact sheets are concerned, I like liberal page margins and tight spacing between thumbnails. To establish the margins, change the **Top**, **Bottom**, **Left**, and **Right** values to 0.25 inch apiece. For the spacing, set both the **Horizontal** and **Vertical** values to 0.05 inch.

11. ***Update the preview.*** Again click the **Refresh Preview** button at the top of the Output panel. In time, you'll see that all twelve images fit quite tidily on a single page.

12. ***Save the PDF file.*** There are lots more options, but they're all perfectly fine as is. (Note that the Overlays area controls the filename labels below each thumbnail. Prior to CS4, you had three font choices; now you can choose any font loaded on your system.) Confirm that your settings look like those in Figure 12-24 and you see twelve images in the Output Preview panel. Then scroll down to the bottom of the Output panel and set the remaining options as follows:

 - In the **Playback** area, turn off the first check box, **Open in Full Screen Mode**. We're interested in printing, not slide shows; turning this option on merely creates confusion.

 - Turn on the **View PDF After Save** check box, located at the very bottom of the Output panel.

 - Click the **Save** button. I recommend you name the file "Max Mural" and save it to the *Lesson 12* folder, if only to make it easy to locate later. A message appears reading "Generating PDF Contact Sheet."

A few moments later, the Bridge will attempt to launch your preferred PDF viewer. (If you don't have one, go to *www.adobe.com* and download the free Adobe Reader utility.) Now you're ready to print the contact sheet. Choose **File→Print** or press that ubiquitous keyboard shortcut, Ctrl+P (⌘-P). Your printer should deliver a page like the one in Figure 12-25.

FYI, you can also use the Bridge's Output feature to print ready-to-go pages for a photo album. Just choose Maximize Size from the Template option at the top of the Output panel. The Bridge will deliver a single multipage PDF file that you can print *en masse*. Plus the document serves double duty as an on-screen slide show.

Figure 12-25.

WHAT DID YOU LEARN?

Match the key concept in the numbered list below with the letter of the phrase that best describes it. Answers appear upside-down at the bottom of the page.

Key Concepts

1. Output
2. Subtractive primaries
3. Color separation
4. Print
5. Photo-grade paper
6. Commercial prepress
7. Color profile
8. Color Settings
9. Dot gain
10. Gray component replacement
11. Output Preview
12. Open in Full Screen Mode

Descriptions

A. A loadable file that describes a specific flavor of RGB or CMYK that is uniquely applicable to a display or print environment.

B. The most popular method for transferring dark pixels from the Cyan, Magenta, and Yellow channels to the Black channel, thus producing rich, volumetric shadows.

C. This command lets you scale an image on the page, determine the paper orientation, and adjust the color management settings before printing an image.

D. The output that occurs before a document is loaded onto a professional printing press for mass reproduction.

E. The act of preparing and rendering an image for mass reproduction, usually as a CMYK document.

F. A new panel in the Bridge that permits you to see a multi-image PDF document or Web gallery before saving it.

G. The command that defines the RGB and CMYK color spaces employed by Photoshop.

H. A printing process that outputs each of the CMYK color channels to independent plates so that they can be loaded with different inks.

I. The degree to which professionally output halftone dots grow when they are absorbed by a sheet of printed paper.

J. An option that turns a PDF document into an all-consuming slide show the moment you open it in the Adobe Reader utility.

K. Cyan, magenta, and yellow, each of which absorbs light when printed on paper and mixes to form progressively darker colors.

L. A variety of glossy or matte-finished paper that holds lots of ink, allowing you to print extremely high-resolution images.

Answers

1E, 2K, 3H, 4C, 5L, 6D, 7A, 8G, 9I, 10B, 11F, 12J

INDEX

ENJOY a Free Week
of training with Deke!

Get 24/7 access to every training video published by lynda.com.
We offer training on Adobe® Photoshop® CS5 and hundreds of other
topics—including more great training from Deke!

The lynda.com Online Training Library™ includes thousands of training videos on
hundreds of software applications, all for one affordable price.

Monthly subscriptions are only $25 and include training on products from Adobe, Apple,
Corel, Google, Autodesk, Microsoft, and many others!

To sign up for a free 7-day trial subscription to the lynda.com Online Training Library™
visit **www.lynda.com/dekeps**.

lynda.com